MW00788761

Postmodern
Advertising in Japan

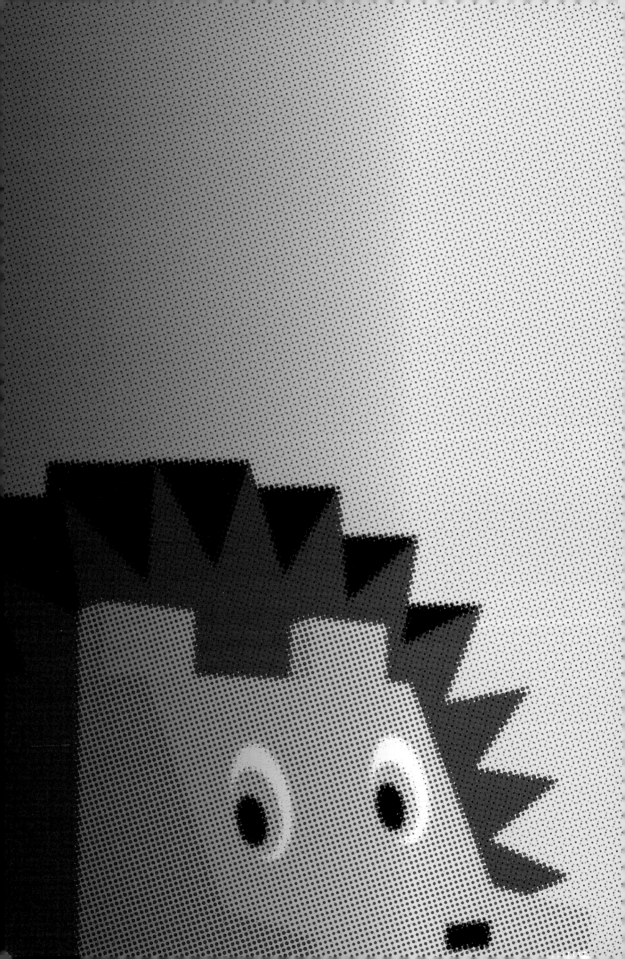

This series, sponsored by Dartmouth College Press, develops and promotes the study of visual culture from a variety of critical and methodological perspectives. Its impetus derives from the increasing importance of visual signs in everyday life, and from the rapid expansion of what are termed "new media." The broad cultural and social dynamics attendant to these developments present new challenges and opportunities across and within the disciplines. These have resulted in a trans-disciplinary fascination with all things visual, from "high" to "low," and from esoteric to popular. This series brings together approaches to visual culture—broadly conceived—that assess these dynamics critically and that break new ground in understanding their effects and implications.

For a complete list of books that are available in the series, visit www.upne.com.

Ory Bartal, *Postmodern Advertising in Japan: Seduction, Visual Culture, and the Tokyo Art Directors Club*

Ruth E. Iskin, *The Poster: Art, Advertising, Design, and Collecting, 1860s–1900s*

Heather Warren-Crow, *Girlhood and the Plastic Image*

Heidi Rae Cooley, *Finding Augusta: Habits of Mobility and Governance in the Digital Era*

renée c. hoogland, *A Violent Embrace: Art and Aesthetics after Representation*

Alessandra Raengo, *On the Sleeve of the Visual: Race as Face Value*

Frazer Ward, *No Innocent Bystanders: Performance Art and Audience*

Timothy Scott Barker, *Time and the Digital: Connecting Technology, Aesthetics, and a Process Philosophy of Time*

Bernd Herzogenrath, ed., *Travels in Intermedia[lity]: ReBlurring the Boundaries*

Monica E. McTighe, *Framed Spaces: Photography and Memory in Contemporary Installation Art*

Alison Trope, *Stardust Monuments: The Saving and Selling of Hollywood*

Nancy Anderson and Michael R. Dietrich, eds., *The Educated Eye: Visual Culture and Pedagogy in the Life Sciences*

Shannon Clute and Richard L. Edwards, *The Maltese Touch of Evil: Film Noir and Potential Criticism*

Steve F. Anderson, *Technologies of History: Visual Media and the Eccentricity of the Past*

Dorothée Brill, *Shock and the Senseless in Dada and Fluxus*

Interfaces: Studies in Visual Culture

Editors Mark J. Williams and Adrian W. B. Randolph, Dartmouth College

Ory Bartal

Postmodern Advertising in Japan

DARTMOUTH COLLEGE PRESS HANOVER, NEW HAMPSHIRE

Seduction, Visual Culture, and the Tokyo Art Directors Club

Dartmouth College Press
An imprint of University Press of New England
www.upne.com
© 2015 Trustees of Dartmouth College
All rights reserved
Manufactured in the United States of America
Designed by Mindy Basinger Hill
Typeset in Parkinson Electra Pro

Library of Congress Cataloging-in-Publication Data
Bartal, Ory.
Postmodern advertising in Japan : seduction, visual culture,
and the Tokyo Art Directors Club / Ory Bartal.
 pages cm. — (Interfaces: studies in visual culture)
Includes bibliographical references and index.
ISBN 978-1-61168-653-1 (cloth : alk. paper) —
ISBN 978-1-61168-654-8 (pbk. : alk. paper) —
ISBN 978-1-61168-655-5 (ebook)
1. Advertising—Japan—History—20th century.
2. Postmodernism—Japan.
3. Art—Japan—History—20th century. I. Title.

HF5813.J3B37 2015 659.10952—dc23

This publication was supported by the Suntory Foundation,
Osaka, Japan.

For permission to reproduce any of the material
in this book, contact Permissions, University Press
of New England, One Court Street, Suite 250,
Lebanon NH 03766; or visit www.upne.com.

5 4 3 2 1

FOR RAMI AND FOR DAFNA

Contents

It was an enigmatic Japanese poster—a powerful, challenging, and seductive advertisement (figure 4.1) that I explore in great detail in Chapter 4 of this book—that first paved my way into this research subject and motivated me throughout my journey. The poster provides a nondescript view into the cycle of death, creation, and life, a notion that took on great personal meaning for me, as this research commenced shortly after the death of my brother and reached its conclusion shortly after the birth of my daughter. I dedicate this book to the memory of my brother and to the wide-open future of my daughter.

My gratitude goes to Saitō Makoto, not only for intriguing me with this powerful image that he created, but also for his warm welcome and his goodwill in discussing with me his fascinating works. I would also like to thank all the art directors of the Tokyo Art Directors Club who kindly assisted me in my research. Their insight was a major contribution to this work. Special appreciation goes to Yoneyama Yoshiko, who introduced me to many art directors and helped me navigate the mysterious field of graphic design in Japan.

I express my gratitude to the many people who saw me through this book; to all those who provided support, offered comments, and assisted in the translating, editing, and proofreading; to my mentors Professor Jacob Raz and Professor Ben-Ami Shillony for their wonderful lessons throughout the years and guidance through this research; to my colleagues Professor Ofra Goldstein-Gidoni, Dr. Michal Daliot-Bul, and Dr. Shalmit Bejerano, who helped me understand the different contexts of contemporary Japanese society.

I am indebted to Professor Orly Lubin and A. B. Yehoshua for their insightful guidance on the structure of the book, and to the late Naomi Aviv, who introduced me to the language of contemporary visual culture.

I give warm thanks to my mother, Dr. Ruth Bartal, for her patient, endless, and merciful reviewing of my research material in its various forms.

Many thanks to Pnina and Brad Young, who translated and edited this

book and encouraged me along this voyage. Their comments were enlightening and of great help.

I would also like to thank the University Press of New England for their professional and caring guidance that enabled me to publish this book. The publication of this book was made possible by the generous support from the Suntory Foundation, Osaka, Japan.

And finally, this book would not have been possible without the support and encouragement of the Bartals and the Samuels, my family, whose continuous warmth envelops me every day with love.

Postmodern
Advertising in Japan

In 1969, Tokyo experienced the opening of a new department store. Now a landmark of the Japanese consumer landscape, the Parco department store was the initiative of the Seibu Saison Group, a Japanese holding company whose broad array of assets included railroads and a baseball team.[1] From its initial planning, Parco was envisioned as a department store that would combine culture and commerce by including small boutiques, gourmet restaurants, quality bookshops, and a gallery.[2] While other department stores were designed to be places of product consumption that provided restaurants and galleries as added value for customers' entertainment, Parco aims to offer its customers consumption of cutting-edge culture in the fields of music, movies, publications, theater, and visual art, as well as fashionable products. By blurring the boundaries between merchandise, leisure, and cultural consumption, Parco transformed shopping into a recreational experience. The new department store enabled Tokyo consumers — mainly women, as they were the primary focus of the initiative — to spend an entire day under one roof, satisfying all their needs without running from place to place in this highly mobile city.[3] The entrepreneurs envisioned Parco as Paris's Georges Pompidou Center crossed with New York's Bloomingdale's. To further underscore the theme of a multinational cultural park, the developers chose the Italian word for "park" as the store's name.

To match the unique nature of this commercial endeavor, Matsuda Tsuji, Parco's manager, turned to Ishioka Eiko, a young graphic artist and member of the Tokyo Art Directors Club,[4] to generate awareness through an innovative advertising campaign. The campaign that ensued represented the start of a new era in the aesthetics of visual communications.

Ishioka, who would later go on to tremendous success in art directing and stage and costume design, including winning an Academy Award in 1992, was given the responsibility of creating an advertising campaign that targeted the young women of Japan, who in the 1970s had recently joined the workforce en masse while still primarily living at home with their parents.[5] This enabled them to save money for travel and recreation, and turned them into

a sector with massive purchasing power in Japan and one of the wealthiest worldwide.[6]

Ishioka met this challenge by kicking off an advertising campaign that presented the department store in a more avant-garde light than the initial idea of the store itself had called for. The campaign established Parco as a location for powerful women to showcase their personality, engage in cultural activities, and fulfill their fantasies.[7] By embedding ideas and messages steeped in the radical feminism and social protest that were prevalent in the United States at the time and had recently arrived on Japanese soil, the campaign's advertising posters spoke out against the social conventions of the time.

The power of women was not presented via glamorous models but rather by highlighting the female roles that had been previously unacknowledged. Ishioka was the first art director in Japan to present women of color, in natural settings. One advertisement showed an African woman dressed in a tribal costume, carrying her baby (an alternative setting of this same subject even showed her breast-feeding), with a slogan stating "Superstar of my heart."

A second poster bearing the slogan "Are they career women?" showed Indian women in the Rajasthan desert carrying heavy water containers on their heads. Ishioka was not trying to exoticize their "primitive" character, but rather to underscore the universal character of female roles and of female identity across cultural borders. One advertisement presented a model posing provocatively with the slogan "A model is not just a face," implying that a woman is more than just a clothes hanger or a sex object for viewing pleasure (figure 1.1).

Ishioka dared to present female nudity with slogans that referenced the male viewpoint, delivering a message that seemed to state "*Stop looking at nudity. Why don't you yourself undress instead?*" The slogans change the meaning of the images by speaking directly to the viewer's gaze, referring to the ideas that were formulating in his or her mind, rather than referring to the subject displayed in the ad.

Ishioka later went on to present male nudity, for the first time referring to the female point of view. The male pop star Sawada Kenji (known as Julie) was shown in the nude with the slogan "It's time to gossip about men."

Another poster introduced erotic undertones and a "gender-bender" theme by placing a jazz dance group and the actress and dancer Ann Reinking in an advertisement for Parco in the Kichijyōji neighborhood, with the all-male band members dressed in skimpy erotic dance costumes usually worn by women. The image was accompanied by the slogan "All That Jyōji!" in reference to the film *All That Jazz* (figure 1.2).

モデルだって顔だけじゃダメなんだ。

PARCO

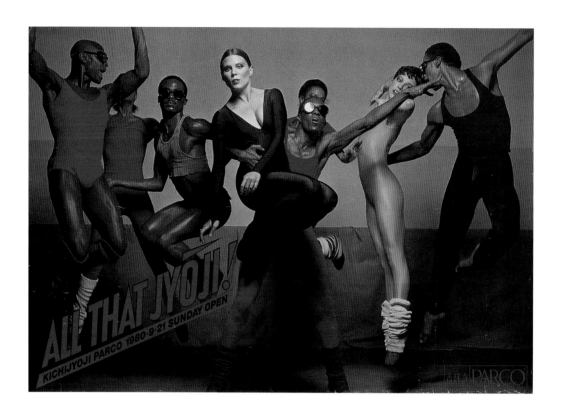

As the campaign continued over a full decade, the revolutionary nature of the posters also continued, through visual graphics as well as slogans: "Man, be beautiful for women," "Women, be ambitious," and more poetic statements such as "The nightingale sings only for itself."

The campaign was so successful that a new slang word, *parco-teki*, was coined. Literally "Parco style," the term came to mean something sophisticated, complicated, and difficult to understand. This advertising campaign, as well as the novel idea of the department store itself, remains strong in the memory of many Japanese to this day. The most remarkable thing about this campaign was the way that it avoided presenting the store itself or any of the products sold by the store. Instead, the campaign presented an avant-garde perspective on controversial social subjects, expressing the values of the target audience. These values of fashion, music, and gender touched on fantasies of the young generation of Japanese women regarding third world cultures, pop culture, and the 1960s American protest movement. This ran in complete conflict with all conventions at the time. "When you look at one Parco poster, you cannot understand it," said Matsuda, the store's manager. "You have to look at the entire campaign to understand who we are."[8] In this statement, Matsuda refers directly to the theme of message fragmenta-

tion and to the new focus on subject matter (i.e., on the social values of the consumer)—the underlying basis of a new postmodern advertising strategy. This strategy represented an emerging zeitgeist that stood out in contrast to the focus on objects (i.e., on the functional value of the product)—the main strategy used in modern advertising.

In Japan of the 1980s—a time marked by tremendous economic growth and significant consumption during a bubble economy—the success of the Parco advertising campaign paved the way for a new genre in Japanese advertising, which was adopted and applied to products in the very heart of the consumer culture. In this genre, the actual products being offered were presented minimally or, more often, not presented at all. Verbal and visual expression appeared to be unrelated to the company identity or to its products. The text is open to multiple interpretations, and the core advertising concept being conveyed appears at times to be the antithesis of advertising. This differed from the modernist approach to advertising poster design prevalent at the time, which came down from earlier in the century via constructivist artists and designers such as El Lissitzky and Alexander Rodchenko as well as functionalist Bauhaus designers such as Herbert Bayer and Jan Tschichold. These designers professed a design concept in which a poster should attract attention, stop the viewer momentarily, and quickly transfer a convincing message about the product. The new advertising genre seemed to lack any concept at all and left viewers (both Japanese and "outsiders") wondering "What is the product/company?" This kind of visual communication shook the advertising world to its core, raising the most basic questions regarding the role of advertising.[9]

The modernist concept had already begun to erode in the late 1960s, when a small group of designers in San Francisco created posters for the rock-and-roll bands that were performing at the legendary Fillmore club. The posters created there—by Wes Wilson, Victor Moscoso, Alton Kelley, Stanley Mouse, and Richard Griffin, who became known as the "Big Five" of psychedelia—were the first bullets fired in a revolution that renounced the modernist viewpoint.[10] According to their new concept, the design idea of any poster is based on its complexity and enigmatic nature. These revolutionary posters strove to break from the inherent coherence and stiffness associated with the dogmatic postwar Swiss design (later known as modern international style) considered "Good Design" of the 1950s.

Avant-garde graphic design began to spread beyond the Big Five of psychedelia, with significant steps taken by Japanese designers such as Yokoo Tadanori and Hirano Kōga, who created posters for the avant-garde theater

FIGURE I.3
Milton Glaser,
"Valentine"
© Milton Glaser

of the 1960s, and the British designers associated with London's punk move-ment in the 1970s.[11] But despite the significant phenomena in graphic design, these advances took place primarily in countercultural margins of society or for entertainment-related events. As innovative as they were, they had very little influence on advertising posters for commercial products.

In a few rare cases, postmodern design concepts were used for mainstream consumer products. The most noteworthy of these is a poster designed for Olivetti typewriter by New York–based Milton Glaser of Push Pin Studio in 1968, with its vague connection between image and product and blurred boundaries between art and design. The poster shows a dog guarding a per-son who is lying down, with only his/her feet shown (figure I.3).

The narrative of the guard dog watching a person whom we presume to be dead is unclear, and the picture is overtly enigmatic. The enigma inten-sifies when we discover the typewriter placed on the floor and we seek a connection between the man and the dog and the typewriter. The metaphor challenges the consumer to find the connections and build the narrative. The first association that comes to mind is that of a murder scene, leaving the viewer to somehow solve the mystery, taking the role of a television-show detective. The viewer finds the next clue in the Italian Renaissance painting style of the poster and the word "Valentine," which refers to a love narrative and to the dog's loyalty to his master. This hints at the national origin as well as the classical quality of the Italian typewriter, a tie that is further reinforced when we discover that the image in the poster is actually a detail from the margins of Piero di Cosimo's painting *The Death of Procris*, which tells the story of the inadvertent killing of Procris by her husband Cephalus.[12] By appropriating a detail of a Renaissance painting, the Olivetti poster blurs boundaries between art and design and creates an enigmatic metaphor for a commercial product.[13]

But unlike in Japan, this revolutionary genre eventually faded out from the Western advertising world, to remain dormant until the innovative corporate identity campaigns of Benetton and Absolut Vodka reignited the flame in the mid-1980s. At least part of the reason for the resurrection of avant-garde in Western advertising must be placed squarely on the shoulders of what came out of Japan. In Japan, the avant-garde advertisements were widely effective within the heart of consumer culture. The Japanese conglomerates were suc-cessful in establishing stronger corporate identities via this advertising genre, and consumer product sales grew significantly. Most tellingly, the advertising style was by no means a passing phase, instead being adopted by department stores, fashion companies, food companies, transportation companies, and other major nationwide corporations.

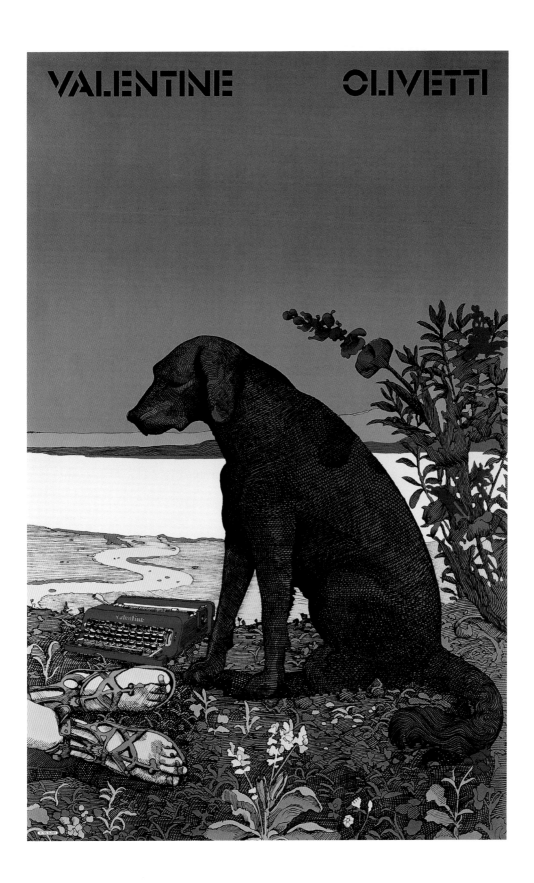

At its core, this genre was developed as a marketing tool and had a clear business objective: improving sales via the development of a noticeable corporate identity, strongly differentiated from competing companies and their products. This new marketing strategy can be seen in Seibu's "image strategy" of the mid-1970s, in which CEO Tsutsumi Seiji, who also led the company's publicity department, prioritized corporate image in the store's marketing presence.[14] Indeed, the genre succeeded in meeting these business goals. But the works, and the art directors behind them, also won much acclaim in another field—the art scene. Curators in Japan and throughout the world praised the works for their artistic value.

The art directors fed off their initial success, and redoubled their focus on developing the purely artistic aspects within their works. Items were shown in numerous exhibitions in Europe and the United States throughout the 1980s.[15] These exhibitions, coupled with graphic design books covering the new genre and prizes for works in different graphic design *biennales*, created a worldwide sense of mystery surrounding Japanese graphic design. This genre had become an ambassador of the new challenging aesthetic, which had arrived from Japan in the 1980s and broke out on many fronts, bestowing Japan with a reputation as being at the forefront of all matters aesthetic. The posters received the same reaction in Japan—art directors and advertisers became celebrities of the visual arts scene and created posters for gallery display, printing some posters as limited editions.[16] Posters were purchased by museums and private collectors in Japan and around the world, including the Museum of Modern Art in New York.[17]

With expanded global exposure, it might have been expected that Japanese culture would become less intimidating, but this did not occur. Japan remained foreign, enigmatic, and seductive in the collective eyes of the West. The "odd" advertising posters with their vague messages confirmed Japan's unique cultural position and became the representation of Japanese advertising. This viewpoint had the effect of preventing Western observers from identifying any similarities between Japanese advertising and Western advertising, leading to the categorization of Japanese advertising and visual communications as different, odd, unclear, exotic, and enigmatic. Many Western scholars were quick to employ the rather stereotypical perspective that raised a pseudo-anthropological discussion emphasizing a scent of Japaneseness, classifying the marketing activity as "soft-sell" or "mood advertising"—advertising that does not communicate information concerning the product, but rather focuses on the creation of a particular mood.[18] Compressing the entire diversity of Japanese advertising into one frame called "Japanese advertising"

provoked a stereotype-driven reductive discussion about "Japan's otherness," a well-known orientalist narrative. All this could then be summarized into the loaded adjective "Japanese," as if the genre was simply an inherent product of Japanese culture. This led to the most natural next question: What is Japanese in Japanese advertising?

The attempt to create a supposed Japanese identity for these advertisements and show the indirectness and vagueness as influenced by Japanese heritage is a convenient path to pursue, but unfortunately is highly oversimplified. For example, it is easy to assume that minimalist design aesthetics of contemporary design are inspired by the minimalism of Zen Buddhist art of the Muromachi period (1336–1573). But in fact, in the interviews I conducted with numerous advertising designers, it was the Bauhaus philosophy that came out as the primary influence for their minimalistic design. As such, general cultural characteristics and unique social terms (*honne, tatemae, uchi, soto*) are not the main driving force in contemporary Japanese design, and most certainly are not the key to understanding the marketing and communicational structure within Japanese advertising. In the era of globalization there is mass cooperation between Japanese and international advertising companies, and the mutual influence among designers runs almost unchecked. They are influenced by their foreign counterparts through books, exhibitions, the Internet, and international campaigns shown in Japan, as well as via designers and foreign photographers who work in Japan. Global technological innovations (e.g., the Photoshop effect) enabled photography and graphic design to become international. In fact, Japanese designers go out of their way to create a purely international façade, while Japanese identity plays a minor role in their creative process.

The Japanese economy of the 1980s and early 1990s, and specifically the Japanese advertising industry, were the second largest in the world.[19] The Japanese economic ideology is fiercely capitalistic and is as competitive as that of any other nation, with no attention wasted on mystic foundations. As in any other postindustrial country, there are various marketing and communication patterns that influence the aesthetics of the final image. Each campaign goes through an approval cycle that involves several strata of management hierarchy, within the agency as well as at the customer that commissioned the ad.[20] Strategic decisions regarding the content of a campaign are influenced primarily by what message the company wants to deliver, in accordance with campaigns of similar and competitive products, as well as the life-cycle phase of the product (product launch, growth, maturity, etc.). Different product fields (food and beverage, cosmetics, vehicles, retail, etc.)

and media (print, TV, etc.) also influence the communication strategy. With such similarity between the business processes of Japan and other countries, any attempt to show "what is Japanese" is fundamentally wrong, just as merging all the diversity of European and American advertising into a single generic "Western advertising" would be pointless. This image of the Western world as logical and rational, as compared to Japanese as intuitive, is a distinction of convenience. As stated by Brian Moeran: "A number of writers have come to regard Japanese advertisements generally as being somehow more 'intuitive' or 'atmospheric' than they are elsewhere in the world, and even link such 'mood' advertising with blatantly orientalist arguments about Japanese 'cultural dispositions.' Such assertions are never based on quantitative analyses of Japanese Advertising, however, but rather on writers' own intuitive perceptions (or moods) which carefully ignore a number of important issues."[21] Moreover, this orientalist representation seems somehow not innocent. The position held by researchers and curators of the uniqueness of Japanese cultural products was used, among other purposes, as a marketing strategy to enable sales of Japan-related books, exhibitions, and other forms of "packaged" Japanese culture.

Consequently, it is clear that Japanese advertising, just like American advertising, is influenced by global trends, combining interaction among various fields (marketing, social values, and aesthetics). Its complexity cannot be explained via a simplistic reduction to a single model in which Japanese advertising reflects the "Japanese culture" in general, distinct from Western culture. However, it is also clear that the advertising posters do have a Japanese character, in that they were created by Japanese designers to represent Japanese companies who target Japanese consumers. The marketing communications within these posters is linked directly to the Japanese culture, since both the communicator and the receiver are products of an identical culture, using words, images, ideas, conversational subjects, and core values that are grounded in local Japanese codes. Thus, I aim to revisit the question "What is Japanese in Japanese advertising?" and offer a new perspective, via the junction of a wide variety of logic structures that act behind the scenes of these Japanese advertising posters. Through analysis of advertisements, I discuss communication patterns and contemporary Japanese values, in all their breadth of meaning, considering contemporary social, economic, and aesthetic parameters. This discussion sheds light on how the posters indeed have noticeable Japanese characteristics, albeit not those that are linked to the orientalist image of "Japanese culture."

The full inventory of Japanese advertising posters includes a large majority that are most often similar to American posters. However, this book

focuses on a very specific genre—the enigmatic and controversial genre that became representative of "Japanese advertising." This genre is relatively small, amounting to somewhere between 3 percent and 5 percent of overall advertising placements.[22] I present the subject as is, not as a representative of "Japanese advertising," but as a subject that is in and of itself worthy of study, for its revolutionary nature and for its function and impact on overall marketing and business strategy.

Most of the advertisements within this genre were created by members of the Tokyo Art Directors Club (Tokyo ADC), a rather small and exclusive club of seventy-eight art directors who have unique and individual approaches to graphic design, based on a clearly defined artistic and business strategy. As most of these posters are centered in the realm of corporate identity (and not product promotion), it becomes clear that corporations typically commissioned these individual art directors to create enigmatic, avant-garde posters in order to present a cutting-edge corporate identity and to adapt their corporate identity to the changing business environment of the late consumer society. The members of the Tokyo ADC approached these new projects with a distinct agenda for change, in both the new business values and the emerging postmodern aesthetic and communication patterns. As such, their work from the outset had a nature of being a sandbox in which to experiment in building something new.

This book presents the Tokyo ADC, their position in the Japanese advertising industry, and the advertising campaigns that they created. The campaigns are explored in their true contextual size and import vis-à-vis the wider Japanese advertising world: as a unique and small advertising genre originated by elite designers who were explicitly tasked with creating enigmatic and complex posters.

The visual strategy of the advertising posters is explored in the aesthetic context of the 1980s Japanese consumer market. In the 1980s a new aesthetic milieu emerged that created avant-garde design. This milieu included architects (Andō Tadao, Isozaki Arata, Maki Fumihiko), fashion designers (Miyake Issey, Kawakubo Rei, Yamamoto Yohji), and product designers (Umeda Masanori, Uchida Shigeru, Kuramata Shirō) who created challenging visual concepts, deviating from traditional Japanese aesthetics and international trends. The Tokyo ADC group and their enigmatic posters represented the graphic design "department" of this milieu.[23] Their works are commonly tagged as part of the Japanese version of the emerging postmodern visual culture that was fashionable in design around the world at the time and has been commonly studied using traditional methodologies for analysis in the field of art history,[24] beginning with the early iconographic and iconological

methods of Erwin Panofsky, through the psychological analysis of Rudolf Arnheim, the sociohistorical approach of Michael Baxandall, and the semiotic studies of Roland Barthes and Judith Williamson. Brian Moeran, whose work employs a semiotic analysis, is nevertheless aware of the fact that this theoretical model does not allow for a full understanding of advertising images.[25] He justly argues that the individual advertisement is one fragment of a wider advertising and sales campaign. Since the advertising campaign is primarily shaped by marketing goals rather than by creative concerns, advertisements are affected by the unfolding of a dynamic social process between the advertising agency, the company, and the art director.[26]

Thus, although advertisements depict visual frames, they cannot be understood in an aesthetic path alone. In order to effectively analyze the full scope of advertising posters, a multifaceted approach is needed that integrates different fields such as the *management-economic variables* of the commercial companies, including the structure of the Japanese advertising industry and the unique procedures that occur in it, along with the new logic of the late consumer culture and new economic values; *social variables* such as the target audience and its changing values in the new social paradigm during these years; and *aesthetic variables* such as the new aesthetics that arose in the 1980s. Investigation of these aesthetic variables — including the new aesthetics of the 1980s, the orientation of the design in this period, and the globalization of the visual image creating international taste of designers and clients — is warranted. An awareness of the dynamics among these fields is essential to understanding advertising in general and Japanese advertisements in particular. However, despite a consensus that visual images not only represent social issues, but also trigger social processes and changes, the different approaches of social sciences (such as sociology, anthropology, psychoanalysis, communication) lack methodological modes and terminology to analyze the aesthetics of images (colors, composition, etc.) and their meaning in social context.[27]

To date, the power of aesthetics as a marketing tool has not been sufficiently researched, not only because aesthetics were not part of social studies, or because their quantitative methodologies were problematic when studying industries that have so many nonquantifiable parameters, but also because until the 1970s, the relevant academic fields (economics, business administration, art history) considered the advertising field to be in the realm of popular magazines and thus not appropriate as the object of academic research.[28] As such, management-oriented research missed the strength of the visual expression and aesthetics as marketing tools. When social sciences and the humanities, under the influence of postmodern theories, eventually ventured to

investigate the fields of popular culture, including advertising, they most often dealt with cultural issues such as the creation of meaning or the relationship of low and high culture, ignoring questions related to marketing, management, and the role that industry structure and procedures play in creating the final image. I propose a new qualitative methodology that integrates grounded theory created by in-depth interviews (a social science–based methodology) with visual social-semiotic analysis (a humanities-based methodology).[29] This model, which investigates the aesthetic and symbolic layers of the image in the socioeconomic context of the time, stems primarily from disciplines of visual culture that involve aesthetics and theories of social issues.

Being an image-driven scholarship, the research started by choosing selected advertisements (which were carefully chosen from a database of six hundred advertisements) according to common sampling methods such as quota sampling and purposeful sampling, in order to represent different industries and different points in question in the advertising field.[30] After the selection of the advertisements, it became clear that they were all created by art directors of the Tokyo ADC. Thus the field of research has been confined to advertising posters created by association members in the 1980s–1990s. From approximately fifty art directors who created the selected posters, I chose thirteen to be interviewed.[31] This selection was also made according to common sampling methods, such as quota sampling and purposeful sampling, in order to represent the different aesthetic strategies and the different generations within the association.

Data collection was done via semi-structured in-depth interviews that were conducted in Japanese. The interviews underwent content analysis procedures and included a critical approach as part of the analysis. The discursive themes that appeared in the analysis created new categories that were not part of the conventional research of Japanese advertisement, such as the influence of the industry structure, the client's demands, and the designer's personal taste. The combined methodology enabled illustration of the involvement of many complex fields and changeable factors, such as the gender, age, and social status of the target audience, as well as the creator's individual style and aesthetic values and standards. It contributed to the understanding of the visual and symbolic layers of the images through the eyes of the viewer, yet gave space to issues that were important to the creators. Moreover, it did not force my point of view as a researcher, or the standpoint of a specific theoretical model that might sometimes determine the result a priori.

On one hand the interviews supplied many details that the semiotic analysis missed. For instance, who was the target audience? What was the life-cycle stage of the product/company? What were the requests of the

customers? What was the part of the single advertising poster in the whole campaign media mix? What kind of parallel advertising campaigns existed at the same time? How was the differentiation between parallel campaigns created? What was the budget of the campaign, and what was the marketing trigger that generated the image? On the other hand, it became clear that the creators could not always describe their aesthetic decisions or the sources of inspiration. The interviews revealed mainly the everyday practice of graphic design processes and the marketing strategies. The semiotic analysis amplified the text by revealing the sources of inspiration such as the influence of international campaigns and graphic exhibitions, local trends, traditional and contemporary local motifs, and the social-ideological contexts in which the works were created.

As part of the interview, I presented to the art directors my primary semiotic analysis of their works. It was very important to see their reaction. Were they able to find their way of thinking and style identity in the semiotic analysis? Do they identify the sources of inspiration? It is important to note that in many instances their associations were different, but all of them agreed that the poster should be read in many ways, and most of them accepted my semiotic analysis and added their own assumptions. The final visual analysis includes their premises.

The data collected in the interviews present the poster not only as a final product, but also as a social process: part of a complex relationship involving the creative industries, the creator, the company, the advertising agency, and the values of the target audience.

This integrative approach makes it possible to study the influence of marketing strategy on the aesthetics of the final image and thus presents the advertising industry as a creative industry that fully integrates socioeconomic factors and creativity. It also shows the role of the image and aesthetics within the marketing context of the late consumer market. Since these posters are multilayer products of the contemporary culture (with communicational, marketing, cultural, and social roles), their analysis as a social process and as a final product constitutes a case study for the new style and visual culture of Japan, which is expressed in the late consumer culture that merges economics and visual systems, creating the contemporary social ideology of Japan. This kind of information cannot be obtained from image analysis alone or from interviews alone. Taken together, the four different parts of this book offer an integrated study of art, design, business practices, social developments, and modern history, reading the aesthetics that are demonstrated in the advertisements back into the sociology of consumption of postmodern Japan. Building

on an examination of the interactions between these underlying forces, I analyze the creation of the images in question and their meaning. Part 1 of the book presents the historical forces that shaped advertising design in Japan. Chapter 1 deals with the history of advertising design in Japan beginning with Japan's industrial revolution, and the development of mass media following the Meiji Restoration. This chapter revisits the question "What is Japanese in Japanese advertising?" and presents evidence from the mid-nineteenth century through the 1980s that shows how Japanese advertising design was involved in a consistent dialogue with Russian, European, and American design trends. This historical data reveal that the orientalist view of Japanese advertising design as representing a unique visual language lacks valid substance. Chapter 2 sheds light on the history and the social context of the Tokyo Art Directors Club. It presents the role of its members—self-identified esoteric creators—in changing the world of advertising design in Japan.

Part 2 of the book presents the aesthetic forces that were involved in the creation of these advertisements. Chapter 3 explores the visual language employed by Tokyo ADC designers. This language, which forged a new avant-garde aesthetic that blurred the boundaries between art and design,[32] emerged within the elite aesthetic milieu created in Japan during the 1980s, which included architects, fashion designers, product designers, graphic designers, and post-pop artists. Although their works constituted only a small percentage of the works created in these different fields during this period, they have come to represent contemporary Japanese style, while bespeaking an affinity with contemporary urban culture. Chapter 4, which constitutes the core of this study, presents the visual communication strategies employed in the Tokyo ADC advertisements, and analyzes the group's avant-garde and postmodern concepts in the context of their works.

Part 3 of the book presents the marketing and business forces that played a part in the creation of these advertisements. Chapter 5 centers on marketing communications in late Japanese consumer culture. The advertising campaigns in question are analyzed in relation to the new "logic" of late global consumer culture and to its new standards, principles, and economic values, as argued by Jean Baudrillard in his book *For a Critique of the Political Economy of the Sign*. As this chapter reveals, the postmodern aesthetic conventions employed in these advertisements served as a marketing strategy reflective of the postmodern economic values associated with the corporate identity of the commissioning company or with the product itself. This new visual strategy created a stylistic shift in commercial design from the ideal of "form follows function" to that of "form follows emotion." Ac-

cordingly, the company identity and image dictated by this "logic," and the related marketing communications strategies, shifted from visual rhetoric to visual seduction, as required in the postmodern era. Chapter 6 presents the impact of the Japanese advertising industry's unique structure and business processes, which dictated new marketing strategies and new forms of visual seduction. This chapter presents the Japanese advertising industry as a creative industry that fully integrates social, economic, and aesthetic values. It also examines the new Japanese consumer, who prefers being challenged to being right. Finally, it shows how art directors took into account the new consumer's values and visual intelligence when creating the advertisement.

Part 4, the last section of the book, presents the forces of social values that appeared in the advertising of the era through local and "glocal" aspects of contemporary Japanese advertising design through the 1980s and 1990s, with "glocal" signifying a meeting point between global influences and local culture practices that creates new values and aesthetics that are synthesis of both. It analyzes the visual expression of the posters and their marketing strategies, while referring to the new socioeconomic context in which they evolved—a context shaped by the circulation of global thinking patterns and ideas that created glocal Japanese experience during the 1980s and 1990s. In this context, the advertising genre analyzed in this book is revealed to be far from a unique Japanese phenomenon. This section examines the advertising genre in question, in relation to two different axes—a global one and a local one. Chapter 7 explores the global axis of the 1980s, while comparing the strategic similarities between Japanese advertising campaigns and other campaigns that represent European postmodern advertising throughout the postindustrial world, such as the Benetton campaign. This chapter also presents the positioning trend of products as local as opposed to foreign product positioning. Chapter 8 presents the glocal atmosphere of the 1990s via the integration of classical Japanese themes that appear in advertising (such as the seasons of the year) alongside contemporary discursive themes (such as body culture, ecology, and virtual technology). This multidimensional investigation compares the Tokyo ADC visual-cultural text to parallel advertising campaigns throughout the world, while exploring aesthetic conventions, changing Japanese social values, and hidden discursive themes. Taken together, these two axes capture the spirit of a polyphonic and glocal multicultural era, in which selection procedures and dynamic combinations bring together traditional and contemporary Japanese and foreign components, merging them into an effective Japanese glocal style.

1

The
Historical
Forces

1 A Brief History of Japanese Advertising Design

Japanese advertising design in the postmodern age, and more specifically during the 1980s and 1990s, was shaped by rapid globalization and the development of the information superhighway. This period was characterized in Japan, as in other postindustrial countries, by the accelerated circulation of products, financial transactions, technological innovations, media, information, values, and ideas. It gave rise to phenomena ranging from institutional isomorphism to exchanges in the realm of popular culture, thus allowing cultural collaborations, interchanges, and adoption of global thinking patterns, expressive forms, and stylistic elements.[1] As part of this process, advertisement design came to be influenced by globally used design software, while international campaigns and design exhibitions allowed for, and sometimes dictated, the circulation of different styles from one country to another. In this context, which was further shaped by global marketing practices, media networking, and the rise of new media, advertising design started to present a range of global styles embedded with hidden values, which served to assimilate new cultural meaning to old products. The global character of these values undermined notions of cultural specificity, so that the concept of a "Japanese style" became evasive or irrelevant.

Yet, despite the association of the postmodern era with the spread of global and eclectic styles, this chapter revisits the question of "What is Japanese about Japanese advertising?" By examining evidence from the period beginning with the Japanese industrial revolution of the mid-nineteenth century through the 1980s, I show how Japanese advertising design consistently evolved parallel to international developments long before the postmodern age, as Russian, European, and American design trends influenced Japanese tendencies and were influenced by them in turn. The impact of these influences, as I will show, was far more substantial than that of traditional Japanese visual culture. In fact, Japanese designers saw themselves as an integral part of the international design world even prior to the global era, and still feel that way today. The following discussion thus serves to undermine the orientalist conception of a "Japanese style," revealing it to be an invalid stance.

Meiji Era (1868–1912):
The Introduction of Foreign Style

The beginning of the Japanese advertising industry goes back to the Edo period (1603–1867), with the rise of the merchant class in the urban centers and the improvement in print technology that enabled new media such as the *nishiki-e*, *hikifuda*, and *kibyōshi*.[2] These types of flyers, billboard posters, and books blossomed during the Edo period following the invention of woodblock printing, and sometimes promotional items (*keibutsu*) were even distributed to consumers along with the actual products.[3] This format is a continuation of marketing strategies that began even during the Heian period (794–1185), when *noren*, or seals, on miso and *nihonshu* (sake) barrels were used for promotional purposes.[4] However, the Meiji era was seminal to advertising design mainly because it brought a new openness to what was perceived by Japanese as "Western" culture, particularly that of Europe and the United States.

During this period, many Japanese students went to study in Europe, importing back to Japan new ideas, objects, technologies, and styles that influenced Japanese commercial design. These new Western technologies and ideas were labeled "modern," so that the terms "Western" and "modern" came to be viewed as parallel or interchangeable concepts.

This period saw the appearance of the first newspaper advertisements for imported Western objects such as fuel oil stoves, and clocks, as well as for cafés, new hairstyles, and a new architectural style represented by the *rokumeikan*—a foreign-style building constructed to provide housing for guests of the government and which became a symbol of this period.[5] Advertisements during this period also introduced books that helped explain English-language influence on Japanese society, such as manuals offering transcriptions of English words in Japanese letters.[6] Since the foreign cultural influences that penetrated Japan during this time were associated with "modernity" and were adopted by high society (as expressed in popular culture, and in parties held at the *rokumeikan* or at the Imperial Theater), these values came to be thought of as desirable by other sectors of Japanese society. In the consumer culture of this period, such objects and the Western style they represented were frequently featured in advertisements. This genre of advertisements, which displayed Western objects, was shaped by the graphic style of foreign advertisements and promoted the new value of "modernity," which differentiated between international commodities and local ones. During this period, for instance, Western couture houses introduced new methods

of tailoring into Japan. These methods were responsible, among other things, for designing Japanese military uniforms that came to be known as *yofuku* (Western clothes), as opposed to *wafuku* (traditional Japanese clothing). An advertisement for the Yanagiyaten fashion house, which was published in *Shimbun Sakushi* in November 1871, depicted a caricature of the Western style: "It's awfully interesting to see people wearing Russian hats, French shoes, English vests, and American army pants. The customers are not to be blamed for this state of affairs—rather, it is the responsibility of the merchants, who are not truly familiar with the Western style. In our store, however, we promise you access to garments made by real Western tailors." This advertisement also featured Western hairstyles. It represents not only the desire to dress in a Western manner, but also to familiarize oneself with this style and with the latest changes in Western fashion.[7] The reception of foreign cultural influences during this period, however, was largely superficial, and was given expression through the collection of material objects and products. The appropriation of items associated with Western culture parallels the trend known as *japonisme*—the collection of Japanese objects among upper-class Parisians during the same period.[8] For example, an important slogan that appeared at the end of the Meiji period was "Today at the Imperial Theater and tomorrow at Misukoshi" (*kyō wa teigeki, ashita wa mitsukoshi*). The Imperial Theater, which was established at the turn of the twentieth century, exclusively featured Western plays, and became one of the symbols of Western entertainment and culture. The Misukoshi department store, which was founded in 1904 and had its roots in the Edo-period store Echigoya, appropriated the theater's reputation and values in order to brand the products it sold.

In the late nineteenth century and early twentieth century, however, the wars with China (1894–95) and with Russia (1904–5) gave rise to patriotic and militaristic tenets and sentiments that led to a new emphasis on virility. In the context of material culture, this emphasis led to the promotion of products such as cigarettes, soap, etc.[9] These new trends and values gave rise to new styles that were presented in advertisements and communicated through the brand names of new products such as Daishōri (great victory) soap, a soup called Nottorijiru (soup of conquest), and cigarettes called Bunkoku muteki tabako (tobacco invincible in a thousand states) and Kinshi (the name of a medal awarded to heroes of the war with China). This allusion to the discourse on war was further elaborated upon in an advertisement published in *Asahi Shimbun* in November 1894, which depicted four Chinese heads skewered on a sword.[10] The hidden forces beyond these trends were

the big conglomerates of that era (*zaibatsu*), which profited from the wars and imposed their imperialistic and capitalistic ideology by introducing new concepts of consumption. The patriotic ethos and the ideal of virility became common publicity codes that served to differentiate the promoted products from other products that were marketed at the time as "Western." One especially interesting example is offered by advertisements for medication against venereal diseases. This subject, which was taboo before the wars, garnered much interest in their aftermath, and was freely addressed in large-format advertisements. Ironically, the sick soldiers were nicknamed *kunsho ni kagayaku* (adorned with decoration)—a reference to the medals they received after the Russo-Japanese War.[11] More common advertisements during this postwar period promoted pharmaceuticals, cosmetics, and books.[12] The Meiji period saw the continuation of marketing techniques that had already been used during the Edo period, such as advertisements plugged into novels.[13] So, for instance, advertisements for Juntendō beauty products appeared in a short story titled "An Aristocratic Marriage," which was published in 1907 in the magazine *Jiji Shimpō*. The protagonist of this story, an aristocratic girl, uses this company's beauty products.

Another common advertising technique, which had emerged already during the Edo period, was created by commercial companies that employed local artists to shape their corporate identity and advertising,[14] such as the story of the Takashimaya department store: During the Meiji period, the store employed *nihonga* (Japanese-style) painters such as Kishi Chikudō and Takeuchi Seihō to design products for both the international and the domestic market and to create store decorations. Moreover, the department store often used the name of the artist to promote their products, which became icons of Japanese culture abroad and signs of Japanese national identity at home. Other department stores, such as Matsuya in Tokyo, hired *yōga* (Western-style) painters such as Okada Saburōsuke to create billboards, posters, flyers, and publicity magazines to advertise their domestic products.[15]

This advertising technique created a new style that combined feudal themes from the Edo period, such as paintings of birds and flowers, with European styles. Other posters, such as those for the Mitsukoshi department store, featured beautiful women in order to sell products. The source of inspiration for this style is not entirely clear. One might point to a connection with the *bijin-ga* ("beautiful women") featured in *ukiyo-e* prints, such as those by Kitagawa Utamaro.[16] At the same time, it is clear that designers such as Sugiura Hisui (1876–1965), who created advertisements for the Mitsukoshi department store, adopted the European art nouveau style of Toulouse-Lautrec

posters and the art deco style of Cassandre (Adolphe Jean-Marie Mouron) and Paul Colin. Interestingly, the Japanese viewed these posters as entirely European, failing to recognize the Japanese influences on the art nouveau style.[17] Sugiura became one of the most significant and influential designers of the time and was known in Japan as the founder of commercial art.

Stores developed the graphic design scene by creating competitions such as Mitsukoshi's competition in 1911 to create a new logo for the department store. This advertising trend of "beautiful women" dominated the advertising scene until the late 1920s. It wasn't until the 1930s that the Japanese adopted the abstract, avant-garde expression of the Russian constructivists and the German Bauhaus.

These new styles adopted from Europe and new techniques following the industrial revolution had been introduced to the academy; in 1901, Tokyo Geidai (Tokyo University of the Arts) had opened its Department of Architecture and Design. Many other design schools followed suit, adopting American and European educational methods. This influence was shown soon in the beginning of the century with the new designers who graduated and started working in the advertising scene. Designers began to adopt Western techniques and styles that found their way into Japan following the technical innovations of the industrial revolution. Modern lithography replaced the woodblock print, radically changing the quality and appearance of the printed image. This turn-of-the-century technological shift from relief to lithography brought Japanese graphic art closer in production quality to the graphic arts of Europe and the United States. By 1902, three-color lithography printing was being used for magazine covers, followed a year later by chromolithographic posters, the first of which was an advertisement for Kirin beer.[18]

The Taisho Era (1912–1926)
and Early Showa Era (1926–1937)

In 1923, the Great Kanto Earthquake, following the economic recession at the end of World War I and the beginning of the 1920s, changed the face of Tokyo in almost every manner. The massive rebuilding effort in the earthquake's aftermath buried Tokyo's feudal past under a layer of modern Western style, and not just in terms of the city's physical appearance.

During this period, print media and films served as the primary means for the information flow that came from the West and influenced the consumer culture. Youth began to show interest in Western material culture,

European classical music, and American jazz. Western concepts such as individuality (*kojinshugi*), which became acknowledged during the Meiji period through European philosophical texts, influenced literary movements such as "I-literature" (*shin-sosestu*).[19] In what may be described as a natural development, Japanese society moved from the stage of collecting objects and imitating behavioral patterns or styles that were considered Western, to the assimilation and absorption of foreign values. During these years, new socialist, communist, anarchist, and fascist ideologies began to flourish in Japan parallel to their emergence in Europe. Japan now had the opportunity to prove, both internally and also to the world, that Tokyo was just as modern as London, Paris, or New York.[20] The changing consumer culture and lifestyle also influenced graphic design and advertising. The press focused on the simple luxuries and conveniences that made life pleasurable, such as candies, cosmetics, pharmaceuticals, beer, soft drinks, exhibitions, and performances.[21] Many of the advertisements addressed women whose independence was growing and made time for leisure and consumption.[22]

The profits that advertising brought both to the media and to commercial companies led to the development of the advertising industry and of a new full-page advertising format. Making use of the offset print process technologies that had recently arrived in Japan, graphic designers produced posters of a much higher quality than the ads seen in newspapers, which typically were in black and white with simplistic text copy. Radio became another important media for the dissemination of advertisements.

Advertisement design began to expand beyond just showing the product by adding slogans.[23] Among the companies leading the way was Shiseido, a cosmetics firm founded in 1872 that had long before adopted a foreign visual expression, with Euro-style packaging dating back to 1910. By 1916 their design department handled all matters relating to packaging, newspaper ads, and shop window displays. They preferred illustrations in lieu of photographs. Like other companies, they also showcased beautiful women, but unlike the *bijin-ga* genre, they opted for illustrations of European women.

Fukuhara Shinzō, the son of Fukuhara Arinobu, the company's first manager, was also a photographer who built up the company's design department from scratch. But the art director who truly led the company to a breakthrough was Yamana Ayao. He was personally identified with the Shiseido image all the way through the late 1950s (except for a period during the war when he worked for the Ministry of Propaganda). Like Sugiura Hisui, he was one of the leading designers of the 1920s and 1930s. Yamana and Sugiura, as well as their contemporaries Yabe Sue and Maeda Mitsugu, were influenced

by European visual styles such as art nouveau and art deco, which were first viewed in Japan in exhibitions such as the one curated by *Yomiuri Shimbun* after World War I.[24]

In the 1920s, Japanese magazines copied images from their European counterparts and published them with Japanese explanations, something that was easy to do at the time because of a lack of copyrights on visual images. The magazine *Advertising Design Trade Journal* (*Kōkokukai*), which borrowed visual images from British, French, and German art and design magazines, became one of the most important magazines for advertising and design in Japan.[25] From 1928 to 1930, the magazine *Complete Works on Modern Commercial Arts* was published in Tokyo, edited by Sugiura Hisui. It stressed the importance of graphic design, interior design, photography, and design shops.

Thus, at the same time that European art nouveau and art deco were embraced by companies such as Shiseido, the new avant-garde styles of the Russian constructivist movement and the Bauhaus penetrated the advertising Japanese scene.[26] In the 1930s, Shiseido's design department began adopting modern Bauhaus photographic techniques, while maintaining an elegant art deco expression.[27] Already in 1927, Kōriyama Yukio curated an exhibition of posters he had collected in Europe and the United States. The exhibition included posters designed in the Bauhaus workshops that influenced Japanese designers of the period. Magazines reported on advertising trends and on elite European designers. These reports also had a major role in leading the design discourse in Japan.[28]

During this time of cultural exchange, in search of a modern design style, Otto Dünkelsbühler, a German designer, was hired in 1923 to design a poster for Calpis, a Japanese soft-drink company. The new logo was chosen from 1,275 posters that participated in the competition and introduced the German *Sachplakat* (object poster) style. It became a classic that was remembered for many decades afterward and was republished and transformed into newspaper ads and neon signs.[29]

The feeling of new freedom and the nihilistic, hedonist atmosphere of the Taisho period penetrated society via new coffee shops, brothels, and the translation of books such as Freud's *Psychoanalytic Theory*, which became a best seller at the time. Many advertisements began featuring erotic images—a common theme in art nouveau and art deco. These images received their legitimacy from the Japanese *ero-guro-nonsensu* movement, which sought to explore the deviant, bizarre, and ridiculous in literature and visual culture, and was popular during these years.

By the end of the Taisho period, modernity came to be associated with an emphasis on sensory pleasures. Thus, the conceptual modernism of Russian avant-garde art and of the German Bauhaus movement appeared ascetic and indigestible to most viewers. As was the case in Europe, decorative styles like art deco and art nouveau were, generally speaking, more easily absorbed in Japan than conceptual modernism. But in the 1930s, modernist ideas penetrated into Japanese design school curricula, in which the Bauhaus theories of form-function relationship and design archetypes were investigated. In 1932, Yamawaki Iwao, who studied in the Bauhaus school, returned to Japan and shared his Bauhaus experiences with the New Architecture and Craft College, a school modeled on the German Bauhaus school and directed by Kawakita Renshichirō. Yamawaki lectured there on photography and theater and in other schools on architecture.[30] Design works of the Bauhaus school were discussed and employed in numerous Japanese art school workshops.

The influence of the modern style can be seen in the advertising campaigns of newly emerging national Japanese corporations such as Moringa Confectionary Company, Matsushita Electric, and Kao Soap.[31] Kao, a competitor of Shiseido, and with an advertising budget during the 1920s among the top fifteen in Japan, launched a campaign that changed the face of the commercial design style and played a role in the formation of advertising professions.[32] Gennifer Weisenfeld relates that in 1927, Ōta Hideshige (1892–1982) was appointed head of design in Kao's advertising department, shortly after he had left his position as editor of the Marxist magazine *Shinjin* (New man). At Kao, he was responsible for selecting visual images and slogans for the company's campaigns throughout the 1930s.[33] As an art director with a Marxist worldview, Ōta introduced a new design style during this period. In contrast to the romantic trend that had reigned since the Meiji period, and with a goal of differentiating the company from Shiseido's art nouveau and art deco visual expression, he encouraged his designers to adopt a modernist style, influenced by Russian avant-garde and Bauhaus, that also expressed his Marxist ideology. Like Yamana Ayao at Shiseido, Ōta was a professional art director; he hired artists, photographers, and designers to execute the campaigns. Two of his earliest hires were recent graduates from the Academy of Fine Arts of Tokyo (Tokyo Bijutsu Gakko), Asuka Tetsuo and Okada Masanori, who were strongly influenced by modern Western art and employed modern European techniques in their advertisements.[34]

In 1930, Kao Corporation held a competition to design packaging for their soap products, which garnered the attention of many designers. The winner of the competition was Hara Hiromu, a young designer who attended To-

kyo Metropolitan School of Crafts (Tokyo Furitsu Kogei Gakko), where he studied a new profession called *insatsu zuan* (literally "print design," later known as graphic design) under Miyashita Takao, one of the first instructors to teach graphic design in Japan.[35] Two years earlier, in 1928, Hara had already translated German Bauhaus graphic designer and typographer Jan Tschichold's *The New Typography* (*Die Neue Typographie*) into Japanese, internalizing the modernist design theories. In his ads, Hara abolished any hint of romantic expression and created ads using photography and graphic design influenced by the Russian avant-garde.[36] Under Hara's influence, the Kao campaign adopted machine age aesthetics, elevating typography to be a key element in design rather than secondary information to the image.[37]

Ōta Hideshige also hired commercial photographer Kanamaru Shigene. Kanamaru distinguished between commercial photography and artistic photography, and his photographs were also influenced by the visual expression and graphic design of Russian avant-garde art.[38] Kanamaru's photography introduced the social ideology of the Russian revolution as found in the works of Alexander Rodchenko and El Lissitzky and the graphic design that appeared in USSR *in Construction* and other Russian magazines.[39] The ads for Kao with Kanamaru's photographs were among the first to be published on full pages of Japanese newspapers.[40]

Kao's advertising campaign had a great impact on the modern Japanese design scene. The seeds of Bauhaus style and ideology planted during this era became an influential design theory after World War II. To this day, many art directors refer to the impact of Bauhaus and the Ulm school on both their studies and their works.[41]

The War Period (1937–1945)

The colorful Taisho era, with its culture exchanges, ended in 1926. Ten years later, at the beginning of the Showa era, Japan fell deep into the Asia-Pacific War and World War II. During these years, Japan collaborated with Germany and Italy, and the cultural exchange with the Soviet Union, England, France, and the United States that was previously so active came to an immediate end.[42]

At the beginning of the war, the press was teeming with propaganda that glorified the regime and the war itself and recruited people for the war effort. Since the occupation of Manchuria, the Japanese public reacted to the war with excitement for the new spirit of imperialist Japan. Any semblance of inferiority toward the West disappeared, replaced by national pride. Patriotic

associations that glorified the war and the new Japanese spirit appeared in all streams of culture and art.[43] The new ideology, which revolved around loyalty to the emperor and to the new empire, was a common subject in the mass media discourse and a common value in advertising and material culture in the early 1930s. This ideology was even given expression in the names of certain products, such as "Mussolini's pen," which was sold in the early 1930s.[44]

This new spirit also led to growing censorship and government control of the media. The propaganda office recruited the film industry, the press, and even the manga industry for government propaganda service. Advertising media representatives and designers were also recruited by the government for war propaganda. Managers of commercial companies realized that in order to influence Japanese consumers, they needed to present their company as a participant in the national productivity and war effort. Thus, advertising of private companies framed their products as related to the war ideology, highlighting their assistance to the national war effort. Some ads, for example, showed the product alongside military and scientific technology or in the background of fighter planes. Weisenfeld, presenting Kao's soap campaign, shows how the company abandoned its modernist avant-garde expression, instead showing photos of the famous German zeppelin hovering over a German march, or images of fascist architecture as signifiers of war-effort support. Weisenfeld also demonstrates how Shiseido campaigns depicted a woman placing Shiseido soap into a comfort bag (*imon bukuro*) being shipped to soldiers at the front line.[45] Other advertisement by Shiseido implored the people "Do not throw away Shiseido containers, you can get 5 *sen* for them."[46]

Slogans, as well, expressed the militant spirit, with advertisements stating clear militaristic messages such as "Fight to the bitter end" (*Uchite yamamu*).[47] This verbal and visual expression was explicitly encouraged by the Propaganda Ministry, which sought to use visual expression as yet another means to keep the home front population in line with the current political changes.

Yet even this emphatically nationalistic visual expression was heavily influenced by foreign styles. Not surprisingly, the primary influences came from Germany and fascist Italy, which build their propaganda styles from both modernist visual strategies and traditional national aesthetics. The Japanese propaganda style also built on the revolutionary and progressive forms of modernism used in advertising before the war, alongside the use of national images.[48] An interesting example can be seen in a famous Nazi propaganda poster from 1936 that shows a radio with a slogan "All of Germany listens to the leader with the People's Receiver" (figure 1.1). This image creates an

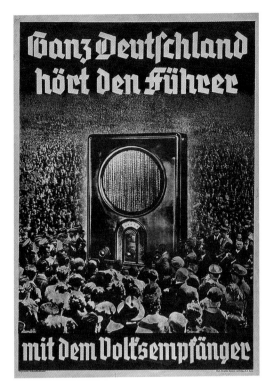

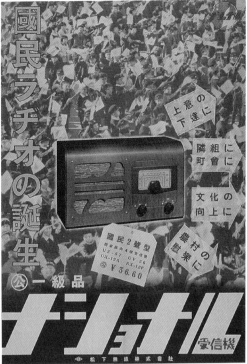

odd juxtaposition in that it combines image manipulation—the photomontage—which is a modern visual strategy, with Fraktur lettering, which is a gothic traditional font.[49] This hybrid visual strategy of German propaganda influenced Japan, as can be seen in an advertising poster for Matsushita Radio (under its National brand) from 1942 (figure 1.2). The radio is shown in a photomontage superimposed directly over a crowd of enthusiastic Japanese children waving national flags to promote "the birth of national radio" (*kokumin rajio no tanjō*), made possible with affordable personal radios for individual household use.

While the German poster is political propaganda (showing the centralized control of the mass media by the Nazi regime), the Japanese poster is a commercial advertisement. However, the copy of the Japanese poster also notes that the radio could be used for transmitting policy decisions from the authorities. As Gennifer Weisenfeld argues, commerce was never far from politics, as both of these dynamic spheres of visual culture production were dedicated to the act of persuasion and the glorification of iconic symbols—in one case representing political ideology and in the other capitalist consumption.[50]

This can be also read as another example of Japanese designers being in-

fluenced by European styles of the period, this time by German and Italian political photography dictated from the Reich Ministry of Public Enlightenment and Propaganda.

Yamana Ayao of Shiseido, Hara Hiromu of Kao, and many other designers worked informally with the government on various campaigns. Although designers wished to refer to themselves as "international modernists," they were instead called *zuanka* (designer), since censorship laws forbade the use of English.[51]

Commercial advertising began to fade away when, in September 1938, the Japanese government issued regulations that restricted the trade of luxury products (anti-luxury edicts), in an effort to reduce domestic consumption and assist the war effort. One popular government propaganda slogan was "Luxury is the enemy" (*Zeitaku wa teki da*). In addition, an advertising tax was issued in 1942. As the war progressed, graphics in newspaper ads became more and more reductive in terms of color and composition.[52] Through 1944, advertisements for cosmetics and drugs that managed to unite patriotic practicality with capitalistic luxury and consumption could still be found, but after the first major Japanese defeat at Midway, these ads practically vanished, and in 1945 advertising of any kind was explicitly forbidden.

Postwar Design

On August 15, 1945, the Second World War came to an end. On this day, not a single advertisement appeared in the Japanese press. In the years that followed, Japan suffered from a severe shortage of materials and sharp inflation. Big cities were flooded by a shockingly dichotomous influx. There were American occupation troops looking healthy and tall, driving American jeeps and gallivanting with Japanese ladies of the night, while unemployed Japanese soldiers and abandoned children filled the streets. Japanese quality of life hit rock bottom. Store shelves were bare, with only the black market offering supplies. Bombed-out cities suffered from a severe shortage of all basic subsistence—food, clothing, and housing alike. It was certainly expected that this post-defeat and economically suffering society would shun advertising, and it seemed as if the entire field of design in Japan ceased to exist.

However, after the war, with the help of the U.S. occupation forces, Japan began its economic rebuilding. As part of the American economic recovery policy, Japan was encouraged to develop an export industry catering to the American market in response to U.S. economic aid. Japanese crafts, which already had a market in the United States before the war, were central to

this new export industry of collateral products (*mikaeri busshi*), since their peaceful associations were seen as an effective way of projecting the new image of Japanese culture. The General Headquarters (GHQ) of the Supreme Commander for the Allied Powers approved the exportation of crafts marked "Made in Occupied Japan," including decorative dolls and dinnerware, beginning in 1947. Another activity promoted by the GHQ was the creation of design projects for Japanese companies and designers in Japan. Such projects included the construction of sixteen thousand houses for U.S. personnel stationed in Japan and their families, and the commissioning of Japanese designers at the IARI (Industrial Art Research Institute) to design all the furniture and household and kitchen utensils used in these houses. During this process, Japanese designers and policy makers learned about the American lifestyle and about American design and taste under the guidance of the GHQ designers—knowledge that proved important for the development of the export crafts industry in the 1950s.[53]

A by-product of the occupation and the massive rebuilding of Japanese industries was the importing of American cultural products to Japan. American magazines like *Life* and *Saturday Evening Post*, films, comics, animation, packaging design, and information about American avant-garde art began to appear in Tokyo. These brought to Japan the modernist styles that were relabeled after the war as the "international style" and would later become to be known as "modern Japanese design."

The international graphic design started in Switzerland in the modernist spirit of the 1950s, which heralded simplicity and unity as seen in sans serif typography, plain and devoid of adornments. Creators of the international style believed that graphic designers were responsible for creating visual images whose simplicity, unity, minimalism, and logic delivered clear meaning and context universally. In this approach, words, images, layout, and information were composed to build clear and universal media elements.[54] This design also became known during the 1950s as "Good Design" in the fields of architecture and industrial design, spreading out in postwar America through Bauhaus instructors who had previously fled from the Nazi regime to the United States in the 1930s, settling mainly in Boston and Chicago. They achieved recognition immediately from institutions such as New York's Museum of Modern Art and commercial furniture companies like Herman Miller.[55] In Switzerland, graphic design that followed the tenets of Good Design also spread via designers who similarly had fled Germany, including Max Bill, Theo Ballmer, and Anton Stankowski, as well as Swiss designer Richard Paul Lohse, who was outspoken in his belief that the international

style stood in opposition to fascism.[56] This style, rejected by the Nazi regime that had already closed down the Bauhaus School because of its Marxist tenets, ended up flourishing in the United States after the war and was thus associated with democratic regimes, standing out as a symbol for victory of the free world and democracy. It was used by institutions around Europe for cultural rehabilitation. Japan was also facing the challenge of rehabilitation not only financially and physically but also culturally. Adopting the international style touched almost every field of life in Japan during the 1950s and served as a proxy representation of Japan's desire to shake off the militant nationalist ideology as Nazi ally, forget the past, and be readmitted as a member in the democratic world.

The masses of information regarding the international style in general, and in commercial advertising in particular, arrived from the United States during the occupation, affecting advertising designers.[57] And so it was in the 1950s that Japanese advertisements used simple and logical advertisements with a straightforward and informative manner that emphasized explanations and product advantages, as was common during this period in Europe and the United States.

1950s: Triumph of the International Style

It wasn't until the 1950s that the Japanese standard of living returned to a humane and even respectable level.[58] The Korean War that broke out in June 1950 spurred on Japanese industry, which provided products for the American and UN soldiers stationed in Korea. The push provided by the Korean War ushered in renewed consumption among the Japanese. The strict controls over the sale of textiles and food were no longer needed, and trade on the open market returned. New products appeared in stores, such as nylon, chocolate candies, and chewing gum. American fashion flourished, in keeping with the look of fashion magazines that could be found in Tokyo. The Japanese government began to encourage local production by investing in industrial means of production. Wartime heavy industry was transformed into light industry for civilian cars, bicycles, and electrical appliances. The Sanyo slogan "The beginning of the electric era" captured the new trend for consuming electrical appliances such as refrigerators and televisions, which became part of many Japanese households during this period.[59] Electric neon signs, such as the Sony neon advertisement that appeared in Ginza in 1957 or the colorful lighting of the *pachinko* parlors, which appeared during the 1950s, transformed the urban landscape. In 1959, millions of televisions were

bought in order to watch the wedding of the crown prince Akihito, which was broadcast on national television. The radio, which broadcast melodramatic plays such as *Kimi no name wa* (your name), was an important part of almost every household.

These were the years of Japan's transformation from a country defeated to a country of industry. With the encouragement of the U.S. government's economic policy, traditional industries were dismantled and built up again according to an American concept. Industrial design was certainly one aspect of the overall American encouragement. As part of its foreign aid program (totaling of $3.3 billion), the U.S. government allocated $600,000 to the International Cooperation Administration (ICA), a State Department unit, in order to study and provide aid for native handicrafts in developing countries.[60] After this project was launched in 1955, the ICA commissioned Russel Wright, one of America's most important modern designers, together with two other American designers, to embark on a research trip to Asia. The objective was to help Asian countries to improve and expand the production of handicrafts, both for domestic use and for export. During this trip, Wright discovered many traditional Japanese products that were unknown in America, and which he believed could be successfully exported. He subsequently presented the Japanese government with a paper suggesting how to promote Japanese handicrafts.[61] Following this trip, Wright initiated a number of projects in Japan that encouraged the Japanese government to create a design infrastructure and national organizations in order to implement a new design policy and production system. The Design Promotion Council was established as part of the Patent Office in 1956. In 1957, the Japanese government established the "Good Design Product Selection System," which selected products that met the criteria of modernist design and marked them with a "G-Mark." A design department established to regulate exports was created as part of MITI (Ministry of Trade and Industry) in 1958. JETRO (the Japan External Trade Organization) expended its activities to support the government, and with the help of MITI and American support it also gave a nudge to develop products that would open new markets abroad. The Japanese government sent students and factory managers abroad to learn the role of industrial design. The establishment of professional design bodies and new exhibitions of modern crafts and designs for export also contributed to this systematization of the design world.[62]

The Japan Advertising Institute (Nihon Kōkokukai) was established in 1947 and held its first exhibition, the "Nippon Renaissance," that same year.[63] Held in the Mituskoshi department store of Tokyo's Nihonbashi neighbor-

日本タイポグラフィ展

hood, this exhibition gave an early peek into the emerging advertising indus-
try and the new advertising design of the postwar spirit.

Universities opened industrial design departments, and in 1952 JIDA, the
national organization of designers, was founded. The IPDC, an organization
for the advancement of design, was formed in 1957.[64] From 1948 to 1952, the
Japanese Advertising Association hosted an annual exhibition that showed
both historical, period-specific ads, and ads designed in the current year. In
1954, Yamawaki Iwao and Mizutani Takehiko, the first Japanese to study at
the Bauhaus school, codesigned the exhibition *Gropius and the Bauhaus* for
the Tokyo National Museum of Modern Art. In the same year, Yamawaki
published the book *People of the Bauhaus (Bauhaus no hitobito)*.[65] The exhi-
bitions introduced the prewar modern style to Japanese designers and led the
way for a new discourse on advertising design in Japan. In 1955, the "Graphic
'55" exhibition brought a specific focus on printed posters, furthering the
popularity of graphic design. The postwar style is exemplified in an ad for
a 1958 typography exhibition designed by Hara Hiromu, which highlighted
Japanese Ming-style letters (*minchō*) in black that referred to the black ink
calligraphy (figure 1.3).

This style was a Japanese variation on the international typographic style,
also known as the Swiss modernist style.

Ads in this new style highlighted the fact that the Japanese workforce
of the 1950s included many good designers, some of whom had extensive
prewar experience but then went through a period of unemployment or ser-
vice in the Japanese propaganda machinery. Their return to the commercial
design workforce brought advertisements that are best described as being
in the international style, but with a Japanese fragrance.[66] The concept was
to carve out a representation of Japan that can be perceived as democratic,
in keeping with the underlying goal of acquiring international standing and
recognition. This style was positioned to replace Japanese posters that were
being published in European graphic magazines that used traditional im-
ages such as Mount Fuji, geishas, pagodas, chrysanthemums, and pine and
bamboo trees. Japanese designers wanted desperately to show the world a
technological, modern Japan that replaced the provincial "souvenirs."[67] But
it quickly became clear that this shift was also well received by the local Jap-
anese society of the 1950s–1960s.[68] These posters apparently filled the void
in the new form of Japaneseness, bringing patriotism to a country that had
lost all pride during the American occupation. That this patriotism could be
channeled through a style representative of a new democratic path and at
the same time position Japan as part of the international community made
it even more appealing. Postwar designers could now openly identify with

FIGURE 1.3
Hara Hiromu,
"Japan Typogra-
phy Exhibition,"
1959 © Courtesy
of Tokushu Tokai
Paper Co. Ltd.

Europe and America and escape the restrictions of traditional Japan and economically struggling Asia as a whole. Perhaps foremost among these clear visual statements of influence is the first Tokyo ADC logo itself. Designed in 1953, it shone with the simplicity of the international style, resembling logos designed by Paul Rand in the United States.[69] An interesting comparison is the ABC television network logo designed in 1961 by Rand that perhaps was influenced by the first Tokyo ADC logo.

A group called Nijuichi (Group 21), led by Kamekura Yūsaku, was founded in 1959 to discuss Bauhaus theories and the international style.[70] In 1959, Katsumie Masaru, one of the most important designers of the period, launched a graphic design magazine that published articles on modern and international style.[71] At the same time, the Japanese government invited designers such as Raymond Loewy, who designed in the American Streamline style, to hold seminars that would teach the secrets of the new design.[72] The Asahi Brewery asked Walter Landor to design its logo to give the company a clearly foreign expression.

At the end of the 1950s, with the establishment of the electronics industry, and other light industries well on their way and beginning to export, manufacturers began to adopt American marketing strategies. Japanese designers were tasked with giving export products a prestigious image that would replace the image of cheap products commonly referred as "Made in occupied Japan." The decade that started deep in the worst possible recession and ended with a healthy and widespread advertising and media industry is widely considered one of the most dramatic decades in the history of advertising in Japan.

The 1960s: Official Recognition as the World Comes to Japan

In the 1960s, the national mood in Japan changed. These years began with the "consumer revolution," a term that appeared in the Economic White Paper published in 1959, which was quoted in newspapers of the early 1960s on a daily basis.[73] The Japanese standard of living was entirely recalibrated, with a new consumption of meat, eggs, and milk, as well as exclusive women's fashion and leisure goods such as electrical appliances. Influences came from the hand of America's growing consumer culture and the emergence of the "American dream" as a symbol of a new future. New technologies from abroad triggered fast development of high-quality, low-price products. The Japanese automotive industry and heavy industry also developed as a result of the government reforms put in place already in the late 1950s. The nature of the products was rooted strongly in the American "Fordism" of

mass-production, low-cost manufacturing and utopian ideals that the entire population should be able to purchase the products.[74]

It was during the period after hosting the 1964 Olympics and prior to hosting the 1970 International Expo that Japan fully emerged as part of the free world. These economic boom years and the new status of Japan in the international arena instilled a sense of optimism for a better economic future, coupled with a strengthened desire to forget, repress, or somehow leave behind the trauma of war. All signals pointed toward starting out on a new path, both literally and figuratively. For the Tokyo Olympics, highways were widened, new roads were paved, and skyscrapers were built one after another. These changes to Tokyo's urban landscape erased memories of the bombed city. This rebuilding and erasing soon expanded out to other cities in Japan. When the government announced an income doubling plan, the Japanese economy went into overdrive in a race for constant growth. Japan became a major exporter of steel, ships, cars, and household appliances. The export of Japanese products was a source of pride that influenced local advertising. The slogan for Yashika cameras, for example, said "Made in Japan—worldwide."

Japan's GNP rose to surpass that of Britain and West Germany, becoming second only to the United States, in large part thanks to the hard work of employees.

The economic boom, the new consumer culture, and the Olympics all led to an increase in advertising expenditures, boosting the advertising industry. This period is considered the first golden age of graphic design and advertising in postwar Japan. Kamekura Yūsaku's Olympic posters and Katsumie Masaru's Olympic event symbols garnered many awards and established a new image for Japanese design.[75] As Jilly Traganou notes, the design of the graphic elements for the Tokyo 1964 Games presented a postwar Japanese identity that embodied both internationalization and tradition. The visual language of these graphic elements adhered to the antihistorical approach of modernism, while simultaneously encoding the visual composition of the traditional crest design pattern established in medieval Japan. Traganou argues that postwar Japanese design was rooted in prewar Japanese modernism. The integration of traditional and prewar graphic resources served to create a distinct Japanese identity in the international arena, while establishing a continuity with the past.[76] Other international events featuring Japanese design to the world were the WoDeCo conference, which dealt with design,[77] and Expo '70, on the heels of the decade in which Japan achieved the status of an industrial and economic superpower. Japan's graphic design had come to equal that of any other industrialized country and was highly appreciated by designers around the world.

FIGURE 1.4
Yokoo Tadanori,
"Zoku John
Silver," *Gekidan
joukyo gekijo*,
1968. Silkscreen
on paper,
1030 × 728 mm.
Collection of
the Museum of
Modern Art, New
York. © Courtesy
of Yokoo Tadanori

Advertising design for these events was still influenced by the international style of the 1950s. However, the atmosphere changed with the 1965 exhibition of belle époque posters curated by collector Katsumie Masaru, which presented over three hundred posters from the collection of the Bibliothèque des arts décoratifs, at the Louvre in Paris. This exhibition was significant mainly because of its impact on designers, guiding them away from the dogmatic Swiss school toward a more personal and romantic expression.[78]

The consumer culture of the private market was fueled by the new credit purchasing that started in the 1960s. Commercial companies, which were moving past their "recovery" mentality, realized the potential of new consumer desire and started to study marketing theories in order to encourage consumption. In order to build up a new corporate image, commercial firms began a process of market segmentation. Advertising media designed specifically for various market segments were employed to increase consumer awareness and connectivity. Young artists were given a stage to showcase fresh creativity and aesthetics that matched these new marketing ideas. As a result, some advertising concepts changed as well. For example, Shiseido, under the patronage of their new art director Nakamura Makoto, started to show Japanese women in their advertisements in order to bring back the Japanese beauty of traditional ukiyo-e painting, at a time when most contemporaries used European and American models.[79] Advertisements began to show the corporate image of the manufacturer rather than the actual products.[80]

During the 1960s, Japan was influenced also by the social protests in the United States, where hippie culture, a new leftist interest in human rights, antiwar demonstrations, and the music scene all were triggering fresh activity in American graphic design.[81] The wave of protest swept Japan as well, as seen in the student riots at the University of Tokyo and the new wave of feminism that had made its way to Japan. Avant-garde art movements including Butoh, Gutai, neo-Dadaist anti-art, and Mono-ha radically altered the course of Japanese art. The impact of these movements can be observed also in graphic design.[82] An avant-garde graphic genre serving the music scene and the avant-garde Japanese theater of the time developed in parallel to the works of mainstream designers like Kamekura Yūsaku that served the changing consumer culture and the new Japanese national image.

Artists like Yokoo Tadanori and Hirano Kōga presented the turbulent spirit of social protests by stepping out against the modernist visual expression and the international style (figure 1.4).[83] In so doing, graphic design reunited with an expressive element that had gone missing in the modern age.

In the mid-1960s, these different trends of the new graphic design were shown in Tokyo in the exhibition *Persona 1965, the Next Generation*.[84]

The 1970s: Returning to Roots and
Searching for an Original Identity

The year 1970 opened with the International Exposition (Expo '70), held for the first time in Asia. The city of Osaka hosted seventy-seven participating countries and over sixty-four million visitors, half of them Japanese. The exhibition received excellent reviews, and it was yet another source of pride for the Japanese. Japan's development and its booming economy were introduced to the world, while the Japanese were exposed to many cultures. But unknown at the time, it was also a swan song, coming immediately prior to the termination of the Bretton Woods monetary agreement, a move that triggered an economic downturn, and the 1973 oil crisis that rocked Japan's economy for the first time since the war.[85] After a century of almost steady growth since the Meiji Restoration, which had eventually led to Japan's GDP becoming the second-largest in the world, the nation's economic growth was stunted in the early 1970s, a fact that also triggered the first real political crisis since the war, as the oil crisis magnified the differences of opinion within the government and the conflict of interests among industrial sectors. Japan also experienced acts of terror, with violent clashes occurring between factions of the radical Left and the Japanese Red Army (Nihon Sekigun), among others. The social crisis gave rise to a wave of pessimism reflected in literary works such as Komatsu Sakyō's *Japan Sinks* (*Nihon chinbotsu*), which became a best seller in 1973. The advertising industry followed this trend with advertisements striking a pessimistic note, such as an insurance company placement that featured an accident accompanied by the caption "Besides apologizing, what else can you do?"[86]

It is a common belief that during these years, a social ideology dominated Japan that emphasized collective values of responsibility, endurance, hard work, and a suppression of personal desires in favor of commercial company and national growth. The Japanese themselves pointed to these positive moral and social values (*kireigoto*) as part of their identity, while the myth was also documented in research literature in the West.[87] While these values were partially true during the 1960s, they did not necessarily reflect the daily practices that were changing in the 1970s.[88] Following the economic and political crisis, the government planned and applied reforms, both social and economic, such as a transition from heavy industry to high technology, strengthening of the services sector, and a shift to a five-day work week (with its associated encouragement of further consumption). Japanese citizens began to feel economic prosperity, and the middle class grew in size. The

government encouraged consumption and leisure culture, which became a part of the national strategy.

The result of the increased consumption led to the bubble of the 1980s. The Japanese began to abandon the mores of hard work and collective commitment to the company, which had served to rehabilitate Japan from the ruins of war. The reforms and the economic situation of the mid-1970s shifted priorities in daily urban lifestyle and leisure culture. As opposed to the 1960s, when the primary ambition was to be a homeowner with a private car, 1970s middle-class consumers began to show interest in housewares, sophisticated kitchen products, and resort vacation homes.[89] Emphasis shifted from needs to pleasures, personal comfort, traveling abroad, and family life, inspired by American lifestyle trends. The ketchup brand Kagome highlighted American lifestyle in its ads, and subsequently doubled its sales. Infrastructure was still insufficient to support a true leisure-time culture in Japan, so a more passive form of leisure developed, centering on spending time with family, watching TV, and relaxing.[90]

This change of mood is seen clearly in a campaign for Xerox, which bore the slogan "From intensive to beautiful" (*Moretsu kara byutifuru he*). The repressed feelings of employees could not have been expressed better. They felt that they had worked hard and intensively for the goal of national growth while ignoring personal needs, but then discovered they did not have a beautiful life. The campaign delivered a critical view of the 1960s work ethic for the first time and in a clear, sharp manner. In so doing, it preached for a better life and the return to the traditional values of beauty and aesthetics. Created in 1970 by Tokyo ADC member Suzuki Hachirō and copywriter Matsuda Kōji, this campaign resonated strongly in Japan. This slogan, with its explicit eschewing of Japanese in favor of the English word "beautiful," expresses a clear change from the 1960s emphasis on intensive labor (*moretsushugi*) to new foreign-style values of the 1970s that spoke of comfort and beauty.[91]

In criticizing Japanese standards, this campaign paved the way for other revolutionary social ideas and values that were fast becoming social norms in the 1970s. A later poster of the Xerox campaign showed two men, one black and one white, with the slogan "Black is beautiful, white is beautiful," clearly referencing American social revolutions concerning race, while in actuality it simultaneously referred to the black and white of the Xerox machine. Another poster showed a blue sky with the slogan "Make the sky beautiful, make the business beautiful," and yet another refers to the pollution of Japanese rivers, stating "That which flows to the beautiful, turn business to beautiful." These slogans addressed ecology issues, mirroring the early adoption of a

new public attitude toward air and water pollution, which took hold on the heels of rapid industrial development. Ecology became a common theme in advertising, as did the oil crisis. Many companies promoted their products by asking their audience to reduce their consumption of oil and electricity in order to support both the economy and the environment. A 1973 Toyota advertisement, for instance, reads: "Drive slowly and save oil." A Nissan campaign for Skyline cars asks people not to dispose garbage in the natural environment, using the slogan "Ken and Mary do not throw trash on the street." A collective advertising campaign jointly commissioned by fifty-nine companies took the form of articles published in *Asahi Shimbun* in May 1973. These articles lamented the destruction of nature, while referring to "the beautiful Japan we wish to preserve for our children."

It was during this time that Ishioka Eiko's classic Parco campaign came out (see Introduction), bringing a message forged from the radical feminism popular in the United States and that had recently landed in Japan. The campaign introduced an avant-garde perspective on controversial social issues, while giving expression to a new feminist discourse that developed in Japan as many young women joined the workforce and demanded gender equality and new career opportunities. Feminist movements called for the establishment of government kindergartens for the children of working mothers. They also objected strongly to sexist advertisements, such as a fast-food advertisement in which the woman said "I will prepare" while the man said "I will manage."

The true innovation in all these campaigns was the fact that they did not present the actual product being promoted, instead focusing on social values and ideological antiestablishment discourse. As such, the continuous evolution of advertising in Japan underwent a dramatic shift. And it was these new discussion points—led by gender relations and employee relations—that became the central elements to which consumers were drawn.[92] The campaigns blurred the distinction between social values (*shakai kachikan*) and corporate values (*kaisha kachikan*), in no small part by inventing a new genre of advertising that did not present actual products nor any clear information about the company, apart from the logo. These campaigns are landmarks in the history of Japanese advertising because they show the dawn of an era in which advertising focuses first and foremost on corporate identity, as expressed via social identity.[93] Not surprisingly, this was the time that the new consumer first sought identity through product consumption.

At the same time, another process was gaining steam in Japan of the 1970s, as society began to reexamine the nature of modern Japan. The rapid development of mass communication, internationalization (*kokusaika*), modern-

ization, and the entry of Western culture brought on a wave of nostalgia. As Japanese tradition began to disappear from view, a new interest in the sources of traditional culture emerged.

Diplomatic relations with China saw a new détente starting in 1972, and scholars began to search for Chinese origins of Japanese art, architecture, and artifacts. Japanese began to ask fundamental questions of their own origins: What in modern Japan has come from the West? What has come from China? What is original Japanese?

The new concept of Japanese uniqueness (*nihonjinron*) and its related search for roots also led to a refocusing in Japanese design. Older designers, among them Tanaka Ikkō, felt that the younger generation had lost connection with or even knowledge of traditional Japanese motifs, and they reacted by promoting interest in this visual culture.[94] The young designers for their part developed a renewed pride in Japanese traditional culture, taking active steps in creating a unique Japanese identity design.

A Japanese Railways (JR) campaign demonstrates this spirit. The "Discover Japan" campaign by Suzuki Hachirō was one of the most successful postwar campaigns, running for many years.[95] The triggers for the campaign included accelerated development of railway infrastructure for the 1970 Expo, along with continuing urban development and its associated abandonment of the countryside by the new city dwellers. After the euphoria of the exhibition, there was a sudden need to attract the public to travel by train in order to justify the massive infrastructure investment. The campaign turned to the population at large, which had begun to take an interest in leisure, in an attempt to create a new concept of domestic tourism. After years of emulating the American dream, an extended period in which Japan suppressed its past and looked only toward the future, this campaign stepped in to respond to the nostalgic boom by flooding the public discourse with a self-searching focus. Young Japanese began to rediscover their identity, the original Japanese self, and the origins of modern Japan. Moreover, this all took place self-contained within Japan, and not as a result of any Western influence, interpretation, or direction. And yet within this realm of pure Japanese exploration, we must still note that the slogan and general concept for this campaign was lifted from a contemporary American campaign called "Discover America," which ran in the United States three years earlier. Even in the most core return to that which is Japanese, the immense reach of globalization on advertising design was still felt.

The core concept of the campaign was "Discover myself via Discover Japan," where the ad transforms a trip for tourism (*ryoko*) into *tabi*, the Japanese

concept of pilgrimage to a holy shrine or search for Japanese self-identity that echoes the trip of traditional poets such as Bashō in search of Japan.[96] The Japanese campaign introduced locations throughout Japan where Japanese tradition still thrived, unaffected by the globalization felt in the major cities.[97]

The campaign simultaneously addressed the new need for cultural heritage discovery as well as the interest in capitalizing on newly formed infrastructure for active leisure culture. The campaign's influence was so immense that it not only succeeded in promoting train travel (its core purpose), but also turned the train and train station into a key location for displaying advertisements (*nakazuri*).

This campaign joined the same new genre with the Xerox and Parco campaigns by eschewing actual product display and instead referencing consumer values. Marilyn Ivy quotes the campaign creator Fujioka Wakao, who named this genre of advertisements "deadvertising" (*datsukōkoku*), since it followed rules different from those of the advertisements of the time. Shimizu Keiichirō calls this genre "living proposal advertisements," since it offered a lifestyle to the consumer.[98]

The creation of this advertising genre was paralleled by the development of a new marketing media—that of product catalogs. These catalogs were mainly informational and were divided into categories pertaining to different industries. They supplied technical and material details and enabled consumers to compare products and prices. One such catalog for the food industry, for instance, provides nutrition facts, prices, and the names of shops where the products can be purchased. These catalogs gathered a large quantity of information that was scattered in many different locations, thus allowing for the development of a new advertising genre that did not need to present the product, and which centered on creating a corporate identity by focusing on abstract qualities and larger cultural concerns—as was the case, for instance, with the Xerox campaign.[99]

While advertising in the 1960s focused on developing techniques for processing information for delivery from company to consumer, the new 1970s advertising instead forms a dialogue between corporate information and consumer value systems. Instead of consuming the product to fulfill material needs, consumers now viewed consumption as a formative experience for individual identity. Noticing this social shift, advertisers employed strategies that seduced the consumer by introducing discursive topics that expressed their core values.

And so the 1970s demarcate the beginning of a new era in which designers such as Suzuki Hachirō and Ishioka Eiko of the Tokyo ADC presented

a brand-new elite Japanese advertising strategy that drew inspiration from Japanese aesthetic sources and global discourse all at once. The great transformation of Japanese advertising had begun, leaving the door open for a new postmodern Japanese advertising genre to develop in the 1980s under the auspices of an economic bubble.

In light of this, we must reevaluate descriptions of Japanese advertising offered in Western literature and research as being enigmatic and inherently different. This orientalist perspective simply falls apart under the weight of the vast evidence to the contrary that shows how Japanese advertising design developed under a decisive influence of foreign styles. This statement was as true in the 1920s as it was in the 1970s and as it is still today. From the Meiji era on, Japanese advertising has corresponded with Western advertising design, drawing influence from many styles, including art nouveau, art deco, Bauhaus, and Swiss design. It was not until a 1970s nostalgia boom and 1980s postmodernism that Japanese aesthetics began to outright quote and appropriate traditional Japanese sources to form a new Japanese design.

During the 1970s, we witness two seemingly contradictory trends running simultaneously in Japanese advertising: the desire to be international and the desire to reference Japanese sources. And as advertising design moves into the 1980s, with its associated globalization and changing social paradigms, a hybrid character is adopted that combines local and global, both in the visual dimension and in the values attached to each product or company.

2

The Tokyo Art Directors Club is an elite umbrella organization consisting of seventy-five of Japan's top art directors.[1] These art directors create ad campaigns for the largest and most important companies in the country. In this role, the art directors decide all matters regarding design. They employ designers, illustrators, photographers, artists, and copywriters to achieve their desired image and build advertising messages into the campaigns.[2] According to former organization president Nakashima Shōbun,[3] the organization creates only 3–5 percent of all advertisements in Japan. But despite the small overall percentage, Tokyo ADC members are involved in many of the most important and prominent campaigns in Japan, such as those for well-known brands Shiseido, Honda, Toyota, and Suntory, large department stores Parco and Seibu, and avant-garde fashion houses Comme des Garçons and Miyake Issey.

The art directors are much more than advertising designers. They also are responsible for corporate and department-store branding, and consulting for product development and store development, as well as periodically serving as exhibition curators. Ad campaigns of the Tokyo ADC members are presented throughout Japan and can be found in galleries and catalogs. As such they have a strong impact on many advertising designers in Japan and inspire young artists.

History of the Club

From 1945 through 1952, with the end of World War II and the seven-year American occupation, the world of Japanese design that had been active since the development of mass media in the Meiji period (1868–1912) was entirely choked off, owing to the simple fact that advertising was quite unnecessary given the severe economic depression and shortage of products. But in the early 1950s, the Japanese economy began to recover, mainly as a result of the policies of the U.S. occupation forces that restructured and restored the entire economy. This was further abetted by the outbreak of the

Korean War in 1950, with the U.S. presence transforming from "beneficent occupants" into "aggressive consumers," giving a strong burst to Japanese industry.

As part of the democratic ideological values advocating freedom of speech and capitalist free markets, the U.S. occupation of Japan encouraged the development of a free press. The first private radio station began broadcasting in 1951, and a private television broadcasting company first went on the air in 1953. The concept of radio and television commercials arose, followed by the resurgence of ad agencies that had been closed since the war. In parallel with the economic recovery, an American visual culture that flourished during this period—American films, comics, animation, packaging design, fashion, and avant-garde art—landed in Japan.[4] American magazines such as *Life*, the *Saturday Evening Post*, and various fashion magazines were available in Tokyo. The wealth of information in commercial advertising that flowed in from the United States influenced Japanese advertising designers.[5]

Many talented designers who had worked prior to the outbreak of World War II but since had been either unemployed or conscripted in the service of the national propaganda industry emerged en masse in the Japanese marketplace as the recovery gained momentum and the new consumer culture developed. These graphic designers began to work independently as creative service providers and advertising designers for commercial companies.

The primary function of advertising agencies in Japan, from the Meiji era on, had been to sell advertising space in newspapers. In contrast to their counterparts in most other countries, the agencies did not provide creative services to their customers. (For more details see Chapter 6.) With the postwar economic development, business relationships were forged between Japanese advertising agencies and media companies. These unique relationships, prohibited by law elsewhere because of antitrust concerns and sometimes even conflicts of interest, enable agencies to be exclusive sellers of their media partners' advertising space. A company that needed such advertising space had to buy it through one specific agency and not its main advertising agency. Agencies found themselves simultaneously managing the accounts of companies that compete with one another. This arrangement forced the agencies to focus on placement and media mix, while the creative aspects of campaigns—creating the visual concept and imagery—were handled by in-house advertising departments within each commercial company, or by graphic designers from outside the advertising agencies. An informal art direction industry emerged as an autonomous entity within the actual Japanese advertising industry.[6] In order to provide independent graphic artists with

a wider association and professional identity, graphic design organizations began emerging in the 1950s.

The year 1951 saw the formation of Nissenbi (Nihon Senden Bijutsukai), also known by its English name JAAC (Japan Advertising Artist Club). This group was founded by the designers Hara Hiromu, Takahashi Kinkichi, Yamana Ayao, and Arai Seiichirō, and led by Kamekura Yūsaku. This association was formed as a union that would struggle for better working conditions and also would create a higher level of graphic design. It remained active until the 1970s.[7] The next organization to be established was the Tokyo Art Directors Club, which unlike the JAAC is still active today.[8]

In 1952 Arai Seiichirō, who worked for the Dentsu advertising agency, traveled to the United States to attend a conference of the Federation of American Advertising. Upon his return to Japan, he released a report that described the two thousand art directors who all belonged to the group known as NY ADC (New York Art Directors Club), founded in 1921.

In the report, he spoke with the greatest admiration regarding the professionalism of these art directors, claiming that Japan had no professionals comparable to them.[9] As a direct result of this report, in September 1952 the Tokyo ADC was founded by an elite group of seventeen advertising professionals.[10]

This new society was organized by Japanese "ad men"—advertising industry executives or advertising department managers from commercial companies—in an attempt to carve out a new role within the advertising industry. The decision to establish an organization of art directors sprouted from a conviction that this new profession could achieve greater recognition within the advertising industry.

To learn what is happening throughout the world and to raise the collective standards of Japanese designers, the Tokyo ADC invited important modernist designers from Europe and the United States to lecture and present their work, including Herbert Bayer, Leo Lionni, George Nelson, and Paul Rand, designers who followed the modern style of the Bauhaus and the international style. Workshops were held that exposed the Japanese art directors to trends and techniques of Western advertising.

From the start, the association saw itself as having a mission to mediate between artists and industry. Its first exhibition, held in 1954, was called *Geijutsu to keiri o baikai surumono* (The mediator of art and enterprise). The next exhibition, held in 1955 and titled *Keiei ni hyōgen o ataerumono* (That which gives expression to enterprise), continued the same concept.[11] These

exhibits indicated the position of this association even in its early steps: as a mediator between art/graphic design and industry.

In the 1960s, as the result of a number of international events held in Japan, graphic design works of various Tokyo ADC members began to attract the attention of the international design world, which identified their high quality. WoDeCo, the first postwar design conference in Japan, was held in Tokyo in 1960. It brought together various designers from different fields, with 227 designers from twenty-seven different countries in attendance.[12] Among these attendees were important European and American designers, including Max Huber, Otl Aicher, Josef Müller-Brockmann, Herbert Bayer, and Saul Bass. For most, it was their first time visiting Japan. They were impressed by what they discovered, and Japanese design began to gain international recognition.[13]

The Tokyo Olympics in 1964 also served to showcase the new world of Japanese design to a universal audience. Kamekura Yūsaku designed the posters for the Olympics, and its symbolic icons were designed by Yamashita Yoshiro under the art direction of Katsumie Masaru. Kamekura's poster presented the Japanese interpretation of the modernism-based international visual communication style. Yamashita's icons, representing each Olympic sport, were designed in a pure international style, crossing boundaries of language, race, and gender. They quickly garnered universal acceptance.[14] This icon concept was adopted by the German Otl Aicher, whose designs for the 1972 Olympics became an international standard.

As the 1960s came to an end, an eight-month World Expo was held in Osaka in 1970.[15] The Expo's logo, designed by Ōtaka Takeshi, looked like a Japanese flag surrounded by five petals of the cherry blossom, symbolizing the five continents participating in the event. The info-graphics pictograms designed by Fukuda Shigeo were based on the universal pictograms of the Tokyo Olympics, and the Expo poster was designed by Ishioka Eiko.[16]

The exhibition capped a decade in which advertising design developed in parallel with consumer culture. During this decade, Japan became recognized worldwide as an industrial and economic power, with graphic design capabilities equivalent to those in industrialized countries around the world. This graphic design, invariably, came from the hands of Tokyo ADC members.

In 1972, the Winter Olympics were held in Sapporo, again attracting worldwide attention to Japanese design, mainly through the posters of Tokyo ADC member Suzuki Hachirō.[17] The same year also saw a joint exhibition of

the Tokyo ADC and the NY ADC. Nagai Kazumasa noted at the exhibition that in the past, the Japanese seemed to be students of the Americans, but "this current exhibition proves the Japanese are no longer students."[18]

In 1973, Kyoto hosted the World Industrial Design Conference, the first of its kind to be held in Asia.[19] Throughout the 1970s, a number of exhibitions of Japanese commercial design roamed the world. The main event of the Twenty-Ninth International Design Conference in 1979 was devoted to Japanese design. This event, held in Aspen, Colorado, was titled "Japan in Aspen."[20]

On the heels of all these events and the enthusiasm coming from Europe and the United States, Japanese designers achieved a great deal of prestige at home, enabling them to penetrate the various commercial companies that now had the confidence to make use of the designers' impressive capabilities. This new acceptance helped the Tokyo ADC consolidate its position in Japanese visual culture and in the Japanese advertising world. In addition to this newfound recognition of the potency of local design, other factors emerged in the 1970s that gave new importance to the role of the art director. This included technological advances in print media, as well as the emergence of the late consumer culture (see Chapters 5 and 7).

Developments in the field of printed media caused art directors to begin distinguishing themselves from graphic designers. Back in the 1960s, advertising had already begun integrating multiple forms, using more than just standard graphic design by adding photography, illustrations, and slogans. It was the art director who had to coordinate between all the artists involved. In the 1970s, the quality of color photography and printing techniques improved drastically. Art directors found themselves working with brand-new media in the field of print, not just classic graphic design.

It was during this period that the Nissenbi association broke up. Its members, including Nagai Kazumasa, Fukuda Shigeo, and Tanaka Ikkō, set out on individual careers in advertising.[21] A clear separation was created between graphic design on one hand and art direction of advertising design on the other. The designers from Nissenbi joined Tokyo ADC, and during this process the Tokyo ADC became a society made up exclusively of creators.

After the merger, Tokyo ADC members stressed a new rationale for the society to serve as a trade union organization of art directors who work solely in the realm of magazine and TV advertising. Studios that focused on providing services to the advertising industry sprouted up at a fast pace. During this time, the late consumer culture was reaching a head of steam. This motivated the commercial companies even more, who realized that in order to succeed in the new economy they must form an effective corporate identity. Prefer-

ably, this identity should be designed by an artist with a personal artistic expression and understanding of how to create complex visual identity, and not by standard graphic designers who were creating informational brochures, product packaging, and the like. For example, the department store Seibu relied entirely on external art directors, including Tanaka Ikkō, Asaba Katsumi, and Ishioka Eiko, to design its advertising campaigns.[22] These changes in marketing concepts generated a tremendous amount of work for the private studios of the art directors.

Since in the 1970s, Tokyo ADC has been the unifying force for art directors who worked solely in advertising. The new importance of corporate identity via personal artistic expression changed the nature of advertising, as exemplified in the work of Ishioka Eiko for the Parco department store. The independent art directors of the Tokyo ADC gained reputations for having the ability to create unique images that require the touch of a master designer-artist.

Upon the dissolution of Nissenbi, a new organization named JAGDA (Japan Graphic Designer Association) was establishment as a parallel to Tokyo ADC. JAGDA positions itself very differently from the elite Tokyo ADC by representing the needs of professional graphic designers in general, not exclusively those working in advertising. This forum was established by 705 designers who were active in packaging design, logo design, typography, shop window design, and more. Since 1981, they have published the yearbook *Graphic Design in Japan*. Today, JAGDA is the largest graphic design association in Asia, with over twenty-eight hundred members.

Tokyo ADC members typically take the role of creative director: designing posters, directing TV ads, and at times also managing Internet campaigns. Since the 1960s, advertising agencies have had their own creative departments, but given the structure and the work procedures of the Japanese agencies, most art directors within the agencies are busy primarily with production. And so the agencies outsource the creative work to external art directors. Nakashima Shōbun explains: "Generally ad agencies outsource works to external art directors. Therefore, art directors within the agencies do not become designer-oriented directors but producer-oriented ones instead. In contrast to this, the members of Tokyo ADC are not only designers but also art directors. Thus Tokyo ADC style is much less common within advertising agencies."[23]

Each art director within the Tokyo ADC has his or her own style and a uniquely identifiable visual expression. So when an advertising agency or a commercial company is seeking a specific visual expression, it turns to a specific art director who suits its requirements.[24]

The Admission Process

Since its beginning, Tokyo ADC has been very selective in choosing its members, in order to maintain its exclusiveness and prestige. In the 1950s there were seventeen members, in the 1960s twenty-eight, in the 1970s forty-four, and in the 1980s membership reached seventy-two. The number peaked at eighty-four in the 1990s and has recently dropped back down to seventy-eight. Arai Seiichirō explains:

> Some leading members of Nissenbi joined Tokyo ADC in 1961. . . . Up until
> that time, Tokyo ADC grew smoothly, but the number of the members
> remained below forty, which means we were still a small association.
> However, we have a concept of "small numbers and exceptional talent."
> We would like to select members carefully rather than forcing ourselves
> to attract many ones. Our next important change was the reorganization
> in 1970. Some members became trustees [kyogiin], and some left the
> association. It was a drastic remedy for us and hurt some members' feelings.
> However, we believed that we should put importance on works and art
> directors themselves. We also should focus on inducting active people to
> the association. In other words, we aim to exclude dormant members and to
> energize our association.[25]

In 1987, Aoba Matsuteru of the Tokyo ADC said that out of the twenty thousand art directors working in Tokyo, only sixty to one hundred of them are noteworthy and unique.[26] Considering the large number of art directors in Tokyo, it is clear that the ADC is an organization with a very strict selection process. The criteria for admission of new members are not based on the popularity of their commercials or their sales impact. Instead, focus is placed on a high level of design, as determined by committee members. Admission is also conditioned upon receiving the annual Tokyo ADC prize.

Nakashima Shōbun claims that there are no formal rules of acceptance. However, for the past fifteen years, the admission process has been quite specific. To become a nominee, a candidate must have received a Tokyo ADC award more than twice in five years. A recipient of only one Tokyo ADC award can still be nominated by special recommendation from Tokyo ADC members, but such cases are quite rare.

A committee of seventeen people that is elected every year discusses and selects nominees. The committee deliberates and finalizes decisions for nominees, but all members are involved in the voting process for selection, submitting their vote by mail. The committee again meets to consider the

voting results of the full membership and decide whom to accept as new members. The association's goal is to bring in five new members every two-year cycle, but in most cases the actual numbers are much lower. Because of the stringent admission rules and small number of actual members, Tokyo ADC became an elite group.

Today there are only four women in the association: Ishioka Ryōko, Morimoto Chie, Watanabe Yoshie, and Hirano Keiko. Nakashima Shōbun provides a rather archaic explanation, claiming that in Japan women tend to leave their jobs after getting married and having children, leading to few women actually submitting their candidacy. With the strict admission process, the number of women eventually accepted is very low. He also associates this career choice factor with a belief that women are more apt to choose copywriting careers, which is a less time-consuming profession than art direction.[27]

Current Activity of the Tokyo ADC

The art directors are located almost exclusively in Tokyo, which since 1980, according to Marilyn Ivy, has the highest concentration of production and distribution of culture in the modern world in general and Japan in particular.[28] However, the physical presence of these creative artists in Tokyo does not indicate that the advertising campaigns are targeted exclusively at a Tokyo audience. To the contrary, in fact. Campaigns have a prominent presence throughout Japan, mainly because Tokyo serves as a gateway for distribution of culture to other cities.

Tokyo's urban style has an impact on the Japanese visual culture, and the members of the Tokyo ADC created an innovative visual language that was an integral part of that contemporary Japanese visual expression. Observing the Tokyo ADC, it is clear that the visual language created by the association's art directors is unique, and is characteristic of an advertising genre that is devoid of explicit information and has an enigmatic, riddle-like nature.

The aesthetics of Tokyo ADC works have gained worldwide acclaim, and their art directors have been individually invited to show their works in galleries and museums in many countries. Catalogs of their works have been issued, awards bestowed in international design competitions, and ADC members' works appear in almost any book featuring graphic design or posters, both in Japan and abroad.[29]

Some Tokyo ADC art directors (including Ōnuki Takuya, Satō Kashiwa, Nakashima Shōbun, Awabayashi Jun, Yonemura Hiroshi, Satō Taku, Nagai

Kazufumi, Sasaki Hiroshi, and Satō Masahiko) started their careers in the creative departments of advertising agencies, but almost all went on to open their own individual studios. Currently only Nagai Kazufumi manages a studio that is under wider corporate ownership (Hakuhodo Design Inc., a subsidiary of the Hakuhodo advertising agency that supplies creative services for accounts managed by Hakuhodo). All the other designers are now self-employed, working as freelancers for ad agencies and commercial companies.

Today, the largest firms are Miyata Satoru's Draft studio and Aoki Katsunori's Butterfly Stroke studio. They operate in a manner similar to that of Japanese architects and fashion designers—as individual creators with reputations as creative artists within Japanese creative circles. Ōnuki Takuya and Suzuki Hachirō each exhibited in various shows around the world and became cultural heroes in Japan's art and design scene. Saitō Makoto and Toda Seijū created what are regarded as the most enigmatic and artistic posters of the 1980s and 1990s, which in many cases were bought by the permanent collections of local and international museums. More recently, they fully crossed the border into becoming full-fledged artists, with exhibitions shown in galleries and museums throughout Japan. Nevertheless, many members of the Tokyo ADC remained anonymous, and the credit for their works goes to the ad agencies.

This independent association, working outside the advertising industry, sets the tone for advertising design in Japan. However, it is the JAGDA association that serves as host to international exhibitions and conferences on graphic design that also cover advertising design. The Tokyo ADC holds professional conferences solely within the advertising design field in which the art directors show their works. These conferences are titled "Tokyo ADC Daigaku" (Tokyo ADC University). The first took place in 2002, marking the fiftieth anniversary of the association. The most recent was held in October 2007. Foreign lecturers are also invited to these conferences, and the most successful campaigns of the year are displayed and analyzed.

The Tokyo ADC also holds annual design competitions in which major awards are distributed. These events bestow prestige on the advertising industry and help the association maintain its position as the critical groundbreaker in advertising design, as the cultural agents of change, and as guardians of the visual culture. Each year, the association receives works from approximately fifteen hundred designers in the advertising field, covering print ads from newspapers and magazines, design books, corporate logos, and television ads. The various categories are judged, with ten ADC Awards given to nonmembers, three awards to members (ADC Member Awards), and

one grand prize awarded, the Hara Hiromu Memorial Prize, a more recent addition to the competition. An ADC Award is highly respected in Japan, and the number of applications has risen each year.[30] Art director Miyata Satoru explains that in 2008, 11,066 entries were received, the largest number of entries ever.[31] There are many additional awards in Japanese advertising every year, such as those awarded by the Dentsu agency. But these awards are granted to the commercial companies themselves, and not to the creators of the actual campaigns.

By opening its awards to both members and nonmembers, the ADC plays an additional role of priming the pump with a talent pool for future generations. Since the judges are a selective group within the association, the award has become highly esteemed in the Japanese designer community, a clear stamp of authority among young Japanese artists. A judging committee gathers each May to discuss the annual catalog as well as the awards to be distributed. Each committee member devotes four days for deliberations. The activities are considered by the entire Tokyo ADC to be of great importance because these sessions pave the way for future design concepts in Japan.[32] According to one award recipient: "Although there are a lot of awards in the advertising industry, to me only the Tokyo ADC Award is credible. I think the Tokyo ADC has been the ultimate goal for creative artists, and it keeps their motivation up. The evaluation criteria for the Tokyo ADC Award is high and pure."[33]

The association also holds annual exhibitions (held in the ggg gallery in Ginza and ddd gallery in Osaka) and has held special exhibitions regarding the history of Japanese advertising (in 1993 and 1997). The association publishes catalogs for each show, as well as books on the history of advertising.[34]

Since 1957, the association has issued an annual publication called the *Tokyo Art Directors Club Annual* (*Nenkan Kōkoku Bijutsu*), showcasing the recent campaigns of ADC designers. The works displayed in each yearbook serve as a trigger for development of common traits and characteristics across the group by creating a common denominator, despite the different styles of each art director. The yearbooks also display criteria for "quality" advertisements, highlighting the current state of expertise among Japanese art directors. Unlike similar publications in other locales or other industries, these yearbooks are also highly regarded abroad, selling well in many countries.[35]

As part of elevating its reputation and branding as the elite designers and the creative core of the Japanese advertising industry, the Tokyo ADC has since 1976 held conferences commemorating the group's anniversary. Its twenty-fifth anniversary opened with an exhibition in the Seibu Art

Museum, for which the Tokyo ADC also published the book *Japanese Art Directors (Nihon no arto directa)*, a collection of conversations among the members of the association.[36]

From the 1980s on, the Tokyo ADC has also joined the Iconograda (International Congress of Graphic Designer Associations), participating in international exhibitions. At times, the association holds an exhibition abroad, such as the annual Tokyo Art Directors Club Award exhibit, hosted by the Museum für angewandte Kunst Frankfurt in Germany.

The Tokyo ADC has also collaborated with its original source of inspiration, the NY ADC. In 1972 the two clubs held a joint exhibit, and some members of the Tokyo ADC have been elected to the NY ADC's Hall of Fame. In addition to setting the tone for Japanese advertising design, the association also establishes a model for the role of art director in Japan. Arai Seiichirō explains: "I know Kamekura often said that we shouldn't import theories of art direction from the U.S. Therefore, we also thought that we must produce an original model of art directors, befitting Japan. If possible, we must represent an example of true art directors, rather than simply introducing the idea of art direction. We believe that it was an important role for Tokyo ADC, to produce such models and examples."[37]

The work and activities of the Tokyo ADC set the standard for the Japanese advertising design industry in the fields of corporate identity and advertising conceptualization. These collective activities have a major effect on young designers in Japan. Working as independent and autonomous artists, outside the structure of the formal advertising agencies, Tokyo ADC members have created an ensemble-built collective language for the Japanese advertising world, with each member still maintaining a unique personal language within this ensemble.

2

The
Aesthetic
Forces

In order to understand the new trends in contemporary advertising since the 1980s, it is essential to explore the context in which they emerged. In the 1980s and 1990s, a new wave of visual culture inundated Japan, mainly in Tokyo. It included architects, fashion designers, industrial designers, art directors, and artists, who together established in Tokyo a new elite and avant-garde aesthetic milieu. The members of this group created in disparate fields and styles, but they shared a common denial of modernism, and a determination to create art in a postmodern mode.

Technological changes such as Internet culture, video, and digital media, as well as changes in academic theories such as deconstruction, simulacra, and rhizomatic structures, served to create the postmodern visual movement. In this manner, postmodern aesthetics in Japan and elsewhere are a product of globalization, which transformed visual culture into a multicultural product. The artists, architects, and designers of the postindustrial world began to represent reality using a revolutionary visual language that shifted away from the modern tradition.[1] The new aesthetics held a discourse with art history, popular culture in forms such as manga and anime (Japanese comics and animation), global trends, and new media such as television and the Internet. This visual culture made use of the cacophony of languages and visual styles while blurring the borders of the different media and high-low hierarchies. This was accomplished by using a pastiche method that quoted styles from classical language all the way through pop art. The pastiche method employed outright reproduction, ownership duplication, quotation, nostalgia, parody, irony, and impersonation. It played with metaphors and traditional compositions, as can be seen in Nara Yoshitomo's 1999 series *In the Floating World*, which depicted an interpretation of the well-known images from the ukiyo-e genre ("pictures of the floating world"). Nara transformed the characters (geisha and samurai) and vistas (Mount Fuji) of these landmark images of Japanese art history into contemporary images by free drawing over the original prints (figure 3.1). Harking back to Duchamp's adding a moustache

to the *Mona Lisa*, the geisha and sa-murai of the precise woodblock print are transformed into *harajuku-zoku* punk.

Nara revisits traditional ukiyo-e images that were among the first to arrive to the West in the nineteenth century and formed the *japonisme* trend that created the orientalist image of Japan in the West. He sought to tear down the traditional orientalist image of Japan and build it back up from scratch. His work raises the questions: What is Japanese today? Can Japanese artists escape their rich visual tradition and create a personal style relying on the new international and global trends? Can they renounce Japanese art history? Answers to these questions are revealed in the iconoclastic expression of his work. The series represents the

FIGURE 3.1
Nara Yoshitomo,
*Punk Ebizo (In
the Floating
World)*, 1999
© Yoshitomo Nara

contradicting and unresolved relations between traditional art and contemporary art in Japan, and reveals the postwar emergence of identity dilemmas in which association with the West and with manga is stronger than the affiliation with traditional Japan. The combining of languages and tearing down of dichotomies and hierarchies between high art and popular art generated new narratives and multiple layers of meanings and messages that can be interpreted in different ways by different viewers.[2]

In his book *The Cultural Turn*, Fredric Jameson argues that the rise of postmodern aesthetics started with architects who detested modernism, such as Robert Venturi, who wrote the influential manifesto *Learning from Las Vegas*, and Charles Jenks, who proclaimed the exact time of death of modernism (July 15, 1972, at 3:32 p.m. in St. Louis, Missouri) at the time of destruction of the utopian, modernistic Pruitt-Igoe housing project.[3] From a structural standpoint, the postmodern aesthetic in Japan does not differ from the global, but it does differ in its content. It quotes from traditional Japanese art and also plays with compositions and concepts familiar to the Japanese viewer. It uses Western metaphors depicted in the context of Japanese visual history.

For example, Morimura Yasumasa photographed himself as characters from Western art history in the 1998 exhibition *Self-Portrait as Art History*, throwing himself into the image of well-known works of art. These self-portraits broke down hierarchies and blurred boundaries: between Western art and Japanese art, between genders (he poses as both man and woman), between high culture (museum painting) and low culture (newspaper photographs of Hollywood stars), between the media of painting and photography. His works combine Western and Japanese art and thus break the traditional visual expression that defined "Japaneseness" and create a new image of Japanese art around the world. In his next exhibition, *Inner Dialogue with Frida Kahlo* in 2001, he photographed himself as the artist, embellishing "Frida" with Japanese elements such as a *kanzashi* hair pin and Louis Vuitton shawl (which interestingly is considered classical contemporary Japanese) (figure 3.2.)

FIGURE 3.2
Morimura
Yasumasa, *An
Inner Dialogue
with Frida Kahlo
(Hand-Shaped
Earring)*, 2001.
Color photograph,
59 × 47.25 in.
© Morimura
Yasumasa

Once more the borders between man and woman and between painting and photography are crossed, directing attention to the way that Japanese and Mexican art are both viewed as exotic in contrast to the Western canon, and how this exoticism becomes a symbolic product in the postmodern era.

These works challenge the idea that American and European art is the true canon of art history, and at the same time present the spirit of a time when Japanese art tradition and local identity ceased being the basis of the Japanese visual styles. According to Jacob Raz, Japanese postmodern qualities were not imported from the West, but rather already existed in the Japanese tradition dating back to the seventeenth century.[4] As such, postmodernism in Japan is a state of mind and not an era. This postmodern condition—inherent in the Japanese tradition—served as a foundation for establishing the contemporary visual culture.

The New Visual Culture and Aesthetic Milieu in Tokyo

The novel concepts can be seen in design and architecture that combined traditional Japanese concepts of space and aesthetics with contemporary visual concepts and technologies. Architects such as Maki Fumihiko, Isozaki Arata, and Andō Tadao, as well as Aoki Jun and Sejima Kazuyo who followed later, combined new and traditional elements in their architecture and are considered the creators of the postmodern language in Japanese architecture.

Avant-garde fashion designers who broke out at the end of the 1970s, such as Miyake Issey, Kawakubo Rei, Yamamoto Yohji, as well as their followers Kurihara Tarō, Watanabe Junya, and Takahashi Jun, created a new language that combines East and West, traditional and contemporary. Their work was considered art despite being consumer products and generated both confusion and excitement on Paris runways in the early 1980s with their introduction of postmodern deconstruction concepts into the fashion world.[5]

In the 1980s, industrial designers also began to build a vocabulary of new aesthetic terms for the Japanese design world. Post–World War II industrial design in Japan was influenced by the international style that was introduced to Japan during the American occupation. But the 1970s brought a change, with the primary influence coming from Italian radical design. Designers like Umeda Masanori, who worked in Milan and designed with the Memphis group, and Kuramata Shirō, who also worked in Japan for the Memphis group, brought the influence of this important group to Japan. Other designers began to leave the employment of large conglomerates in favor

of opening private studios, creating one-off products for galleries and thus blurring the boundaries between art and design. Designers such as Uchida Shigeru created unique items that quoted traditional Japanese motifs. Other important designers, including Morita Masaki, who worked in Finland, were influenced by foreign trends. These designers developed a new design language, paving the way for contemporary designers such as Fukasawa Naoto and Yoshioka Tokujin.

During this period, the Tokyo Art Directors Club presented avant-garde graphic design and created new and challenging visual communication patterns. Their works should be seen as part of the visual revolution.

The collaborative ties between the members of these creative fields played a key role in Tokyo developing a new avant-garde elite aesthetic milieu. Kuramata Shirō designed Miyake Issey's boutiques, while Miyake employed artists like Morimura Yasumasa for textile design. Miyake also worked together with the architect Andō Tadao to create the Tokyo design museum "21_21 Design Sight." Kawakubo Rei worked with the architect Kawasaki Takao. Similarly, Tokyo ADC members participated in cooperative works, including advertising campaigns for Miyake Issey (art director Satō Kashiwa), Comme des Garçons (art director Inoue Tsuguya), and many others.

The challenging, un-decoded concepts of this milieu sparked the curiosity of various researchers who sought connections to Japanese aesthetic sources. The space concept of Andō Tadao was related to the empty space concept of Zen shrines; Miyake Issey's and Kawakubo Rei's patterns that do not follow body shape were related to the traditional kimono; and the unfinished clothes of Comme des Garçons (by Kawakubo Rei) were related to the Japanese wabi-sabi tradition.[6] But the new visual expression was not truly connected to traditional Japanese tradition. It primarily linked to the postmodern concepts and aesthetics that developed in Japan through the postwar technologies, the appearance of television, internationalization, globalization, and the growing importance of popular culture (manga, anime, and pop art).

The appearance of television in the 1960s caused visual and social changes.[7] Television broadcast to cities and village prefectures, which until then were disconnected, creating a new collective awareness built on common values throughout Japan that spanned the gaps between cities and villages and also between the various dialects spoken in different regions. The power and the attraction of television subverted traditional values and boosted the popularity of entertainment industries and media culture. Those born after the war and who grew into maturity in the 1980s developed a collective worldview that differed from that of their parents. This generation that

was reared on television created a culture that turned its back on traditional Japanese roots. Some of the new visual trends naturally stemmed from this new collective awareness.

Internationalization (*kokusaika*) and globalization of the 1980s contributed to the new visual culture through various art trends that found their way to Japan via the new information avenues of foreign magazines, international exhibitions, art importing, and eventually the Internet bringing new ideologies and visual concepts.

As throughout the world, digital technology grew in influence in Japanese visual culture in the 1980s and 1990s. Graphics software, the Internet, and virtual worlds changed the visual boundaries of artists, enabling them to converse in a visual language that expressed globalization not necessarily connected to Japanese tradition.

The new visual culture developed in Tokyo and gradually spread to other cities in Japan, blurring traditional distinctions between low and high, academic conversation and street culture, traditional and contemporary aesthetic expression, analog and digital, global and local. The new visual expression penetrated into all areas—art, architecture, advertising, and the press—selecting and refining its various sources, including traditional art (such as *emakimono*, *sumi-e*, *ukiyo-e*, *yamato-e*, *nihonga*), art from the Taisho era that already included Western influences (*yōga*), and global influences.[8] This blurring of boundaries challenged symbolic hierarchies stemming from artistic traditions hundreds of years old.

In order to illustrate the complexity of the postmodern era in Japan, the new trends and the ideologies of the different artists and designers, I will present two different aesthetic languages that are vital and flourish side by side in the visual culture of Japan. On the one hand there is the elitist milieu of architects and designers that created the new avant-garde aesthetic expression bringing the postmodern ideological discourse into aesthetics, and on the other hand there are the popular aesthetic languages that emerged from the streets and conveyed the desire of the young generation to be free from the bonds of the traditional Japanese way of life. Both trends are demonstrative.

The art directors of the Tokyo ADC are an elite group that is part of the avant-garde aesthetic milieu. Yet their works consist of popular currents as well. I commence with an analysis of the work of the fashion designer Kawakubo Rei as an example of the Japanese avant-garde and elite aesthetic milieu, keeping in mind the words of the influential designer Yokoo Tadanori, who said, "Fashion became in the 1980s the most influential aspect on

the visual culture of this time."[9] The work of Kawakubo shows the complexity, contradictions, conceptuality, and multiple layers of meaning that are also expressed in the works of other designers of this elite aesthetic milieu, including the works of Tokyo ADC members.

Kawakubo broke into the fashion world in 1981 in Paris. Her models walked down the catwalk under a flashing, bright neon light with music being abruptly switched on and off.[10] The clothes were in contrast to the strict rules and codes of the European fashion world of that time: designers in Paris presented perfect cuts that followed the body outline, using patterns that highlighted the ideal woman's body and high-quality materials that emphasized glamour and wealth; the main change from year to year was in color and hemline. Kawakubo's clothes were characterized by the breaking of the prevailing codes of fashion. First and foremost, they rewrapped the body in a way that does not consider the shape of the body but rather the space surrounding it. The clothes were asymmetric, with random sewing patterns, resulting in sculptural objects dressed upon the body. Kawakubo brought to the glamorous fashion capital an aesthetics of poverty that was not at all welcome in Europe and earned ice-cold reviews, such as "Les Japonais jouent Les Miserables."[11] Some researchers linked Kawakubo's clothes to the aesthetic traditions of the Muromachi period, when the philosophy of Zen Buddhism was expressed via monochromatic coloring. Accordingly, the beauty of the incomplete was connected to the aesthetics of the *wabi-sabi*. However, I contend that the work of Kawakubo was influenced more by foreign ideas and global trends than by the traditional Japanese aesthetics.

In order to understand Kawakubo's ideology, we must understand the new visual culture that developed in postwar Japan, as well as the ideologies and behavioral patterns that penetrated Japan in the 1970s, liberating Japanese visual expression from traditions, techniques, coloring, and the reliance on national foundations.

The first influential source on Kawakubo was the cultural revolution (followed by a visual revolution) that took place in the 1960s worldwide, including Japan. The avant-garde movements of this time—Gutai, neo-Dada, Butoh, and Mono-ha—created subversive experimental art. They protested against the values of the established institutions of government, industry, and culture and against accepted beauty values. They struck out against the rigid hierarchy of Japanese traditional art. This radical art attacked the corporate mentality with an art of unconventional materials and style and created new art forms, freed of shackles of convention, power structure, and marketplace. The visual expression of their art seemed somehow poor.[12] Kawakubo's post-

modern and avant-garde visual expression was linked to the conceptual and subversive aesthetics created in the Japanese avant-garde in the 1960s, as she was highly attuned to the art world surrounding her during her days as a student.

At the same time, foreign artistic and design trends found their way to Japan, like the 1960s Italian anti-design trend created by groups like Studio de Pas, D'Urbino, Lomazzi[13] and Gatti, Paolini, Teodoro,[14] as well as by individual designers such as Gaetano Pesce and Ettore Sottsass. These designers, who were influenced by the *arte povera* (poor art) movement and other subversive artworks of the Italian art world, defied all that was expected of furniture and modern design and undermined the "Good Design" of modernism, which believed in functionality, perfect ergonomics, timeless design solutions, and classic aesthetic values. Kawakubo was fascinated by how Italian radical design focused on destruction of the imagery of the object and the creation of new images. The "strange" products of the Italian avant-garde provided solutions that contradicted user expectations regarding the function of the object. These objects raised questions about the purpose and the goal of design in general. It was an explicit attempt to evaluate design as a social-cultural process and not just as a service provider. The radical designers wanted to create a design that blurred the social class issue and sought new visual strategies that redefined the role of design, the status of the designer, and the relationship between design and society. They called their works anti-class, anti-consumer, anti-marketing, and thus also anti-design. The resulting design had social and political messages that successfully excluded it from the capitalistic system.[15]

We must also note that Kawakubo studied philosophy and literature in Keio University and never underwent any formal fashion training. This is why, as Patricia Mears says, her skills are not in her hands or her patterns, but rather in her ability to engage in theoretical discourse.[16] When she was a student, deconstruction and feminist concepts were highly influential, spurring on social revolutions that were an inspiration to her. Deconstruction, which was largely incubated in philosophy departments in France and literature departments in the United States, spread to art, architecture, and design. When it reached the fashion arena—via the British punk movement and its fashion designers such as Malcolm McLaren and Vivienne Westwood, and later Kawakubo—deconstruction broke the dominance of modernist fashion that had produced finely finished cuts that fit the body snugly. Deconstructive fashion presented clothing with an unfinished look, including loose, frayed hems and edges. The clothes appeared to be falling apart or

made of a combination of different parts. Deconstructed patterns tended to hide the body rather than show it. These clothes were quite the opposite of glamour, presenting a poor look, devastation and degradation. Mears argues that deconstruction theory, which heavily influenced the visual world, was also the driving force behind Kawakubo's work.[17] Deconstructive fashion existed before Kawakubo, but she was the first to formalize and appropriate it completely with the monochromatic colors and asymmetric baggy look that destroyed modernist patterns. Figure 3.3, for example, shows the destruction of the body silhouette constructed by fashion designers and fashion photographers during the twentieth century. This is achieved while simultaneously deconstructing the grid that was the basis of modern design. In reference to her new draping, the discourse in the French fashion world referred to Kawakubo's fashion as "Le Destroy."[18]

Kawakubo's ragged edges, irregular hemlines, crinkled fabrics, and loose-fitting layers that fell aimlessly over the body were described in *Le Figaro* as the "World War Three survivors' look" or "Hiroshima bag-lady look." Via these protest clothes, Kawakubo defied the rigid social and cultural codes of Japan, in the same way that the Italian designers fought against social class concepts using design.[19] However, Kawakubo also seemed to be influenced by the postmodern freedom to use irony and paradox in her compositions, as manifested in her quoting from traditions such as neo-punk or Walt Disney.

In addition to the deconstruction and the postmodern trends, she was influenced by the radical feminist ideology that was just reaching Japan at the time, influencing a milieu of Japanese creative women such as art director Ishioka Eiko, who embedded feminist messages in her revolutionary advertising campaign for the Parco department store, as discussed in the introduction. Other feminist artists rose at the time, including Ono Yoko from Fluxus and Kusama

FIGURE 3.3
97 S/S Collection, "Body Meets Dress—Dress Meets Body" Comme des Garçons

Yayoi, who had just returned from a stint with Andy Warhol in New York. Although Kawakubo has never referred to herself as a feminist, these creative and influential women, who worked in the art arena when Kawakubo was building the conceptual foundations of her fashion company, undoubtedly had a major influence on her work. In 1972, when she founded her company she chose to call it "Comme des Garçons," a name that insinuates her concept of gender equality. Kawakubo claimed at the time that she wished for women who wear her clothes to be financially independent with self-esteem and power—women who are interested in emphasizing their strength and who attract men with their intellect and power rather than with a sexy appearance. In an interview, she said, "We must break away from conventional forms of dress for the new woman of today. We need a new, strong image, not a revisit to the past."[20]

This feminist and deconstructive platform, in combination with the avant-garde aesthetic visual expression of 1960s Japanese art and the Italian anti-design, are clearly represented in Kawakubo's work. Not only did this style not derive from kimono outlines and *wabi-sabi* design; it actively challenged and opposed Japanese fashion traditions. The clothes effectively blurred boundaries between art and design, high and low, global and local, and paradoxically between avant-garde and luxury.

Kawakubo's work represents the complexity of the avant-garde visual culture that developed in Japan, based on a new conceptual platform that goes against both Japanese and European traditional aesthetic values. These postmodern concepts prevailed in the works of the different artists, architects, and designers of the elitist aesthetic milieu.

Popular Visual Cultures: The *Kawaii* Style

Geographically close to Kawakubo's flagship boutique, but on the opposite side of the scale conceptually, a fringe style culture known as *kawaii* was developing in the 1970s. This style would eventually make its way to the mainstream in the 1980s under the auspices of consumer culture (figure 3.4).

The word *kawaii*, which originally meant "cute," adopted a wider connotation of "childishness" that includes naïveté, purity, simplicity, and vulnerability. Japanese youth who saw day-to-day adult life as gloomy and full of compromises—in which most of the day is dedicated to hard work for big companies and in which people are burdened with obligation to the nation, to social codes, and to family—wished to shake themselves free of all this. They started to behave in a childish manner, assuming that being a child brings

freedom. The *kawaii* style began as a youth rebellion against Japanese social codes and found its expression in the new visual culture. The form of protest was embodied by childlike behavior, speech, and writing, and by choosing cute products designed in a childish style.[21] This style was characterized by a saccharine look or fairy-tale style that was devoid of any power or sexual attributes that were considered part of maturity.

Sharon Kinsella revealed in 1990 that most youngsters were not sure of their political association or to which social class they belonged. However, they knew with certainty that they belonged to the *kawaii* culture, which defined their identity.[22]

Cultural anthropologist Ōtsuka Eiji explained that this behavior began first among young women who refused to grow up, surrounding themselves with cute childhood objects and in this manner prolonging their adolescence and postponing the role of wife and mother. These young women preferred fantasy over reality, since it protected them from the difficult and permanent role of the woman as determined by the Japanese traditional social codes.[23] Like a typical teenage revolt in which youth seek to achieve adult rights and independence, this "childish" movement was also a type of revolt—though one in which young Japanese women actively chose to defer responsibility or independence, creating an alternative to maturity as a way of life. As opposed to the worldwide postwar protest movements (punk, rap), *kawaii* ideology was led by women. It differed from the feministic ways of Kawakubo Rei, Ono Yoko, or Ishioka Eiko, but it was still a form of feminist protest. Although the *kawaii* style was supposedly created in an air of lacking awareness (since this is an important part of childish behavior), the youngsters created a lifestyle revolving around personal pleasure and high self-awareness in regard to style and dress. Thus, a core part of the protest focused on overconsumption of products. Young Japanese women in the 1970s had recently joined the workforce but by and large remained at home, living with their parents, thereby leaving disposable income that transformed them into the richest sector in Japan and a powerful consumer group.[24] Their exaggerated consumption was perceived as antisocial, immoral, and irresponsible (thus childish), since it flew in the face of commitment to family and society. The rise of *kawaii* is thus best understood in the context of the late consumer culture. The *kawaii* style was established in the margins of society, but businesspeople quickly recognized the market potential concealed in this trend and established a commercial path for its continuation. The companies created products that fit the specific needs of this target audience that followed in step and furthered the style's develop-

ment to such a degree that it overtook Japanese visual culture. For example, starting in 1971 the Sanrio Corporation brought to market stationery, writing implements, school bags, and lunch boxes that dripped with the cuteness of the *kawaii* style. These products included characters such as "Hello Kitty" that were small, soft, childish, round, with short limbs (that do not enable movement) and no mouth (dumb) and devoid of sexual identity, hinting at helplessness and a lack of self-confidence. A more grotesque representation of *kawaii* was apparent in the celebrity success of the one-hundred-year-old twins Gin-San and Kin-San. These images reflected precisely the fragile behavior and the ideals that Japanese youth were attempting to achieve. Sanrio claimed that their products were social communication goods: objects that were meant to strengthen interaction, which was the heart's desire of this youth.

The new consumer culture and the attempt to express a new femininity via cuteness and sweetness brought prosperity to the fashion houses of the Harajuku neighborhood, such as Milk, Pink House Ltd., and Angelic Pretty, that created fantasy and fairy-tale clothing. They created a trend of young women dressed in Lolita clothing.

Popular Visual Cultures: The *Moe* Style

On the other side of town, far from the Aoyama and Harajuku neighborhoods, an additional trend made headway in the Akihabara neighborhood. Akihabara was the main shopping area for electric appliances in the 1970s and 1980s, and it shifted to a center for computers, computer games, and animation products in the 1990s. As part of the shift in consumer products, the neighborhood adopted a new visual identity, at first via street advertisements for manga and anime icons and later by designing interior space of the stores based on the design of computer games themselves. The urban structure of the neighborhood also changed gradually, with new buildings arising, bearing advertisements that were equally outsized. By the mid-1990s the entire neighborhood took on the look of a computer game, with the customers playing the part of wandering images (figure 3.5).

Along with the changes in the products sold, the target audience also changed from middle-class consumers of electrical appliances to a new group of youngsters referred to as *otaku-zoku* (Otaku tribe). The *otaku-zoku* were computer geeks who congregated in the stores buying manga and anime. This new audience also purchased sexual illustrations and animation (*hentai anime*), which led to the opening of fantasy sex shops, nightclubs, and

FIGURE 3.5
Ooshima Yuuki
(character de-
sign and figure
model), "Arina
Shinyokohama
in Akihabara,"
installation from
the Japanese pa-
vilion of the Ninth
International
Architecture Bi-
ennale in Venice
© 2004, Ooshima
Yuuki / Kaiyodo

"cosplay" (costume play) theme restaurants such as Maid Café that added a
subversive and dark look and feel to the neighborhood.

In his book *Learning from Akihabara: The Birth of Personapolis*, which
leans on Robert Venturi's *Learning from Las Vegas*, the architect Morikawa
Kaiichirō explains the birth of the new urban people whom he calls Per-
sonapolis, as a parallel to the metamorphosis of city into megalopolis. In
the book, he focuses on the Akihabara district, which became a mecca for
manga, anime, and video game hobbyists built on daydreams, hallucina-
tion, and delusion. He describes the neighborhood with a look toward the
future, stereotyping a culture in which technology becomes the core essence,
giving shelter to the different and the unpopular who do not meet norma-
tive social expectations. The architecture throughout Akihabara creates a
sense of affiliation by providing the *otaku-zoku* with a space protected from
the outside world. He explains that this milieu was formed around the *moe*
style, whose name is indicative of an affection toward manga characters As
the *moe* (literally, burning) style was based on the look of Japanese manga

Aesthetic Forces

characters, it was considered by the *otaku-zoku* to be an original, native, and pure contemporary Japanese style.[25] Visually, the *moe* style references specific manga and video game characters who are clearly identified as being Japanese. This is in contrast with the *kawaii* style, which references different manga characters, such as in *The Rose of Versailles*, who represent Westernness. The *moe*-referenced manga characters have a sexy edge, another important point of distinction.

Using the *moe* style, the *otaku-zoku* differentiated themselves from the Harajuku and Aoyama subcultures, which had a foreign sense to them, in part because those neighborhoods became universal fashion centers that saw the opening of globally oriented foreign designer stores including Prada, Dior, and Armani, followed by American lifestyle chains such as Gap. Manga, with its countless characters and stories, became a popular consumer product during this time and affected the visual Japanese expression in the 1980s and 1990s via magazines, toys, video games, fashion, and architecture. The Japanese pavilion in the International Architecture Biennale in Venice 2004 held an exhibition titled OTAKU: *Personality = Space = Cities*, which presented the immense influence of the *otaku-zoku* style on Japanese visual culture (figure 3.6).[26] The *otaku-zoku* viewed their style as a source for a new national identity.

The *kawaii* and *moe* styles emerged from the streets as part of the new social paradigm shift of the 1980s and the division of Japanese society into many subcultures that identified themselves via style. These new aesthetics were radically different from traditional Japanese styles and added color and depth to a Japanese aesthetic experience that had begun to appear futuristic in foreign eyes.[27] As part of this mosaic, advertising also took part in the construction of Japanese street aesthetics through television screens, street signs, neon lights, and advertising in trains.

FIGURE 3.6 Ooshima Yuuki (character design and illustration), "OTAKU: Personality = Space = Cities," poster for the Japanese pavilion in the Ninth International Architecture Biennale in Venice © 2004, Ooshima Yuuki / Kaiyodo

From Street to Art
and Back Again

The new popular subculture, together with the consumer culture, was the primary and leading stream of the entire Japanese culture of the 1980s and 1990s, and the world of art and design responded in part to the aesthetics and new styles that emerged from the Japanese street. Just like American pop artists who adopted images from consumer culture and transformed them into works of art, Japanese pop artists also created images and products rooted in consumer product aesthetics. However, the images didn't just respond to or express the strength of the 1980s Japanese consumer culture. They were aggressive consumer products in and of themselves. Whereas American pop represented consumer culture, criticized it, and attempted to expose its absurdity, Japanese pop does not criticize consumer culture. Instead, it welcomes consumer culture and regards art as an inseparable part of it. Although the *kawaii* and the *moe* subcultures differ from the avant-garde of the elite aesthetic milieu, their styles also influenced Japanese contemporary artists, and the influence of their art objects eventually bounced back into the design scene as well.

The works of Murakami Takashi, the most influential Japanese artist of the 1990s, presented a contemporary Japanese style inspired by a wide variety of sources: consumer culture, *kawaii* style, and *otaku* culture and its *moe* style. Murakami's work also reflects the characteristic flatness of traditional art, as is seen in his manifesto "Superflat." His work has been defined as a calculated disorder that oddly seems to carry an echo of the luxury and exuberance of the baroque.[28] His exhibition in the Versailles Palace in 2010 expressed his view on contemporary Japanese visual language and culture (figure 3.7). Its colorful, kitschy, and decadent characteristics were closer to the ornamented rococo style of Versailles than to traditional Japanese visual culture.[29]

Murakami sees himself as an artist, entrepreneur, curator, and art theoretician. His concept is that art contains creativity, production, theory, distribution, and marketing. Murakami studied the visual languages of popular culture and consumer culture and used them to create works of art that present the consumer culture and its products as a reflection of thinking patterns and cultural structures. His works present *kawaii* culture, the processing of nuclear holocaust memories, and the subconscious fantasies that often appear in popular Japanese culture.[30] For example, some of his works presented the seduction motif of *kawaii* objects and the dependence of the *kawaii* cul-

ture youth on these objects that provided them with identity. Murakami's works revealed how the products of the *kawaii* consumer culture encouraged the regression of consumers back to childhood, releasing them from the responsibilities of contemporary society. This exposed the narcissistic structure of the *kawaii* culture and the deep influence of these "naive" items on the psychology of the Japanese consumer. Murakami exposed *kawaii* to be a psychologically dangerous social phenomenon, and not at all a saccharine, childish, fairy-tale look that need not be taken seriously.

At its core, Japanese pop art unveiled the important place of popular culture and materialistic consumption as expressive tools for consumer emotions, fantasies, unspoken fears, and repressions. In his 2005 exhibition *Little Boy*, Murakami depicted the unspoken fear of mass annihilation by the atomic bomb as reflected in popular culture, drawing a line directly from Hiroshima through to Hello Kitty. Consumerism was presented as a reflection of thinking patterns and cultural phenomena. In this way, his work expresses the idea that art, society, and consumption join together to form a visual culture that can no longer be understood solely from one point of view.

FIGURE 3.7
Murakami Takashi,
Tongari-Kun

This pop art no longer tried to describe the external world, but rather spoke the language of the virtual worlds of computer software, manga, anime, and television, including aspects of the erotic, the grotesque, and the nonsense of *kawaii* and *otaku* cultures. Suddenly, a new Japanese culture that resides far away from the "formal" Japanese culture known throughout the world manifested and highlighted the new arena in which youth lived. Japanese pop art presented urban postmodern culture in order to show, paradoxically, the authenticity of this culture for its consumers, despite aspects of this culture that by definition were artificial, virtual, decadent, lacking in values, and escapist.

As part of the blurring of the boundaries between art and design, Japanese pop artists began to design consumer products as well. Murakami redesigned the Louis Vuitton monogram canvas from scratch. He designed the Multicolor monogram, the Cherry Blossom bag, and the Eye Love monogram, all clearly inspired by the *kawaii* style. In his studio, Murakami creates art side by side with T-shirts, key chains, and mouse pads. He explains that the art process also includes producing and selling products, and that is why he presents his works both in museums and in areas of consumption, such as his exhibitions in boutiques and bookstores in the Harajuku neighborhood. In his exhibition in the Brooklyn Museum, he added a Louis Vuitton handbag shop, thus bringing the consumption experience directly into the museum.[31] He even on one occasion sold works in a convenience store—the Superflat Museum convenience store edition—to take part in consumer culture.

The legitimization that the popular styles acquired via contemporary pop art reflected back into the design of the elite aesthetic milieu, influencing and enriching its visual expression. In 2009, Kawakubo Rei, who is still continuously creating pieces today, cooperated with Murakami Takashi, as part of Kawakubo's "Magazin Alive," a new concept shop launched in association with Japanese *Vogue* magazine. The first show in this new forum was titled "Takashi Murakami Magical Princess," with Murakami's works shown alongside Kawakubo's clothes.

Similarly, Takizawa Naoki, who designed clothes for Miyake Issey, cooperated with artist Takano Aya, a member of Murakami Takashi's Kaikai Kiki studio. Takano's painting *Moon* was transformed into a textile pattern. The name of the piece was taken as the name of the fashion line collection.

An additional example of the influence of art on consumption culture is seen in the works of fashion designer Hirooka Naoto, who designed "h. Naoto," comprising twenty-nine specialized collections of Lolita variations, one of which showed the dark side of the *kawaii* culture. This particular line

was created with the assistance of Gashicon, an animator and creator of the characters Hangry and Angry, a combination of a very cute punk character (Hangry) and a gothic character with a devilish side (Angry) (figure 3.8).

The characters are a take-off on the cuteness of Hello Kitty, in a style referred to as *guro-kawa* (short for grotesque-*kawaii*), whose lineage comes directly from the Japanese pop art that showed the unconscious dark side of *kawaii* and fused the avant-garde with the cute.[32]

To conclude, the various visual expressions in art and design that emerged in Japan since the 1970s and 1980s, including avant-garde, cool, cute, and sexy styles, all responded in some manner to social, economic, and technological changes of the era and in their own way expressed the globalization and novel postmodern discourse that grew at an accelerated pace during this time of bubble economic growth. Their visual language introduced unique styles that fit the social fabric and new paradigms of 1980s society. The new visual language, with its many colors, achieved universal recognition and was explained in many books to be a representation of a new "Japaneseness," despite the fact that the visual language comprised only a small percentage

FIGURE 3.8
Gashicon (designer) and Kushida (art director), "Hangry & Angry" © Gashicon

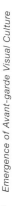

of the many styles present in Japan during this time, and despite the fact that it was more indicative of a global urban style than of a Japanese style.

I would like to argue that it is impossible to bundle the artists and designers that emerged in Japan at that time under the collective umbrella term "new Japanese style," for the simple reason that each artist brings his or her own personal language. When approached directly in interviews, each art director emphasized not only his or her own personal expression, but also its distance from a Japanese visual language. Toda Seijū works in a surrealistic style, while Saitō Makoto delivers a provocative look with dual Japanese and Western inspiration. Inoue Tsuguya's avant-garde approach made him a natural choice to cooperate with Kawakubo. Aoki Katsunori is a pop-style designer and a friend of Murakami Takashi. Satō Kashiwa is a wild, youthful designer who makes use of new technologies, making him a perfect choice to create campaigns for Miyake Issey. The sole exception is the Buddhist art director Suzuki Hachirō, who quoted visual icons, styles, and schools from Japanese art history while creating ad campaigns for Buddhist shrines.

As we have seen, the Tokyo ADC should be viewed as part of a wider avant-garde aesthetic milieu. However, as advertising belongs in whole to consumer culture, the aesthetic values of the ADC works also represent the social paradigm and economic values that emerged in Tokyo during this time. They include the related street styles of *kawaii* and *moe*, as well as the new Japanese pop art. Although the Tokyo ADC works do not represent a singular "pure Japanese style," when we observe their visual output, each piece independently and altogether as an ensemble, a noticeable visual style with a local flavor emerges. It could be defined as "Japanese postmodern style," but I find it preferable and more accurate to define them as several styles of the aesthetic subcultures that found their feet in Tokyo starting in the 1970s.

The next chapter will focus on Tokyo ADC works that created a new visual communication, just as the works of the artists, architects, and designers of the elite aesthetic milieu displayed many aesthetic trends, concepts, and values of the time.

4

The Visual Communication Strategies within the Tokyo ADC

In the previous chapter, I described the new visual cultural sphere of artists and designers that emerged in Tokyo in the 1980s. Among the elite aesthetic milieu of designers and artists were the members of the Tokyo Art Directors Club. They created new concepts, visual styles, and perceptions that established throughout the world a reputation of high honor for the aesthetics of Japanese advertising. In this chapter, I turn attention to the wide range of works of these Tokyo ADC designers: their divergent styles, their polyphonic nature, the cultural and artistic references found in their works, and how we can decode the visual strategy that was used to create meaning within their advertisements.

Before analyzing the wide range of works of the members of Tokyo ADC, I will first demonstrate their new visual communication strategy via an in-depth analysis of a single example: the posters designed by Japanese art director Saitō Makoto for Hasegawa Corporation. This analysis demonstrates the methodology employed throughout this chapter, in which I combine semiotic analysis with direct interviews of the creators.[1] The analysis also shows the innovative visual strategy of Tokyo ADC in the sphere of Japanese visual culture and explores how the integration of high art into commercial advertising created new postmodern visual texts that allow the companies to distinguish their brand-name products.

In 1985, art director Saitō Makoto designed two posters for an advertising campaign for Hasegawa, a manufacturer of domestic Buddhist altars (*butsudan*) and religious ossuary products. The posters, with their abstract messaging and minimalist visual intonation, generated significant interest within advertising circles and far beyond. They were featured in numerous design books, presented in museums around the world, and subsequently purchased by, among others, the Museum of Modern Art in New York.

The first poster (figure 4.1) offers a close-up of a blue-toned human femur, centered upright on a white background. Upon initial viewing, the bone captures the viewer's attention. Eventually, the eye begins to wander, discovering

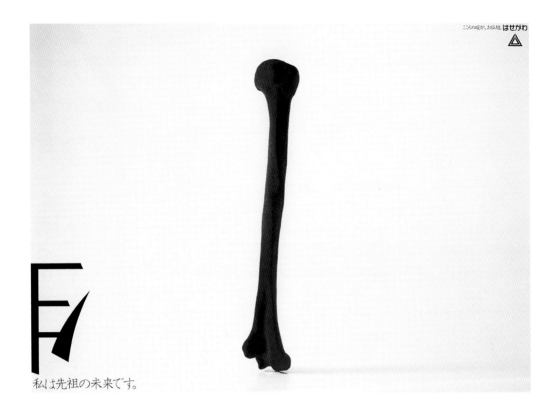

FIGURE 4.1
Saitō Makoto,
advertisement
for Hasegawa
Corporation,
1985 © Saitō
Makoto

a partial ideogram in the lower left corner of the poster. It is one half of the *ikiru* (生) ideogram (meaning "life"), presented upside down. The eye moves next to a slogan proclaiming "I am the future of the ancestors," and only then identifies the company's name and logo positioned conspicuously small in the upper right corner. At the end of this wandering, the eye returns to the bone and identifies its subtle shadow.

In the second poster (figure 4.2), a pelvis bone is similarly set in blue on a white background. The second half of the *ikiru* (生) ideogram appears lying on its side, alongside the contrasting slogan "I am the ancestor of the future." As in the first poster, Saitō again establishes a vague visual identity. The bone itself resembles an image from a Rorschach test (figure 4.3), adding ambiguity by establishing a subliminal association with a visual form whose very purpose is to have no definite meaning, intentionally designed to leave everything open to personal interpretation.

In contrast to conventional advertising campaigns, in which a poster is expected to be an entire unit of information and deliver a full message, neither of these posters represents a complete piece of work. Instead, the message is created via a dialogue that prevails between the two posters: a dialogue between the complementary bones (the pelvis and the femur), between the

80 *Aesthetic Forces*

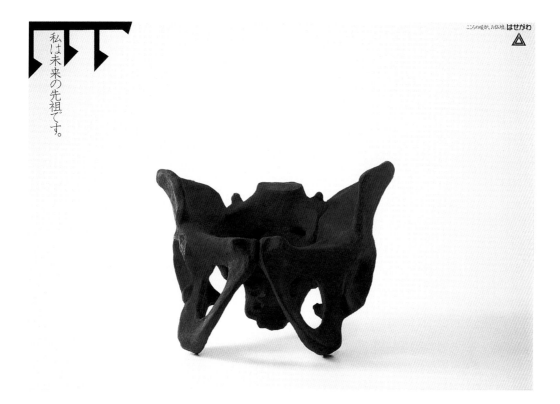

私は未来の先祖です。

こころの暖炉、お仏壇 はせがわ

Figure 4.2
Saitō Makoto,
advertisement
for Hasegawa
Corporation, 1985
© Saitō Makoto

FIGURE 4.3
Rorschach
inkblot test,
card number 1

inherently masculine and feminine shapes, between the two partial ideo-grams that together create *ikiru* (生, life), and between the reversed slogans "I am the future of the ancestors" and "I am the ancestor of the future."

Even the textual content of the campaign—the slogan, which typically anchors any unclear meanings in the visual imagery—serves neither to focus nor even to clarify the imagery. Instead, it is poetic and vague in and of itself. A literal reading of the first slogan ("I am the future of the ancestors") could be understood as being stated by the Hasegawa company itself. They man-ufacture the ossuaries that hold the ashes of the dead and are thus, literally, the future of all ancestors. Yet the alternate slogan ("I am the ancestor of the future") remains entirely open to interpretation. And to whom does the "I" refer?

These posters broke almost every conventional rule of visual and market-ing communications of their time, first by choosing not to display the actual product, and second by using visual and verbal narratives that do not guide the viewer into an understanding of *what is the product, who is the company,* and *what is that company's identity.* The only indication of the company is via the logo and company name, which is extremely small with respect to the visual elements of the poster. As such, the image becomes a free-floating signifier, detached from any explicit context.

The minimalist abstraction and poetic visual identity of this campaign are indicative of a contemporary genre of advertising posters that leaves the entire realm of meaning to the interpretation of the viewer. Saitō Makoto's posters are indicative of the innovative, riddle-based advertising genre that took form in the 1980s under the flag of the Tokyo ADC. Many campaigns de-signed by Tokyo ADC artists employed an abstract aesthetic visual language, breaking with commonly accepted conventions in Japan at the time. Most notably, Tokyo ADC ads seemed to be devoid of any clear sales-promotion marketing qualities.

This advertising genre has been explored by many researchers who attri-bute this obscure and uninformative style to some inherent ambiguity in Jap-anese culture and communication patterns. Upon closer investigation, how-ever, a different conclusion is reached. Looking beyond the photographed image and exploring the new aesthetic, its sources, and the ideological context exposes a rich visual text with a postmodern visual communicative expression. This explorative approach paves the way to understanding the manner in which advertising of the Tokyo ADC succeeds in attracting the eye of the viewer and influencing his decision. The new visual text raises a discussion regarding the visual language and the aesthetics of contemporary

Japanese advertising for this specific genre, which was not a majority of the actual ad placements, but had significant impact nonetheless.

Returning to the blue-toned bone in the advertising, we see an object that calls to mind pop art iconography. Saitō separates the bone from its full body context and photographs it on a white background devoid of any graphical context, thus transforming it into an object. As an object, it is photographed in magnified form, lacking any context and presented in a duotone graphic method typical of the pop art visual language.

Saitō employs pop art visual language because it represents consumer culture. Pop art developed in the United States as a reaction to the culture of consumption, as seen in its outdoor signage and billboards, brusque graphics, and supermarket-as-cathedral attitude. This art employed strategies borrowed from advertisements, magazines, and supermarkets to create a dictionary of American life in the modern age: a can of Campbell's soup, Marilyn Monroe, an electric chair. Andy Warhol dealt often with death as well, a subject artists have focused on since the beginning of time. But Warhol gave death a new dimension. Unlike previous artists, he did not scrutinize the core essence of death, but rather its consumption by a wider audience. Warhol documented celebrities who had died (Monroe, JFK) and dealt with memory or with objects affiliated with death: electric chairs, accidents, earthquakes, and even the atomic bomb.[2] The original photographs were often quite painful, but Warhol handles this with a technical remoteness typical of an artist observing and documenting a media event, lacking any core feelings or sense of "I." Warhol exposes a society overflowing with information images and visual clichés in which even death becomes a metaphoric image devoid of emotion, and thus a consumer "product." A story or photograph of a terrorist act on a newspaper's front page is as effective at selling the paper as a photograph of a beautiful model. This attitude toward death differs significantly from that of artists in other periods, such as the romantic trend that associated death with the sublime. Pop art explains that there is no hierarchical difference between the various metaphors of the marketing system, even for a tragic metaphor such as death. In other words, pop art presents death as a consumed product. This is most clearly exemplified in Warhol's photograph of a skull, which he presents as an object similar to his Campbell's can of soup (figure 4.4).

According to Warhol's account, the skull was purchased in Paris, where it was offered for sale, sitting on a shelf, just like any soup can in a supermarket. This work represents modern life in a supermarket of metaphors, in which there is no high or low. Everything simply sits on the shelf, including life and death.

FIGURE 4.4
Andy Warhol,
Skull, 1976
© Courtesy of
the Andy Warhol
Foundation for
the Visual Arts,
Inc. / Artists
Rights Society
(ARS), New York,
2013

Saitō follows up on Warhol's theme, using a similar visual strategy. Having been asked to design an ad for a company whose products are explicitly related to death (Buddhist altars, ash vases), Saitō clearly envisioned the link between death and consumer products.

Saitō photographed the blue bone as a pop object—flat, and with pop art's duotone graphical attributes. Even the colors that Saitō uses are similar (and not coincidentally) to those used by Warhol: blue, white, and black. The duotone quality emphasizes the surreal impression of the image. The blue symbolizes detachment from nature, flattening the object and transforming it into something artificial. Warhol transformed the consumer object into art, while Saitō uses the pop art styling in an actual ad, thus returning the work of art to the consumer arena.

However, this poster is not American pop. It is inherently Japanese pop, wrapped in minimalism and reductionism. The photographic technique used in the poster instills it with meaning, and investigating these techniques sheds light on the difference between *what* is said and *how* it is said. Ac-

cording to Roland Barthes, photographic technique (frame, depth of field, perspective, focus, light) creates meaning that is inherently associated with a cultural visual vocabulary.[3] In the Hasegawa ad, the bone is photographed from a straight-on angle, establishing objectivity. This angle imitates reality and creates an illusion that we see the real thing.[4] The empty space, lack of frame, and white background in which the bone is set leave the picture without perspective, which turns the object's implied shape into a symbol in the eyes of the viewer. This staging is automatically recognized by the viewer as a familiar composition referencing the rich Zen painting tradition. Saitō appropriates a well-known composition from the Muromachi period of the fourteenth through sixteenth centuries, as well as the *zenga* drawings of the seventeenth and eighteenth centuries, transforming them into a contemporary photograph. These Zen drawings were characterized by the aesthetics of the *ma*—a term referring to the empty space. Saitō reconstructs this empty space composition by placing the bone almost, but not quite, in the center. This lack of symmetry, created in the advertisement by the slight shift of the bone to the left, is also a common tactic in Zen drawing. The viewer's eye can't help but to seek balance, wandering aside in search of the full picture and thus discovering the other objects in the poster (the half ideogram, the slogan, the shadow, and the company logo). But while Saitō appropriates the composition, he also plays with it. He reminds us that this is a photograph (in contrast to a Zen painting) through his inclusion of a shadow trail, adding a depth of field and giving the bone a three-dimensional effect. At the connotative level, this shadow is interpreted in the sense of mystery and divinity (*o-kage-sama desu*). The composition of a single line surrounded by empty space appears in the drawings of Jiun from the eighteenth century (figure 4.5), and the line is also often painted today in calligraphy. Saitō photographs the bone as a replica of Jiun's line. Jiun's line has a thick upper edge, the stroke falls toward the left from the brush entrance, is thin all the way through, has several shades, and then leans to the right at the bottom where the brush exits. The bone, just like Jiun's line, is thick in the upper part, tilts slightly in the same direction as Jiun's line, is thin almost all the way, in several shades, and is thick again at the bottom, leaning to the right, owing to the nature of the bone.

Japanese viewers recognize this composition thoroughly, with its empty space composition and precise positioning of a small number of objects. In the poster, the empty space (*ma*) has several roles, emphasizing each of the objects. The space is obvious not only in the graphical sense but also as a space between the work of art and the viewer. The empty space triggers

FIGURE 4.5
Jiun Onkō (1718-
1804), *Staff*.
Hanging scroll,
ink on paper.
Private collection.

the viewer's imagination, leading to a better understanding of the artwork. The flexible nature of the empty space allows the viewer to create his or her own meaning, filling it with personal substance and identity. The lack of any framing and boundary creates continuity, enabling the viewer to merge with the image.

The composition distills the rich ideology and discipline of the Zen world-view down to the essence of a single straight line. Saitō Makoto similarly distills death in its myriad meanings into one single bone. The composition of the advertisement is a direct quotation of the well-known visual statement, and this reference is most certainly identifiable by the Japanese consumer. It delivers a clear sense of the religious, aesthetic, and elitist aspects of Zen Buddhism, and also succeeds in referencing another abstract ink image, just as with the Rorschach reference. In this manner, the ad refers to pop art's visual representation of death and the consumer culture through the object, but it does so by means of a visual form and composition that is well identi-fied by Japanese viewers, with Zen motifs delivering a message of Buddhist religious practice.

The bone as a symbolic object is steeped in metaphysical potency and ma-jestic glory. It challenges the viewer, who is led directly into abstractification and conceptualization. According to Jung's concept of the collective subcon-scious, among the archetypes that transcend cultures, the bone is a symbol of death and thus a memento mori. This holds true in Japan as well, but in Japan, bone (*hone*) has several connotations. This is evidenced in the expres-sions "hone ga aru" (literally "he has bones"), which means "he is alive," and "hone ni naru" (literally "turned into bones"), meaning "he is dead": thus, the bone carries the concepts of both life and death. From an advertising perspective, this reductive object simultaneously implies both the product (the *butsudan*) and the idea (death). The bone with its death symbolism is in a visual dialogue with the fragmented ideogram, which symbolizes life. The ideogram is presented as a letter that expresses an idea (its meaning is "life") but is also presented as an aesthetic object. The half-ideogram, turned upside down in the femur poster, and on its side in the pelvis poster, has the appearance of a partial fish skeleton. Both the bone and the ideogram are extracted from their natural whole. Thus life and death live side by side in the same sphere.

Saitō also adds depth to the narrative through the use of color. When I interviewed him on the subject, he related how he initially painted the bone red in an effort to create the Japanese red-white combination (*kohaku*), but the result was grotesque. This led him to blue, which gave the poster a colder

look (he explicitly used the English term "cool") that is easier to digest. He chose blue for its metaphysical symbolism of the infinite (ocean, sky). His choice of the specific tone, International Klein Blue, is not at all casual. He explained: "In my first steps, I visualized the bone, and I thought that it is not a white bone. After I considered various colors, the blue seemed the most mysterious—it has that ability to be mysterious. Yves Klein took the Japanese blue and turned it into an international color. I understood why he was attracted to this blue. He was in Japan, and he has a high ranking in judo. He took this color from the Japanese indigo [*ai*]. I completely understand why he felt that this specific blue is the most mysterious. I'm fine with people thinking that this is Yves Klien's. I don't mind."[5] In other words, Saitō used an international color that is not an explicit symbol of Japan (as is the red-white combination), yet he took into account the Japanese origin of this special blue and assumed that the Japanese viewer would recognize it for its Japanese tradition and its association with infinity, including death.

The dialogue among all the objects in the poster (composition, bone, ideogram, and slogan) establishes meaning and identity for the company. Visual language creates axes that connect Japanese with American and traditional with contemporary. The medium effectively eliminates hierarchy: it is both low (a street poster) and high (displayed in galleries and museums). The poster speaks in multiple voices delivering narratives that reference death and life, religious ritual, Zen aesthetics, and the contemporary consumer culture. The visual communication is constructed via the lexis of visual expressions composed in the art world: on one hand, death as a consumer product, as visually composed by Warhol, and on the other hand, visual expression of the Buddhist worldview, as composed by Zen monks. The combination between the expressions creates a new visual text, with a new syntax and a new message. The poster's aesthetic can be called postmodern, due to its overlapping, simultaneous citations and its multiple layers of meaning.

The Meaning of Style

Judith Williamson argues that the meaning of advertising posters is established by positioning the product alongside an object that is meaningful to the viewer. According to Sergei Eisenstein's montage theory, an advertisement that presents a product and a parallel object in the same frame forces the viewer to consider the connection between them. The viewer is placed in the gap between the product sold and the parallel object, thus giving the product meaning. Williamson explains this meaning transference via the

metaphor of money. Money represents value, but is replaced by other items, thus giving them a value.[6] In the same manner, the product is replaced in advertising by a desired value (ecological, sexy, etc.) which is presented via a narrative or a parallel object. The advertisement breaks down the existing relationship between the signified and the signifier embedded in the product, and builds a new relationship in which the product sold is the signified, while the parallel object or narrative becomes a new signifier for the object being sold, and thus transfers its meaning.

Yet the new posters of the Tokyo ADC members do not show the product or any parallel product/narrative to it. Instead, they bequeath meaning to the product or company by tying the company (represented in the ad only by logo) to a specific aesthetic and style known to the consumer at an emotional level. In order to understand the posters, it is important to understand the meaning of the style used within each one. Using a style as a parallel object is especially effective in Japan. In Japan's visual culture history, there were numerous art schools that expressed their social ideologies by practicing different styles (technique, composition, color spectrum).[7] Since the arrival of postmodern aesthetics and the use of computer graphics in the 1990s, no single style has been considered as the "ruling style" or "pure style" of contemporary ideology. Graphic artists make use of a wide spectrum of techniques, compositions, and colors to create a variegated pastiche. Software applications such as Photoshop made visual expression a global style, yet enabled artists to create their own personal style and vocabulary. Further to the loss of ideology in the postmodern era, colors also lost their ideological meanings. Red, for example, no longer symbolized communism exclusively, as in the 1960s. Other colors received a commercial meaning with the rising importance of consumer culture as a central ideology. The combination of red and yellow became associated with McDonald's, while black and orange implied the phone company Partner. Still, various styles were created expressing different meanings and representing different sectors of the population that sought to differentiate themselves via style. Posters created by Tokyo ADC members are characterized by different styles and visual languages—minimalist vs. colorful, melancholic vs. cute, avant-garde vs. *moe*, traditional vs. digital. In the following examples, I present the visual language typical of the Tokyo ADC members, which covers an entire spectrum of styles. Just like the postmodern language itself, this language has multiple styles, creates a dialogue with visual history, and stands for intertextual and hybrid design via the use of quoting, acquisition and reproduction, blurring between the languages of design and art.

Minimalistic Style and Monochromatic Coloring

Monochromatic coloring and the aesthetics of traditional ink paintings (*su-mi-e* and *suibokuga* of the rigorous Zen traditions) are used in many advertisements. Contrary to expectation, this visual expression is not used exclusively for building a traditional image in advertising traditional Japanese products (seaweed, kimonos, sake). It is also seen in advertisements for contemporary products like computers and golf clubs.

Suzuki Hachirō's advertising poster for Apple computers presents computers and the Apple logo in an ink painting style with the monochromatic coloring typical of traditional Japanese ink paintings. Figure 4.6 refers to traditional *raigō-zu* painting that presents the Amida Buddha and attendants descending from heaven. In the advertising image they are holding an Apple logo that refers to an apple from the tree of knowledge. It mixes Buddhist and Christian mythologies in a traditional format.

When interviewed, Suzuki said,

> At the time, Apple computers were black and white, and since there was only an English version and no Japanese, they thought that it would be difficult to market the product in Japan. When I was invited to Silicon Valley, I was asked about my idea. My answer was that in Japan it is preferable to use Japanese expressions. . . . Although they could build a color screen, for the business sector they had a black-and-white version. I found it amazing, since although they had the ability to produce color screens, they still produced a black-and-white screen. . . . So I told them that the Japanese are a nation that is able to see full color in black and white, and they were very surprised. In order to create the company's advertising expression, I took the *sumi-e* ink style from the Zen, the traditional Japanese art . . . as represented in the aesthetic term *wabi-sabi*. It is only called "wabi" or "sabi," but for us these are the daily sense of life, everyday life.[8]

Suzuki described how he built the marketing concept for the launching of Apple computers in Japan in 1984 and how he advised Apple managers to display computers in the advertising. That was totally different from the famous advertising made by Ridley Scott to launch the McIntosh in the United States in 1984, the year with Orwellian connotations. Suzuki felt that the style of the monochromatic ink paintings could represent the computers, since the style expressed in this coloring had a clear cultural meaning of prestigious value in Japan.

Other designers, including Miyata Satoru, do not quote ink paintings but instead use the monochromatic coloring in order to refer to the qualities present in the Zen painting genre. We can see this in posters for the Mos Burger restaurant chain and for PRGR's golf products (figures 4.7 and 4.8).

Miyata Satoru concurs with Suzuki that in black and white, one can see many things. When he refers to his golf poster (figure 4.9) he says: "Yes, even though you do not see the mountain beyond it, you can see the mountain. I think that from here you can see a floating island [*ukishima*]. Whether it is sport or nature, these elements come up in this advertising. It is photographed on a black background, but just because the background is black, it does not mean that it is not nature."[9]

In other words, he explains that monochrome colors give the sense of nature as seen in a Japanese Zen painting style. In this style, nature was designed symbolically in black and white, and in his opinion the Japanese consumer can see nature through the black. Qualities such as this, in which one can see in the painting more than just what meets the eye, have their origins in Zen paintings.

FIGURE 4.6
Suzuki Hachirō, advertisement for Apple computers, 1984 © Suzuki Hachirō

FIGURES
4.7 and 4.8
Miyata Satoru
(creative
director), "Mos
Burger" poster,
1997 ©Miyata
Satoru / Draft
Co. Ltd.

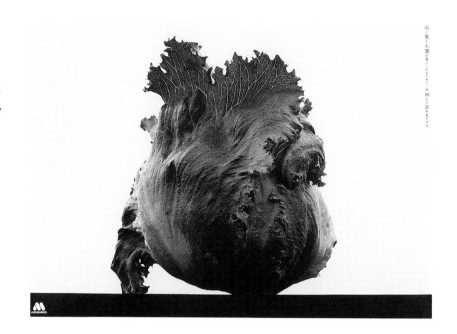

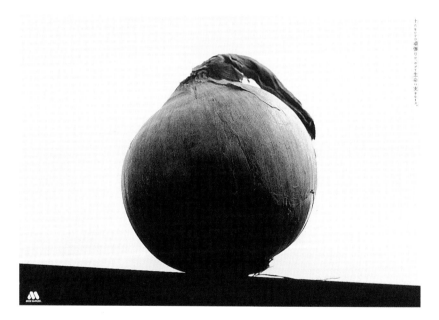

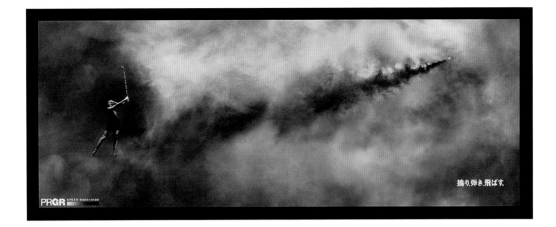

FIGURE 4.9
Miyata Satoru
(creative director),
"PRGR" poster,
2000 © Miyata
Satoru / Draft
Co. Ltd.

Macintosh computers, hamburgers, and golf equipment are not traditional Japanese products. In order to give these foreign products a Japanese character, the advertisements link the product via color and style to a social ideology and way of life from the Muromachi period, thus giving them an air of precision, elegance, momentary existence, perfection, restraint, and Japanese flavor. And in this way, they become contemporary Japanese products for the local target audience.

Polychromatic Coloring

In contrast to the "color-lacking" style of *wabi-sabi* or the simplicity (*jimi*) aesthetics of the Muromachi period, the contemporary *hade* style has motifs that are polychromatic, daring, colorful, exaggerated, dramatic, vociferous, and at times psychedelic and aggressive, yet still harmonious and non-vulgar. Ōnuki Takuya, who loves to use this style, says that although the style exists in the artistic tradition, when he uses it he refers more to contemporary street culture as seen in the Harajuku neighborhood, which is full of colors. This street culture and the *hade* style are contemporary, but the unique coloring originates in the colorful aesthetics of the Edo period of the seventeenth through to the nineteenth century, which was known as *yabo*, a noisy style that stood in contrast to the simple, sophisticated style that was known in those days as *iki* style. When Ōnuki Takuya advertised the Laforet department store, located in the Harajuku neighborhood, he used the showiness, flashiness, and gaudiness of the *hade* style that could be seen in contemporary street culture (figures 4.10 and 4.11).

The campaign consisted of two posters: one showing an aquarium with colorful fish, and the other a large industrial cage full of colorful birds of

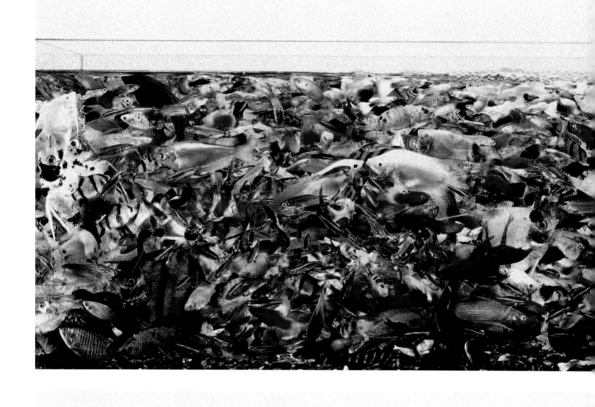

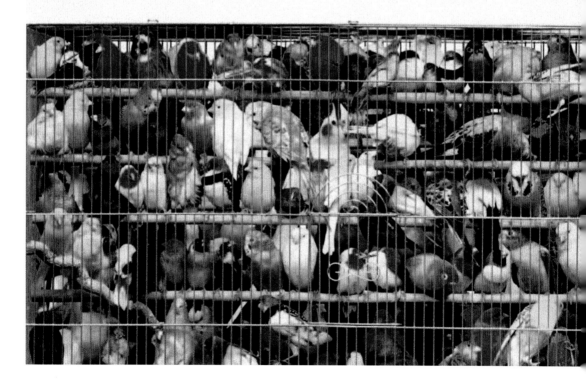

FIGURE 4.10
Ōnuki Takuya,
"Fish Scape,"
advertisement
for Laforet
department store,
1999 © Ōnuki
Takuya

FIGURE 4.11
Ōnuki Takuya,
"Bird Scape,"
advertisement
for Laforet
department store,
1999 © Ōnuki
Takuya

multiple species. A human hand feeds the pets in each poster. The logo of the Laforet store is placed on the aquarium and cage, blending with the coloring to the point of being blurry, despite the long strip of white space in the upper part of the poster where a logo could have easily been placed clearly and conspicuously. The composition speaks about overstimulation, with the *hade* style coloring emphasized by a transparent strip above the aquarium and the bird cage. The posters present many colors, each placed within its own boundaries. The coloring conveys a message of many choices, since it presents a situation in which somebody chooses a fish or a bird, insinuating that consumers can choose any color or shape. On the other hand, it raises the questions "How can one choose just one object out of this huge and colorful selection, which becomes one confusing jumble? Is the specific choice important? Is it even possible?" The style and the coloring represent the wide selection of colorful products offered in the department store, as well as the postmodern idea that each color or style has a place. However, the style also presents the idea behind the term *hade*—a loud explosion of colors—discussing the confrontation with the overload that the consumer feels while shopping in the department store, the feeling of a colorful cage so full of treasures that the consumer no longer knows if he is the consumer or the consumed. The brands and the products invite the consumer to the large and colorful cage called "department store." The coloring in the advertisement also hints at the fashionable young audience wandering the neighborhood. Ōnuki relates: "Harajuku is a unique place. There is no place like this in the entire world. I wanted to create a poster with the colors that are typical of the youth and the clothes that they wear in this neighborhood."[10]

Aoki Katsunori also used loud coloring in order to represent the Laforet department store in ads that he designed (figure 4.12). But he displays a psychedelic color burst that references the *moe* style, belonging to manga and anime, yet also taken from contemporary international colorful traditions.

The advertisement presents an energetic superhero woman with a muscular, manly body breaking out through a colorful background and flying up toward the sky. The character appears on a screen of colors that looks like an artificial color burst. Her blue eyes, red hair, and facial structure are typical for manga characters, but are represented in a coloring that harks back to the color transitions of 1960s British pop art, which rebelled against conservative British artistic styles while building a new visual culture. Designers like Alan John, who designed the décor for the movie *A Clockwork Orange,* and pop artist Peter Blake, who designed the Beatles' *Sgt. Pepper's Lonely Hearts Club Band* album cover, created psychedelic explosions with

FIGURE 4.12
Aoki Katsunari,
Shin Laforet
Spring Fair, 1995

no boundaries between objects, people, and colors. The prism coloring was meant to represent the sense of lack of barriers under the influence of LSD, in which all the colors explode at once. The artists of this trend presented a new coloring by using colors as a material that expresses the supernatural. The background of the Laforet poster also looks like a burst of colors coming from a prism. This coloring that originated in British street culture in the 1960s also corresponds with the lifestyle of the Harajuku youth and their club culture, drugs, and eclectic street fashion that peaked in Japan in the 1990s. But this loud coloring has Japanese sources as well, and it is meaningful in Japanese culture. The conspicuous red hair of the character symbolizes a supernatural demon in the Japanese visual tradition. The Japanese term *komo* (red hair) was applied to the Dutch during the Edo period.[11] Since their hair was not black, they were viewed as being different and were named after various demons and monsters of Japanese mythology. This motif appears in the Kabuki theater, in which the redheaded character is a supernatural demon.

Aoki Katsunori spoke of the style and coloring of the poster:

> I think that in this advertisement there is a Japanese visual expression. It is almost a manga style. When you think about Japanese style, there is both traditional and popular in Japan, and this is close to the popular . . . and if there is pretty and not pretty, then this is more not pretty. This differs from the traditional Japanese aesthetic. It is more brutal, more popular, and has nothing to do with beauty. It has something Asian about it. How to put it . . . very crude and clear. The colors as well—for example the red—are undefined and not as gentle as in the traditional and graceful Japan, which is detached from popular things. This is a simple coloring which can be understood by everyone.[12]

And indeed the coloring and the narrative expressed in the poster are linked to the popular contemporary culture, manga and the *otaku-zoku moe* style. In this poster, viewers discover a male and female at the same time, which does not settle with the binary stereotypes of gender. Such a body brings up questions of sexual identity, a common subject in the 1990s and a key part of the *otaku* subculture fantasies and the *yaoi* manga genre that deals with homosexuality.[13] In this context, the coloring receives an additional layer of meaning since it also alludes to the gay pride flag. Raising this subject was relevant to the *harajuku-zoku* youth for whom gender is a subject close to their heart.

Via boundless outburst of colors and various visual expressions, the poster

blends many worlds (manga and anime, Harajuku street fashion, *moe* style,[14] Japanese mythological demons, and 1960s pop art coloring) and is open to different interpretations by the viewer.

Childish and Cute Style Illustrations

Some advertisements relate to contemporary social conceptual systems, which also have a representation in color and style. The *kawaii* (cute) style, also thought of as "childishness," was the most significant style in the 1980s and 1990s. As described in the previous chapter, this style-based culture spread out to girls and women who adopted the childish speech, writing, dress, and sweet behavior of teenage girls (*shoujo*). This subculture was characterized by childish clothes, soft foods, toys, and cute teen idols.[15] An entire industry of cute products called "fancy goods" was created for this target audience, among them the products of Sanrio.

This social ideology has a clear visual expression of coloring, innocence, and naïveté that brings to mind children's drawings. Some advertisements make use of this desired value—childishness—in order to give meaning to a product and link it to an appropriate target audience.

Aoki Katsunori's campaign for the Aiwa line of products of Sony Marketing contained several posters (figures 4.13–4.16). In each poster, a pair (or more) of animals appears on a uniform colored background. The characters are designed plainly, with a cardboard-like feel. The posters are designed with only five to seven colors per poster. The game of light and shadow, bright and dark, gives a three-dimensional look. The design clearly implies characters from children's books, and the style is close to the innocence found in the "cuteness" style.

The coloring of the characters and the backgrounds provides a fresh contrast; the complementary colors emphasize the characters and maintain plainness. The childish coloring also brings a message of lightness. The slogan says "Enjoy 100%, Aiwa" and in small letters, also in English, appears the text: "We have the present. This is the time to play, laugh, enjoy. Give it 100%." The toy animals and the cute coloring transfer a cute meaning onto the product. Aoki defines the word *kawaii* not as "cute" but rather "contemporary" or "cool." He says "Contemporary items are things that are *kawaii*. Anything new or contemporary can be *kawaii*. When the Japanese see something new, they don't say 'new,' they say '*kawaii*.' When girls see new things, they will say '*kawaii*.' In other words, if it's OK for them, it is *kawaii*."[16] The ideology of *kawaii*, which developed in a generation that did not want to

FIGURE
4.13 – 4.16
Aoki Katsunari,
"Enjoy 100%,
Aiwa," Copet
© 2003–2013
Seijiro Kubo /
Butterfly Stroke
Inc. All rights
reserved.

grow up, says that the present is the time to play, to enjoy. This ideology is manifested in the advertisement by colors and style.

More examples of the cute style, presented in a different way, can be seen in Watanabe Yoshie's advertisement for Mos Burger (figures 4.17, 4.18).

Watanabe says: "I made it based on images from childhood memory. Me and my older sister or friends from the neighborhood."[17] In other words, she does not use the typical "cuteness" culture coloring, but rather presents cuteness using her own childhood memories and a child's style of illustration and painting. These arouse the association of returning to childhood, a key foundation of *kawaii*.

The art director Satō Kashiwa uses this style in an ad for Honda (figure 4.19), although the car is not part of the cute product genre or marketed for youth, and is not among the group of small, cute cars (such as those by Smart, Fiat, and Nissan) that emerged at the time.

According to Yamamura Naoko, the budget manager for the Hakuhodo advertising agency who was responsible for the project, the art director's concept was to target the young audience that enjoys the toys of the cute culture or young fathers via the attention that their children will draw to the advertisement. In this way, purchasing the car will give the parents a sense of satisfaction that they do something good for their kids.[18]

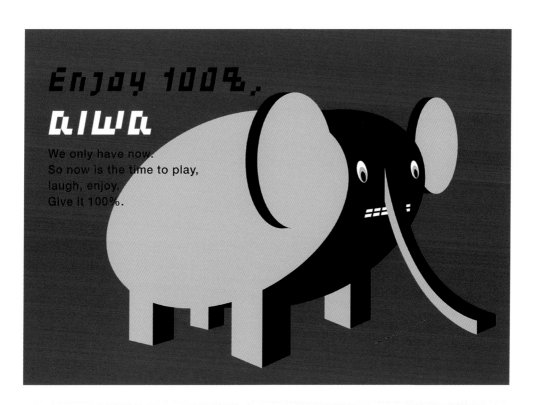

Enjoy 100%,
aiwa

We only have now.
So now is the time to play,
laugh, enjoy,
Give it 100%.

Enjoy 100%,
aiwa

We only have now.
So now is the time to play, laugh, enjoy.
Give it 100%.

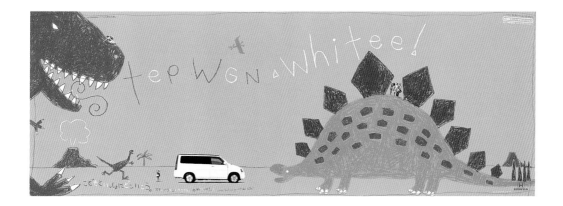

We should note that just as the traditional monochromatic style was used for products that are not at all Japanese, the cute style does not advertise products that were meant only for the use of children. The style associates the various products (electric appliances, hamburgers, cars) with a popular ideology that attracts women and young men to *kawaii* culture.

The Digital Aesthetics

In other projects, such as a campaign for Uniqlo, which will be discussed in Chapter 8, Satō Kashiwa uses a digital aesthetic known as "the aesthetics of the second machine age" when targeting web communities with Internet-based interactive campaigns, including the Uniqlo Fashion Map, Uniqlo March, Uniqlo Try, Uniqlo Grid, and Uniqlock projects. This aesthetic genre, typical of the computer and video game era, associates products with the virtual world that surrounds so many customers, presenting products as linked to the progress of technology and globalization.

Tokyo ADC members used color and style as signifiers ("parallel object"), employing them as references to various value systems that gave meaning to the products they sought to advertise. Miyata Satoru speaks of the conscious use of colors that creates Japaneseness:

I think that relatively speaking, Japanese are *hade* [colorful and exhibitionistic]. Both with colors as well as thoughts they are relatively energetic. So, there is a *hade* side, but there is also another side which is the *shibui* [subtle, delicate, and modest taste], and there are other sides as well. Many styles exist, but there is a very clear principle of the *hade*. This *hade* was successfully hidden throughout Japan's visual culture history. In this sense, I am aware of the Japanese character. For example, in the kimono—

FIGURE 4.19
Sato Kashiwa,
Honda Step WGN
Dinosaurs, 1998
© Samurai Inc.
Creative director,
art director, and
illustrator: Sato
Kashiwa; client:
Honda Motor
Co. Ltd.

FIGURE 4.20
Nagai Kazufumi,
advertisement for
Toshima-en and
Sega Corporation,
1996 © Nagai
Kazufumi

on top of the *ma-aka* [bright red color] they add a layer, and if the upper
layer is lazuli or light blue, it results in a gentle red color. I am aware of
things like this, and when I wish to express Japan, I work with this awareness.
Still, at times I do not want to emphasize this knowledge [of Japanese
aesthetics] and place it in the front. Sometimes I wish to banish
this [Japanese] side.[19]

The Saitō Makoto poster for Hasegawa that opened this chapter also cre-
ates a dialogue on the subject of Japaneseness when it uses a color that is con-
sidered international (International Klein Blue) and not typically Japanese.
Saitō specifically chose this color knowing that its origin is indeed in Japan
and that customers will identify it as traditional Japanese indigo, linked to
death by cultural association.

In this section, we have seen color and style used in advertisements as
signifiers or narrative that give meaning to a product or a company. This
strategy succeeds because of the diverse visual cultures that were created by
the various visual traditions of artistic schools, which continue to develop
today. Advertisers can enhance products with meaning, values, memories,
and lifestyle by using styles and colors that can be identified and appreciated
by the Japanese viewer. The product—the signified—changes its meaning via
the new signifiers of style and color. The style and color also differentiate the
product from other products in the same category.

好きな時計は、目に匂う。

SOCIE
SEIKO

Quotations

So far we have analyzed the appropriation of style and color in order to establish meaning in products. Another tactic for adding meaning to a product is by creating parallelism between the product and structures or compositions that have a well-established meaning in the consumer's realm. This is achieved by quoting from and appropriating ink paintings, wood prints, modern paintings (both Japanese and European), and contemporary art, as well as quoting actual verbal expressions.

VERBAL QUOTATIONS The most common form of quotation is the verbal quote from classic texts, which typically changes context by creating a play on words. However, for Tokyo ADC club members, the emphasis tends to be on the visual. As such, verbal expression is often transformed into a visual expression.[20] Nagai Kazufumi translates the name of a popular Japanese casserole, *kamo-negi*, into a visual expression. The advertisement presents the duck (*kamo*) and the onion (*negi*) and goes on to say "Two birds with one stone" (figure 4.20).

The advertisement launched a new video game by Sega in the Toshima-en amusement park, stating that you could enter the amusement park and play with the new games with one ticket.[21]

Another advertisement, by Inoue Tsuguya for Seiko watches, presents the

accuracy of the watch using the visual translation of the term *hatarakibachi*, or "worker bee" (figure 4.21). This idiom refers to both the accuracy of the bee and to the accuracy of the *sarariman*, the Japanese hired worker who is as punctual as a watch.

In these advertisements, visual structure is created from an expression that is quoted not verbally but visually. Advertisements that illustrate a verbal sentence differ from advertisements in which the narrative is based purely on visual image. Suzuki Hachirō called this *iwazu gatari*, meaning "to tell without words."[22] He said that the Japanese consumer is familiar with this type of expression.

Beyond the illustration of verbal phrases, we also find in Japanese advertisements visual quotations of visual expressions from the art world. Engaging in dialogue with and quoting from visual history is a clear characteristic of postmodern aesthetics in Japan, as well as around the world. Quoting replaced originality and innovation, which were central to a modern art world in which artists were expected to create images without basing them on previous works. Postmodern aesthetics instead finds innovation in the new composition of motifs via quoting from visual history and integrating the different visual expressions into new works. New images were created by selection, processing, and assembly in which the quoted elements appear in a different context that gives them new meaning. Tokyo ADC members often used quotations from the Western and Japanese visual culture for commercial purposes.

QUOTING FROM TRADITIONAL JAPANESE ART Quotation from classic Japanese art is employed in many advertisements. In an advertisement for Mercedes cars, for example, the art director Suzuki Hachirō quotes from the legend of the Mount Shigi scroll (*shigisan engi emaki*) of the Kamekura period (1192–1333) (figures 4.22 and 4.23).[23] The scroll tells folk stories about a monk who would send his flying bowl down to the residents living at the mountain's foot to collect contributions for the temple. The scroll is loaded with miraculous tales, such as one that describes an aristocrat who refused to give rice for the temple, only to have the flying platter carry away his entire rice barn to the temple. One of the stories (quoted in the poster) is about Gohodoshi, the divine child who protects the dharma coming down from the sky. Gohodoshi comes down with the *rinpo*—an eight-spoked dharma wheel, which symbolizes the Buddhist's road of eight stages. According to the legend, Gohodoshi comes flying from Mount Shigi into Kyoto, dressed in armor and sword, crossing the sky as a shining blue-gold cloud, rolling the dharma wheel in front of him. He eventually lands in the emperor's yard and

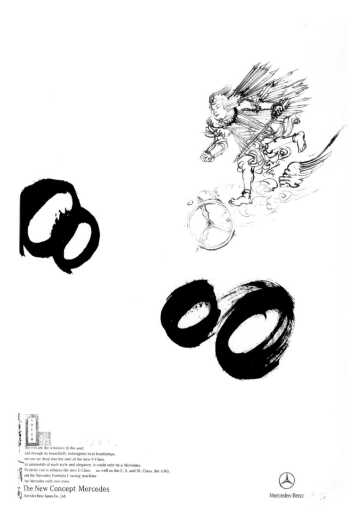

FIGURE 4.22
Suzuki Hachirō,
advertisement
for Mercedes
© Suzuki Hachirō

The eyes are the windows to the soul.
And through its beautifully redesigned oval headlamps,
one can see deep into the soul of the new E-Class.
An automobile of such style and elegance, it could only be a Mercedes.
We invite you to witness the new E-Class as well as the C, S, and SL-Class, the AMG,
and the Mercedes Formula 1 racing machine
See Mercedes with new eyes.
The New Concept Mercedes
Mercedes-Benz Japan Co., Ltd.

Mercedes-Benz

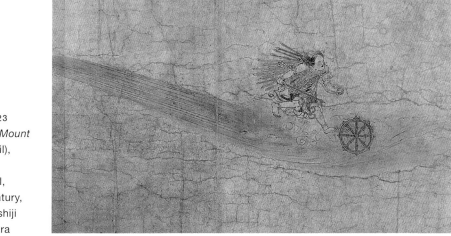

FIGURE 4.23
*Legend of Mount
Shigi* (detail),
illustrated
hand-scroll,
twelfth century,
Chogosonshiji
temple, Nara

FIGURE 4.24
Suzuki Hachirō,
advertisement for
Apple computers,
1984 © Suzuki
Hachirō

heals his illness. The dharma wheel, with its eight spokes, is transformed in the advertisement to a three-spoked wheel, the logo of Mercedes.

This quote brings together twelfth-century art and twentieth-century automobile, the dharma wheel and the Mercedes wheel, thus giving a new meaning to the German vehicle. Suzuki explains the idea behind the advertisement: "The advertisement presents the Mercedes as a gift from the gods to humanity, via the legend." The logo is presented not only visually, via the transformation of the dharma wheel, but also via the Japanese letters: *hito* (人), meaning "man," appearing inside a circle, referring in this context to Japanese *ensō*, presenting the concept of "whole" or "perfect." This adds an image of perfection to Mercedes.[24]

QUOTING FROM INK PAINTINGS Another type of advertisement quotes from *sumi-e* or *suibokuga* ink paintings, which come from Zen temples in Kyoto in the fifteenth and sixteenth century and eventually became *zenga* in the Edo era. For another campaign promoting Apple's Macintosh computers, Suzuki Hachirō chose to quote a famous painting of Hakuin, a seventeenth-century painter (figures 4.24 and 4.25).

The painting shows the *ensō*—an empty circle that is a prominent symbol

of Zen Buddhism, symbolizing enlightenment, the universe, the infinite, and expressing the here and now. Empty circles were often painted by Zen monks during their enlightenment, presenting one perfect moment just like the circle itself, which is an ideal, cosmic shape. Suzuki quotes one of the most famous paintings of the empty circle and attaches its meaning to Macintosh computers, thus giving the product a value of perfection. Paradoxically, the advertisement sells the splendor of futuristic technology via a seventeenth-century painting. Yet Suzuki sees no contradiction here, since the poster presents the Zen Buddhist tradition, which is considered a conceptual breakthrough and a period of glory and spiritual superiority. This sense of breakthrough is associated now with the birth of the computer, which creates a new way of thinking.[25]

QUOTING FROM WOODBLOCK PAINTINGS Another advertisement makes use of the ukiyo-e genre from Japanese art history that developed during the Edo period (1603–1867).

Katsushika Hokusai's *The Great Wave of Kanagawa* is a woodblock print in the ukiyo-e style of the nineteenth century (figure 4.26). It is a travel picture, part of a series called *Thirty-Six Views of Mount Fuji*, printed in 1832. Suzuki transfers the woodblock print to the medium of photography and uses

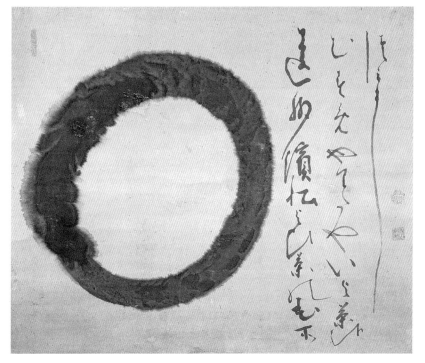

FIGURE 4.25
Hakuin Ekaku,
Ensozu, eigh-
teenth century
Courtesy of Eisei-
bunko Museum

FIGURE 4.26
Katsushika Hoku-
sai, *Great Wave
off Kanagawa*, ca.
1830–32. Poly-
chrome woodblock
print, ink and
color on paper,
25.7 × 37.9 cm.
© Trustees of the
British Museum

FIGURE 4.27
Suzuki Hachirō,
advertisement for
Japan Railways,
1984 © Suzuki
Hachirō

it as a source of inspiration for a Japan Railways advertisement (figure 4.27). By quoting from the famous work, he links the railway to the traveling series, and in this new context it is used as advertising for train travel and tourism.[26]

QUOTING FROM WESTERN WORKS OF ART Many art directors appropriate Western works of art, especially iconic works, as an inspiration for advertising posters. One advertisement for the amusement park Toshima-en quotes Rodin's *The Thinker* (1902) in a composition evoking a corporate brain trust, meant to inspire the feeling that this is a sophisticated and well-organized amusement park (figure 4.28).

Another advertisement for a sweetener quotes Leonardo da Vinci's *Mona Lisa* (1503–6) (figure 4.29).

These posters appropriate, quote, and play with the Western artworks. In the first one, Rodin's sculpture is replicated seven times, sitting around a conference table, appearing to be in a business meeting. In the second poster, Mona Lisa is presented as a woman supposedly in need of a diet. These famous artworks change their meaning in a new context and me-

FIGURE 4.29
Fujita Takahisa (creative director), "Koonaruto de vinci," 1990. Art director: Adachi Norifumi; copywriter: Tanaka Aki. © Courtesy of Ajinomoto Co. Ltd.

FIGURE 4.28
Ōnuki Takuya, "The Thinker," advertisement for Toshima-en, 1991 © Ōnuki Takuya

dium, from a statue or a painting into a photo-
graph. The quotations cancel dichotomies and
hierarchies between high art and popular visual
images. The integration of the famous works of
art in the new context enables a perspective that
is at times an ironic parody of the original mean-
ing of the quoted object.

QUOTING MODERN WESTERN ART In the advertisement for Inaba
Yoshie Parfum, the art director Watanabe Kaoru quotes Magritte's 1928 sur-
realist painting *The Lovers*, in which a couple, their heads covered in white
hoods, kisses (figures 4.30 and 4.31).

Watanabe quotes from a well-known painting that is paradoxical, provoc-
ative, and communicative all at the same time, transferring the surreal ten-
sion of the kissing couple to the advertisement. But in this new context, the
tension takes on a different meaning. The painting's subtext of blind love is
transformed in the advertisement into interpersonal communication via the
scent of the perfume. Watanabe shifts the painted picture to a medium of
photography, and adopts the very Japanese monochromatic hue, thus making
the advertisement inherently Japanese.[27]

QUOTING MODERN JAPANESE ART In an advertisement for Suntory whiskey, art director Suzuki Hachirō quotes *Princess Looking Back*, a wood print from 1955 by the modern Japanese artist Munakata Shikō (1903–75) (figures 4.32 and 4.33).

Suzuki imitates the wooden print, embedding the Suntory product within it. He replaces the poem of the original print with a slogan that introduces the product's name, "Suntory Old," using the same lettering style.

FIGURE 4.32
Suzuki Hachirō,
advertisement for
Suntory Whiskey
© Suzuki Hachirō

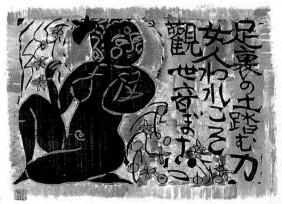

FIGURE 4.33
Munakata Shiko,
*A Woman Looking
Down*, 1949
© Courtesy
of Munakata
Shiko Memorial
Museum of Art

QUOTING CONTEMPORARY JAPANESE ART Various advertisements quote contemporary art as well, referencing fine-art installations that appeared in galleries. This form of quoting is different in nature, since the postmodern art being quoted is already blurring the borders of art, design, and advertising. In these quotations, it is unclear who is inspired by whom, as contemporary works of art are sometimes influenced by consumer culture, while advertisements are sometimes influenced by contemporary pop art.

Aoki Katsunori created an advertisement for the Parco department store that used pop artist Murakami Takashi's installation DOB *in the Strange Forest* (figure 4.34). Murakami investigated the subject of the long-term durability of characters from the world of popular animation, such as Mickey Mouse, Hello Kitty, and Doraemon, in an attempt to decode the secret power of these images and their long survival in the collective consciousness. Following his study, he created the DOB comics character, which appears in many of his works and which also became a toy (i.e., became both high and low culture).

In Aoki's poster for Parco, DOB represents the customer, wandering in the department store as if walking in a strange forest, surrounded by tempting attractions. The poster uses pop art that extols consumer culture. Aoki used Murakami's image intentionally because Murakami was a renowned and successful artist who also designs consumer products, including Louis Vuitton bags that are sold in the department store. The artist, his personality, and his trademark symbol (the eye, which was used as the *O* in Parco) all give meaning to the department store. The image blurs the borders between art and design, positioning Parco as being somewhere between department store and art gallery, selling works of art that are also consumer products. Innovative imagery has been part of Parco's line of advertising since the end of the 1970s, as discussed in Chapter 1.

FIGURE 4.34
Aoki Katsunari,
"Parco, Murakami
Takashi Exhibi-
tion" © Takashi
Murakami /
KaiKai KiKi Co.
Ltd. All rights
reserved.

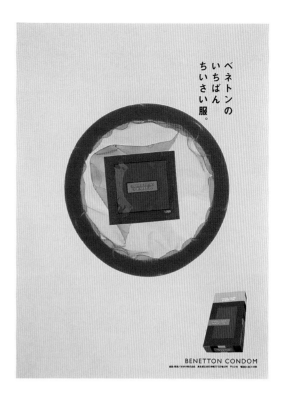

ベネトンのいちばんちいさい服。

BENETTON CONDOM

QUOTING STRUCTURES AND COMPOSITIONS Another form of quotation in Japanese advertising does not quote works of art, but rather structures and compositions—visual compositions that exist in art history or contemporary Japanese visual culture. In the case study of the Hasegawa advertisement by Saitō Makoto that opened this chapter, we saw the acquisition of the vertical-line-in-empty-space structure from Zen paintings (figures 4.1, 4.5). This composition appears over and over again throughout Japanese history, in utmost exactness. It is therefore viewed by Japanese observers as a precise composition that presents the aesthetics of Zen art. The composition is fraught with meaning that is acquired by the advertisement, where the countless meanings of death are distilled into a single bone. The composition, which is clearly recognized by the Japanese viewer, is used as a reference system to the rich world of the Zen, with Zen's aesthetic, religious, or elitist connotations becoming associated with the Hasegawa products.

Composition quotations are well understood by the Japanese viewer. Traditional Japanese visual culture has structures that have been accurately repeated over time, becoming clearly noticeable forms. The advertising posters that appropriate the structure or composition are complex and subtle, as the parallel object in these advertisements is not an actual object but rather an

家 無印良品

FIGURE 4.37
(*above*) Hara
Kenya, "House"
poster, adver-
tisement for Muji
(Mujirushi Ryo-
hin), 2004, Mo-
rocco © Ryohin
Keikaku Co. Ltd.

"unseen" subtext. The composition gives a meaning to the advertisement on a less conscious level, adding multiple narrative layers to the image.

One of the most well-known structures in contemporary culture is the Japanese flag template. This template is used for design in various fields, such as a children's meal on a lunch box (*bento*), in which you put a red dried plum (*umeboshi*) on a bed of white rice. This dish is called "a lunch box shaped like a flag" (*hi-no-maru-bento*). Advertising similarly makes use of a red circle on an empty space pattern (figures 4.35 and 4.36).

Another example of composition appropriation is seen in the poster for Mujirushi Corporation, designed by art director Hara Kenya (figure 4.37). The poster presents a vista of nature photographed from a distance, with a small image of buildings. This is drawn directly from paintings traditionally known as *suibokuga*. This genre of painting came to Japan from China during the Kamakura period, but became truly popular in the Muromachi period in the fourteenth through the sixteenth century (figure 4.38). *Suibokuga* imi-tated the panoramic Chinese paintings in which the Chinese scholars did not paint a real-life setting, but rather expressed thoughts and inner impressions via the view that they created. Visually, these paintings presented nature as infinitely broad, with people and man's creations in reduced size, thus sec-ondary in importance. Man is presented as small, but still a harmonic part of nature with a presence that cannot be ignored. These descriptions differ in spirit from European romantic paintings, such as Caspar David Friedrich's *The Monk and the Sea*, which depicts a small-scale man against vast nature, demonstrating the insignificance of man and emphasizing man's loneliness and helplessness against intimidating nature.[28] The *suibokuga* composition phrased man-nature relations differently. The vistas present a location where everything is in its place, in perfect proportion and harmony, thus repre-senting nature's timelessness and eternity. Nature, in *suibokuga*, is indeed powerful and grandiose in contrast to mankind. Yet at the same time, each

man has a proper place in nature, with a clear harmonic relationship between the two, thus negating the nature-culture dichotomy.[29] The paintings arouse the yearning for simplicity, proportional sizing, and values inherent in nature.

The composition is quoted in the Mujirushi poster, transferring the formula of man-nature to the company being advertised. Indeed, this harmonic relationship between man and nature matches the core tenets of Mujirushi Corporation, which sells recycled and ecological lifestyle and home products.

The art director Hara explains: "In creative fields, there is a kind of rule that one must always take one step forward to discover new worlds. I personally don't believe that this is necessary, since it is impossible to perfectly copy something. I claim that the attempt to copy is actually a creative act. Most of the traditional Japanese arts are very much based on copying existing shapes. . . . The perception is that sophistication emerges from the creation of a slightly different meaning while creating a perfect copy."[30]

Advertising posters for Mujirushi often divide the field into two symmetric upper and lower halves (figure 4.39).

This composition style is borrowed from a famous series of photographs by contemporary Japanese photographer Sugimoto Hiroshi (figure 4.40).

Sugimoto's series of photographs of the horizon in different places in the world show the sea and the sky in perfect symmetry in order to deliver a message of balance and harmony in nature. Sugimoto tried to capture nature as simple pureness of the first day of creation, as seen by the first person on earth. There is no chaos, but rather an absolute and perfect balance shown via symmetric compositions and broad depth of field as far as the eye can see. The photographs present a primordial nature, untouched by man, but the composition is explicitly manipulated by the human hand in a balanced and symmetric manner. Similarly, Mujirushi's products, with their natural coloring and clean design, seem just as untouched by man, despite being processed and used as consumer products.

FIGURE 4.38
Sesshū Tōyō,
Landscape of the Four Seasons (detail),
Muromachi period (second half of the fifteenth century).
Hand-scroll, ink and light color on paper, 21.5 × 1151.5 cm.
© Kyoto National Museum

FIGURE 4.39
(*right*) Hara
Kenya, "Horizon"
poster, adver-
tisement for Muji
(Mujirushi Ryo-
hin), Uyuni Salt
Lake, 2003
© Ryohin Keikaku
Co. Ltd.

FIGURE 4.40
Hiroshi Sugimoto,
"Sea of Galilee,"
1992. Gelatin
silver print on
paper, 45.5 ×
54.5 cm. © The
Israel Museum,
Jerusalem. Gift
of the artist.

Sugimoto's photographs introduce an additional concept. While the me-
dium of photography typically shows time and location, these indications
are completely absent in the *Seascapes* series. This concept in Sugimoto's
photographs is also transferred to Mujirushi's posters. The posters have no
distinguishable time, season, or place, and this idea fits into the marketing
concept behind Mujirushi's products. While most lifestyle companies are
driven by fashions and seasons, Mujirushi takes pride in the fact that it pro-
duces "fashion" products that are so primary and archetypical that they can
be used in any season, any year, without ever becoming unfashionable. The
products are suitable for any time and any place. This also was Sugimoto's

purpose when he photographed the horizon in various locations in the world: to see the one thing that has not been altered since the creation and is still the same today. Hara's posters for Mujirushi, which were also photographed in various locations around the world, elicit different moods without revealing the location or season.

In the Mujirushi advertisements, the objects in the poster (sea, fields of flowers, clouds, sky) are neither significant nor symbolic. The posters are built solely on composition. The elements/objects that appear in the posters are presented only within the context of the nature-man equation, showing man's relation to eternity, harmony, order, and simplicity. The composition itself presents nature in a precise and exact packaging. It eliminates the nature-culture dichotomy by processing nature into culture via the use of filters and computer programs. Hara took both the essence of the nature-man relationship as phrased in the *suibokuga* tradition, and the primordial-yet-ordered essence of nature as photographed by Sugimoto. By combining the two visual expressions that had a meaning in the visual Japanese culture, he created a new visual text. At first glance, the pictures seem devoid of information and definitely do not highlight Mujirushi products, but this is precisely the power of the posters. On this, Hara commented:

> When I ran the Muji[rushi] campaign, I conducted market surveys. They showed that each customer sees Muji differently. One sees it as sophisti-cated, another as natural, the third as very basic, the fourth as inexpensive, the fifth as ecologically friendly, the sixth as relax design, and the seventh as Zen design. I had to build an image that will contain all these views. This is why I designed blank posters that can contain all the concepts that exist in the eyes of the viewers. The image that I built was very simple, yet very sophisticated at the same time. Only Japanese emptiness can contain two such contradictory concepts simultaneously. This demonstrates the extreme power of emptiness. It does not lack information, but rather provides the viewer a place to insert his own meaning.[31]

Blurring between Design and Art

Although advertising posters and works of art have different target audiences, visual strategies, expression, and language, the posters discussed here are both art and advertising at the same time, shifting between the gallery and the street. Art is typically viewed as a personal expression, conceptual and acting in the realm of the imagination. Design, on the other hand, is con-

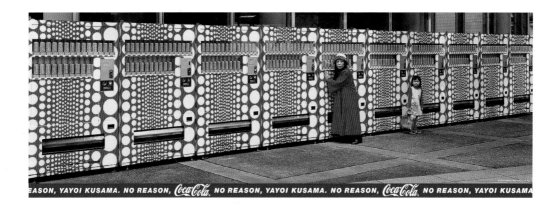

EASON, YAYOI KUSAMA. NO REASON, *Coca-Cola.* NO REASON, YAYOI KUSAMA. NO REASON, *Coca-Cola.* NO REASON, YAYOI KUSAMA

FIGURE 4.41
Yayoi Kusama,
Coca-Cola "No
Reason" art
project, dots
on vending
machines, 2001
© Yayoi Kusama

sidered a consumer product that first and foremost presents some functional qualities. However, the Tokyo ADC posters use postmodern aesthetics that intentionally blur the borders between high and low, between art and design. Among the Tokyo ADC members, art directors Toda Seijū and Saitō Makoto create works that are both art and advertisement, obscuring the borders between the two visual languages.[32] Toda explains: "There are many vague works. Today, one can create contemporary art from almost anything—like this [pointing to a work shown in his *Heian* exhibition]. I am in favor of loose borders. . . . In postmodern art we make everything into works of art . . . this reflects the current era. . . . The difference between art and design is that in art you are free to create unconsciously, and in design you create consciously. The difference exists in the mind of the creators."[33]

The blurring between design and art languages is common in many contemporary designed products. For instance, the Japanese designer Yoshioka Tokujin presented a *Snow* installation in the *Sensing Nature* exhibition at the Mori museum in 2010 that blurred between industrial design and art. Tokyo ADC art directors also presented works that can be considered graphic design or art, depending on the context in which they were presented: museum or street posters. The innovation of the Tokyo advertising posters is that they used this vague style in their visual communications as a persuasive and seductive marketing tool. Namely, the functionality of these posters is expressed in activating the imagination.

In a poster for Coca-Cola, Kusama Yayoi created an installation of Coca-Cola vending machines, which she redesigned in her unique style (figure 4.41).

Kusama is a Japanese pop artist who worked in New York with Andy Warhol in the 1960s and returned to Japan the following decade. Diagnosed as schizophrenic, to this day she talks of hallucinations, experiences of body

disintegration and loss of boundaries. Her artwork hints at netting with gaps, endlessly multiplied obsessive dots as a metaphor for loss of coherence. In the Coca-Cola work too she used her trademark dots, and also appeared in the photograph of the installation. This is not a quotation from contemporary art, but rather a work of art in and of itself that also happens to be a poster. Kusama was selected for the Coca-Cola advertisement based on her work in the United States with pop artists dealing with popular consumer products. A Coca-Cola bottle was a central element of this trend and became, through the works of the pop artists, a cultural icon. Since Kusama was known in the United States, she represented a bridge between the United States and Japan, just like Coca-Cola, a drink that bridges the two countries. The combination of red and white colors conspicuously represent both Japan and Coca-Cola. Kusama's obsessive dots could also symbolize the bubbling gases of the drink. This advertisement clearly demonstrates the blurring of the boundaries between art and design. Pop art represented consumer culture by taking objects such as a Coca-Cola bottle into museums. Kusama's poster returns the pop art to advertising, and by doing so it closes the circle.

A complete blurring of boundaries is found in the posters created by Toda Seijū, who was both an artist and an advertising art director. His 1980 ad-

FIGURE 4.42
Toda Seijū,
"Linea Fresca,"
1984 © Toda Seijū

vertisement for the Japanese fashion company Linea Fresca, an importer of Italian fashion, won many prizes (figure 4.42).

After his advertising work achieved recognition, he expanded his works into a full-fledged photography exhibition in 2005 in the Tokyo Metropolitan Museum of Photography, under the name *Heian*. Images from the exhibition then became advertising posters for another client—the Japanese magazine *Luft*.

The advertisements became works of art, and then returned to the streets as advertisements. The only difference between the photograph shown in the gallery and the street poster was a reduced-size company logo. Toda says that the logo size is small because "it interferes with the visual image, since the image is art . . . and the customer respects that." In other words, the clients deem the artistic image to be of such importance that they are willing to pass up the opportunity to focus on the product, and are even willing to minimize their own logo.

Hybrid Visual Text

The final characteristic of postmodern aesthetics that I raise here is intertextuality: the hybridization of structures, genres, styles, and different visual terms into one visual text, layered and rich in meanings. Such a visual expression is interdisciplinary and multicultural, combining visual ideas and creating a visual intertextual hybrid that directs the viewer toward many associations.

I will refer specifically to an advertising campaign designed by Saitō Makoto in 2001. The poster design contains graphical elements and concepts taken from many sources, creating new visual texts that are multilayered and intertextual. The advertising campaign consists of two posters (figures 4.43 and 4.44).[34]

The first focuses on the breasts of a woman raising her right arm. However, rather than hair, her armpit sprouts green grass. The second poster portrays an even more provocative image: a sideways view of female genitalia, topped by a grass-covered sand mound resembling green pubic hair. These two images enter into a dialogue with each other based on exposure of parts of the female body that are usually concealed. Both images are accompanied by the slogan "Love Mother Earth" and the name "Green Homes," which reveal the poster to be an advertisement for a real estate company. As in other posters of the same genre, meaning is predicated on an intertextual dialogue with many visual and textual fields and creates a new hybrid text.

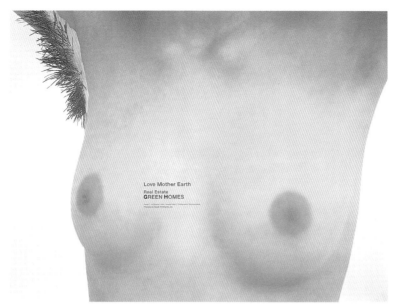

FIGURE 4.43
Saitō Makoto,
"Love Mother
Earth," advertise-
ment for Green
Homes company,
2001 © Saitō Ma-
koto

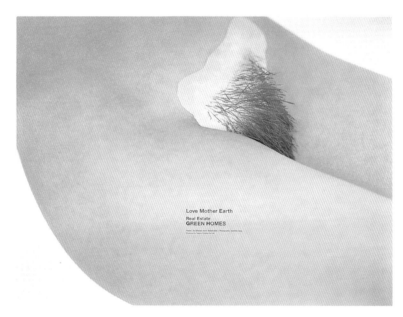

FIGURE 4.44
Saitō Makoto,
"Love Mother
Earth," advertise-
ment for Green
Homes company,
2001 © Saitō
Makoto

The posters' visual iconography, as well as their encoded meaning and cultural values, engage in a fascinating dialogue with the traditions of Japanese and European art. Nudity in general and female genitalia in particular are common themes in both Japanese and European art, where they are depicted in a variety of ways. A prominent example is Gustave Courbet's 1866 painting *The Origin of the World*.[35] In Japan during the same period, the *shunga*—an erotic sub-genre of ukiyo-e popular in the Edo period and adopted by artists such as Suzuki Harunobu (1724-70) and Utagawa Toyokuni (1769-1825), was already widespread. These images also served as advertisements for theater houses and women selling sexual services. In the context of a nascent consumer society, *shunga* images can therefore be understood as commercial erotic images. A subversive, bold, and erotic visual culture continues to exist in Japan today, as evident in the subcategory of manga known as *hentai* manga. It is this erotic visual culture that legitimizes Saitō's posters—though, as already mentioned, they also refer to Western images and sources.[36]

Saitō's use of grass relates the figure to nature, and thus belongs to a long representational tradition that conflates the female body with landscape. Painters such as Botticelli, Titian, and Giorgione all depicted female nudes in natural surroundings. This tradition was continued by modern-era artists such as Georgia O'Keeffe and Robert Mapplethorpe, who explored the relationship between female genitalia and flowers.[37] This relationship is explained by Freud, who describes a system of dream symbols that alludes to the female body: "Boxes, cases, chests, cupboards and ovens represent the uterus, and also hollow objects, ships, and vessels of all kinds. Rooms in dreams are usually women [*frauenzimmer*]."[38] Gardens and flowers symbolize the female sex, virginity, and purity, while "the pubic hair of both sexes is depicted in dreams as woods and bushes."[39] Freud's explanations shed light on the visual connection between female nudity and nature. Freud explains that these symbolic relations are based on myths, folktales, poems, and linguistic metaphors such as Mother Earth.[40] This term is the basis for the unconscious visual connection between woman, earth, and landscape. It only makes sense that this relationship also appears in Saitō's advertising slogan—"Love Mother Earth."

These visual and conceptual ideas also form the basic notion of the works of environmental artists Christo and Jeanne-Claude. In 1983, they created a work titled *Surrounded Islands*, in which they encircled a number of islands in Miami Bay with woven polypropylene sheets. They chose islands that were partially created out of garbage—the product of an accelerated culture of consumption—and surrounded them to appear seductive and alluring. This

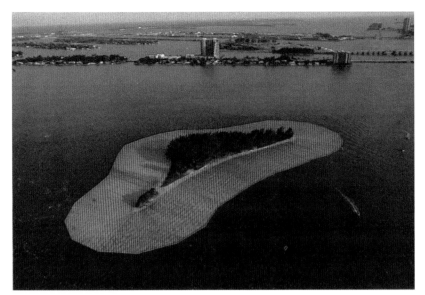

FIGURE 4.45
Christo and
Jeanne-Claude,
*Surrounded
Islands*, Biscayne
Bay, Greater
Miami, Florida,
1980–83. Photo:
Wolfgang Volz.
© 1983 Christo

act, according to my reading, embodies a double critique of consumer culture, which creates superfluous but seductively packaged products, thereby generating enormous amounts of garbage.[41]

One of the islands was surrounded in a manner evocative of female genitalia: the green bushes growing on the island play on the double meaning of the word "bush," a slang term for pubic hair, and allude to Freud's interpretation of bushes in dreams. The work continues the tradition that ties female genitalia to nature (figure 4.45).

Saitō's work can be read as being both visually and conceptually inspired by Christo and Jeanne-Claude's work in terms of the connection it makes between female genitalia, real estate, packaging, and consumer culture.

These references to Christo and Jeanne-Claude's artwork and to Freudian analysis enable the understanding of Saitō's choice and the connection he made between this visual motif and a real estate company. Freud referred to visual dream images of houses or rooms (both of which relate to real estate) as symbols of female genitalia, and interpreted bushes as symbols of pubic hair. Saitō, meanwhile, represents both female genitalia and bushes as signifiers for homes and real estate. Freud also employed the term "Mother Earth," which appears in the poster's slogan as "Love Mother Earth," to evoke a love of the earth (real estate) that is at the core of the advertisement.

The advertisement refers also to Japanese cultural sources. Grass was used to symbolize pubic hair in the *shunga* tradition, specifically in the image of *Beauty Enjoying the Cool* by Kitagawa Utamaro (1753–1808), in which a

FIGURE 4.46
Kitagawa Uta-
maro, *Beauty
Enjoying the Cool*,
1794–95 © Cour-
tesy of Chiba City
Museum

courtesan appears beside a flowerpot filled with a grass called *sekisho* (sweet flag) (figure 4.46).

According to Timon Screech, plants and flowers in *shunga* images are symbolic representations of sexuality. He argues that in *shunga* art, grass represents female pubic hair, because of the morphological resemblance. Saitō was probably familiar with this symbolic use of grass in eighteenth-century *shunga* images, and consciously transplanted it to a contemporary advertising poster, in which it literally replaces pubic hair.

An additional meaning of the advertisement pertains to the history of Japanese cultural symbolism. Since "Green Homes," the name of the company that commissioned Saitō's poster, appears in English, it could initially be associated with a greenhouse or hothouse. A closer reading, however, reveals that the term "green homes" has a unique meaning in Japanese culture, which is also related to *shunga* art. During the Edo period these images evolved partially as advertisements for brothels and courtesans in Edo's Yoshiwara district. The brothels were known in Japanese as *seiro*—a term frequently translated into English as "green houses" or "green homes."[42] When Saitō was commissioned to design an advertising poster for Green Homes, he likely associated this name with the green homes of the Yoshiwara district. Hence, Saitō appears to have embarked on a journey to discover the semiotic and symbolic sources characteristic of eighteenth-century advertisements for "green homes." Subsequently, he chose to focus on the female nude and the

symbolic use of grass—two specific elements that appear in these ancient advertisements. By reassembling them into a surreal postmodern visual image, he evokes and resuscitates the *shunga* tradition. In doing so, Saitō pays homage to the commercial dimension of *shunga* prints and to the famous eighteenth-century artists who created advertisements for "green homes" to sustain themselves economically.

In conclusion, while the Tokyo ADC members belong to the elite aesthetic milieu (as described in detail in Chapter 3), advertising addresses all kinds of target audiences, and the works of the Tokyo ADC also referred to wider populations and their unique styles, such as those that grew in Akihabara (as seen in the works of Aoki Katsunori) or in Harajuku (as seen in the works of Ōnuki Takuya). Each ADC member developed his or her own personal visual language. We can find designers such as Satō Kashiwa who use a digital style, and others like Suzuki Hachirō who adopted the ink-painting style of the Muromachi period or *zenga* from the Edo period. The styles of the club members present polyphonic personal languages, a tapestry, a multitude of voices in contemporary Japanese visual culture.

This chapter deconstructed the visual language and the aesthetics found in the posters of Tokyo ADC members in order to emphasize the revolutionary postmodern language. By selecting and reassembling visual expressions from various eras and cultural sources, they created new, challenging visual texts. The posters contain elements and compositions taken from traditional, modern, and contemporary Japanese aesthetics, as well as from Western visual culture. These hybrid compositions create texts with a new syntax and meaning. They are multilayered, ambiguous narratives that can be understood differently by each viewer. The blurring of boundaries between art and design is used by art directors of the Tokyo ADC to create a new visual language and visual communications in the consumer culture arena.

The combination of meaningful visual expressions in a single image presents a new pattern of visual communications in which an element of surprise emerges upon first viewing, with an initially unclear meaning that remains open to interpretation even upon further consideration. Thus, each consumer is encouraged to read the image individually and to give it his or her own meaning. Solving the riddle of the poster is a challenge for the viewer and a source of seduction.

The newly formed aesthetic vocabulary changed the rules of the modernist advertising poster concept. According to the modernistic concept, the elements of an advertising poster (visual, denotative, connotative, and linguistic) should focus the viewer on a single product message. In contrast to

this, postmodern aesthetics create images with many narratives. The single meta-narrative dissipates and is broken into fragments that construct inter-textual references to various verbal or visual texts. All these components are combined into a multilayered single picture. In this manner, they represent a typical postmodern aesthetic, with quotations, appropriations, reproductions, and intertextual hybridization. This aesthetic is based on a dialogue with Japanese and Western visual history. It uses a mash of languages and visual styles while blurring boundaries between visual languages, various media, and high and low. The images cull nostalgia by playing with contemporary and traditional images. This aesthetic expression is typical of the 1980s and 1990s, a time when Japanese visual culture had been released from traditional or modern styles, enabling reflexivity and elimination of visual hierarchies. All this enables the bi-directional transfer of images between the gallery and the street and the use of contemporary art or installations as advertising. In this environment, a conglomerate's forefront imagery is often devoid of any ties to the design and graphics of the products or the company, with the exception of the logo.

The hypothesis that these posters are enigmatic and lack information is simply not true. These posters have vast information content, but it is hidden sophisticatedly in color, style, and composition. These are the new signifiers that deliver meaning to a signified product or company. Moreover, the aesthetics in these posters present a complexity of styles that does not refer to the product or the company but rather to the consumer's identity, and as such is indicative of the new commercial society. In such a role, aesthetics that had previously been defined as style or decoration are transformed into a functional vehicle. The immense power of style in these posters comes from the dissonance between the innocent and unconscious look on one hand, and on the other hand a highly functional language that weaves in social content that gives meaning to and constructs an identity for various subcultures. Style initiates integration, association, and social relevance for one social group while at the same time differentiates it from other groups within the population. As such, it is used not only as a new visual communication tool but also as an effective means of marketing communications.

3

The Marketing and Business Forces

The enigmatic visual and verbal expression in Saitō Makoto's poster for Hasegawa (figure 4.1) creates a riddle that calls for decoding. It attracts the attention of the viewer, who tries to understand the meaning of the image and to fill the space between the imagery and the company name and logo.

When asked in an interview about the poster's message, Saitō explained: "The message in the poster is the most important element. I want to do something that no one does. . . . This is the reason that I am so direct. There are very few people who follow such a direct path. Maybe it's only me."[1]

This statement of directness is certainly puzzling considering it is in reference to such a vague poster. He further clarifies that in order to capture the viewer's attention amid a noisy urban visual environment, he enjoys using a shocking motif. According to him, the visual images are of such power that "those who see them once will never forget them. And that is marketing."[2]

In a visually saturated era, with advertisers seeking ways to attract attention and grab the consumer's eye for just those few extra seconds, Saitō used the element of shock as a communication strategy. In this poster, the shock is caused by a cognitive dissonance that the bone projects, appearing both realistic and chilling.

The bone is clearly identifiable to all, but in the poster it is enlarged, painted unnaturally, presented out of context and thus surrealistic. The techniques of displacement, deviation, and defamiliarization bring the viewer in contact with something that is familiar yet unknown. Freud coined the term *unheimlich* (literally, uncanny) in order to explain such objects or images that we are familiar with while still seeming strange and shocking.[3] According to Freud, seeing an object that is identifiable from explicit reality but has not actually been seen before leaves one shocked and chilled, because the experience brings out repressed contents from previously unknown past experiences. The meeting between the familiar external reality and the internal reality unknown to the conscious self creates this chilling sensation. In the same manner, the ad is disturbing because it raises projections of personal associations and instantiates a fear of death, at least until the viewer comes to his senses and realizes that it is "simply" a picture of a blue-colored bone.

What most often makes the posters of this genre so compelling is their cognitive dissonance and their difficulty in being decoded. This riddle-like nature is in fact a core strategy of Japanese postmodern marketing communications as seen in Tokyo ADC posters. In reference to the famous Hasegawa poster, art director Hara Kenya stated: "Good design is design that provides no answer, but rather raises a question. Saitō's bone design raises several questions: What is life? What is death? What is prayer?"[4]

Ads of this genre typically concealed the product, asking the viewer to fill the void between the logo and the image. But this enigmatic and intriguing strategy alone is not enough to explain the enormous success of the genre. The success is also attributable to the changes in the new consumer culture and visual culture that began in the late 1960s, with its enormous impact on marketing communications.

The rise of postmodernism, as put forth by Fredric Jameson, is closely related to the rise of consumer capitalism and should thus be seen as central to the market structure of consumer culture.[5] Marketing, in which advertising is a powerful cultural-economic agent, influences the postmodern aesthetics of the entire postindustrial world, Japan included.

The marketing communications in Tokyo ADC advertisements, whose effectiveness often seems questionable because of the use of open visual texts, is best understood in the context of contemporary consumer culture and the rise of postmodern visual culture, which altered conventional advertising patterns and the role of the image in advertising. As such, the persuasive and seductive elements of the posters presented in this book simply cannot be understood through classic models. The persuasive elements inherent in these advertisements can be understood through a model that links the hitherto disparate research fields of business administration (marketing), sociology, and visual culture. Such a model enables the reading of an advertising image and its aesthetics in the broad social context of late consumer culture.

In the previous chapter, I introduced many images of the genre and showed how meaning is built in them. This section contains two chapters. In the first, I endeavor to answer the question "How do these ads build up a company's image, and how do these open visual messages convince the potential customers?" After all, this is their primary purpose. Several factors are involved in the process of creating the new advertising concepts, and in this chapter I observe the two most prominent of these factors: first, the ethics of the new global consumption culture, which dictated new marketing strategies, and second, the emergence of a new consumer who prefers being challenged over being right or being informed. These factors exist through-

out the postindustrial world, yet they take a different form in every country. In the following chapter, I describe business processes that are unique to the structure of the Japanese advertising industry, and their impact on marketing communications. This exploration of the global and the local influences on marketing communications will point out how this in turn determines the nature of imagery within Japanese advertisements.

Modern Marketing Communications

Marketing and advertising activity was employed in Japan as early as the Heian era (794–1185), when restaurants advertised using *noren* (a sign curtain) hanging in the entrance. More sophisticated marketing operations methods, many of which are familiar from the postindustrial revolution in Europe, were already present in Japan during the Edo period (1603–1867). These marketing methods emerged in parallel with the development of urban consumer culture in the city of Edo (Tokyo) and technological developments in the field of printing. During this period, sales and marketing strategies evolved, including advertising posters for the emerging stores, small businesses, craftspeople, merchants, wholesale trading, and restaurants.[6]

Nevertheless, modern marketing as we know it today—including advertising, branding, and market segmentation—didn't fully develop until the 1950s and 1960s, with the development of postwar consumer culture in the United States and its influence on the Japanese emerging postwar economy. It was during these years that many researchers, especially in the United States, began to develop the language and phrasing to describe the marketing activity of postindustrial countries.[7] Models and theories were initially developed for the purpose of business consulting for corporate managers, and not as a theoretical research field. Subsequently, marketing and advertising as economic activity developed in academic programs with emphasis placed on the importance of the marketing and advertising system within the new consumer culture. In fact, the complex economic systems involving marketing were often classified as one of the most important success factors for a commercial society.[8]

Today still, the study of marketing is driven by American and European concepts, and covers multiple research fields. It starts with the brain activity (e.g., memory research, and the exploration of various brain regions during the exposure to the familiar brands), continues through the spreading of global values, the power of mass media, communication patterns, anthropology of consumption, and on through the social and cultural influences

on marketing.[9] Each discipline investigates one aspect of marketing, but researchers across many disciplines agree that marketing's importance resides not only in the economic-commercial realm (planning and execution of marketing mix, product design, and advertising), but also within the social realm as a driver for cultural activity and as cultural agent influencing consumer lifestyle.[10] Since marketing research is by and large done with an American orientation, the perspective with which company-customer relationships are explained is tuned to the American concept, and not necessarily applicable to what takes place in Japan.

Marketing communications is a key element within the wide array of marketing activities such as advertising, sales promotion, and public relations.[11] It includes elements of persuasion intended to cull changes in attitudes, values, and behavior, shape the response of the viewer, and cause a cognitive change.[12] These elements have a major influence on the design of advertising campaigns: the visual imagery and the verbal text, as well as the actual product design and packaging.

The method of persuasion varies according to the nature of the industry, target audience, and subject matter and according to the content that it is meant to deliver.[13] Methods of persuasion changed dramatically between the modern and the postmodern eras. To understand the postmodern advertising phenomenon that we have explored so far, we must understand this transformation between the two periods, and what spurred on this change.

From Modern to Postmodern

The theories that cover persuasive media in Western culture are rooted in the classical period. The Greeks engaged in the development of rhetoric as a profession that was imperative for the advancement of political life of Athens. Aristotle's famous treatise *Rhetoric* had a formative influence on how the art of persuasive communication is perceived in Western culture.[14]

Aristotle explained that (verbal) language in the form of a speech expresses the human mind and is the tool used for persuasion, showing that this tool serves as intermediary between speaker and listeners. He claims that rhetorical persuasion is built upon three principles: *ethos*, *logos*, and *pathos*.[15]

THE LOGIC OF MODERN ADVERTISING If we translate the rhetorical elements to contemporary advertising terminology, we quickly get to the credibility of a company's reputation (*ethos*), a logical explanation of the product offered and its unique points in comparison to competitors (*logos*),

and "emotional branding" that aims to associate products with feelings inherent in the target audience (*pathos*).

Aristotelian rhetoric is a cornerstone of Western thought. Still today it is considered the bellwether of the art of persuasion via language. The term "Aristotelian rhetoric" refers to the use of linguistic and figurative means in political speeches and mass media as well as advertising. These classical foundations of persuasion served as the basis for modern advertising that emerged in the early twentieth century and that stemmed from the Russian constructivist artist-designers Alexander Rodchenko and El Lissitzky, as well as modernist-functionalist German Bauhaus designer Herbert Bayer and designer and typographer Jan Tschichold.[16]

The Bauhaus school set the accepted rules for graphic design and arrangement of information, covering typography, pagination, layout, and positioning of photographs within a page. According to the modernist paradigm, a poster should stop the observer, capture attention, and then quickly and clearly communicate a message about the product's unique advantages. Therefore, the image in a modernist advertising poster derived from and was dictated by the product and its features.

Roland Barthes, in his essay "Rhetoric of the Image," steps out beyond the theory of (verbal) rhetoric into a theory of visual rhetoric as it is expressed in modernist advertising. He contends that although visual communication is built upon a system of images and doesn't enjoy a rich syntax as is found in verbal language, visual image does have richness and capabilities that cannot be found in verbal language.[17]

In his book *Mythologies*, Barthes adds an additional element to the classical theories of persuasion: the advertising-created myth. In the chapter "Soap Powder and Detergents," he shows how an advertisement swaps the conventional signifier (cleanliness) for a signifier of desired values—depth and foam—that create a myth out of everyday laundry detergent. In a standard communications system, the sign is created from the well-known relationship between the signified and signifier. But in a mythmaking communications system, a new signifier is associated with the original signified, one that is not its natural signifier.

Despite the disruption of the commonly accepted signified and signifier, the new sign is read by the viewer as factual, and thus persuasive, even though it is merely a semiotic system. In this way, the visual system manages to establish a complex argument, and the consumer ends up purchasing more than just another simple product. It is now a mythical product.[18]

Thus, beyond the *ethos*, *logos*, and *pathos* there is an additional persuasive

FIGURE 5.1
Advertising
poster for
"Regain,"
1993

element in modern advertising—the *mythos*. Communications in ads that employ all four as means of persuasion are found universally today, including in Japan.

Consider an ad campaign for the energy drink Regain (figure 5.1). In the campaign posters, we clearly see the product name and slogan that together form its reputation (*ethos*), the price compared to others (*logos*), the slogan ("I am going with full power, I am going with Regain") that creates the *pathos*, and the visual image that creates the *mythos*.

In the campaign, which was introduced in the early 1990s, the actor Motoki Masahiro represents the businessman as heroic adventurer: photo-

graphing in the wild, parachuting, or flying a helicopter. The advertisement presented a message of an energetic person who manages to devote time to his work while still finding time for self-fulfillment. The visual imagery introduced a new mythical signifier (adventure and courage) for the signified (energy drink), which marketed the drink as a myth of energy and adventurousness.

The values presented match the early 1990s, when business persons began to demonstrate interest in leisure, forgoing the days of focusing only on working hard (see Chapter 8). In 1996 the mythical message was replaced by a more logical one, and the company took another actor, Satō Kōichi, who projected characteristics that any employee could identify with: a worker in his thirties, battling the boredom, mediocrity, and fatigue associated with being an employee in a Japanese company. In this advertisement, the energy drink is presented as the logical solution to a problem, by connecting between the signified (energy drink) and signifier (new energy).[19] This type of advertising can be understood via classical models of rhetoric or structural semiotic models, in accordance with Barthes's claims.

These models that drove modern advertising and marketing theories grew upon Marx's foundations of dialectical materialism, presenting a logical worldview. These perceptions still exist in advertising today. But most researchers today believe that the models of classical marketing communications do not match the existing multifaceted reality of contemporary society.[20]

THE LOGIC OF POSTMODERN ADVERTISING Studies written in recent years in various fields of research regarding persuasion have focused on the psychological basis of the viewer, and how it impacts the decision-making process.[21] These studies help in understanding the new persuasion strategies found in contemporary advertising. Still, the rhetoric and marketing communications present in the Japanese advertising posters discussed in this book are different—both in terms of design and as the ideas that guide them. These posters not only depart from the modernistic concepts but also differ from contemporary advertising posters in other industrialized countries.

In order to understand the marketing communication methods that these ads employ, we should widen our understanding of contemporary marketing. The study and research of marketing has traditionally been the realm of business schools. These institutions by nature rely on models built around quantitative and statistical methodologies. Therefore, they did not adopt the postmodern philosophies or post-structuralist theories whose popularity in academia was primarily in the hallways of humanities departments. But

postmodernism is not only a visual expression or a theoretical opinion. It is also, and perhaps primarily, a mixture of economic, social, and political practices that created a new reality. Already in the 1960s, social revolutions and economic development that rejected modernism transformed product design characteristics and marketing strategies in all postindustrial countries. Thus at the heart of the postmodern practices and social aesthetic paradigms stands the postindustrial economic transformation that brought us from a state of scarcity to a state of abundance. This transformation also caused a change in product characteristics that altered consumer attitude toward products that no longer simply fulfilled functional needs. Products now existed to meet the pursuit of experiences, desires, and pleasures. The new consumer culture, with its associated "logic" of late capitalism, became a central ideology of the 1980s and 1990s. This specific phenomenon, with its new variety of products and new marketing mechanisms, was perhaps the clearest representation of the postmodern reality and postmodern spirit that emerged worldwide. This ideological revolution did not skip Japan, which during the 1980s became a country with postmodern values and social paradigms, like other postindustrial countries. Moreover, with Japan's economic bubble, the late consumer culture seemed more intense, and the daily practices of consumers were more extreme than perhaps anywhere else in the world.

During the 1980s and early 1990s, Japanese employees worked more hours than those of any other nation, and wages began to climb.[22] While institutional investors preferred real estate (after the retreat of the Hong Kong and New York stock markets as a reaction to the Louvre Accord), middle-class people had no attractive investment avenue available and put most of their investments in bank savings accounts, resulting in high liquidity.[23] Banks reinvested these savings in financial vehicles that pushed up the Tokyo Stock Exchange, leading to a speculative economic bubble that reached its peak in 1988 for real estate and 1989 for the stock exchange.

Japan transformed during this time, from an industrial superpower into a financial superpower with the world's strongest economy. But while Japan's image in the world was of a wealthy financial superpower, new income gaps and class levels emerged in Japanese society. Real estate tycoons and newly rich stock market investors were only about 10 percent of the population. While the top echelon of society enjoyed their luxury apartments and golf club memberships, the new middle class could no longer afford to buy an apartment. They compensated for this by spending more money in leisure and consumption of fashion, electronic goods, and vehicles, thus creating

a new consumer culture with a wide variety of consumer products, brands, new kinds of shops, new magazines, new leisure culture, and a new kind of advertisement.

Thus after years of austerity and savings, the younger generation, those who did not know the trauma of war and the hard work of rebuilding the nation, could join the bubble party. During this time, Japanese were called "economic animals," not because of their hard work as in the 1970s, but because of their ever-increasing consumption of quality products and brand names. Akabane Makoto and Saitō Maki describe this period as a snow avalanche.[24] This massive middle-class spending, created in large part by generous bonuses received from corporate employers, also contributed to the bubble economy. Japan stood out as having a fast-paced curve for changes in consumption behavior. Cars were replaced every four years. Purchases of electronic appliances and luxury brands (European classics such as Louis Vuitton and Chanel, as well as domestic luxury brands) were the norm. The pursuit of desire and pleasure indeed became the face of this new consumer culture.[25]

John Clammer, who studied the Japanese consumer culture, claimed that "it is in Tokyo that the consumer culture of Japan has reached its apotheosis."[26] Marilyn Ivy, who researched the economic bubble period in Japan, talks about this period as a time of "Accelerated Symbolic Consumerism." She claims that the developments in Japan differ in comparison to other countries where brand-new consumer cultural values emerged. In Japan, she explains, the late consumer culture values went to extreme and sometime radical levels because of a strong polarity, not seen elsewhere, between the strict and well-defined structure of government and bureaucracy on one hand and the accelerated energy flow of innovative consumptive culture on the other. One holds back, aiming for stability and resistance to change, while the other is pure release.[27]

In Japan and throughout the postindustrial world, extreme consumption brought on a phenomenon contradicting classical economic logic. In the modern economy, the value of a product rose in conjunction with its scarcity, according to the principle of supply and demand. Postmodern economics turned this principle on its head: a product becomes greater in value once it becomes a ubiquitous brand. The postmodern market saw a plethora of products emerge whose production did not follow any economic consumption logic, neither functional value equations nor production cost equations. The American consumer is exposed to endless parallel products, such as

yogurt on the supermarket shelf, and the Japanese consumer is exposed to countless electronics products and cell phones with little to no functionality differences.

Technology also added to Japan's extreme drive into the late consumer culture by changing the way products are purchased. Television advertising, which started in 1953 (with a Seiko commercial), increased to an overwhelming amount during the 1980s with the development of satellite broadcasting and cable TV. Virtual shopping channels emerged on television, on the Internet, and on cellular phones, all of which were further replicating the visual imagery of the product. Thousands of commercials were broadcast daily from five major commercial TV stations in Tokyo. This was followed by Internet and mobile advertising via networks such as I-Mode.[28] Many products were detached entirely from physical presence and transformed into pure image, especially digitally replicated products (e.g., software) or experience-based products (e.g., leisure culture products). Postmodern consumer culture establishes a brand-new product characteristic, dropping both the physicality of the product and the authenticity value that was so important in the modernist market viewpoint.

This was true not only for virtual or digital products. Even the most physical products changed their material nature. This can be seen by revisiting the American yogurt aisle and the Japanese electronics discussed above. The number of yogurt varieties continued to grow, with low-fat varieties earning their place on the shelf. But this new option started a race down to zero fat, with almost all varieties shifting to low fat and no fat. In a similar way, electronics such as LCD screens and smart phones got continually smaller and smaller, a phenomenon that started in 1960s product design but reached a more noteworthy level in the 1980s thanks to technological developments, leading to what can be termed "product anorexia."

In the 1980s and 1990s, the sheer volume of information available about consumer products increased. And in this, too, Japanese consumer culture took it to the extreme. Clammer describes Japanese society as bursting with information and Japanese consumers as "informaniacs" (*informaniaku*).[29] The abundance of products and the vast information available about them led to the phenomenon of consumers who could no longer make rational purchase decisions. American consumers choosing from an endless selection of yogurt typically base their decision on packaging or advertising—that is, according to the image rather than the product quality or ingredients.

In Japan, this phenomenon is quite acute in the field of electronics such as digital cameras and cell phones. As these products turned digital, and

numerous competing options with similar technology and prices emerged, consumers could no longer distinguish between products. This despite—or perhaps because of—the volume of product information available.

In such a market, the final choice is often based on the physical image (product design and aesthetics) and metaphysical image (company name, branding, and reputation generated by advertising). As early as the 1960s, these new elements impacted on the modernist economic concept that claimed that a product's market value is determined by functional importance and investment in manufacturing. Marketing methods, according to modern concepts, were thus dictated by the product utility. Today, products are positioned one against another according to their branding, with each product having its own imagery and its own myth thrust upon it by advertisements.

Cultural critic Amano Yukichi, who writes on the subject of advertising for *Asahi Shimbun*, one of Japan's leading newspapers, explains that many Japanese advertisers in the 1960s and 1970s were in a bind. On the one hand, manufacturers wanted to show off their products in their ads, but on the other hand, there simply were not significant differences in their product from the consumer's perspective when compared to other products available.[30] Ad designers in the 1980s and 1990s realized that talking about the differences in functionality between different washing machines was like talking about the insignificant difference between Pepsi and Coca-Cola. Amano writes that in the 1950s and early 1960s, when Japanese goods were synonymous with cheapness and low quality, the main criterion used for selecting one product over another was price, but during the 1970s the quality initiatives of the government began to be successful, and high-quality products appeared. At the time, competition regarding price bore results, and product quality became the criteria for selection. But subsequent technological advances made products practically identical in quality, leveling the playing field again and leaving consumers to make their selections based mainly on design, style, or image. For this reason, ad designers began to use images that didn't reflect explicit product qualities. Instead, designers sought an emotional reaction from the consumer, which would differentiate via style or trendiness. Consumer reaction followed in kind, and shoppers began to buy products according to design and personal taste.[31]

The idea of reflecting consumer values instead of displaying actual product values was traditionally acceptable in fashion and cosmetics, but starting in the 1980s it crossed over into products such as cars and electronics. This form of marketing presented new values representing the postmodern

economy, in which products have a fetishistic nature. In such an economical environment, phantasmagorical relationships were formed between products and consumers, as a reflection of the consumers' social relationships with their surroundings.

In their book *The World of Goods*, Mary Douglas and Baron Isherwood seek to answer the broad question "What lies at the core of people's need for products?" claiming that "goods work as communicators." For them, in an information society, products are communication elements, and every act of consumption or selection of product is a sociocultural act.[32] Indeed, the post-modern world offers a huge variety of products that do not meet materialistic needs, instead answering communicative and social needs.

For example, the Japanese bubble period was characterized by a desire to consume more and more new products, a desire that was rooted not in the need to fulfill a function but rather to reflect social status. This caused a production system that launched new products with short shelf lives. When social-cultural anthropologist Arjun Appadurai talks about the pleasure derived by the consumer from the act of consumption, he is implicitly referring to the fast-changing trends and temporary nature of value that create short shelf life. He argues that the key to modern consumption is the pleasure of ephemerality:

> The pleasure that has been inculcated into the subjects who act as modern consumers is in the tension between nostalgia and fantasy, where the present is represented as if it were already the past. This inculcation of the pleasure of *ephemerality* is at the heart of the disciplining of the modern consumer. The valorization of *ephemerality* expresses itself at a variety of social and cultural levels: the short shelf life of products and lifestyle, the speed of fashion, the velocity of expenditure . . . the aura of periodization that hangs over both products and lifestyle in the imagery of mass media. . . . The search for novelty is only a symptom of a deeper discipline of consumption in which desire is organized around the aesthetic of *ephemerality*.[33]

Sociologist and consumer culture researcher Stuart Ewen adds that "in today's economy, the preeminence of *hard goods* has given way to that of abstract values, immateriality, and the ephemeral."[34]

The principle of planned obsolescence lies behind the concept of the new consumption. Manufacturers infuse in products an aesthetic or fashionable value that will be quickly lost, only to be replaced by products with a newer trend or style. Consumers opt for a new replacement product not because it

will be more effective, but because it will be more attractive. In other words, from the 1960s onward, product style and design usurped product functionality as the essential product characteristic.[35]

In Japan, adding the term "new product" (*shinhatsubai*) to a product is perceived as having greater value than actual product functionality. This was clearly expressed in Japan's automotive industry in the late 1980s, where new models were introduced at a breakneck pace, flooding a market that no longer worked according to economic logic, shifting instead to social patterns.

We must therefore examine postmodern economics (including product values, consumption, and marketing patterns) as a social system. As Jean Baudrillard argues, "An accurate theory of objects will not be established on a theory of needs and their satisfaction, but upon a theory of *social prestations* [social benefits] and *signification*."[36] Brian Moeran, who examined Japanese consumer culture, presents four values (use value, technical value, appreciative value, and social value) that form a system of *sign* exchange values, yet also coalesce to form two other exchange values: the commodity exchange value and the symbolic exchange value.[37] John Clammer adds "play values," referencing Barthes's term "the pursuit of *jouissance*," since many goods in the market are experiential by nature.[38]

All these values are without doubt important factors in the consumer's determination of whether or not to buy the product. But when discussing images in advertising, it seems that Baudrillard's "sign value" of the 1970s still remains valid. Baudrillard claimed that "an object is not an object of consumption unless it is released from its psychic determinations as symbol; from its functional determinations as instrument; from its commercial determinations as product; and is thus liberated as a sign to be recaptured by the formal logic of fashion, i.e., by the logic of differentiation." He continues: "Today consumption defines the stage where commodity is immediately produced as a sign, as sign value, and where signs (culture) are produced as commodities."[39]

The sign value is the currency of the social system in which the commodity was created and is used as a motivating factor and as a basis not only for understanding the new social paradigm but also for understanding the economy and contemporary consumption. In such an economic system, consumer purchase is based on branding and on information provided in the imagery rather than the product itself. In the process, the product is voided of its functional identity and is instead used as a sign. Robert Goldman follows on to Baudrillard's argument, stating that selling consumer commodities has become centered on the image, on the look, on the sign. The sign value of

the commodity gives a brand name its zip, its meaning. A sign value estab-
lishes the relative value of a brand where the functional difference between
products is minimal.[40]

The product has lost its link to its original meaning, functionality, material
and production values. A pickup truck, for example, has transformed from
being a field-use vehicle built for hard work into a status symbol reflecting
power and prestige.

The emergence of sign value, and the consumer-culture revolution that
satisfies desires instead of needs, are the joint triggers for excessive consump-
tion and the multiplicity of products and services. Unlike functional value,
the information-based sign value is limited in time and quickly loses validity.
This leads to a tendency to consume more and more information and mean-
ing and thus more and more products. Thus the postmodern opulence.

The theory of signs within consumer society provides us with insights
on how manufactured needs and values played a crucial role in organizing
contemporary societies around consumer objects, needs, and practices. Bau-
drillard explains: "Like the sign form, the commodity is a code managing the
exchange values . . . it is the code which reduces all symbolic ambivalence in
order to ground the rational circulation of values and their play of exchange
in the regulated equivalence of values."[41]

In order to explain the new social paradigm and its relation to the late
consumer market, Baudrillard focuses on the "logic of social differentia-
tion," whereby individuals distinguish themselves and attain social prestige
and standing through the purchase and use of consumer goods. For him,
consumption is a system of exchange. In the new consumer culture, many
products of the same category exist side by side. They thus achieve meaning
and identity only via differentiation from a parallel product. In this process
the products are positioned as sign against sign, creating new hierarchies and
new differentiation between the products and, as a result, between those who
consume them. In the postmodern social paradigm, individuals or groups
of people attain significance only in relation to individuals or other groups.
Or, in other words, social significance and identity are also a system of ex-
change, with identity being based on the logic of differentiation. According
to Baudrillard, the new consumer society is motivated by need and desire.
However, it is not by a need for a materialistic object but rather by the need
for differentiation, which is actually a desire for social meaning.[42]

The need for a social-psychological differentiation is stronger than the
materialistic need for functional objects, and thus is the primary motivator
for the new consumer culture. Moreover, in the new product culture, need

and desire unite to present a new social networking and social psychology in which consumers purchase signs and identity.

The principles of differentiation and groups gathering around a sign existed in primitive societies in which subgroups within tribes or clans united around a totem that offered a common understanding of symbols. This enabled the development of communication and community identity. According to Claude Lévi-Strauss, totemism also occurs in advanced societies, where people gather around an object that symbolizes group identity and gives its followers inspiration and strength, protecting the society from the constant threat of breaking up from within.[43]

Moreover, in the late consumer culture, the utility of totemism lies not only in providing community significance but also in providing differentiation of one group from another. The totem that bequeaths meaning, identity, and differentiation in the late consumer culture is of course "the brand," with its almost magical influence on the consumer. The brand is a symbol that does not indicate the quality or role of a product, but displays an image that represents a name, reputation, and social characteristics, and offers the buyer an identity.

In the process of consumption, consumers yearn for brands, collecting social signs and using them to build up their own personal or group style. This creates affiliation and differentiation. As a result, each individual functions as a guidepost saturated with signs that testifies to his or her identity, social association, and status. In the postmodern economy, then, consumers purchase signs in order to build their social status, their affiliation to a specific group, and their personal identity. Thus, the purchase of a product from a wide pool of alternatives boils down to the selection of a sign. We can also restate this by saying that whenever consumers purchase products, the actual "product" that is being purchased is identity. As Clammer argues: "Shopping is not merely the acquisition of things. It is the buying of identity."[44] Stuart Ewen, who highlighted the blurring of boundaries between product identity and personal identity, quotes Robert Lynd, who labeled this phenomenon "commodity self."[45]

The brand offers a lifestyle and gives identity that is reflected in style and aesthetics, and therefore by extension the principle of social differentiation in postmodern society is related to aesthetics and style. We most typically view taste and style as personal issues and the act of selection as intuitive and subconscious—a gift of nature. But as Pierre Bourdieu argues, taste and style are closely linked to the different positions in social space and the system of dispositions (habitus) characteristic of the different classes. In his words,

"Taste classifies, and it classifies the classifier."[46] Thus, taste and style are cultural constructions, acquired similarly to a language. They are the means by which an individual declares his affiliation to a specific class, group, or subculture. That is, the style found in the product or its sign value is not innocent. Instead, it is an identity-building element, forging connectivity, creating differentiation, and shifting the balance of power between social groups.

Advertising is the mechanism that turns a product into style-bearing signs. It does this by adding a new signifier to the product. It is not simply a sales promotion tool. Its sign-building mechanism creates a language system for everyday interpersonal visual communication.

This new consumer psychology established many new segmentations, beyond the standard ones of age, gender, and economic status. Suddenly, levels of knowledge, areas of interest, and aesthetic style all became equally strong segmentation factors, by positioning people within a clearly defined peer group. This new segmentation begets new types of advertisements and media-mix strategies based on targeting niche markets, which indirectly create new consumers who do not buy a product but the narrative it represents.[47] Ōtsuka Eiji defined this new consumption as "narrative consumption."[48]

These concepts can be seen in two very different ads for two department stores. An advertising poster for Parco positions the department store as young and fresh by using style and colors taken from the manga world (figure 4.12), thus associating it with the youth culture (see Chapter 4).

In contrast to this, the Odakyu department store uses pastel coloring, referring to a classic Renaissance image, a quasi-quoting of Botticelli's *Birth of Venus*, positioning it as a classic department store for a more mature population (figure 5.2).

This rich and colorful differentiation between department stores enables audiences to distinguish and choose, and also to build their own desired status.

Looking back at the Hasegawa ad from the beginning of this chapter, we again see an explicit choice of aesthetic style used for positioning. The poster frames the company within Zen Buddhist aesthetics. This grants the company and its products an affinity to Zen, with all that this implies: aesthetic cleanliness, pureness, sophistication, elite sense, and prestige. It connects the Hasegawa Buddhist altars to a family of exclusive objects associated with this tradition (architecture, gardens, ceramics, etc.). The purpose of ads of this genre is to give companies a sign value that refers to a body of knowledge that the Japanese public is familiar with, while bathing the company in sign significance that differentiates it from companies that sell similar products.[49]

夢、咲、咲きました。

RENEWAL OPEN

町田小田急

広く、美しく、リニューアルオープン。

やわらかい陽ざしに蕾がほころびる3月。
町田小田急にも新しい大きな夢が咲きました。
広く、美しくなったフロアが
メルヘンの国からやってきたカリヨン時計が
くらしにすてきなストーリーをおとどけします。
なかでもご注目いただきたいのが
ファッションフロア。
レディス、メンズともに新しいブランドを加えて
いっそうおしゃれになりました。
15周年をむかえて
リニューアルした町田小田急を
どうぞご覧ください。

小田急・町田

It should be noted that advertisements in Japan also differentiate by inserting other values such as technological value, historical reputation, and social values (politics, religion, ecology, etc.), but aesthetics have a critical role in establishing social differentiation and influencing consumers. The actual product plays only a small part in identity and differentiation. It is primarily a function of the style one chooses to convey. In other words, style is the new function of the product.

The importance of aesthetics in Japanese society is evident in how the "tribes" of Tokyo unify around fashion and aesthetic elements. With the variance of society and the fading out of modernist social paradigms throughout the industrialized world, Japan's homogeneous culture that was known for its strong sense of collectivism and unity began to break into subcultures. This was seen in the strength of the local tribes emerging in Tokyo neighborhoods starting in the late 1970s. During this period, the *karasu-zoku* (crows tribe) appeared as a parallel to the British punk movement, as well as the tribe of fashionable young women called *an-non-zoku*. The idea of tribes unifying around style and fashion intensified in the 1980s, specifically in Yoyogi Park of Tokyo's Harajuku neighborhood, where the *take-no-ko-zoku* (bamboo tribe) rebelled against the establishment by smoking cigarettes, greasing their hair, and dancing in the streets. They were replaced in the mid-1980s by the *bando-zoku* (band tribe), who in the twenty-first century were subsequently replaced by various groups including the *visual-kei-zoku*, the gothic-Lolita *harajuku-zoku*, and the *ganguro* tribe of young women in the Shibuya and Ikebukuro neighborhoods.

We could define the young culture evolving in Harajuku or Shibuya as "street culture" rebelling against the conservative establishment. But in the Aoyama neighborhood right next door, the *kurisutaru-zoku* (crystal tribe) emerged. This was a group of young urban people who built their image by wearing upscale fashion, driving expensive cars, and sitting in luxury cafés. Like the other groups, this group also formed around consumer products, brands, and an aesthetic style that defined their social identity, creating distinction using style and fashion, clearly separated from other groups. Clammer argues that the primary way that individuals and tribes distinguish themselves from one another in contemporary Japan is consumption.[50]

Aesthetics has been used as a reference system since the beginnings of civilization, mainly limited to the high arts and high-class consumers. But the use of style as a seductive reference in advertising is a postmodern cornerstone. Bourdieu argues that "the barbarous reintegration of aesthetic consumption into the world of ordinary consumption abolishes the opposition of high and low aesthetics."[51] Indeed, the postmodern aesthetic style

is not limited to galleries and museums, and it certainly is not restricted to the upper class. In Japan it exists throughout the urban space of Tokyo, in advertising posters, in the spectacular neon signs, architecture, and display windows of department stores—the cathedrals of consumer culture—all together forming a postmodern pastiche. Japanese consumers of the 1980s and 1990s were exposed to an endless eclectic offering of products and styles in the department stores that also housed galleries showing art exhibitions from all over the world.

The world of product design also experienced a shift, from the modernist "form follows function" to a postmodern stance described as "form follows emotions" by Hartmut Esslinger of Frog Design, designer of the Apple Macintosh computer in the 1980s. In Japan, however, according to design critic Stephen Bayley, products traditionally put an emphasis on style and emotional seduction more than on functionality and ergonomics.[52] This traditional characteristic of Japanese product design enabled a smooth transformation to the postmodern marketing standpoint in which aesthetics are an economic function, fueling the new advertising to catch on like wildfire.

The role of the posters presented in this book was to create a brand image for the company and differentiate it from the parallel campaigns of competitors. This was done using aesthetics and styles that established a meaningful reference system. The different styles presented in Chapter 4 become the new signifiers for companies to work with: colorful style or monochromatic style, *kawaii* style or *moe* style were the new agents that emerged. To paraphrase Marshall McLuhan: *The style is the message.* The art directors that I interviewed spoke of information as their core product (as opposed to the object being advertised), and as with any product, they sought to create the highest quality possible. The nature of this high-quality information, which at times expresses itself via style as "open" visual images, makes these images complex signifiers, with several layers, unlike traditional single-dimensional advertising signifiers such as "natural" or "sporty."[53] With such emphasis on style in the postmodern era, it is no surprise that the role of the art director became an inseparable part of the success of any commercial company.[54]

Aesthetic Reading in the Social Context of Late Consumer Culture

The logic of consumer culture as a communicative social system sheds light on the relationship between an advertisement's visual image and the actual product. It also points out the new place of the visual image and style in the postmodern economy. With the economic boom of the 1980s, two closely

related processes occurred in the postindustrial world: the new consumer culture took full form as the leading ideology of the period, and new position and importance was given to popular culture. Both of these processes put great importance on media and visual culture.

Along with the development of newly widespread media outlets during this period, advertising and branding saw unprecedented growth. Broadcast networks, TV stations, newspapers, and Internet websites, as well as powerful public institutions and private organizations such as sports teams, all became dependent on these advertising budgets. This phenomenon saw large conglomerates dictating cultural contents on one side, but on the flip side becoming fully dependent on branding, or in other words on the image.

Sign-value branding became a measurable and negotiable asset in and of itself, and the path from here was paved for the forging of relationships that interconnected economics, aesthetics, and social significance. Commercial companies in the postindustrial world began to relate to design and aesthetics (physical images) and corporate identity (conceptual image) as marketing tools.

As the commodity culture emerged in the 1980s, products were drained of their utility value, replaced instead by new signifiers. The separation between product and image was blurred to the point of disappearing, with the product becoming a social sign first and foremost. Consequently, companies ceased competing on product functionality, shifting instead to innovative and seductive design, focusing on the quality of the corporate image in the market. Investment in branding, advertising image, and product packaging rose to the levels of research and development investment.[55]

As a result, advertising in the 1980s began to show more and more complex images, and companies launched massively budgeted campaign productions. For example, a multimedia campaign for Suntory that included photography in foreign countries was a landmark campaign of the time. This campaign was clearly on a previously unimaginable scale that marked the change in relations between product and advertising image. The campaign seemed to scream out *There has been a change in power. Advertising is now the dominant economic force.*

Along with the transformations in consumer culture and status of image, there was also a shift in the structure and content of the new visual culture. A visual culture experience built on postmodern aesthetics was emerging, and not just in the world of art and cultural consumption. It emerged equally in popular visual culture, within products, and served as a marketing strategy. American author and columnist Virginia Postrel described it as "the rise of look and feel."[56]

In 1980s Japan, consumer culture bequeathed a new language of design—in architecture, in product design, in fashion, in urban space, and certainly to no lesser degree in graphic design. Under the baton of the Tokyo ADC art directors, graphic design's transformation built the aesthetics of the new magazines (such as *Yasei Jidai*, designed by Ishioka Eiko) and the new TV commercials, as well as the aesthetics of the streets (through posters, shop windows, etc.), representing a new visual experience.

The designs of these art directors were tied directly to the new consumer culture and the economic boom that caused the growth of companies and abundance of products and created the accelerated need for a new kind of advertising. In their role, the art directors used the new aesthetics to boost consumption by instilling products with seductive signifiers and building a complex corporate identity via multilayered and open imagery. The mind-set of these art directors centered on the idea that if the market structure, the corporate structure, and the new products all have postmodern values, then certainly a postmodern visual strategy—with all its variety of motifs (pastiche, fusion, quoting, layers of meaning, multiplicity of narratives)—would best represent the spirit of these companies and their commercial strategies. The result of this collective endeavor was a cavalcade of images that emphasized sign value and instantly made aesthetics the primary means of marketing communications. Postmodern images came off the gallery walls, and postmodern concepts came out from the halls of academia, along the way creating a new reality: a body of advertisements that perfectly described the spirit of the times. Just like the works of the fashion designers, product designers, and architects of the period, these advertising images blurred all differentiation between design and art.

Fredric Jameson argues that the formal characteristics of postmodernism in general, and specifically postmodern aesthetics, express in various ways the deep logic of the late capitalist social system.[57] In other words, postmodern aesthetics is no longer another autonomous theory of art and philosophy. It has become a functional dimension that serves as a marketing strategy in the late consumer culture and the new social system.

The resulting advertisements were artistic expressions that at first viewing appeared uncommunicative, lacking a clear point of view or marketing orientation. However, the advertisements used the fluid quality of the visual text as a source of power. Paul Messaris, who discusses the fluidity of the visual image, explains that visual communications are characterized in the same way as any other type of communication: in terms of semantics and syntax. Semantic characterization of the visual image is very clear, because the iconic character represents reality. But unlike verbal communication, the

visual image lacks a clear syntax to describe how elements within the image relate to one another. A picture cannot explicitly establish constructs such as dependent clauses or cause-and-effect phrasing that can be easily achieved in the syntax of verbal language. So the meaning of the visual image and the relationship between elements within the image become fluid, not absolute. They are open for viewer interpretation, according to each viewer's personal associations. This fluidity of visual images was long considered a deficiency, but Messaris claims that, in certain respects, it is actually their strength.[58] Indeed, for the posters presented in this book, the fluidity and openness that stimulate human curiosity are precisely the secret to their success.

The human brain is obliged to place meaning on all objects it encounters, and so the viewer becomes involved in the process of observation and decryption, like it or not. The advertisements do not step out into the consumers' space in an attempt to show a clearly phrased idea. Instead, they invite the viewers into the ads' own space to participate in revealing hidden meaning or even create a brand-new meaning. The viewer identifies familiar visual expressions and establishes associations among them, while also associating the logo (sign) with the interpreted meaning. It is exactly this process that engraves the logo in the mind of the consumer. By taking an active role in the act of decoding, the viewer takes credit for the interpretation, establishing himself or herself as an intelligent person. The process of observing the ad and establishing meaning requires a non-insignificant investment of time, therefore the decrypted solution remains in the viewer's memory for a long time. The key goals of advertising—Attention, Interest, Desire, Memory, and Action (AIDMA)—are thus achieved.

We can see that a trio of forces—the logic of the new consumer culture, the newly established importance of visual image in the postmodern economy, and the increased importance of aesthetics and style in postmodern culture—together worked like an incubator for the new concept in advertising posters in which Tokyo ADC art directors instilled a new rhetoric.

The art directors went further than just postmodern aesthetics in order to construct their marketing communications. They also borrowed ideas characteristic of the period. For example, in the postmodern spirit (beyond postmodern aesthetics, using postmodern values and concepts), and in accordance with the new logic, ads did not present an objective or "real" perspective of the products, ignoring completely any functional or material qualities. By removing the product and instead emphasizing the artistic, personal image, ads shifted attention from the object (the product) to the subject (the consumer and his/her values). By disconnecting the image

from the product, the ads introduced a new relationship between image and consumer. This idea completely fits late consumer culture concepts, with consumers using products as a sign that builds their identity. Moreover, as advertisements frame the consumer's identity as an object of desire, the new seductive marketing patterns are based on the gaze and the complex identity of the postmodern customers.

The Challenge-Seeking Consumer

The concept of marketing communications that do not highlight the product or its inherent qualities, but rather present it via differentiation, is related directly to postmodern changes in self-definition. The perpetual need to build an identity is the engine that drives advertising. Judith Williamson explained that advertisements of the 1970s presented a consumer lifestyle as an object of desire. By doing so, the ad invited the viewer to identify with the ideal presented within it, despite the gap and space between the consumer and the ideal. Williamson argues that the object of desire was not the image in the advertisement, but rather the "self" of the viewer, who attempted to become a "coherent self" by identifying with the myth portrayed in the ad.[59]

Modernist advertising presumed that people are coherent and act rationally, and the ads simply presented another well-phrased sentence (verbal and visual) for the viewer to comprehend and use. But the postmodern consumer does not act solely by pure logic. In his book *Le système des objets*, Baudrillard argued that the change in attitude toward products has caused consumers to drift away from coherence.[60] Given that the postmodern consumer culture no longer works according to economic logic, it is clear that the new marketing communication changed respectively. It no longer assumes that man is coherent and rational, instead seeing a creature with a complex personality, triggered by different and sometimes contradicting forces, with a wide range of thinking patterns. Thus, there are many psychological factors that determine persuasion strategies.

John Clammer claimed that the Japanese consumer is in search of the "social self" constructed of two opposing forces. According to him, the construction of a sense of self in the context of the Japanese society, in which both conformity and aestheticism have reached high levels, is defined not so much in the terms of individual "essence" as relational. The presentation of the self as both internally integrated and as socially acceptable requires a synthesis. The self is a product of a dialectical relationship between interior cultivation and external canons of acceptance. Shopping—the material

construction of this dialectical self—takes on an almost metaphysical significance as a result, since this self identity must be constantly reaffirmed in ways that are socially visible and aesthetically pleasing: "The 'correct' appearances of one's individual self requires the acquisition of the emblems appropriate to both self image and objective status." In other words, the new consumer achieves identity through the aesthetics by which he or she chooses to be viewed by society.[61]

And so, postmodern advertisements built their marketing communications according to the awareness of the new complex identity of the consumer; it is this new gaze and identity that dictate the new image. These ads use meta-communication to connect with a sophisticated and multilayered viewer with broad visual intelligence. The postmodern viewer is capable of coping with complex visual texts. Without the new viewer, such complex advertising is meaningless.

In constructing seductive communications, the art directors consider the visual world of postmodern consumers, which was built by the fragmentary structure of the new visual culture. Images are not complete in and of themselves. They are but one sign within a chain of signifiers in a fragmented and rhizomatic visual culture that envelops the consumer. The art directors use different styles that refer to distinct bodies of knowledge and social values. This strategy assumes a visual intelligence among viewers who have postmodern vision that can comprehend intertextual references to other visual texts or to their own world of values. For this reason, we sometimes see signs or fragments of signs in an ad that seem to say nothing on their own and certainly nothing related to the product, but do act as triggers for contemplation in the chain of signifiers that float freely in the viewer's mind. The poster lets the viewer participate in the "view—decode—interpret" process via references to different signs, visual expressions, and reference systems, some that have been seen and some that will be seen in the future. In that way, the advertisements flatter the intelligence of the consumer, who must complete the identification of elements (some familiar, some less so) within the ad.

Sometimes the viewer does not decode the message but rather creates a message of personal meaning. This strategy engages the viewer not only as a member of postmodern culture, but also as an individual with unique worldviews, preferences, and desires. Hara Kenya states: "Everyone says the 21st century is the information century, and even complains of too much information, but I disagree. All the information we get is fragmented, half-baked."[62]

When the viewer reads this fragmented information, power relations are built up between the viewer and the unsolved puzzle of the advertisement.

This strategy empowers the ad with a seductive element (the temptation to decode) instead of the persuasive elements found in the rhetoric of modern advertising. The advertisements shown in this book use the open, fluid quality of the visual text and the lack of connection between logo and image as a seduction strategy that is much stronger than logical persuasion.

Hara explains the concept of emptiness in designing advertisements and the role it gives to the consumer: "The concept of 'emptiness' is one of my methods of communication design. I don't launch a message at my viewers, but instead provide an empty vessel. In turn, I expect them to deposit something there, their own messages or images. This is an important aspect of communication, accepting what the other has to say."[63] This description was in reference to a campaign he designed for Mujirushi Ryohin (see Chapter 4). Hara explains: "The Muji posters carry less 'information' than the typical advertisement poster. They are an empty vessel which is ready to accept and hold the image of the viewer."[64]

As mentioned before, Hara Kenya argues that a good design is one that raises a question and does not give the answer. That is, advertisements in which there is an undecoded image and lack of connection between image and logo actively create the new consumer, who prefers being challenged over being right. The statement that every viewer constructs his own meaning seems to hint at Roland Barthes's "Death of the Author" as well as the post-structural ideas from the school of Jacques Derrida and Paul de Man, which stated that a text's meaning is not determined by the author's intentions, but by the reader. But the resemblance is only external. We should remember that advertisement is not a subversive literature text, but has a clear purpose, which is to market the company and its products. Thus, these advertisements bear the "logic" of the late consumer market and build a corporate identity via a variety of strategies.

When viewed through the contextual lens of late consumer culture values, the posters of the Tokyo ADC members that seem to lack information in the eyes of foreign researchers are in fact richly informative. It is just that this information is not about a product or company, but rather about the consumer and the consumer's values. The information is not transmitted via known reference systems (natural, sporty, glamorous, etc.) but via new signifiers created by postmodern style and aesthetics and by images bearing partial information that challenge the viewer to create personal or communal meaning.

This is the manner in which sign value is constructed, which subsequently builds up the complex identity of the company being advertised. Identity is

not created autonomously but via differentiation from identities of competitors or, perhaps more accurately, via differentiation from the signs of competitors. These elements underlie postmodern marketing communications and show the sameness between Japan and other countries. But despite the fact that postmodern rhetoric exists throughout the postindustrial world, the advertising style of Tokyo ADC members is unique to Japan. Therefore, in order to understand the underpinnings of this visual strategy, we cannot be satisfied just with postmodern consumerism theories and the new viewpoint of the consumer and its impact on advertising, no matter how central their role may be. We must also examine the structure of the advertising industry and the marketing mix that are unique to Japan, and how they together dictate the new marketing communications and encourage the emergence of a new type of image.

6
The Impact of Creative Industry Process and Structure on Visual Rhetoric

Advertising is a creative industry that fully integrates economic values and aesthetic production, with each and every final product being an offspring of both. Advertisements are the result of social processes within the industry (negotiations between different sources of power, industrial structures, target audience expectations) and the art director's personal language, which influences the visual image.[1] The Japanese advertising industry is the world's second largest, smaller only than that of the United States, and is driven like any other advertising industry by competitive and capitalist ideology. In such an environment, ads must function on an economic and marketing basis.

The previous chapter presented the global consumer culture and its related value system, showing how it influenced Japanese marketing communications. In this chapter, I wish to review the impact of various elements within the unique structure of the Japanese advertising industry, business processes within ad agencies, and the marketing mix in Japan that affects the formation of marketing communications and the final image. Together they frame this style of advertising as a "glocal" result between these two forces.

In my interviews with Tokyo ADC art directors, I discovered that each advertising poster is the result of a lengthy back-and-forth process between the art director and the client company, with the goal of understanding the marketing logic behind the advertisement. Thus the advertisement cannot be nonsensical or purely conveying atmosphere, with no marketing message or purpose, as has been claimed by some researchers.[2]

At first glance, in reaction to these advertisements that seem to lack any clear message, one might ask: "If the image is open for interpretation, how will the company know if the advertisement achieves its goal?" The answer lies in the fact that although postmodern advertisements indeed challenge viewers to decipher the meaning of the advertisement, they only create the illusion that the true meaning has been assigned by the viewer. Usually the viewer adopts one of the "solutions" imbued in advance in a sophisticated and hidden way by the creator of the ad. Yamamura Naoko, the Honda account manager at the Hakuhodo advertising agency, says that each Japanese ad-

FIGURE 6.1
Sato Kashiwa,
"Honda Step
WGN Elephant,"
1996 © Samurai
Inc. Creative
director, art
director, and
illustrator: Sato
Kashiwa; client:
Honda Motor
Co. Ltd.

vertisement "has immense amounts of logic. The art directors must present their ideas to each department of the advertising agency, and the agency representatives in turn explain the concepts to the managers of each department at the client company, all the way up to the company president. Each department manager must sign off on the conceptual basis."[3]

For example, when the Hakuhodo agency receives a campaign for Honda, it presents its advertisement idea to Honda's advertising department, and if that department can be convinced that the idea is good, the Hakuhodo account manager will prepare a presentation that explains the logic behind the ad to all the relevant departments at Honda.

Each campaign is inspected and approved across multiple hierarchies, checking the communication and marketing qualities and ensuring a convincing logic of the visual expression. This process is also influenced by the hierarchical structure of Japanese companies, with many departments to be navigated. Each advertisement, no matter how complex or enigmatic, must be grounded strongly in market research and embody a succinct marketing logic that can be clearly explained and justified: Who is the target audience? What are their values? How does this ad differentiate the product from similar products in the market? What persuasive elements does it use?

Yamamura Naoko explains: "Executives are not interested in visual expression. They want to see numbers, statistics, and market research to gain an understanding of how this advertisement will promote sales. In many cases, the many people involved will eventually reach a compromise, resulting in a boring poster."

Yamamura presents an interesting example of a campaign for a Honda car. The advertisements show children's drawings, which seemingly have nothing to do with the product (figures 6.1 and 6.2). But in actuality, there is

a rational marketing notion. The ads were designed by Satō Kashiwa, who also conceived the marketing concept.

These ads aim at the thirty-to-forty-year old target market, who are often parents of young children. The ads in essence reach out to these children, using children's drawings. The text is written in hiragana script, as is customary in children's books. The resulting posters seem more to be an ad for a toy car than the actual family car.

As already mentioned, the idea was to attract the attention of children. Young parents, who spend much time with their children, will be drawn after their children's enthusiasm for the drawing, and will take the time to examine it, making note of the brand. A parent who purchases the car will feel like a good parent for spending the money not on himself or herself, but rather for the family, supposedly including the children in a mutual family decision. The target audience is addressed indirectly, but with a clear rationale.[4]

Satō Kashiwa is not alone in using this process. All art directors are forced to consider marketing as well as creativity. Saitō Makoto comments: "I very much think about marketing. In fact, this is the reason why my ads are successful at selling. I create for a particular goal. The customers' goal is to make money, and I help them do so, using more marketing creativity than

FIGURE 6.2
Sato Kashiwa, "Honda Step WGN Whale," 1997 © Samurai Inc. Creative director, art director, and illustrator: Sato Kashiwa; client: Honda Motor Co. Ltd.

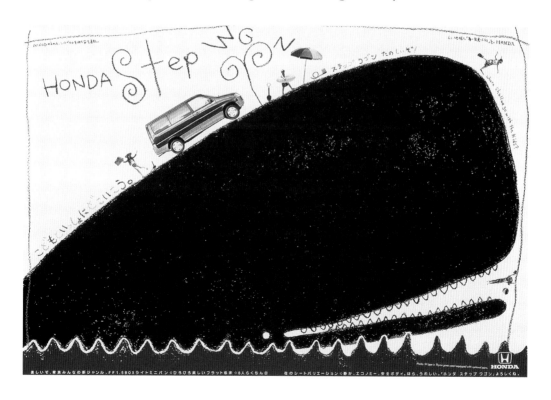

aesthetic creativity." Looking again at his Hasegawa ad (figure 4.1), we might think that the bone appears as an object open for discussion and free association. However, for the Japanese viewer it is overloaded in emotional cultural narrative. There is no doubt that the ad refers to the Buddhist cremation ceremony. After cremation, family members transfer the bones to a vessel. The single bone in the ad, a femur, is loaded with associations. The femur is known as a bone that often remains whole even after the cremation fire, owing to its thickness. Relatives must then break it into pieces before it can be transferred along with the remaining ashes and bone fragments into the vessel. The image of the bone triggers a chain of associations, from bone to ash vase (*tsubo*) and finally to the home altar (*butsudan*), which is the product for sale. This narrative sequence closes the gap between the bone and the logo and instantiates the product in the viewer's imagination.

With focus in many ads centering on some form of void, this genre is often characterized as minimalist. But the void is loaded with cognitive messages of cultural, emotional, or religious narrative that is deciphered by the Japanese viewer. The minimalism and the void that exist in the Japanese visual culture are usually symbolic and meaningful, enabling the art directors to use such aesthetics as information that builds significance for companies and their products.

The Honda posters use a marketing communications approach different from that of Saitō Makoto's Hasegawa poster, yet they still use emotional branding, touching the emotions of the target audience. Both also show the "logic" behind each advertisement and the effect of marketing thinking on the final image.

It is clear here that strategic decision making within Japanese advertising agencies regarding visual expression is based, as elsewhere, on the type of information that the client wishes to convey, in accordance with the product life-cycle stage (launch, growth, maturity). Moreover, different product types (food, toys, cars, etc.) use varying elements of persuasion. For this reason, it is problematic to generalize using the catch-all, one-dimensional term "Japanese advertising" or "Japanese marketing communications."

Market Structure and Work Processes in Japanese Ad Agencies

In the 1980s, spurred by economic growth in the United States and the trend of globalization, American conglomerates began to open branches around the world. American advertising agencies would often follow in tow. Com-

mercial relations and partnerships between American advertising agencies and local agencies around the world sprouted up as a result, influencing the marketing style and advertising communication patterns in each country where American agencies established a foothold, adding fuel to the fire of globalization and the spread of American cultural patterns.

Surprisingly, the American agencies failed to penetrate the Japanese market or establish strong connections with Japanese agencies, with only a few small exceptions. Thus, Japanese agencies maintained control of the local market and grew independently without the American influence on advertising style, allowing for a Japanese style to develop unhindered.[5] There are several reasons for this phenomenon. First, Japanese economic growth and the expansion of Japanese conglomerates at this time enabled local companies to compete successfully with the American firms. This generated work for the Japanese agencies, who went on to reach customers overseas as well, giving them the confidence to feel that they did not need to partner with their American counterparts.

However, the independence of the Japanese agencies, and the strong commitment to an advertising style associated with this independence, cannot be attributed solely to the postwar economy. Another reason, and most likely the key reason for the failure of American agencies to penetrate the Japanese market, was the unique structure of the Japanese market in general and the unique structure and work processes within its advertising industry.

A Brief History of the Advertising Industry in Japan

Advertising as a core marketing element has existed in Japan since the Edo period (1603–1867). However, advertising as a formal industry did not develop until the Meiji era, in parallel with the development of mass media. The first modern newspaper in Japan was the English-language *Nagasaki Shipping List and Advertiser*, whose first editions hit the streets of Nagasaki in 1861. One year later, the newspaper *Bunkoku Shimbun* was published in Japanese, containing news and ads translated from English. The first Japanese daily newspaper, *Yokohama Mainichi*, came out in 1871, and as is the natural course of journalism elsewhere, newspapers began to rely on ads for income, serving as a springboard for the development of an advertising industry. Advertising agencies were first established after the Meiji Restoration in 1868 paved the way for mass media, modern economic concepts, and advanced lithographic printing technology as part of the industrial revolution. The first advertising

agency was formed in 1880, followed by a plethora of additional agencies over the following decade. These agencies started out as mediators between private merchants and ad placement. They purchased advertising space in order to sell it to individuals or wholesalers, bargained over the amount to be paid for advertising space, gave instructions to printers, and ensured that the ads were in fact properly placed as ordered. On the other hand they supplied ads, and thus budget revenue, to the newspapers. Sometimes, agencies also provided actual news items.[6] Thus both advertisers and newspapers appreciated the middleman.[7]

However, as the agencies developed into intermediaries and not actual providers of creative services, the creative aspect remained in the hands of artists (as was the case during the Edo period) or internal creative departments within the companies that were emerging at the time.

For example, the cosmetic companies of the time, such as Kao and Shiseido, were pioneers in advertising campaigns and set the tone of the working procedures in the newly emerging advertising industry. These companies produced their advertisements within their own creative departments, with the agencies simply arranging the purchase of the actual advertising space in the newspaper.[8]

The groundwork for the structure of the advertising industry as stated above had significant influence on the structure and working processes of the advertising industry in postwar Japan. However, the development of this industry as it is known today is most associated with the post–World War II economic growth and the influence of U.S. occupation on Japanese culture and market structures.

Fostered by the American ideology, which advocates freedom of speech and capitalism, the first newspaper and advertising associations were established shortly after the war.[9] These included the Japan Newspaper, Publishers, and Editors Association (1946), the Japan Magazine Advertising Association (1946), the National Association of Commercial Broadcasting in Japan (1951), and the Japan Advertisers Association (1958).

The American presence was also felt in the field of commercial broadcasting, with the first private radio station launched in 1951. The commercials heard on these broadcasts soon became an integral part of the new lifestyle. Shortly afterward, in 1953, Nippon Television Network Corporation (NTV), the first private television station, was established. In addition to the new media outlets, this period also saw advertisements showing up in trains and buses. With the development of commercial media, along with rising living standards and renewed business prosperity, the Japanese advertising industry rebuilt itself after the war as a civilian marketing vehicle.[10]

But this blossoming was impelled by more than just economic prosperity. A cultural prosperity also helped guide this growth. Television, in its first exploratory steps, and American magazines exposed the Japanese audience to a luxurious lifestyle outside Japan and lit a fire of consumer desire. These forces created the postwar advertising industry.

Advertising Industry Structure and Agency–Media Interaction

Despite the American postwar intervention and its attempt to impose its capitalist and privatized free-market values, the Japanese economy evolved into a market structure different from that of the United States, or anywhere else, for that matter. Japan grew newly active, and remains so, in many large industries (in heavy manufacturing, including shipbuilding, steel, and automotive, and in technology-driven industries such as cameras, watches, and electronics) in which there are, on one hand, a large number of active companies, but on the other hand, a very limited number of conglomerates that control this production throughout Japan. This is a direct descendant of the traditional market structure that ruled Japan from the late nineteenth century until World War II.

In the late nineteenth century, the large mercantilist operations, such as Mitsui, Mitsubishi, Sumitomo, and Yasuda, were given the moniker *zaibatsu* (literally, financial cliques). These concerns were structured as a parent holding company with subsidiaries. The subsidiaries would often branch into many unrelated industries: banking, trade, manufacturing, transportation, and insurance.

The *zaibatsu* controlled roughly half of the Japanese economy, but they did not crush the small enterprises, who serve an important role as subcontractors. This symbiotic relationship helped the duality of giant conglomerates and thousands of small companies to evolve in the Japanese economy.

The governments of the late nineteenth century and early twentieth century preferred and encouraged the *zaibatsu* over smaller companies, since they were able to raise capital, provide professional training, and take large-scale risks.[11]

During the postwar reconstruction, U.S. authorities asked Japan to change this structure, compelling it to dismantle the monopoly of the *zaibatsu*. In December 1947, the Japanese parliament enacted a law that prevented excessive concentration in the market, thus dismantling the large concerns. This process was achieved by eliminating the parent companies and making each subsidiary independent. But in reality, the subsidiaries remained in close

contact with the other companies of the concerns from which they were born, with the bank or trading company at the top of the pyramid. These latter companies had access to, and sometimes control over, a portion of other companies in the group and thus effectively continued to operate as conglomerates.[12] These giant unofficial business groups (called *keiretsu*) were active in many different fields. The Mitsubishi group, for example, is active in the banking, automotive, insurance, hotel, food, and real estate industries, with each associate company having close relations but no formal or legal connections. Each company operates independently, but the informal connections to sister companies will ensure that if Mitsubishi Heavy Industry needs a loan, it will most likely come from Mitsubishi Bank.

As a result, the market structure remains centralized today. In each field, there is a wide collection of small companies providing local services, with most of them guided or influenced by a small number of large corporations that dominate the industry. Thus, in essence, the duality of nineteenth-century Japanese industry remains almost exactly intact today.

This is certainly true for the advertising industry, where there are thousands of agencies, but only five that really control the market.[13] These market leaders are larger and stronger than a typical "large" agency in other countries. Dentsu, the world's largest single-brand agency, controls approximately 25 percent of the entire Japanese advertising budget. For comparison, Young & Rubicam in the United States has only around a 7 percent market share, despite being one of the world's largest consumer advertising agencies.

Dentsu, Hakuhodo, and other such large agencies maintain ownership of many subsidiaries and affiliated companies. Dentsu, for example, owns sixty-six subsidiaries in Japan, thirty-eight domestic affiliated companies, and approximately seventy-six overseas subsidiaries and branch offices. This centralization has granted the large agencies great power in the market, earning the name "monopolistic agency" (*senzoku dairiten*) for the agencies that formed this elite cartel.

The major agencies have financial and manpower resources and connections within media. With these abilities they can provide customers with many different services (event promotion, corporate PR, and various forms of merchandizing) aside from advertising services. Most small agencies do not work independently. Instead, they join larger commercial groups. For example, the Dai Ichi Kikaku agency belonged to the Mitsubishi Group (prior to its merger with Asatsu-DK) and thus received the lion's share of the advertising budget from many companies within the group.[14]

But advertising agencies in Japan often have a unique dual association. In

addition to belonging to a large conglomerate or business group, they also establish business partnerships with media companies. There is a complex network of interlocking corporate equity shareholding among agencies, newspaper, magazine publishers, radio and television stations. Therefore, agencies have direct access to particular media organizations that enable them to obtain the desired advertising spaces for their clients. Moreover, the agencies have a say in the media content programming as well as in economic interests.[15] The agencies can thus prevent harmful information or plant desirable information regarding their clients. In this manner, complex relationships were formed between the agencies and newspapers, magazines, radio, and television.

Advertising industry involvement in media outlets provided a platform that could be leveraged. The Daiko, Yomiko, Asahi, and Nihon Keizaisha agencies all hold such relations with the major newspapers *Mainichi Shimbun*, *Yomiuri Shimbun*, *Asahi Shimbun*, and *Nihon Keizai Shimbun*, respectively. Not surprisingly, they each enjoy precedence for placement in key advertising space.[16] The Dentsu agency follows this up with almost total control of prime-time spots on NTV, thanks to its investment in the founding of the station.[17]

In the Untied States and Europe, such business relationships between advertising agencies and the media are usually prohibited or controlled by law, to prevent conflict of interest. But in Japan, the agencies have direct business influence in the media, and at times even publish their own magazines.

The strong links between the agencies and the media institutions indirectly resulted in a shift in the relationship between agencies and advertisers. Since agencies have exclusive access to advertising placement and also maintain loose ties to other media representatives, it is essentially impossible to find a single agency that has all the connections necessary for distribution and placement. Customers are obliged to distribute at least some of their budget to the big agencies for prestigious ad space, bypassing the main office that manages their budget if necessary.[18] For example, a customer who wishes to advertise in prime time on NTV must advertise via Dentsu, even if its primary advertising agency is Hakuhodo.

Most advertising agencies around the world are considered strategic business partners of their customers and therefore also grant exclusivity. This is not the case for Japanese agencies, who work with many competing companies within the same field, without exclusivity. For example, an American agency that produces ads for Ford would not likely be simultaneously working for another car company. In Japan, however, the relationship of the agency

to the customer is more in the nature of a pure service provider, with little strategic commitment.

The net result is that companies competing in the same field end up advertising via the same agency. Dentsu manages budgets for Toyota, Nissan, Honda, Mazda, and Subaru simultaneously. Likewise, it juggles the Kirin and Sapporo beer accounts.

The huge budgets funneled from the agencies to the media caused magazines, newspapers, and television stations to become dependent on the agencies. At the same time, companies that seek desirable advertising placement also depend wholly on the agencies that can provide them.[19]

It is this structure, with significant power vested in the few large agencies, that caused American companies to fail in their efforts to penetrate the Japanese market. Despite the American agencies' comparative advantage in creative forces and clear communication patterns, the Japanese customers preferred agencies that are connected to the same group of companies to which they belong and who have strong media connections. No American company had such connections with which to compete with the major Japanese agencies. A small number of foreign agencies still do operate in Japan, but not at a significant level of participation. Thus the Japanese advertising industry has been able to develop and thrive independently, free of a direct American or other foreign influence in management patterns, marketing communication patterns, and style.

Budget Management:
The Split Account System

When an agency is not a business partner of the client and the client doesn't enjoy exclusivity, each commercial company manages its advertising budget quite differently. Large companies in Japan maintain advertising departments and budgets within the company (an in-house advertising department). Creative work is done by the in-house department or is outsourced to a private art director. During the 1980s, for example, among the three S's of advertising—Suntory, Shiseido, and Seibu—the former two employed their in-house creative staff, while Seibu relied totally on external art directors.[20] The overall media mix is determined within the company, based partially on consultation with a number of advertising agencies. Only after deciding on the campaign and the media mix does the company turn to advertising agencies to settle details of the actual ad placement, almost always spreading

the advertising budget among numerous agencies. Distribution is determined according to various criteria: geographic region (Kanto, Kansai, etc.); media that the agency can offer (newspapers, magazines, Internet, or TV); and specific needs (advertising, PR, market research, direct marketing, exhibitions, events sponsorship, etc.).

For example, Laforet owns four department stores in Japan. It conducts an annual competition among art directors, and then divides its budget among seven agencies (including the above-mentioned Dentsu and Hakuhodo). These agencies are considered suppliers for Laforet, but it is Laforet itself that determines the content of the ads.

Sometimes, in-house advertising departments give each of their product lines to a different art director, thus creating a different visual look for each product. For example, Kwepie, a mayonnaise manufacturer, distributed its work between two art directors: one for its regular mayonnaise and the other for its reduced-calorie mayonnaise, in two entirely separate campaigns.

In some extreme cases, two campaigns are created in parallel for the same product. In 1988, a campaign for Suntory Dry beer featuring the American boxer Mike Tyson was active (via Dentsu) at the same time that a campaign managed by Hakuhodo had the Australian football player Jacko presenting the same beer.

The split accounts method, which is rarely seen outside Japan, has many advantages. The customer benefits from in-house advertising that is solely dedicated to its needs, as well as its economic interests. The agencies can simultaneously manage several competing accounts, allowing for growth that most agencies in other countries can't even dream of.

In the post-bubble economy of the 1990s, in light of the sudden budget reductions that led to companies closing their in-house advertising departments, and the entrance of foreign companies during the 1980s that needed local advertising services, some agencies sought to change the industry structure. For example, Tugboat was established in 1999 by Oka Yasumichi together with the art director Kawaguchi Seijō, in an attempt to challenge Japan's advertising establishment. They had two goals: the first was to create a truly independent agency, and the second was to challenge the accepted rules of Japanese advertising by making creativity the focus of the agency. But several years later, Tugboat remained a small company, with a total of sixteen employees engaged in creative consulting.

Having agencies manage accounts of different customers within the same industry clearly affects the competitive environment. To achieve fairness, the

agencies guarantee their clients that competitive accounts will be managed by different teams. The size of the agencies enables this separation between teams working on competitive products.

In Tokyo alone, Dentsu has thirty-one budget departments and six creative departments housed in several buildings to ensure that competing budgets will be managed in a different building by teams not familiar with each other's activities. Moreover, some of the work is done outside Tokyo. Since the turn of the twenty-first century and the opening of the Dentsu Tower building in Tokyo's Shiodome neighborhood, most teams have begun working in the same company headquarters location. But the company assured its customers that each team sits on a separate floor, with compartmentalization of teams across competing budgets.

This working procedure has a direct effect on the style and the inherent communications within any advertisement. For example, since the same agency is charged with producing campaigns for competing products, it cannot base an ad on a direct product comparison or attack the other's weakness. Thus emerged a noncompetitive marketing communication style, in which differentiation between companies or products is built around imagery that links the products or companies to lifestyles, using aesthetics as information.[21] Western views of this form of advertising labeled it as "soft sell," which was conveniently attributed to an assumed nonaggressiveness inherent in Japanese culture. But this in fact is far from the truth. The differentiation-via-lifestyle motifs or aesthetics have been adopted extensively as a key marketing tool throughout the postindustrial world as well as in Japan, owing to the structure of the late consumer culture. However, it has double validity in Japan simply because of the unique advertising industry structure.

In addition to this "aesthetics-as-information" model, Japan's advertising structure is also influenced by the sheer numbers of active budgets. Japanese agencies typically manage hundreds of customer budgets, when an American agency of similar size would be managing only a dozen or two dozen active campaigns. As a result, employees of a Japanese agency cannot focus on one account or one field, instead moving from budget to budget regularly. Little effort is thus invested in understanding the nature of their customer for the purpose of effective corporate branding. Agency staff tend instead to focus primarily on practical tasks, leaving a gap for true creative work that must be filled elsewhere. Even the art directors and graphic designers working within agencies are more producers than creators.

Unlike American and European agencies that emphasize creativity (thus building a relative advantage over competitive agencies), Japanese agencies

emphasize their relationships with the media as their foundational value offering. As a result, important, unique, and large-budget activity is usually outsourced to private art directors such as Tokyo ADC members.[22] This spurred on the rise of creative, independent art directors.

In a self-propagating process, this type of account management further strengthens the industry interconnectivity. Agencies must be in constant touch with one another in order to see the full scope of a campaign. Each agency must also keep tabs on the media outlets themselves, in order to know the exact placement timing and strategy for parallel ads. This constant, direct contact helps forge new relationships and strengthen existing ones. Such intertwining relationships simply do not exist elsewhere.

This tight connectivity also fosters personal relationships, which can influence business just as much as purely professional relationships. Although there is no true strategic partnering between customer and agency, with each agency representing several competing customers simultaneously, a tradition and mentality of commitment and personal relationships, commonly built upon in the Japanese business environment, serves in the advertising industry to handle problematic issues.

Marketing Mix

The industrial structure, budget management, personal involvement, and relations among the agency, media, and clients come together to influence the structure of the campaign and media mix that builds marketing communications.

Marketing campaigns, by definition, are composed of some mix of print, radio, television, Internet, and viral advertising. Each portion of the campaign has a distinct role, and together they form the overall advertising message. This holds true in Japan as well, but in Japan we find a clear division between the marketing channels. With a market structure dominated by well-established and mature conglomerates, more importance is placed on the company name than on its products, with the name itself presumed to be indicative of product quality. These companies are highly attuned to managing their reputation, in part because as large public companies, a significant portion of their growth in value comes from their stock portfolio rather than direct product sales. The primary goal of advertising for these conglomerates is to reinforce their corporate name and its associated reputation, to remind viewers of the company's rich history and tradition, and only then to introduce the products, which change seasonally or yearly.

Advertising via signage and mass-market print (in train stations, street billboards, neon signs, on buses, or in daily newspapers) by definition has a wide, non-focused audience. For this reason, this first, or higher, level of advertising is used for presenting the corporate image, establishing the sign value, and filling only one portion of the overall marketing mix. Posters are not assigned the role of delivering true product information or tempting the consumer with product/feature benefits. Their role is simply to keep the company logo in the forefront of the consumer's thoughts.

A second level of advertising exists in more segmented outlets, most notably in the countless consumer magazines and websites available in Japan, with magazines dedicated to very specific realms of interest divided by products (e.g., cameras, fishing equipment, Nintendo games) or by a highly specified target audience (e.g., university freshmen, gothic Lolitas). Ads in these magazines and on websites show the products themselves, with product information and photos, detailed product specs, place of production, price, and where it can be purchased.

Each prong of the campaign delivers its portion of the story, together building the full narrative. In this method the consumer gets information about the company's image as well as its products.

Within this marketing mix, the art directors of Tokyo ADC are hired to fashion a company's identity, with the sole aim being to draw attention to the company sign value, with little regard to its specific products. Advertising campaigns of different product lines of a specific company are managed by different graphic designers or art directors, according to the product or the project and depending on the media used (print, web, television). Understanding this role within the entire mix sheds light on how Tokyo ADC posters differ from American posters that typically deliver much more product-specific information.

This element of the marketing mix that gives importance to the sign value is not unique to Japan and can be seen in many well-established companies in Europe and the United States like Nike or Coca-Cola, but it has a different significance in Japan because of the business market structure, in which each industry is dominated by large and mature conglomerates, and the economic bubble that created an extreme symbolic consumption. It should also be noted that such distribution of information did not originate in the late consumer culture economy but has roots in the Japanese advertising tradition since the earliest steps of consumer culture in the Edo period (1603–1867).

It was during this time that advertisements that lacked information first appeared, seducing the viewer while delivering only a general idea. The ukiyo-e

paintings of the era evolved in part as advertisements for Kabuki theater or for pleasure houses in the Yoshiwara district, showing Kabuki actors or celebrating the beauty of the geisha or the working girls (*bijinga*). These images were artistic and seductive, loaded with symbolic meaning, yet lacking explicit information.[23] In other cases, the famous Kabuki actors or beautiful girls served to promote cosmetics, food, stores, or other goods and services. This was quite similar to how celebrities and beautiful women are central to the advertising world today.[24]

Alongside these ads, more detailed popular books (*kusazoshi*) and illustrated guidebooks were published with deep levels of product information. One well-known guidebook with maps was a guide to the Pleasure District (Yoshiwara Saiken) of the city of Edo.[25] This guide presented maps showing the locations of teahouses, theaters, and brothels, and also contained descriptive information about the district. By the year 1700, there were already more than two hundred maps showing the way to each house of pleasure in Yoshiwara, including information about the status of each house, pictures of women working there, and prices.

In essence, the paintings and guidebooks formed a marketing mix much like those of today. The painting-advertisements had a strong artistic expression, with coded symbols meeting a clear yet subtle purpose, while the informative books contained detailed information about the service, fulfilling a second purpose. Together, they formed a clear advertising message for the teahouse, brothel, or theater in the eyes of a consumer seeking to enjoy himself in Edo. This duality in marketing strategy points to a shared genetic identity, both visually and strategically, between the Japanese consumer culture of the Edo period and late consumer culture.[26]

But despite this shared genetics, there are still clear differences between the marketing strategies of the Edo period and contemporary Japan. During the 1980s the speculative financial bubble expanded, leading the consumer culture to reach new heights. This period is known as an extreme time of accelerated symbolic consumerism. This is true also in relation to other postindustrial countries. During this period, Japan was saturated with brands and also saw an influx of products and values coming from all corners of the world. An interesting blend arose, with a cornucopia of products, well-established companies, and a market of symbolic consumption. This blend forced art directors to find new ways of advertising that would increase the importance of the sign value. In many cases, art directors turned to postmodern aesthetics to meet this goal.

The use of postmodern images provided companies with an air of sophisti-

cation, projecting an up-to-date and even upscale image onto their products. The structure, management, and business strategies of the commercial companies, which changed along with the social paradigm during this period, sought to establish a multidimensional image that would deliver a message on many levels, including association with social issues. Using images that bordered on art and presented multiple layers served the goals of these commercial companies, building their corporate image in the postmodern era. And indeed, these advertisements that bordered on art also found their ways into various graphic design galleries and museums in Japan (such as the Tokyo ADC's annual exhibition in ggg) and worldwide. The migration from ad to art is also an intentional part of the marketing concept for these commercial companies, who expected the art directors to deliver sophisticated and artistic posters.

In the late 1980s, Matsumoto Ruki, who owned one of the world's largest collections of vintage advertising posters, founded the Japanese apparel manufacturer Batsu. Based partly on his own passion, he wanted to create posters with an artistic expression for his new company. To this end, he hired Saitō Makoto as well as the German graphic designer Gunter Rambow, who designed a campaign that visually appeared to be more like a conceptual artwork than advertising posters.

Some companies even asked art directors to conduct campaigns as if they were an art exhibit. For example, a poster campaign designed by Saitō Makoto for Virgin in 1991 included only four posters. In the first week only sixty copies of two different versions of the poster were posted. Then 370 copies appeared for one month, and that was the end of the campaign. All the posters were shown in one neighborhood, where youth culture abounded. The scope and limited time of the campaign were ridiculously small in comparison to the huge campaigns and media planning of the time. But by conducting the campaign as if it were an exhibition in a gallery, it created a buzz and spurred people to seek out these posters, making a point especially to see them, as if going to see an exhibit.[27] This strategy was successfully used before in the United States by Apple's iconic commercial for their Macintosh computer launch directed by Ridley Scott. It was broadcast only once, during the opening of the 1984 Super Bowl, and thus raised high expectations. That ad positioned Apple as a truly one-of-a-kind player.

Toda Seijū, an art director of Tokyo ADC who uses design-art strategy, explains: "Since high school, I have been an artist. It is just by chance that graphic design became my business, but I still see myself as an artist. My office deals with art direction, but the works created are more artistic than

those of other offices. I find advertisements, particularly those in Japan, to be very interesting. They are artistic, and I think that is why I chose this field. I wish to distinguish myself from others via the art. I want to be different."[28]

Another element that creates this kind of marketing communications is the context in which the posters are presented. Unlike in modernist posters in which the product dictates the poster's character, the design of postmodern posters relies heavily on external sources, whether it be the physical context in which they appear or the context of parallel campaign activity across multiple media formats. As a result, information seems to be lacking when a poster appears in a design book, at an exhibition, or at another location outside the original context.

Throughout many interviews with Tokyo ADC art directors, the subject of placement and context came up regularly, leaving no doubt that the art directors strongly take context into account. Suzuki Hachirō explained that his "Exotic Japan" campaign for JR (Japan Railways) did not show the actual trains, instead focusing on destinations. Suzuki took into consideration that the posters would be displayed in railway stations, which allows for not presenting the train itself. Posters for Watanabe Yoshie's Wacool campaign were displayed within the actual shops, allowing her to focus solely on atmosphere (examples in Chapter 3).

On this subject, art director Nagai Kazufumi explains:

> It is said that Japan is a high-context society,[29] that is to say that we can understand each other without using words because of the fact that we have homogeneous culture that shares the same values. Outside of Japan, there is a widely held tenet that a message must be inherently clear. When working with foreign clients, Japanese designers will often utilize a more "wordy" look, to meet this expectation. But in Japan there is a strong dependency on emotion and atmosphere, which are sufficient to achieve clear understanding among the target audience, even without words to convey the message. The same applies for visual expression.[30]

Of course, the idea that context plays an important role is not exclusive to Japan, but a central element of postmodern culture. In Japan, however, context is used in advertising posters to deliver meaning and convey information while other key elements of the ad are missing.

To conclude, Tokyo ADC posters build new marketing communication patterns. We can explore the ways that these posters influence consumers when viewed through the prism of the system of values that emerged in the postmodern consumer culture and advertising industry structure in Japan.

It is evident that these are not "nonsense" ads, nor are they simply meant to transmit "atmosphere," as has been claimed by many researchers. The posters do not present explicit information, nor do they provide a "true" objective view of the products in question. But they do define sign value and mediate between product/company and consumer identity, which happens to be the key differentiator between companies and products.

As a result of the emerging postmodern visual culture, sign values received a visual expression that at first glance seems non-communicational and lacking a clear statement, but in fact embeds style and aesthetics that deliver vast information. It therefore seems that the logic of the new consumer culture, the new status of the visual image, and the rise of a new visual culture with different aesthetics and structures all join together to provide the space and context for new imagery to emerge within advertising posters. This imagery shifts attention away from the actual product, instead focusing on consumer social identity and values that create seductive visual rhetoric.

This visual rhetoric has strong relevance in Japan specifically because of the country's unique advertising industry structure, including the direct involvement of agencies in the media outlets and the work processes within each agency. Additional factors are the different structure and function of marketing channels and disconnection from the influence of American advertising style. The result was new marketing communication patterns and sign value that successfully tied together socially conscious contemporary Japan, economic considerations, and postmodern aesthetics.

4

The Social Forces

In 1992, a Benetton advertising campaign featured a photograph of an African guerrilla fighter carrying a Kalashnikov rifle and holding a human femur—the same kind of bone that appears in Saitō Makoto's advertisement for Hasegawa (figure 7.1).[1] In fact, there are numerous similarities to Saitō's poster. None of the objects are whole (neither the person nor the Kalashnikov), and the backgrounds—blurred in the Benetton ad, plain white in the Hasegawa ad—do not hint at the context. Both emphasize the bone as a central object. Moreover, similar to the Hasegawa ad, the Benetton ad also chooses not to show the actual product. In fact, the photograph seems to be completely unrelated to any Benetton product.

The photograph gives a mysterious glimpse of a soldier in a war or some unknown regional conflict, perhaps in Africa.[2] The supposed regional conflict or guerrilla war is presented abstractly, raising questions: "What kind of soldier is he? Which conflict is it? What is this bone he is holding?" The non-explicit image, specifically the bone, is a free-floating signifier, detached from the situation in which it is photographed.[3] Like Saitō's ad, it is open for interpretation and brings up many associations in the viewer's mind.

The Benetton poster is a quintessential representation of the postmodern advertising revolution built around an anti-ads strategy that seems to be similar to the postmodern strategy of the Tokyo ADC campaigns. Apparently, in both, the image creates links between the company and social values.[4] In both, this marketing strategy is a cultural phenomenon associated with the global late consumer culture. Brian Moeran claims that in the globalization era, consumerism in the United States or Japan leaves the category of culture irrelevant: "Thanks to global marketing practices and the workings of advertising and the media—all objects are potentially released into a floating world of signification and values from the cultural prisons in which they were formerly incarcerated."[5]

Indeed, any attempt to point out the uniqueness of Japanese advertising in the global, postmodern era is no easy task. With the advent of globalization, features similar to those in Japanese advertisements can be found worldwide.

FIGURE 7.1
*Civil War in
Liberia* © Patrick
Robert / Corbis /
Visualphotos.com

However, analyzing the Japanese advertisements, we can detect a local imprint (see Chapter 4).

In order to underscore the common elements shared by global and Japanese advertising campaigns, while identifying the distinct characteristics of local Japanese ads, the following section will be divided into two chapters: Chapter 7 analyzes the Benetton campaign as a case study representing global, postmodern advertising, and compares it to Japanese advertising campaigns during the 1980s. During this decade, which was characterized by the rise of the Japanese bubble economy and a thrust to become part of the global network, advertising in Japan underwent a significant process of change—adopting a new postmodern aesthetic and marketing strategies as well as new discursive themes influenced by global social issues.

Japanese advertising in the 1980s was influenced by parallel waves of internationalization and a nostalgic search for roots, which had erupted during the previous decade (see Chapter 1), and gave rise to a vibrant discourse covering global, local, and traditional subjects. Beginning in the 1980s, however, art directors not only borrowed international styles, but also reflected the changing cultural and economic values that penetrated Japan as a result of worldwide events and globalization processes. At the same time, the erosion of local culture by these same processes triggered opposition to the pene-

tration of foreign values and styles, resulting in a comeback of local values and aesthetic conventions. In this context, global issues and local/traditional themes were transformed into a "glocal" style, becoming the signature language of the Tokyo ADC art directors from the 1980s onward.

Chapter 8 focuses on the socioeconomic changes that took place in Japan during the 1990s following the collapse of the economic bubble, and the new values that emerged in Japanese society and consequently in Japanese advertising. Although it is difficult to draw a clear line between advertising practices in the 1980s and in the 1990s in terms of their style and communication strategy, they do differ in terms of the values and discursive themes they champion, which clearly feature commercial companies operating under different socioeconomic conditions.[6]

These two chapters present a unique characteristic of contemporary Japanese advertising, whose designers form an integral part of the global design world, while creating works that are rooted in their own contemporary urban culture and that target a local Japanese audience. Like many other mainstream campaigns of the postmodern period, such as the Absolut Vodka campaign, the Japanese ads introduce social issues as signifiers of the product/company (such as nature, luxury, etc.) rather than discussing the product itself. At the same time, the social values promoted in these ads are distinctly local. This dichotomy generates designs that are simultaneously local and global.

To investigate this duality of global and local characteristics, I start this chapter by revisiting Benetton's global campaign. As previously noted, this campaign incorporates noticeable postmodern social and political elements. Boundaries were blurred between news and entertainment, between high culture and mass culture, and between consumer culture and news. This blurring of boundaries is a byproduct of the postmodern era, in which images are taken out of context for alternative usage.

The Benetton campaign is similar to the Japanese ads produced by Tokyo ADC designers, in that both use postmodern strategies and styles. However, a thorough examination of the style used in Tokyo ADC advertisements (as seen in Chapter 4) shows that their postmodern styles attest to different characteristics. The analysis of this genre reveals that although it is rooted in local culture, it simply cannot be explained accurately from the archaic "orientalist" perspective. Moreover, global discourse themes and values attain a "glocal" treatment by Japanese art directors, so that the discourse is presented with a contemporary Japanese flair, bringing up the question: What is "Japanese" about these Japanese advertisements?

However, in pursuing a comparison between Tokyo ADC advertisements and global postmodern advertising such as the Benetton ad, we must beware of a global-local dichotomy that can easily take on the form of the orientalist Japanese-Western dichotomy. Such a debate distracts us from the main issues such as contemporary cultural values and discourse themes, and specifically how these values became new signifiers in advertising.

The Benetton Campaign

Benetton started out as a family business in Italy selling locally produced woolen sweaters. The company's fashion strategy focused on color. Sweaters were designed in classical patterns, but then offered in a wide variety of colors all year long rather than in accordance with seasons, as was previously customary.

Photographer Oliviero Toscani of the Eldorado ad agency began working with Benetton in 1982. In order to establish a distinct corporate image, he suggested using a full range of human skin colors as a communication strategy of "All the colors of the world" that later became the interracial slogan "United colors of Benetton." Eldorado's chairman Bruno Sutter explained: "There is no difference anymore between one fashion photograph and another. They all simply present a beautiful model, and therein ends the concept. In Benetton's advertising, we sought to emphasize the theme of colors. In order to say that 'Benetton means colors,' we presented interaction between people of different skin color, with the core idea being that fashion is like a second skin. It was fantastic, and so entertaining, to show the product/company in such a simple and novel way."[7]

The campaign, of course, turned out to be much more than just entertaining. Already in its first steps, it created provocation in South Africa, where only magazines read by blacks published the ads, while magazines with primarily white readership refused to run them. What started out as a purely semiotic game was received by the public as a political or social statement. Few remained indifferent to the campaign, with responses being strongly positive or negative, depending on the viewer's tenets.

At the end of the 1980s, the campaign raised its provocative bar a notch with one ad featuring a photograph of a black woman breastfeeding a white baby, and a second ad showing a black-clad priest kissing a white-clad nun. Responses were vocal and immediate. The poster of the black woman nursing caused the strongest reaction in the United States, specifically among the black community, many of whom felt it commemorated the days of slavery

and supported racism. The priest/nun poster garnered severe responses in the Catholic world. In France, citizen groups objected to the poster and filed a court complaint against Benetton, seeking removal of the posters.

From a marketing perspective, this was the exact response the campaign was aiming for: shock viewers, to get their attention using offensive imagery that supports the theme of colors via political and social debate.

Later, the Benetton campaign went on to present "reality advertising." Posters presented documentary-style photographs, showing images that supposedly come from regional conflicts of a political or religious nature or from incidents of social injustice. Ads became extremely candid, showing harsh images such as a man dying of AIDS with his family by his side, a ship packed with Albanian refugees, or Indians stranded in a flooded Calcutta. One poster that particularly struck a nerve showed a newborn baby, covered in blood and with umbilical cord still connected. This advertisement was banned even in the most liberal countries in Europe and by many magazines in the United States and Japan.

At a time when other fashion companies stuck with the pedestrian myth of perfect beauty, Benetton presented a supposed "photographic truth" reflecting a merciless, unjust world. The later ads used universal issues of social discourse that had absolutely no connection to the company or its products, not even via a vague reference to colors, as was seen in the earlier ads. The only reference to Benetton was the company logo.

From a marketing communications perspective, the campaign created provocation on two levels. The images themselves were clearly provocative, while an additional conspicuous dissonance between the photographic image and the company logo could not be ignored. By confronting viewers with harsh images of murder, AIDS, war, terrorism, violence, misery, and human suffering, the ads emphasized an implied commitment to social justice and world peace. Like-minded consumers could then identify with a company that stood by the weak. But in doing so, the ads also served the company's marketing objective, and the provocation proved itself as an excellent marketing strategy. The campaign led to arguments in the streets and the press about the purpose of advertising. Benetton was drawn into battles in countries that banned its ads and was forced to defend itself in numerous lawsuits.[8] The campaign aroused controversy largely because the context in which the issues were raised was an ad, as opposed to an article in the newspaper or on the television news. Blurring of boundaries between documentary photography and advertising photography broke the rules for classical marketing communications.[9] The cacophony of boycotts, bans, and heated public debate not

only did not harm Benetton, but served to promote it. As the controversy appeared in the news, it became a widely discussed subject, and many people were anxious to see the next image. It exposed more customers to the ads, engraving the company logo as a value mark in the viewer's memory.[10]

Tokyo ADC art directors also used postmodern aesthetics and social discourse issues as a marketing strategy. One can easily draw a line connecting Benetton's campaign back to Ishioka Eiko's use of 1970s feminist values in her Parco campaign. Both belong to an advertising genre that uses provocative social issues to brand commercial companies. Noguchi Isamu wrote about Ishioka's work: "Commercial work's purpose is to sell merchandise, but Eiko used it to fight a battle, to move a message into society—to subvert consumerism."[11] The same can be said about the Benetton campaign, which unites two different Japanese advertising strategies: Ishioka's marketing strategy, which presents social issues rather than a product/company, and Saitō Makoto's visual strategy, which reveals a gap between the visual image and the logo. This genre became feasible because the postmodern viewer, in Japan as well as throughout the industrialized world, is exposed to global issues, is familiar with images from a variety of fields, and is able to establish a connection between the image, the social and political narrative behind it, and the company logo.[12] Looking beyond Ishioka Eiko's Parco ads, we can find a great deal of advertising in Japan of the 1980s-1990s that refers to social issues and local values. This advertising genre is a kind of postmodern pastiche that creates a hybrid between the global and the local to form a new contemporary "Japaneseness." This is certainly seen in Saitō's ad for Hasegawa covered thoroughly in this book (figure 4.1).

Saitō's image presents a postmodern aesthetic derived from American pop art combined with imagery from Zen paintings. The poster reflects the encounter between traditional Japanese values and late consumer ideology, showing a new multicultural and glocal character of Japan in the 1980s that dynamically selects from and merges traditional, contemporary Japanese, and foreign elements, making them "Japanese." Strangely, both the Hasegawa and the Benetton campaigns present a "death style" rather than a "lifestyle" (figures 4.1 and 7.1). However, unlike the Benetton ad that shows a global discourse theme, Hasegawa's poster is locally oriented, focusing inward, with a traditional Japanese culture narrative (Buddhist cremation) combined with the topic of the aging population and death—an important social issue in contemporary Japan and one that will be covered later in this chapter.

While Japanese advertising of the 1980s was seen to express international

trends resulting from globalization as well as the internationalization of consumption, it is important to note, as Clammer points out, that Japanese consumer culture has several basic, foundational elements that are direct consequences of the Japanese way of life. These include the important role of women in consumer culture, and traditional cultural elements like their attitudes to the body and to hedonism, which differ greatly from such attitudes in Europe and the United States.[13] In this context, ads created by Japanese designers are different from the Benetton campaigns or other global campaigns. Japanese designers representing Japanese companies and targeting a Japanese audience most certainly offer a forum in which to express those foundational elements. Their style and their persuasive communications are forged from words, images, ideas, discussion topics, and values steeped in local cultural codes that affect visual expression.

The 1980s: The Economic Bubble Years

In the 1980s, along with a worldwide economic boom and a changing socioeconomic paradigm, Japanese local values also changed. During these years, Japan the industrial powerhouse also became a financial superpower, creating the world's most dynamic economy, with large trade surpluses and a strong currency. This new status further reinforced Japan's own pride, as well as its strength in the international arena. The development of the bubble economy increased the power of popular cultural institutes and products and altered Japan's leisure culture practices. These were the basis for the growth of late consumer culture, with its new values that promoted an alternative worldview and contributed to the increasing importance of leisure culture, consumption of brands, and convenience products and services.[14] During the 1980s, consumers began to devote themselves to the pleasures of consumption and the pursuit of "the good life." Using brands in order to build lifestyle and emphasize individualism became not just a legitimate, but also an important social activity. For this reason, companies positioned their products as powerful, sexy, and luxurious, targeting the individual leisure-time focus. The late consumer culture, which blurred the distinction between the identity of brands and consumer's identity, challenged existing cultural values by giving consumers new labels that defined identity, status, and social association. This new economic disposition formed a middle class that became 90 percent of the population, thus erasing the strict distinction between classical social hierarchies.

The growth of commercial companies led to an associated increase in

advertising spending. This period in Japan was labeled "the Advertising Age" and is sometimes referred to as "Advertised Society" because of the major influence of advertising on popular culture and society, and vice versa.[15] The rising use of advertising within the business world and its status in popular culture in the 1980s not only reflected values of the period, but also created new signifiers and new values via the sharpening of discourse and myth-building for consumer appropriation. Marshall McLuhan argued that since advertising budgets in industrialized countries typically are larger than education budgets, advertising is a larger educational institution than government-sponsored school systems.[16] In this mind-set, the visual expression of 1980s posters not only represented the themes of social discourse, but also created and stimulated social, economic, and aesthetic forces that constructed new myths that in turn influenced the values of a renewing Japanese society. For example, a television ad campaign titled "Name Series," starring Kiki Kirin and Kayoko Kishimoto for Fuji Photo Films, launched in March 1980, shows the influence of advertising on popular culture and street language.[17] The slogan stated "Pretty girls come out more beautiful, and even if you are not so . . . the photograph will be developed in its own way." Responses to this series of ads, which touched on the issue of "photographic truth," were stormy. The term *sorenarini* ("in its own way") became a trendy slang at the time.

The art directors also enjoyed the new economic affluence, the internationalization (*kokusaika*), and the new technologies that collectively instilled a sense of vitality in Japanese society and stimulated their desire to take a larger role in global activities. The economic growth generated much work for the art directors, which in turn increased their status. They adopted an urban lifestyle and popular culture befitting many large cities around the world. They were well versed in the global culture and desired to be an integral part of it rather than remain in an exotic bubble. Nevertheless, they felt uncomfortable with, and objected to, the powerful effect of American "cultural colonialism," described by Joseph Nye as "soft power." This soft power is usually associated with the penetration of software, the Internet, popular culture, and mass media, which are easily absorbed and highly influential. The art directors explored new directions in advertising mainly via trial and error, taking advantage of the artistic freedom granted them by the large companies that sought new marketing directions in order to build up an original identity and brand.[18]

A new generation of designers created a unique visual language that abandoned the 1950s international style, the 1960s pop style, and the 1970s nostal-

gic style all at once. Instead the designers promoted personal visual language and creative solutions in both visual imagery and textual slogan.[19] Thus even though Tokyo ADC advertisements suggest an adoption of global postmodern concepts, we can still see in them a Japanese uniqueness and a local touch. These local aspects arise also in the creative style and local discourse issues raised during this period.

The seductive forces of globalization had an erosive effect on local culture, triggering contrary forces of longing to return to roots and preserve local traditions. Consequently, Japanese-Western differentiations were highlighted as signifiers in advertisements that positioned companies and products as either Japanese or international, alongside other signifiers (such as luxury, nature, or sex) more commonly used in advertising. This positioning created a "Japanese," as opposed to an international, value.

Distinction between Western and Japanese is conspicuous in postwar Japanese language, which developed different streams in order to explicitly differentiate between Western style and Japanese style. For example, a Japanese-style hotel is a *ryokan*, while a Western-style hotel is a *hoteru*. A Western dance, *dansu*, differs from its Japanese counterpart, the *nihon buyo*. Western clothes, *yofuku*, differ from the Japanese *wafuku*. *Raisu* refers to rice that is served on a Western plate, while the exact same rice served in a Japanese bowl is *gohan*. This distinction between coexisting styles is important to the Japanese, helping to nurture Japan's unique ability of transculturation: to absorb and assimilate foreign influences while still retaining its own natal traditions.

An extreme example of such product positioning can be found already in the 1970s in a radical campaign that altered the image of Japanese whiskey. At a time when whiskey production in Japan was celebrating its hundredth anniversary, whiskey producer Suntory wanted to shift Japan's opinion of whiskey from that of a European drink into one that is inherently Japanese. The successful rebranding gave whiskey a local pride and led to increased popularity of whiskey and a parallel drop in sales for sake (*nihonshu*). Sake manufacturers countered by rebranding sake as well, transforming the original traditional Japanese drink into a contemporary international beverage served over ice (just like whiskey) and not hot as was customary, in clear crystal glasses rather than traditional clay cups (*tokuri*), or as a cocktail named "samurai on the rocks."[20] The new image appeared in ads that showed young people drinking sake from glasses, wearing Western clothes, and playing rock music. Japanese youth that pursued an international, modern identity fell for sake's new image and began to relate to it as a modern drink. During

this period of internationalization in which modernization was associated with the West, the new image was well received, enabling sake to successfully compete with whiskey. The positioning of whiskey as traditionally Japanese, and sake—which was considered one of Japan's original national symbols, on a par with the kimono, sushi, and Mount Fuji—as modern and Western demonstrates the importance that Japanese endow to the Japanese-Western distinction in the social discourse.

Another example to express "Japaneseness" is the use of the seasons, which was always a favorite topic for Japanese consumers. Moeran claims that the importance of seasonality in Japan finds direct representation via the concept of color change from spring to summer to fall to winter, as seen in advertising, in product packaging, or in storefront windows. Springtime, for example, is customarily accompanied by a plethora of cherry blossoms appearing in ads and packaging. This then gives way to a wave of green bamboo in the summer. References to the seasons are also found in product slogans, as well as in the products themselves. This is also tied to production and consumption cyclicality and product seasonality, with cold beer in the hot summer being replaced by hot sake in the cold winter, for example.

Holidays also play a role, but the concept of holiday advertising has a strong glocal twist owing to Japan's adoption of foreign holidays. The Japanese new year—*oshogatsu*—sees wide usage of national symbols such as Mount Fuji and traditional symbols from the natural world, but it is celebrated alongside Valentine's Day, which was naturalized in Japan as White Day during the 1950s–1960s.[21] Christmas is another holiday successfully adopted by the Japanese, joining national holidays such as *Ochugeno* (Gift Day, a midsummer gift-giving holiday) and *Oseibo* (year-end gift-giving when employees typically receive annual bonuses).[22] The national/seasonal symbols carry deep meaning for Japanese consumers still today, and they continue to evoke patriotic feelings that seduce the consumer into purchasing products.

The attitude toward Japanese-Western differentiation is also noticeable in company and product naming. Until the 1970s, most companies chose Western names in order to avoid an association with "provincial" Japan. Names like Olympus, Minolta, Sharp, and Sony stood out, while successful names with Japanese roots, such as Canon, enjoyed a clear and non-coincidental Western significance as well.[23] In 1971, amid the wave of nostalgia and renewed interest in tradition, the (aptly named) National Corporation introduced a vacuum cleaner with a product name *hayabusa* (falcon) that surprised many Japanese.

In the 1980s, as Japanese consumers recognized and warmly accepted the

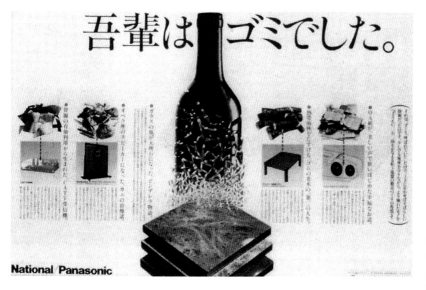

吾輩は ゴミでした。

National Panasonic

FIGURE 7.2
"I am garbage,"
advertisment
by National
Panasonic,
Matsushita, 1994

high quality of local products, more Japanese names emerged, such as the Shizuka Gozen washing machine manufactured by Hitachi.

The name chosen for this washing machine refers to a famous mythological story dating back to the twelfth century about a *shirabyoshi* dancer named Shizuka Gozen who sacrificed herself and her unborn child for her lover, the military leader Minamoto Yoshitsune. The name also serves as a play on the Japanese word *shizuka* (quiet), implying that the washing machine operates quietly.

Slogans also changed during these years, with an increased use of subtle implications, idioms, onomatopoeia, play on classical proverbs, and double-coded Japanese puns, as was customary in the postmodern era.[24] For example, a slogan in a National Panasonic ad stating "I was rubbish" (*Wagahai wa gomi deshita*) plays on the title of Natsume Sōseki's famous novel *I am a Cat* (*Wagahai wa neko de aru*) and thus makes the slogan catchy while suggesting that the company is concerned about the environment and is proactive in recycling (figure 7.2).

Such slogans are idiomatic in nature and cannot be translated into other languages, thus making the ads local and charging the company with a Japanese imprint.

Japanese-Western differentiation in Japanese advertising carries over into the selection of human models who are photographed in commercials, with the use of Western models vs. Japanese models serving as a clear proxy for occidental vs. oriental branding. Many researchers have covered this usage of models.[25] William O'Barr, for example, believed that advertisers use Western

Woody Allen

千年も万年も。

おいしい生活

長いようで短かい一年ではありましたおいしい生活」の年1982年も、終幕が近づいてまいりました。いよいよ人類は、いまだかつて経験したことのない1983年を迎えようとしております。こんな調子で生きていると、遠い先のように考えていた21世紀に、すぐ追いついてしまいそうです。その時がきても、「おいしい生活」。今日も明日もだけでなく、千年も万年も、幾億年も、ひとりひとりの「おいしい生活」が続きますように。西武は、今日も、ずうううっと先も、お手伝いする所存です。

SEIBU
西武

models because they suggest freedom of movement and flexibility of thought, and thus represent an alternative to what is expected of women in Japanese society.[26]

With this said, it is essential to take into account economic and fashion issues as well. The use of presenters, mainly Hollywood actors or celebrities, was commonplace during the bubble era, fueled by vast monetary resources and rampant internationalization that made the foreign look fashionable. Stars such as Jodie Foster, Farrah Fawcett, Harrison Ford, Madonna, and Arnold Schwarzenegger all became presenters in Japan.[27] But among this genre, one particular ad stood out and became a symbol of the era. In an ad for Seibu department store, Woody Allen appeared surrounded with traditional Japanese products. He is dressed in a kimono, sitting on a *zabuton* (traditional cushion) in a *tatami* (traditional flooring) room with a *tansu* (traditional cupboard) and *hibachi* (traditional heating device). He holds a *kakejiku* (scroll) in his hands, with a slogan saying "delicious life" (*oishi seikatsu*) (figure 7.3).[28]

This advertisement combines traditional signs with a clearly American movie star. The slogan symbolized the new consumer psychology of the 1980s integrating the new hedonistic lifestyle, within a traditional Japanese context. It also emphasized the glocal aspect of Japanese advertising. However, along with declining ad expenditures and eroding enthusiasm for anything foreign in the 1990s, the use of Western models dropped drastically. By the mid 1990s, local stars were used almost exclusively.

Western cultures were not the only ones to be differentiated from Japanese culture. Other Asian nations also were presented via differentiation, yet typically in a more subtle manner. Numerous large-scale ad campaigns in the 1980s were photographed in China and Southeast Asia. This was not at all for the purpose of cost savings. The intention was again to introduce the Japanese models and products in a foreign, Asian context. This brought a refreshing, exotic feel, while indirectly introducing Japan's new power in an Asian context and thus highlighting cultural differences between Japan and these countries.

In conclusion, the 1980s saw the advent of a new style in advertising design, which was related to the emergence of new marketing practices and techniques. This style reflected the rise of values associated with late consumer culture, global advertising trends, postmodern aesthetics, and new discursive themes such as global social issues. During the 1980s we can also observe the hierarchical positioning of products in relation to competing products, which was propagated by commercial companies and advertising

during the bubble era. These product hierarchies put an emphasis on local values and Japaneseness as opposed to foreign influences, as well as on other values such as luxury, as opposed to inexpensive commodities. The next chapter centers on the period following the collapse of the economic bubble, and draws attention to the fall of product hierarchies and to the process of merging global and local values and styles into a "glocal" style.

8

In 1993, following a stock market crash, declining real estate, and a drop in
GDP, the bubble period in Japan came to an end. The economic crisis hit
most industries, including construction, automotive, and the information
industry, as well as advertising. Large businesses carried severe debts. Real
estate prices in major cities dropped 40 percent from their 1989 highs, and
periphery real estate lost even more value, reaching 50 percent drops. Some
sectors, such as discount clothing for men, video games, and affordable
restaurants, remained profitable and stable.[1] Consumers began to value their
money, and according to a survey conducted by Akabane Makoto and Saitō
Maki, impulse purchases decreased from 36 percent in 1990 to 27 percent in
1994. Consumers realized that expensive does not necessarily equate with
quality, triggering changes in the business sector. Supermarkets and discount
stores such as DaiEi opened all over Japan, selling at prices up to 50 percent
cheaper than in the smaller private stores.[2] Price drops in the 1990s changed
the face of consumer culture and negated many symbolic product hierarchies
of high and low, as propagated by commercial companies during the bubble
era. As a result, advertising expenses went down as well during this period.

Commercial companies offered early retirement for older employees and
laid off many others, leading to a spike in unemployment and a new mobility
between jobs.[3] These changes were partially a result of the economic crisis
and partially a new management concept inspired by the foreign (mainly
American) companies that came to Japan in the 1980s.[4] Internationalization
and the information revolution in the 1980s clarified to Japanese employees
that they were working exceptionally hard. They were working on average
more than any other workers in the world, and even foreigners became fa-
miliar with the term *karoshi* (death by overwork) relating to work in Japan.
Workers realized that during the previous period of economic growth, the
GNP went up and banks got richer, but the individual standard of living did
not go up in stride. Long commutes in crowded trains, and small and crowded
houses in the suburbs known as "rabbit cages" (*usagi-koya*), pointed to a low
standard of living in comparison to that of other industrialized countries, a

fact that seemed incompatible with the effort and time workers invested in their jobs. This led the new middle class to question the working style and to criticize corporate and economic oversight during the bubble period.

On the heels of this disillusionment, the younger generation found it difficult to trust financial establishments or large companies. The middle class of the mythological employee role model (*sarariman*) was undermined. Recession and economic upheaval also led to political instability. The Liberal Democratic Party (LDP) saw an end of its long-running rule, which had continued since the end of World War II, sending a clear message that the socioeconomic system of the 1980s was not as shiny as it first appeared. Anything related to the capitalist system earned a negative connotation by association, while the new economic principles so highly esteemed during

the bubble—the new markets, unlimited growth, a speculative stock market and real estate investments—all proved unsubstantial.

The upheaval was not limited to political-economic values. As the recession revealed that the economy was indeed a bubble that had burst, social problems were also exposed, including public-sector corruption, increased suicide rates, and the environmental-ecological problems resulting from rapid development. The Japanese began to understand that the excessive consumption in many ways was making up for a void in values that was created when foreign norms and ethics, especially American, replaced traditional values. The Japanese began to wonder how their hostility and vitriol toward the United States (a war enemy that dropped atomic bombs on Japan in order to achieve full conquest!) had suddenly transformed into blind admiration. The supposed error of their judgment and contradictions in their internal ideology suddenly became visible, causing a reconsideration of lifestyle. This raised questions such as "What is Japanese lifestyle?" and "How should our culture be shaped in the future?"

Advertisements of the 1990s showed an alternative to the 1980s way of life and built a model for a new lifestyle. Ads dealing with the Americanization of Japanese society began to sprout up as part of the resistance to American influence. This opposition to Americanization is a global subject, but when it concerns Japan it receives a special character because of the history of the American occupation and the postwar American-Japanese love-hate relationship. For example, consider art director Okumura Yukimasa's ad for Nice & Safe condoms in 1993 (figure 8.1).

The ad tells the well-known story of the devastating American bombing of Japan during World War II, prior to the atomic bombs on Hiroshima and Nagasaki. The poster shows a bombardment by aircraft that bring to mind the American B-29 bombers, dropping thousands of condoms whose visual appearance clearly implies bombs. In the background, Okumura shows the eruption of Mount Fuji, while the central focus of the ad frames an *oiran*—a Japanese prostitute in traditional hairdo—naked with legs spread, smiling and holding a puppy in the shape of a condom, while a globe hits her belly. The condom stands between the sex-offering woman and the clearly phallic symbol of the mountain. Between her spread legs, an American-style cartoon character similar to Mickey Mouse stands beside a Japanese-style computer game character similar to Mario, and a military marching stick lies beneath the prostitute. The globe seems to allude to the effects of globalization. In the lower part of the poster, a pile of condoms in the shape of a garbage pile insinuates the ecological impact of overconsumption.

This ad is a metaphor for Japanese-U.S. relations as male-female inter-course in which the United States (an invasive culture conqueror) is the penetrator and Japan is being penetrated. The World War II bombing narrative is well-known to all Japanese viewers, and serves to describe the American invasion as a reference to the new invasion of popular American culture. But the ad suggests that this time it is a soft-power occupation, led by the American entertainment industry and executed with the consent and even encouragement of the conquered. Yet it is still dangerous and has a destructive effect. The ad suggests that although condoms do not prevent the American and global penetration, they will prevent the resulting negative impact of such penetration.

An alternative to the 1980s way of life is also seen in the visual language of the art directors. When interviewed in 2005, most Tokyo ADC designers emphasized that while during the bubble economy it was trendy to position products as "Japanese" or "foreign," later on they developed their own individual languages that differed from studio to studio and were not considered by them as local Japanese visual languages. They explained that they had no intention to base their work on traditional aesthetics or topics, and described their work as speaking a personal language or corresponding with international design trends. Nevertheless, they pointed to elements within the work process that they considered Japanese, including the use of hand-icraft methodologies that are in contrast with the almost exclusive domain of graphical software in the ad design process. They spoke of creativity and personal touch in each visual image, in more than just the processing and directing of the overall image. The art director Hattori Kazunari, for example, said that he personally takes most of the pictures for his ads, abstaining from using a professional photographer. All photos are taken in nature and not in a studio, to take advantage of natural light to add a nature-photography feel. In a poster for JR Higashi Nihon (Eastern Japan Railways), a single bee is photographed above a train (figure 8.2).

Despite the fact that commonly accepted practice and efficiency considerations would point to using Photoshop to simply add the bee, the picture was taken naturally. Hattori explains: "We collected many bees in a bottle and released them. This time I used some photographers waiting with their cameras. And it just so happened that one shot was enough." The importance he placed on showing a rare moment was typical for the nature photography genre. Each photograph was still processed with Photoshop, but it seems that the artist's touch and the motif of randomness (the bee's position) are central for the work in order to create a sense of a documentary image, effectively saying to the viewer "Please note that this is real" and restoring the

FIGURE 8.2
Hattori Kazunari,
"Traing," 1999
© Hattori Kazunari

authenticity of "photographic truth" that was lost with the introduction of graphics software.

Another ad that exemplifies the sense of primordiality is Nagai Kazufumi's work for a mutual event of Toshima-en and the Sega Corporation (figure 4.20). Nagai explains that when he photographed the duck that appeared in the ad, he wanted to bestow a special atmosphere, "since it is just a photo of the sky, and perhaps it did not matter where we would photograph it. We could have shot it on the roof of any building. Yet in order to give depth and thickness to the air in the sky, we preferred a clean and clear sky over polluted sky. So we climbed high up Mount Fuji and hung the stuffed animal on a string. We wanted to give a sense and an atmosphere of the world, and to express the unique atmosphere, we photographed the sky above Mount Fuji."[5] Although Mount Fuji is not visible in the photograph, and despite the fact that nobody can notice the difference in the background, Nagai felt that the photograph of the fresh Fuji air would create a unique atmosphere. This perhaps is another clear example of how "photographic truth" imparted a Japanese sense for these artists.

In an interview with *Themes* magazine, Hara Kenya remarks about another expression of Japaneseness. He explains that he designs without thinking of shape, since Japanese design deals more with feeling of the product. He notes what anthropologist Nakazawa Shinichi said of his works: that they do not use traditional icons to express Japaneseness, but they do express what was known in medieval Japan as *kizen*, meaning "before becoming explicit in the real world" or "latent possibilities that exist prior to an event taking place."[6] Hara points out that he did not know this Japanese term, but when

he heard Nakazawa's description, he felt it was quite relevant to his work (figures 4.38 and 4.40).

Alongside the creation of local Japanese visual language, the dominant values of post-bubble Japan changed as well. Unlike the individual, materialistic leisure culture of the 1980s that served as an accelerator for the new economic growth, the post-bubble 1990s saw a significant change in which consumers wished to satisfy spiritual and emotional needs more than material ones. In the 1990s, leisure culture as well received a new face accompanying a new discourse. For example, instead of focusing on entertainment and new-product consumption as in the 1980s, Japanese employees adopted more convenient working hours, which led to more free time. The constant purchase of brand-name products and electronic devices was replaced by devoting time to personal essentials.[7] This came at a time of the end to total and absolute dedication toward employers, who had proven to be not entirely stable, as had previously been believed. Consequently, the institute of the family, which had been neglected in the 1980s under the burden of work, returned to its central position. Home management, family time, and a return to basic values of personal happiness, freedom, and health all reemerged. Travel abroad also became part of the new family leisure life.[8] Urban cultural centers offered courses in foreign languages, art, history, cooking, painting, modern dance, and yoga. A renewed interest in aesthetics and traditional Japanese beauty rituals like the tea ritual, floral arrangements, and ceramics also saw a new resurgence.

The new yearning to satisfy emotional and spiritual needs rather than material ones was also reflected in the changed approach to fashion, which had become a new religion in Japan during the bubble period.[9] Influential graphic designer Yokoo Tadanori argued that in the 1980s, in a crowded, homogeneous society, people sought to express their personality and social status by using fashion brands and labels. Fashion and brand names became the most relied-upon signifier for consumers to build their social and personal identity.[10] During the late 1980s and early 1990s, body awareness as understood throughout the world also arrived in Japan. Urban youth not only dressed in colorful and eclectic styles, but also developed body attitudes similar to those found abroad. Body and skin were no longer simply wrapped in fashion. Instead, they themselves actually changed in accordance with fashion, which expanded its boundaries to include muscle-building in the gym or by taking steroids; tanning machines; the dyeing or bleaching of hair; tattoos; body piercing; and breast implants and other plastic surgery (mainly to increase the size of the nose, or eyelid surgery).

FIGURE 8.3
Hoshiba
Kunikazu, "Le
Ciel Bleu," poster,
1999 © Cour-
tesy of Hoshiba
Kunikazu / Kata-
chi Co. Ltd.

However, in the mid 1990s a new discourse developed that negated the pursuit of fashion brands. An ad for the fashion company Le Ciel Bleu designed by Studio Katachi shows a tattooed hand dangling loosely (figure 8.3). This image challenges common fashion photography, in Japan or elsewhere.[11] The hand in this ad, without any accessory, establishes a certain association with death via its loosely hanging position and dim lighting, linking death to fashion in an intricate dialogue.

With no signs of life, the arm seems as if it were chopped off or hanging from a corpse, an association further strengthened by a posture that hints at numerous death scenes in artworks.[12] The victimized dead body communicates with the fashion world via the concept of "fashion victim," a term strongly tied to the Japanese society of the bubble period.[13]

A tattoo on the hand visually imitates a care instruction label for clothes (ironing, washing temperature, etc.), but it actually gives care instructions for a human body or skin. Rather than appearing on a separate cloth label, it is instead stamped directly on the arm, describing a consumer composed not of cotton, linen, or polyester, but of pure, spiritual elements: 45% willpower, 30% pride, and 25% passion. The poster for Le Ciel Bleu speaks out against the creation of identity via brands and against the victimized souls of the 1980s, suggesting instead a new spiritual identity for the consumer. The tattoo shows the impact of street culture and contemporary discourse on visual expression by referencing the concept of skin and body changing with fashion trends, reflecting the concept of a "second skin."[14]

Advertising of the 1990s seemed to turn its back on that of the 1980s. From the years of waste and extravagance in which people created identity out of material products, the focus shifted toward social issues, spiritual activity, and taking interest in others while emphasizing individual identity. This identity differs from the individual sacrifice of the 1960s–1970s or the brand-identity individualism of the 1980s. In the definition of 1990s individualism, each person gives proper consideration to the encompassing society, an approach that is reflected in one of the most important themes of the 1990s, ecology and recycling, which contrasts with the previous decade's tendency of continuously throwing out products just to replace them with new ones. This trend was framed perfectly in Toyota's 1997 electric-car ad, designed by Sasaki Hiroshi of Tokyo ADC (figure 8.4).

The "Ego to Eco" campaign demonstrated the transition from egoism to ecology, a clear message on the surface that also runs deep by tying in the Buddhist concept of "erasing the ego." In the ad, the car, a symbol of the material status and masculine consumerism of the 1980s, now represented the new individual concerned about a clean environment, emphasizing the preference of society's interest over personal material needs.[15]

Commercial companies suddenly looked to craft new corporate identities by creating an air of a moral social agenda that reflects contribution to society, community, and ecology. This was in contrast with product or corporate differentiation via establishment as status symbol, traditional symbol, or by international appeal, as was de rigueur in the 1980s. An ad for Hitachi at-

tempts to show that although the company produces many products (which then become trash) and technologies (which advance destruction of the environment), Hitachi encourages the public to recycle with the slogan "The earth is turning sour."

The new economic discourse of Japanese industry in the 1990s called for a green economy and an economy that is concerned with the emotional needs of its citizens. This became an attractive sign in the consumer's eye, reflecting the new values found in a discourse that was not exclusive to Japan. But despite ecology and recycling being a global trend (which actually concerns the globe!), in Japan it maintained a local aspect and was rarely presented as an international issue. The local hue of earth awareness got even stronger following the 1995 Kobe earthquake, whose destructive forces also triggered a social earthquake. Many commercial companies stepped up to assist the homeless and later made their assistance known to the community.

Advertisements focused on humane messages and constructed an image that met the new expectations of consumers who wanted to know a company's values and how they contributed to the well-being of society.[16] This new image contrasted with the focus on materialistic prestige of the bubble years.

An ad for Matsushita that appeared shortly after the Kobe earthquake showed the company's headquarters and the English word "fight" transliterated into Japanese, written in the office lights of the building (figure 8.5).

The ad references the darkness in which the disaster victims lived and tries to offer them a glimpse of hope and support. The ad is meant to in-

夜まはええんです。
暗うなったら不安で不安で
そやからデンキついた時は
うれしかったです。

FIGURE 8.5
"Fight,"
advertisment
by Matsushita
Corporation,
1995

form consumers about the contribution and assistance given to the victims by Matsushita, thus bestowing on the company an image of supporter and contributor to society.

Another important discourse topic of the period was the aging population. In the 1990s, life expectancy in Japan was the highest in the world (seventy-six years for men and eighty-two for women), while the birthrate during the 1980s had dropped from 2.1 to 1.57. As a result of these factors, 1995 saw the number of citizens between the ages of fifteen and sixty-four reach its maximum level and then begin to decline, while the overall population aged rapidly. In 2010, the number of citizens under fifteen reached 16.9 million, or less than 13.3 percent of the population, while adults ages sixty-five and over comprised 23 percent of the population. Projections for 2020 expect that this sixty-five-and-over demographic will reach 25 percent of the population, with half among those over seventy-five.[17] This would make Japan a society older than any other in the history of the world.

These forecasts that came out in the 1990s forced a rethinking of economic and political plans that were put in place in the 1980s based on previous projections. Government policy began to take into account the decline in birthrate in preparation for an elderly population.[18] This social phenomenon created a new elderly market segment that had plenty of money as well as time. It wasn't long until new products for the elderly emerged, including cultural centers and social activities for retired adults. And, of course, advertisements soon followed, such as television commercials for various health-care products targeting this segment. As this advertising genre became popular and awareness of the aging population grew, death issues became more

prominent in the collective consciousness. Many chose to prepare for what is called *daiojo*, or a "peaceful death."[19] Wills, funerals, and death-related products became important to such an extent that Hasegawa opened a branch in the young and trendy Shibuya neighborhood.[20] In turning to this younger audience that looked upon death-related products as consumer products in every respect, the company seemed to announce: "We want to present a style of healing for a wide spectrum of customers, from the elderly to the young."

In 1994, Hasegawa came back to Saitō Makoto, asking him again to design ads for the company (figures 8.6 and 8.7).

The new ads showed a skull and a spine with moss growing on them, peeping out from wooden boxes. Saitō Makoto explains: "On these bones—death grows moss (*koke*), a symbol of life. Moss grows in cemeteries, meaning that life emerges from death. This is something cool that people typically do not understand. This [ad] is my expression of the fact that on death, life grows. This is the immense power of the natural world." Once again, and in another form, Saitō returned to the notion that death and life dwell side by side. It also refers to figure 4.4 both visually (the position of the skull in figure 8.6), and in the notion that Warhol's skull projects a shadow of a baby referring to the beginning of life.

Decentralization was an additional factor that played an important role in the social transformation influencing advertising in the 1990s. Along with the social problems related to the collapse of the bubble, Japanese society also became acutely aware of the inefficiency and waste inherent in its centralized administration and bureaucracy. It wasn't always like this. From the twelfth century through the nineteenth century, Japan was divided into areas of control. But during the Meiji era, Japan centralized all its administrative and economic power in Tokyo, as was common in modern states at the time. In 1973, as part of the new national reforms following the oil crisis, Prime Minister Tanaka Kakuei embarked on a reorganization to develop infrastructure that linked all major cities to Tokyo, with the aim of encouraging development and industrialization of rural areas. But this also caused Tokyo itself to grow. By the 1990s it had become a true mega-metropolis.[21] This centralization of power and hierarchical structure did not seem to match the air of the postmodern era that changed society's paradigm into a horizontal network structure that reflected or resulted from an increasing population, new technology, and a more complex economy. In the 1990s, transportation, technology, and communication also developed and enabled distribution of power. Thus began the decentralization process, with a new division of administrative power among the major cities, prefectures, and villages further

FIGURE 8.6, 8.7
Saitō Makoto,
advertisement
for Hasegawa
Corporation,
1994 © Saitō
Makoto

spurred on by a national government that encouraged the development of local administration.

The distribution of administrative power created sharper differentiation between regions and aroused local pride, creating a direct parallel to Japan's shaking off of Western political, economic, and cultural influence. Similar to other postindustrial countries, Japan began to build a local identity by appropriating premodern images and elements such as folklore, tradition, and local history. Many regions built a regional narrative through advertising, emphasizing the region's local character. Regional tourism, traditional knowledge, and local art, heroes, stories, products, and food all shored up this type of advertising.[22]

Consider a 1996 advertisement for Mie Prefecture that announced a haiku-writing contest (figure 8.8).

The ad leaves significant empty space, and the slogan states "One haiku poem, please" on the background of an image of famous haiku poet Bashō from the seventeenth century. This serves to remind the Japanese audience that the Mie region is Bashō's birthplace, branding the region as a haiku homeland. Over 137,000 haiku poems were sent in from all over Japan, attesting to a renewed interest in the region and traditional values.

FIGURE 8.8 "One haiku poem, please." Advertising for Mie Prefecture, 1995.

Whereas the pursuit of the exotic in the 1980s sent ad agencies and art directors to China and Southeast Asia for photo shoots, in the 1990s the exotic scent shifted to the local regions of Japan.[23] In this new advertising trend, products were presented according to the region they came from, as regional identity became a key advertising characteristic of the period.[24] Not only rural regions were creating their local identity, but also major cities that previously were considered representatives of Japanese national identity. An interesting example is seen in a campaign that constructed a new identity for Tokyo. Prior to this, Tokyo was an international city and a global financial center. But now, city managers sought to make it a local cultural center in a global context. This 1990s positioning of cultural and ideological identity was formulated by

the Tokyo metropolitan government and was called the Tokyo Renaissance Campaign, which began in 1989 and continued throughout the 1990s. To realize this goal, Tokyo's municipality held events, published articles, and reconstructed symbolic sites.[25] The campaign, which was intended to build a cultural identity, emphasized a clear glocal message. On one hand, it pointed out Tokyo as a city built on the tradition and heritage of the city of Edo (Tokyo's name prior to the Meiji Restoration), and on the other hand, it held up the city's cosmopolitanism in direct comparison to New York, Paris, and London.[26]

Digital and virtual technology also had a hand in changing the face of society, in a process that started in the 1980s and reached full maturation in the 1990s. The impact of PCs, digital information, and virtual communities was similar in Japan to its impact throughout the world. Satellite and cable television and the Internet provided seemingly unlimited amounts of information and virtual purchasing options. The new technology excited consumers, and despite the collapse of the bubble, development of the information industry and cellular communications was not affected by the recession.[27] Cell phone adoption grew through the 1990s, and 1999 saw the launch of cellular Internet, which increased the use of phones for shopping and for delivering advertising.[28] In 2005, "blog" (burogu) was chosen as word of the year in Japan.[29] Many social networks were launched, including MIXI, Gree, and Mobage-town. These networks offered anonymity for users, a fact that led to much success in comparison to Facebook, which had only two million users, or 2 percent of Japanese Internet users, in 2011.[30]

These new media channels were powerful agents in forming new interpersonal communications and establishing virtual communities around areas of interest. While this is clearly global in nature, it went to an extreme in Japan with the *hikikomori* phenomenon, in which users locked themselves in their own rooms and avoided any social activity other than online socializing. These online communities seemed to replace the "tribes" of the 1980s that had formed in Tokyo neighborhoods around material objects such as fashion and style. The new technologies changed the accessibility to information and led to a revolution in the pace of life in Japan, just as in the entire industrialized world. They also impacted consumer culture and the Japanese street. Huge screens broadcasting digital advertisements and short video clips began popping up in various street locations. Websites providing all the required information about a company and its products took the place of consumer magazines, leaving room for posters to become more purely poetic, without the burden of providing concrete information. The aesthetics of the adver-

tising style also changed as a result of the new technological capabilities. Interactive sites packed with text and colors created a new digital aesthetics.

The Tokyo ADC art directors were not late in grasping the potential and the great level of seduction inherent in this medium. Innovative campaigns soon ensued. A campaign by art director Satō Kashiwa for Uniqlo is an excellent example of the influence of technology on advertising and the new use of modern communications models. Satō created several interactive projects, including Uniqlo Fashion Map, Uniqlo March, Uniqlo Try, Uniqlock, Uniqlo Calendar, and Uniqlo Grid. These were not proper advertisements by the classical definition, but instead captured attention via user interaction. For example, the Uniqlock project centered on a search for dancers, who were invited to post auditions on YouTube. The company's website enabled users to create personal blogs. Satō explicitly used the term "Internet project" instead of "campaign" and also swapped out "customer" to make place for "user," to reflect the dynamic nature of the Internet communities. These Internet campaigns and the new terms are a fundamental change to the concept of advertising and to the global viral marketing trend that has become commonplace. Yet in Japan they seem to convey a local Japanese flavor, both aesthetically and ideologically.

And so we witness two parallel trends in Japan during the 1990s. On the one hand, a materialistic and extravagant society transforms into a society that cares for spiritual needs of the individual, family, leisure, and ecology. And at the same time, the same society ushers in new products based on new virtual technologies and information channels that increase the pace of life. Imagery in advertising during these years attempted to deliver these two experiences: an antiestablishment, virtual experience, sometimes touched by fantasy with references to manga, anime, and popular subversive or counter-culture aesthetics, alongside social ideological values regarding family, the elderly, recreation, and ecology.

In conclusion, the sociohistorical narrative examined in this section, which concerns changing social paradigms and new global and local discursive topics that emerged during the 1980s and 1990s, served as the socioeconomic platform for the emergence and development of a new advertising genre. As this section shows, international influences on Japanese advertising are a constant factor, while changing over time in accordance with changing socioeconomic and political conditions. In the postmodern era, the new consumer culture became intertwined with popular culture as the dominant form of Japanese culture during 1980s and 1990s. A new ideology celebrating consumer culture and popular culture replaced earlier ideologies—the mili-

tant and imperialistic ideologies (dominant during the 1930s and 1940s) and the establishment-oriented ideologies advocating hard work for the sake of the nation and corporation (dominant during the 1960s and 1970s).

As I pointed out in the previous chapter, the 1980s were marked by a new style in advertising design, which corresponded to new marketing practices and techniques that emerged in the context of values associated with late consumer culture and with the bubble economy. At the same time, the erosion of local culture by globalization processes aroused objection and served as a trigger for opposition to foreign styles and values, encouraging instead a restoration of local values and aesthetic principles. This process gave rise to two main trends: the first focused on global issues, while the second centered on local and traditional culture. Local values and Japaneseness were emphasized as part of a positioning strategy that opposed them to "foreign" values, alongside other product-positioning strategies such as luxury items as opposed to inexpensive ones.

The new consumer culture also dictated new values and new forms of social organization and segmentation, including the creation of subcultures, anti-class social paradigms, shifts in the inter-gender balance of power, and the rise of a new individualism. The ads created during the 1980s reflect the enthusiasm for global values and new advertising communication techniques, alongside the positioning of many products as local. The ads created during the 1990s put an emphasis on values that are simultaneously both local and global, such as ecological issues and personal, spiritual growth. Advertising during the 1990s also emphasized local social themes such as aging or the decentralization of Japan. The rise of digital and virtual technology, which followed upon the launching of Microsoft Windows 95, led not only to the rise of digital styles as part of the techno-utopia of the time, but also to a return to local handicrafts and styles that represented opposition to the use of global graphic-design software in the design process. Significantly, however, this latter trend was not positioned as a reaction against foreign influences, as had been the case during the 1980s. The dominant values of the 1990s represent a combination of traditional, contemporary, foreign, and Japanese values, which shaped a contemporary, glocal Japanese culture. These social changes are reflected in the visual culture of this decade by means of the desirable values conveyed in advertisements designed by members of the Tokyo ADC. Yet while these advertising campaigns represent contemporary Japanese values, these values are very different from the ones ascribed to them from an orientalist perspective, which saw them as relying on traditional codes of Japanese behavior.

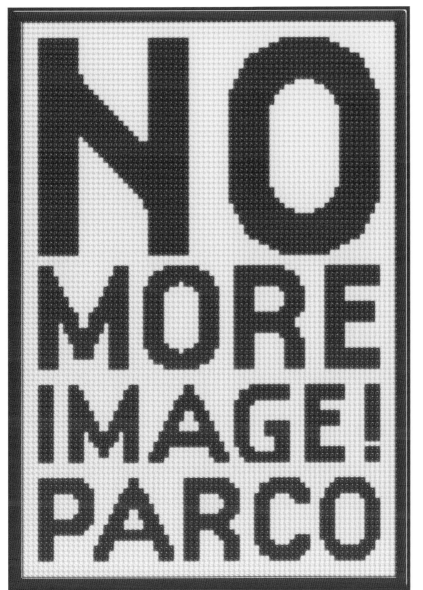

FIGURE 8.9
Sato Kashiwa,
NO MORE
IMAGE! PARCO,
2003 © Samurai
Inc. Creative
director: Sato
Kashiwa; copy-
writer: Taniyama
Masakazu; client:
Parco Co. Ltd.

This study began with the story of Ishioka Eiko's campaign for the Parco department store, whose phenomenal success paved the way for a brand-new genre of advertising that does not convey direct information about its products. In the twenty-first century, with its information overload flooding the consumer, Parco continues to surprise, with advertising posters by art director Satō Kashiwa of Tokyo ADC (figure 8.9).

The ad presents a poster with no image whatsoever, stating "NO MORE IM-AGE! PARCO." This poster eliminates the idea that advertising should display a visual image, and in so doing, it defies the flood of images surrounding us. It also openly approaches the subject of corporate identity with the consumer, a subject that is usually left for hidden strategies.[31] We witness here, as we did in Ishioka Eiko's challenging campaign in the 1970s, the appearance of a new pattern of visual communications (devoid of images) and a new marketing communications (imageless corporate identity), again challenging the conventional advertising marketing patterns and opening a new road for future advertising concepts.

Throughout this book, Japanese names are given in the traditional order—surname followed by given name.

INTRODUCTION

1. The Seibu Saison Group is said to be one of Japan's most aggressive post–World War II conglomerates. The group renamed itself the Saison Group in 1990, when the conglomerate consisted of twelve core groups with a total of two hundred companies and more than 110,000 employees. See Sato Toyoko, "Organizational Identity and Symbioticity: Parco as an Urban Medium," *Journal of Management History* 16, no. 1 (2010): 54.

2. Parco was not a traditional department store, in the sense that it rented out spaces for different boutiques, restaurants, etc. See Ueno Chizuko, "Seibu Department Store and Image Marketing: Japanese Consumerism in the Postwar Period," in *Asian Department Stores*, ed. Kerrie L. MacPherson (Honolulu: University of Hawai'i Press, 1998), 203. For more about Parco identity see Sato 2010, 46–47.

3. For department store culture in Japan see Brian Moeran, "The Birth of the Japanese Department Store," in MacPherson 1998, 159–61.

4. Ishioka Eiko graduated from Tokyo National University of Fine Arts and Music and became the first art director from the Tokyo ADC group who presented advertising with an avant-garde style. She moved on to work in New York and was considered an absent member of the Tokyo ADC until her death on January 21, 2012. Ishioka published several books, and her works are placed in the Museum of Modern Art in New York. She was chosen as an honored member in the hall of fame of the NY ADC.

5. In the United States, Ishioka designed decoration and costumes for movies and theater. She received the Academy Award for costume design for the movie *Dracula* directed by Francis Ford Coppola.

6. Karen Kelsky, *Women on the Verge: Japanese Women, Western Dreams* (Durham, NC: Duke University Press, 2001), 85. Brian Moeran, "Homo Harmonicus and the Yenjoy Girls: Production and Consumption of Japanese Myths," *Encounter* 72, no. 5 (May 1989): 19–24.

7. The campaign for Parco was part of a larger advertising campaign called "The Age of Women" (*Onna no jidai*) that was created for Seibu department store with copywriter Itoi Shigesato. See Ueno 1998, 189.

8. Jeremy Golden, "Mood Advertising Pioneer Agitates Images, Stimulates Minds," *Asian Advertising & Marketing*, 1986, 61–63.

9. Ueno 1998, 192–94.

10. Stephen Eskilson, *Graphic Design: A New History* (New Haven, CT: Yale University Press, 2007), 338–39.

11. David Goodman, *Angura: Posters of the Japanese Avant-Garde* (New York: Princeton Architectural Press, 1999), 1–13.

12. Piero di Cosimo (1462–1521), also known as Piero di Lorenzo, was an Italian Renaissance painter.

13. The original picture is known for its mystical and seductive atmosphere. Erwin Panofsky said that he was mesmerized by the "strange lure emanating from the picture." See Rose-Marie Hagen, Rainer Hagen, *What Great Paintings Say* (Cologne: Taschen, 2003), 104–9.

14. From the mid-1970s, companies in Japan started shaping their corporate image. Seibu department store, for example, started promoting its new corporate image from 1975 by creating a new logo, emphasizing the stores' interior design, and creating an overall image strategy that was presented in all mass media. Part of the new image was the creation of a museum of art of the company. See Ueno 1998, 186–87.

15. Including *Japan Style* (London: Victoria and Albert Museum, 1980); *Tradition et nouvelles techniques—12 graphistes japonais* (Paris, 1984); *Japan Future of Avant-Garde* (Italy, 1985); and *Tokyo Form and Spirit* (traveling exhibition, 1986). See Richard Thornton, *Japanese Graphic Design* (London: Laurence King, 1991), 180–82.

16. Ueno 1998, 195.

17. Ibid., 229–32.

18. Brian Moeran, *A Japanese Advertising Agency: An Anthropology of Media and Markets* (Honolulu: University of Hawai'i Press, 1996), 18–19.

19. In 1991, during Japan's economic bubble, the Japanese ad industry registered a turnover of 5.7 trillion yen (approximately $42.5 billion), representing 1.3 percent of GDP. During the 1990s, Japan had 4,858 advertising agencies. See A. Campbell and D. Noble, eds., *Japan: An Illustrated Encyclopedia* (Tokyo: Kodansha, 1996), 9.

20. For further reading about Japanese advertising agency working processes see Moeran 1996a, 39–133.

21. Ibid., 18. Moeran is quoting Shein 1991, Burton 1983, Day 1984, Fox 1990, Knibbs 1992, and Creighton 1995.

22. Based on an interview with art director Nakashima Shōbun (president of Tokyo ADC at the time), July 4, 2005, in Tokyo.

23. Regarding the theory of the creative class and super-creative core see Richard Florida, *The Rise of the Creative Class* (New York: Basic Books, 2002).

24. Paola Antonelli, "Postmodern Angel: Shiro Kurama," in *Postmodernism: Style and Subversion, 1970-1990*, ed. Glenn Adamson and Jane Pavitt (London: V&A Publishing, 2011), 150–54.

25. Brian Moeran, "The Orient Strikes Back: Advertising and Imagining Japan," *Theory, Culture & Society* 13, no. 3 (1996): 78.

26. Ibid., 77–78.

27. Visual sociology and anthropology study visual images as representations of social phenomena. Janet Wolff (1993), for instance, sees the visual image as a social

creation. She considers ideological and social factors such as politics and socially constructed gender identity as central to the analysis of a picture or work of art. Wolff also examines the dynamic relations between the creative process, the creative product, and the viewer's perception. Visual anthropology similarly views images as objects of study. Bateson and Mead (1942) studied the ethos of the Balinese based on photographs they took there. Goffman (1979) studied different representations of gender and cultural codes in Western society by analyzing advertisements. A similar approach can be found in the research performed by Fowles (1996), who studies the sociocultural values expressed in advertising. The anthropologist Brian Moeran examines stereotypes of Japan in English advertisements, and their construction of an orientalist image of Japan in England (Moeran 1996b, 77-112). In his book *A Japanese Advertising Agency* (Moeran 1996a), he studied work processes in a Japanese advertising agency and showed their influence on visual imagery. Another methodology used in the social sciences is the psychoanalytic approach, which attempts to reveal unconscious themes in the visual imagery and to understand their meaning in terms of the aspirations embedded in the creator's inner world. Diem-Wille (2001, 119-33) argues that every picture, painting, or visual image in a dream represents unconscious aspirations. Williamson (1978, 15) makes use of this approach to study advertising images as if they were dream images subjected to psychoanalysis. She calls this approach "advertising work," a paraphrase on Freud's "dream work." Another approach, which is used in communications studies, analyzes advertising posters based on models of communication and persuasion. Dyer (1982) examines advertising's place in the mass media. Another scholar concerned with the role of pictures in communication patterns in the context of American advertising is Paul Messaris, who shows that visual communication is characterized by the absence of a clear syntax and grammatical structure (analogies, contrasts, causal explanations). Messaris argues that the resulting ambiguity, imprecision, fluidity, and lack of clarity are the source of visual communication's power, endowing it with an important role in the process of persuasion (Messaris 1997, 12-14). Another approach used in the social sciences to study visual images is quantitative methodology, an empirical, objective process designed to quantify visual representations through the use of predetermined categories (which are in some instances also defined using a quantitative method). Such an analysis must begin with a structured hypothesis and ask questions about predefined elements in a clearly circumscribed field of visual contents, a specific period, or a specifically defined type of visual image—for instance, the examination of the number of men vs. the number of women represented in advertisements in a predefined selection of magazines (such as women's magazines) during a specific period (Bell 2001, 10-34).

28. Richard E. Caves, *Creative Industries* (Cambridge, MA: Harvard University Press, 2000), 1-2.

29. Contemporary semioticians such as Van Leeuwen criticize traditional structuralist approaches to semiotics such as the one developed by Saussure, Barthes, and Williamson, which assume that the meaning of the sign is embedded in the image, and that the meaning of the visual image is dependent on its relation to a written text. Van Leeuwen argues that a text may be interpreted in numerous ways, all the more

so in the case of an advertising text that builds on wordplay, metaphors, and images. According to him a text is dependent on its context just as much as an image (Theo Van Leeuwen and Gunther Kress, *Reading Images: The Grammar of Visual Design* [London: Routledge, 1996], 17). This new semiotic approach, which is known as "social semiotics," underscores the viewer's role in endowing the visual image with meaning, as well as the importance of the person consuming the images and his interaction with the image. The term "social semiotics" was first used by Hodge and Kress (1988) and further developed by Van Leeuwen and Kress (1996). Van Leeuwen and Kress analyzed the relations between structure and content as relations between a signified and a signifier. Yet they also argued that signs are not a static system, and that they must be understood as part of a dynamic sociocultural practice. The meaning of the sign is created through a dynamic mechanism or process of producing meaning, which is undertaken by the individual or by society. Moreover, their treatment of the sign as a dynamic process is related to their conception of people as "agents" or "creators" rather than receivers. Van Leeuwen and Kress emphasize the changing interpretations of images during different periods and in different places, and argue that every image is read in accordance with certain grammatical rules created over time in the context of visual culture. Moreover, they argue that visual culture is not composed merely of visual elements and signs, but is also shaped by a visual syntax that is universal rather than culturally specific. In a joint study, Jewitt and Ōyama (2001) analyze what they define as the "semiotic sources" of the image rather than the "semiotic code" defined by classical semioticians. Semiotic sources are unwritten rules created by society by the way it examines and interprets images. The photographic angle, for instance, is a semiotic source that structures the power relations between the viewer and the photographed object, while the vectors within the picture construct a certain narrative or type of connection between the viewer and the object. This new semiotic approach, which studies the functioning of signs as part of a dynamic sociocultural practice, is important for the examination of advertising images. For grounded-theory methods see Hutchinson 1988, 124; Glaser and Strauss 1967; Strauss and Corbin 1994.

30. Advertising campaigns were chosen according to the following criteria: (1) campaigns created by art directors who were members of the Tokyo ADC, defined as the field of research; (2) campaigns created during a specific period (from the early 1980s, a period marked by the emergence of late consumer culture, to the present); (3) campaigns that present either a corporate image or that present an image of products—two categories shaped by a unique marketing and visual strategy; (4) campaigns representing a wide range of industry and product type, which appeared in a variety of media (magazines, billboards, etc.) and appealed to different target audiences.

31. The parameters that guided my choice of interviewees were: (1) members of Tokyo ADC (the association whose members created the genre of advertisements analyzed in this study), who have been part of the advertising industry for more than ten years; (2) those who created works during the 1980s and 1990s, or continue to create advertisements in the present; (3) those who created advertising images that were selected for the study. In addition to the ten male interviewees, I explicitly included a woman interviewee (one of only two woman art directors active in the association).

32. Hayashi Michio, "Tracing the Graphic in Postwar Japanese Art," in *Tokyo, 1955-1970: A New Avant-Garde*, ed. Doryun Chong (New York: Museum of Modern Art, 2012), 104-12.

1. HISTORY OF JAPANESE ADVERTISING DESIGN

1. Ian Condry, "Japanese Hip-Hop and the Globalization of Popular Culture," in *Urban Life: Readings in the Anthropology of the City*, ed. George Gmelch and Walter Zenner (Prospect Heights, IL: Waveland Press, 2001), 357–87.

2. Along with the rapid development of consumerism, the book *Edo kaimono hitori annai* (Your personal guide to shopping in Edo city) was published in 1824. This guide was an index of 2,622 merchants, businesses, artisans, restaurants, and bars. See David Pollack, "Marketing Desire: Advertising and Sexuality in Edo Literature, Drama, and Art," in *Gender and Power in the Japanese Visual Field*, ed. Joshua Mostow, Norman Bryson, and Maribeth Graybill (Honolulu: University of Hawai'i Press, 2003), 75.

3. For many companies, names and logos were printed almost ubiquitously: on *noren* (curtains) hung in shop entrances, on *happi* coats (short kimonos), on umbrellas and parasols, lanterns, wrapping materials of their products (*furoshiki*), on hand towels and on fans sold or handed out to customers. Some of this packaging even included advertising slogans. The term *keibutsu* referred to promotional items produced in conjunction with the marketing of medicines, cosmetics, food, clothing, and other merchandise.

4. Moeran 1996a, 6.

5. In 1872, the twenty-four-hour day was first introduced in Japan. It replaced the traditional division of the day into twelve units named after the zodiac symbols of the lunar calendar—six daytime hours (beginning at dawn) and six nighttime hours (beginning at sunset), whose duration varied according to the changing seasons. With the introduction of the twenty-four-hour day and new clocks, advertisements were used to explain the correct way to read them. During this period, coffee was first imported to Japan. The first Tokyo café, which opened in 1888 in Nishikuromom-chou, was called *kohi-chakan*. The new *rokumeikan* (deer-cry hall) style was in fact a hybrid style that combined elements of French Renaissance design and Japanese style, yet was perceived during this period as Western. It was associated with high society, and was viewed as desirable and unattainable by the common people. See Watanabe Toshio, "Josiah Conder's Rokumeikan: Architecture and National Representation in Meiji Japan," *Art Journal* 22 (Fall 1996): 21–27.

6. Kanehisa Tching, *La publicité au Japon: Image de la société* (Paris: Éditions Maisonneuve et Larose, 1984), 18.

7. Ibid., 14.

8. Julia Sapin, "Merchandizing Art and Identity in Meiji Japan: Kyoto Nihonga Artists' Design for Takashimaya Department Store, 1868-1912," *Journal of Design History* 17, no. 4 (2004): 325.

9. Cigarettes became a common commercial product in Japan in the late nine-

teenth century following the arrival of industrial cigarette-rolling machines, which were first imported from Vienna in 1873. See Kanehisa 1984, 28.

10. See figure 3 in Kanehisa 1984, 6.

11. See figure 5 in Kanehisa 1984, 8.

12. In 1872, the first commercial eau de toilette appeared on the Japanese market. See Kanehisa 1984, 37.

13. In the Edo period the practice that is known today as embedded marketing also began to develop. Products were promoted via placement in literature, plays, and within other highly influential cultural products. For example, in 1713, Kabuki actor Ichikawa Danjūro II played the role of Sukeroku in the play *Sukeroku—the Flower of Edo* (*Sukeroku yukari no edo-zakura*). The hero in the play hides behind an umbrella, seeking protection from the weather as well as from bullies. The Yabuzaki-brand umbrella that was used in the play quickly became an essential fashion accessory for any self-respecting Edo-era male. See Michal Daliot-Bul, *Licensed to Play: Play and Playfulness in Japan* (unpublished dissertation, Tel-Aviv University, 2004), 6. The play was translated to English by James Brandon.

14. During the Edo period, advertisements were created by famous artists and painters. Utagawa Kuniyoshi, Katsushika Hokusai, Kitagawa Utamaro, and Utagawa Kunisada all created works in the *ukiyo-e* style, while Suzuki Harunobu worked in the *nishiki-e* style. These and other artists could often make their living exclusively from advertisements for cosmetics, pharmaceuticals, and commercial shops, a fact that enabled them to maintain their freedom in the arena of art making. The texts for these ads were written by famous writers such as Santō Kyōden, Shikitei Sanba, and Ōta Nampō. The poet and writer Santō Kyōden, for example, wrote ads for Bunshichi, a producer of paper hair-ribbons, while the writer Shikitei Sanba, who was also the owner of a drugstore, advertised his products via his books.

15. Sapin 2004, 317–33.

16. Thornton explains that Mitsukoshi had a competition of "beautiful women" paintings that received over three hundred entries. The competition was won by Hashiguchi Goyō (1880–1921). The other department stores kept a close eye on these proceedings. Hashiguchi's painting also shows art nouveau influences. See Thornton 1991, 35–38.

17. Campbell and Noble 1996, 474–75.

18. Thornton 1991, 35–36.

19. Regarding the movements such as "I-literature" see Chap. 3, note 8.

20. For further reading see Elise Tipton and John Clark, eds., *Being Modern in Japan: Culture and Society from the 1910s to the 1930s* (Honolulu: University of Hawai'i Press, 2000).

21. Thornton 1991, 42.

22. On Taisho "modern girl" and women consumption see Kendall H. Brown, "Flowers of Taishō: Images of Woman in Japanese Society and Art, 1915-1935," in Kendall H. Brown and Sharon A. Minichiello, *Taishō Chic: Japanese Modernity, Nostalgia, and Deco* (Honolulu: Honolulu Academy of Arts, 2001), 19–21; Ito Ruri, "The 'Modern Girl' Question in the Periphery of Empire: Colonial Modernity and Mobility

among Okinawan Women in the 1920s and 1930s," in *The Modern Girl around the World: Consumption, Modernity and Globalization*, ed. Alys Eve Weinbaum, Lynn M. Thomas, Priti Ramamurthy, Uta G. Poiger, Madeleine Yue Dong, and Tani E. Barlow (Durham, NC: Duke University Press, 2008), 240–43; Barbara Sato, *The New Japanese Woman: Modernity, Media, and Women in Interwar Japan* (Durham, NC: Duke University Press, 2003).

23. Designers such as Yamana Ayao brought advertising graphic techniques from Europe to Japan during the Taisho era. This is seen in his posters, brochures, and packaging for Shiseido. Photographers such as Yōnosuke Natori, who edited the magazine *Nippon*, brought new photographic techniques to Japan. See Campbell and Noble 1996, 474, and Weisenfeld 2004, 578–79.

24. Gennifer Weisenfeld, "Selling Shiseido: Japanese Cosmetics Advertising and Design in the Early 20th Century," pt. 3, in *Visualizing Cultures* website (Cambridge, MA: MIT, 2008).

25. Weisenfeld 2004, 579.

26. Art deco was also fashionable during this period in China and India. Regarding art deco in Japan see Kendall H. Brown, *Deco Japan: Shaping Art and Culture, 1920–1945* (Alexandria, VA: Arts Services International, 2013).

27. Weisenfeld 2008, pt. 3.

28. Such as in the article by Nakada Sadanosuke, "Kikuritsu Bauhasu," in *Mizu-e*, no. 244 (June 1925), 2–7.

29. Thornton 1991, 39–40.

30. Kawahata Naomichi, "Yamawaki Iwao: His Life and Work," *Déjà-Vu, a Photography Quarterly*, Photo-Planete, no. 19 (Spring 1995): 34.

31. Gennifer Weisenfeld, "Publicity and Propaganda in 1930s Japan: Modernism as Method," *Design Issues* 25, no. 4 (Autumn 2009): 13.

32. Weisenfeld 2004, 581, 557.

33. Ibid., 558.

34. Asuka Tetsuo (1895–1997), who is also known as Takahashi Tetsuo, graduated from university in 1919 and presented his works in post-impressionist art exhibits. Okada Masanori (1901–67) completed his studies in 1925 with an abstract, post-impressionist final project. Okada worked for Morinaga Confectionery Company. See Weisenfeld 2004, 578.

35. Winning this competition helped launch Hara's career as one of the most important Japanese graphic designers until his death in the 1980s.

36. Hara Hiromu was influenced by the Russian avant-garde, especially the cinema montage of Sergei Eisenstein, Alexander Rodchenko, and El Lissitzky. Hara later became the president of Nippon Design Center. He is considered the one that introduced modern style to Japan and helped to change modern Japanese visual expression.

37. Another designer who brought the modern style to Japan was Kono Takashi, who, just as Hara Hiromu did, shifted design expression in the 1930s from romantic to modern. See Thornton 1991, 56.

38. Weisenfeld 2009, 17–18.

39. Weisenfeld 2004, 581–82.

40. Kanamaru Shigene (1900–1977) founded the field of commercial photography in Japan. His works represent the beginning of using photography in Japanese print advertisements.

41. Most art directors I interviewed mentioned the Bauhaus influence on their work. Watanabe Kaoru of Tokyo ADC explained that when he studied, Bauhaus theories were discussed in most design classes. One of his teachers in Nihon University was Miyawaki Dan, who studied in the Bauhaus school and subsequently taught its theories in Japan when he returned.

42. Hitler's biography was translated into Japanese in 1934. See figure 11 in Kanehisa 1984, 41.

43. For example, English language studies were replaced by German language studies; see Shillony 1997, 233.

44. See figure 12 in Kanehisa 1984, 42.

45. Weisenfeld 2008, pt. 4.

46. See figure 15 in Kanehisa 1984, 42.

47. Weisenfeld 2008, pt. 3.

48. Weisenfeld discusses the design of the Japanese pavilion and the Japanese section of the Hall of Nations at the 1939–40 World's Fair in New York, as well as the interior of the Japanese pavilion at the Golden Gate Exposition in San Francisco in 1939. The photo-mural panels in the pavilions were both designed by Yamawaki Iwao, who presented Japanese national icons using a modernist visual strategy. See Weisenfeld 2009, 23–25.

49. Leonid, the designer, attempted to have it both ways, referencing the modern technology of the radio by putting it into the context of traditional German nationalism. According to modern design principles nothing clashes more than a mix of ornamental script with a photo. See Eskilson 2007, 281.

50. Weisenfeld 2009, 19.

51. Designers such as Ohashi Tadashi and Arai Seiichirō worked on government projects. Others worked for advertising agencies such as Japan Telegram that designed the Japanese propaganda campaigns. Regarding the context of the term *zuanka* see Thornton 1991, 62.

52. Starting in 1940, ads became very small (two to three lines in black and white) owing to government publishing regulations on space allotments in an effort to avoid any ostentatious appearance during a national period of sacrifice. See Weisenfeld 2008, pt. 3.

53. Kikuchi Yuko, "Russel Wright and Japan: Bridging Japonism and Good Design through Craft," *Journal of Modern Craft* 1, no. 3 (November 2008): 360.

54. This style was influenced by the De Stijl movement of 1920s–1930s Netherlands and by Russian constructivism, which later gained further momentum in the Bauhaus school.

55. In Japan, as well, a "Good Design Committee" was established during the 1950s. Its mission was to select and popularize "Good Design" in Japan through exhibitions.

56. Jan Tschichold also escaped from Germany to Basel in 1933, following his arrest by the Nazis. By 1935, he had published his book *Typografische gestaltung*. After the

war, he gave a new interpretation of his own typography theories. He suggested that the absolutist tone in which he had formulated the style paralleled the dictates of the Nazis. See Eskilson 2007, 247, 302.

57. During the period of American occupation, New York saw an influx of Japanese calligraphy, which had an impact on avant-garde trends of the New York school and on the abstract expressionist "action painting" style, especially that of Jackson Pollock, who painted on the floor, as do Japanese calligraphers.

58. Yūsuke Kaji, "The Florescence of Advertising Communication: The 1950s," in *Advertising History, 1950-1990*, exhibition catalog (Tokyo: East Japan Railway Culture Foundation, 1993), 28.

59. During the 1960s, the expression "three sacred treasures" (which was historically used to refer to the symbols of the empire—a sword, a mirror, and a precious stone) came to refer to electric appliances: an electric fridge, a washing machine, and a TV. These were later replaced by "three *Ks*"—car (*kuruma*), color TV (*kara terebi*), and air conditioner (*kura*).

60. This financial help to Asian countries was part of the American Cold War policy that aimed to create close political and cultural relations with noncommunist counties, as was done in Europe with the Marshall Plan.

61. Kikuchi 2008, 362-63.

62. Ibid., 369-70.

63. Shimamura and Ishizaki 1997, 235.

64. The organization is known today as JIDPO (Japan Industrial Design Product Organization).

65. Yamawaki Iwao, *bauhausu no hitobito* (Tokyo: Shokokusha, 1954).

66. Kashiwagi Hiroshi, "Post-war History in Advertising Design," in *Advertising History, 1950-1990*, exhibition catalog (Tokyo: East Japan Railway Culture Foundation, 1993), 14-15.

67. Thornton 1991, 72.

68. Kashiwagi 1993, 14-15.

69. The first logo of Tokyo ADC can be seen in Thornton 1991, 71.

70. The group was organized by Yusaku Kamekura with the cooperation of Ryuichi Yamashiro. This association held study meetings for young designers in a Roppongi cultural center on the twenty-first of each month. Members included Nagai Kazumasa, Tanaka Ikko, Katayama Toshihiro, Kimura Tsunehisa, Sugiura Kohei, Fukuda Shigeo, Katsui Mitsuo, Nakajo Masayoshi, Hosoya Gan, and Awazu Kiyoshi. See a conversation between Hara Kenya and Nagai Kazumasa titled "Post-war Japan and Design" on the Nippon Design Center website, http://www.ndc.co.jp/en/people /polylogue01.html.

71. This publication included articles on constructivist theories written by designers of the international style such as Josef Müller-Brockmann, Karl Gerstner, Max Bill, El Lissitzky, and Alvin Lustig. Thornton 1991, 68.

72. Raymond Loewy was even employed by Japan Tobacco in 1952 to design cigarette packaging for the Peace brand, which sought to repeat the tremendous success of Lucky Strike. Ibid., 72.

73. Yūsuke Kaji, "The Era of Individualization of Expression: The 1960s," in *Ad-*

vertising History, 1950-1990, exhibition catalog (Tokyo: East Japan Railway Culture Foundation, 1993), 56.

74. Kashiwagi 1993, 14-15.

75. Thornton 1991, 97.

76. Jilly Traganou, "Tokyo's 1964 Olympic Design as a 'Realm of [Design] Memory,'" in *Sport in Society: Cultures, Commerce, Media, Politics* 14, no. 4 (2011): 466-81.

77. The Tokyo World Conference 1960 was held on May 11-16, 1960; 84 designers from twenty-seven other countries joined 143 Japanese designers. Many important European and American designers attended, including Max Huber, Otl Aicher, Josef Müller-Brockmann, Herbert Bayer, and Saul Bass. For most, this was their first visit to Japan, and they were impressed by what they found, leading to initial international awareness. In the 1960s, some designers continued to work in and develop the international style. This includes Sugihara Kohei, who studied at the Ulm school after the war and helped the style penetrate Japan. See Thornton 1991, 93-94.

78. Ibid., 230.

79. When Yamana Ayao resigned in 1959, he was replaced by Nakamura Makoto.

80. Yūsuke 1993a.

81. As can be seen in the works of the California designers known as the Big Five.

82. Since the 1950s, subversive art movements struck out against traditional hierarchy, paving the way for the rise of postmodern art. These included Gutai (active from 1954 to 1972), neo-Dada (active from 1960 to 1964), the anti-intellectual Butoh (1960s), and Mono-ha (active from 1968 to 1973). Doryun Chong, "Tokyo 1955-1970: A New Avant-Garde," in *Tokyo 1955-1970: A New Avant-Garde*, ed. Doryun Chong (New York: Museum of Modern Art, 2012): 46-69.

83. Goodman 1999, 1-13.

84. The exhibition gave a stage for young designers who were of the second generation to come after the Graphics '55 event.

85. After years of accelerated growth, political and economic crises arose when OPEC cut back on its supply of oil to any countries that supported Israel in the 1973 Arab-Israeli War. The spike in oil prices caused a shock to Japan's economy. The ensuing political crisis led also to changes in Japan's Middle East policies. See Shimizu 1993b, 100.

86. Kanehisa 1984, 84.

87. Japan was described in professional literature as homogeneous, with a nationalist ideology that emphasizes collective public matters of society. This generalistic view with its widely painted strokes of orientalism is known as *nihonjinron* (theory of Japanese society). See Peter Dale, *The Myth of Japanese Uniqueness* (New York: St. Martin's Press, 1986); Iwabuchi Koichi, "Complicit Exoticism: Japan and Its Other," *Continuum: The Australian Journal of Media and Popular Culture* 8, no. 2 (1994): 49-82.

88. Befu Harumi, "The Group Model of Japanese Society and an Alternative," *Rice Studies* 66, no. 1 (1980): 177.

89. Joseph J. Tobin, "Introduction: Domesticating the West," in *Re-made in Japan: Everyday Life and Consumer Taste in a Changing Society*, ed. Joseph J. Tobin (New Haven: Yale University Press, 1992), 23.

90. Yamaki Toshio, "Consommation, publicité et crise au Japon après l'éclatement de la bulle speculative," in Kanehisa Tching, *Société et publicité nipponnes* (Paris: Éditions You-Feng, 2002), 1:1-17.

91. Shimizu 1993b, 98.

92. Kashiwagi 1993, 14-15.

93. During this era, companies that had been established after the war were reaching their stage of maturity, and their advertising strategy began to focus more on corporate identity.

94. Thornton 1991, 131.

95. Previous successful campaigns would run approximately six months. This campaign lasted eight years, only to be superseded by a "Discover Japan II" campaign that ran for another two years, and after that the "Exotic Japan" campaign. All these were the works of the art director Suzuki Hachirō.

96. Matsuo Bashō, *Narrow Road to the Interior and Other Writings* (Boston: Shambhala, 2000).

97. Marilyn Ivy, *Discourses of the Vanishing: Modernity, Phantasm, Japan* (Chicago: University of Chicago Press, 1995), 29-48.

98. Shimizu 1993b, 100.

99. Kanehisa 1984, 83.

2. THE CREATIVE CORE

1. Tokyo ADC consisted of eighty-four members in the 1990s. (Ishioka Eiko held the status of "absent member," an honorary position in the association.)

2. Nagai Kazufumi, in an interview on July 6, 2005, explained that outside of Japan, there are only art directors and copywriters. In Japan "there are art directors; copywriters; CM planners [i.e., planners of commercials], and creative directors. The CM planner deals mainly with television ads by preparing the narrative. Art directors deal mainly with posters and newspaper and magazine ads. The creative director is responsible for both TV commercials and prints."

3. The current association president is Hosoya Gan.

4. Avant-garde styles arrived in Japan during this period, including the New York school and the abstract expressionism of "action painting." During the American occupation, many samples of Japanese calligraphy made their way to New York, influencing artists such as Jackson Pollock, who painted on the ground just as Japanese calligraphers do. These works made their way back to Japan, influencing the postwar avant-garde artists there.

5. Thornton 1991, 65.

6. Kashiwagi 1993, 14-15.

7. Thornton 1991, 162-63.

8. In 1959, an additional organization, the Nippon Design Center, was formed by large conglomerates (Asahi Brewers, Nippon Kogaku, Nippon Kokan, Toshiba Electric, and Toyota Motor Sales), in conjunction with important designers of the period (Hara Hiromu, Yamashiro Ryūichi, and Kamemura Yusaku). It is still active today and

aims to be the Japanese center of advertising design and commercial art. The current head of the Nippon Design Center is Hara Kenya, who is also a Tokyo ADC member.

9. At the time, there was no art director profession in Japan. This role was split among a variety of job functions within the industry.

10. The names of the founders are Akabane Kiichi, Arai Seiichiro, Doikawa Shuichi, Fujimoto Michio, Futawatari Adō, Imaizumi Takeji, Kaneko Kenjirō, Kawasaki Tamimasa, Kurosuda Shinjirō, Saigō Tokuo, Shiihashi Isamu, Shimada Shin, Uemura Ei, Wakabayashi Riichi, Watanabe Hachirō, Yamana Ayao, Yūjōbō Nobuaki.

11. Both exhibitions were held in Shiseido Gallery (Shiseido garō). See Ōhashi Norio, "Dezain shinenpyo," in *Advertising History, 1950-1990*, exhibition catalog (Tokyo: East Japan Railway Culture Foundation, 1993), 177.

12. At the conference, which ran May 11-16, 1960, 86 international designers from twenty-seven countries participated alongside 143 Japanese designers.

13. Thornton 1991, 93-94.

14. As Japan did not adopt the principles of the 1949 Geneva Convention on Road Traffic, the Olympics were seen as an opportunity to devise a system of visual navigation that would be intelligible by international audiences. See Traganou 2011, 471.

15. Design decisions for this Expo were made well in advance, as early as 1966, and thus the design style belongs still to the 1960s.

16. The design committee of Expo '70 included Katzumie Masaru, Kenmochi Isamu, Kōno Takashi, Hara Hiromu, Hayakawa Yoshio, and seven others. The committee stared working in 1965, and in 1966 they chose Ōtaka Takeshi's symbol as a logo of the exhibition. Each component of the campaign was designed by a different designer: Fukuda Shigeo designed the pictograms, and Ishioka Eiko designed the poster. See Thornton 1991, 119-21.

17. Nagai Kazumasa designed the pictogram, and Kōtō Takashi designed the official Olympics poster.

18. Thornton 1991, 146.

19. The conference posters were designed by Kamekura Yusaku.

20. Thornton 1991, 165.

21. Shimizu Keiichirō, "When Advertising Was Transformed: The 70s," in *Advertising History, 1950-1990*, 100.

22. Ueno 1998, 195.

23. Quote from an interview with Nakashima Shōbun on June 28, 2005.

24. Ueno 1998, 195-96.

25. Nagatomo Keisuke, Aoba Masuteru, Asaba Katsumi, *Artodirecta—watashi no shigoto* (Tokyo: Keizai Inc., 1987).

26. Thornton 1991, 144-46.

27. Quote from an interview with Nakashima Shōbun on June 28, 2005.

28. Marilyn Ivy, "Formations of Mass Culture," in *Japan as Post-war History*, ed. A. Gordon (Berkeley: University of California Press, 1993), 242; Sharon Kinsella, *Adult Manga: Culture and Power in Contemporary Japanese Society* (Honolulu: University of Hawai'i Press, 2000), 20.

29. Gisela Kozak and Julius Wiedemann, *Japanese Graphics Now* (Cologne: Taschen, 2001); Thornton 1991.

30. *Yomiuri Shimbun Advertising Bureau Newsletter* 10, no. 9 (December 2007).

31. *CM Journal*, Tokyo, no. 628, 2008.

32. All information is taken from an interview with Nakashima Shōbun in ggg gallery in Ginza, Tokyo, on June 4, 2005.

33. Tokyo Art Directors Club, *Nenkan Kōkoku Bijutsu* (ADC Annual, 1983) (Tokyo: Bijutsu Shuppan, 1983), 9.

34. *History of Advertising in Japan, 1860-1956* was published in 1967 by Tokyo ADC.

35. Tokyo Art Directors Club, *Nenkan Kōkoku Bijutsu* (ADC Annual, 1982) (Tokyo: Bijutsu Shuppan, 1982), 8.

36. Sezon Art Museum was an annex of the Seibu department store. It was closed in 1999.

37. Tokyo Art Directors Club, *Nenkan Kōkoku Bijutsu* (ADC Annual 1983) (Tokyo: Bijutsu Shuppan*, 1983), 14-15.

3. EMERGENCE OF AVANT-GARDE VISUAL CULTURE

1. The architect and designer Robert Venturi coined the phrase "Less is a bore," a paraphrase on Mies van der Rohe's famous sentence "Less is more" that summarized the minimalism and functionalism of modern aesthetics.

2. Postmodern characteristics are well demonstrated by popular art such as music videos: breaking from linearity, incorporation of quotes from various sources, edginess, use of multiple styles and genres (pastiche), in opposition to the modern values of maintaining borders between high and low culture, creating coherent visual statements, and striving for originality and innovation. On Postmodernism see Adamson and Pavitt, *Postmodernism*. On postmodernism in Japan see Miyoshi Masao and H. D. Harootunian, *Postmodernism and Japan* (Durham, NC: Duke University Press, 1989).

3. Fredric Jameson, *The Cultural Turn: Selected Writings on the Postmodern, 1983-1998* (London: Verso, 1998), 10-12; Fredric Jameson, *Postmodernism: Or, the Cultural Logic of Late Capitalism* (Durham, NC: Duke University Press, 1991), 2-6.

4. Jacob Raz brings examples from the traditional Japanese culture such as the various conventional styles that were popular in the same time during the Edo period (the colorful Tokugawa Mausoleum in Nikko side by side with the minimalistic Villa Katzura in Kyoto). See Raz, "Japan: Image and Reality, or Japan: Reality of Images," *Studio—Art Magazine*, August 1991, 42-47 (Hebrew).

5. See Dorinne Kondo, *About Face: Performing Race in Fashion and Theater* (New York: Routledge, 1997), 55-58; Kawamura Yuniya, *The Japanese Revolution in Paris Fashion* (New York: Berg, 2004), 125-50; Susannah Frankel, "Issey Miyake, Rei Kawakubo, Yohji Yamamoto, Junya Watanabe, Jun Takahashi, Tao Kurihara," in *Future Beauty: 30 Years of Japanese Fashion*, ed. Catherine Ince and Rei Nii (London: Merrell, 2011), 145-225; Valerie Steele, "Is Japan Still the Future?" in *Japan Fashion Now*, by Valerie Steele, Patricia Mears, Kawamura Yuniya, and Narumi Hiroshi (New Haven, CT: Yale University Press, 2010), 1-141.

6. A Japanese aesthetic term that originally belonged to the Japanese ceramic world

from the traditional Japanese tea ceremony. See Leonard Koren, *Wabi-Sabi: For Artists, Designers, Poets and Philosophers* (Berkeley, CA: Stone Bridge Press, 1994).

7. In 1964 Japan hosted the Olympic Games, and this encouraged people to purchase TVs. For the first time, television in Japan created a new collective identity. This went hand in hand with the postwar closing of the economic gaps between different sectors in Japan owing to American reforms, *zaibatsu* dismantling, agriculture reform, and new labor laws.

8. During the Taisho period, new styles and cultural hybrids were created. Artists of the era were influenced by Western art, including techniques, materials, and various painting subjects. As a result, new fashion, art, and even new advertising posters were created. These advertising posters presented new coffeehouses, ballrooms, and fashionable alcoholic drinks, such as in a poster for beer served by a waitress dressed in Western clothes. The new painting style created under Western influence (*yōga*) was characterized by the use of Western mediums such as oil on canvas, as well as techniques, themes, motifs, and iconographies of European painting. It differed from the *nihonga* that used traditional materials, techniques, and subjects. Beyond the encounter with Western art and techniques, it is commonly believed that one of the factors that brought Japan into the modern era was its encounter with the concept of individualism (*kojinshugi*) as influenced by Western political philosophy during the Meiji Restoration era (*Meiji ishin*). During these years a new literary trend was created that was called the "I-literature" (*shin-sosetsu*) and included many authors, such as Natsume Sōseki and Tanizaki Junichirō, who presented everyday life and personal issues. The aspiration for individualism was also seen in the visual art of the era. New art movements such as *mavo* dealt with the development of modern art in Japan, raising questions about the social role of the new autonomic individual in the time of aggression and national recruitment. See Gennifer Weisenfeld, *Mavo: Japanese Artists and the Avant-Garde, 1905–1931* (Berkeley: University of California Press, 2002), 123–24.

9. Thornton 1991, 179.

10. Lise Skov, "Fashion Trends, *Japonisme* and Postmodernism: Or 'What Is So Japanese about *Comme des Garçons*?'" *Theory, Culture & Society* 13, no. 3 (1996): 129.

11. Other critics' remarks included "L'après troisième guerre du feu" (After World War III); "Le bonze et le kamikaze" (The monk and the kamikaze); "L'offensive japonais" (The Japanese offensive); and "Fripe nippone" (Japanese secondhand). See Patricia Mears, "Formalism and Revolution," in Steele et al., *Japan Fashion Now*, 158.

12. In 1954, the Gutai movement launched as the first postwar avant-garde art movement, creating experimental art installations and performance art that combined movement and sound. This was followed by the neo-Dadaist movement in 1959, which created conceptual art known as anti-art. At the same time, the Butoh dance movement developed in the 1960s, led by the Ono Kazuo dancers and Hijikata Tatsumi, who protested against Western rationalism and the conventions of the Japanese art world and challenged the boundaries of dance and body. Mono-ha started in 1968, emphasizing the material aspect of the works of art and planted the seeds for contemporary art in Japan. See Alexandra Munroe, *Japanese Art after 1945: Scream against the Sky* (New York: Harry N. Abrams, 1994); Doryun Chong, "Tokyo 1955–1970: A

New Avant-Garde," in *Tokyo 1955-1970: A New Avant-Garde*, ed. Doryun Chong (New York: Museum of Modern Art, 2012): 46-69

13. Founded in 1966, Studio de Pas, D'Urbino Lomazzi was notorious for witty and unconventional architecture and products. Designers Jonathan de Pas, Donato D'Urbino, and Paolo Lomazzi created pieces that bridged the gap between design and art, like the giant baseball glove "Joe Chair." Known for its flexible, modular concepts in industrial design and architecture, the studio was awarded the Compasso d'oro. See David Seth Raizman, *History of Modern Design* (London: Laurence King Publishing, 2003), 345-46.

14. Piero Gatti (Turin, b. 1940), Cesare Paolini (Genoa, 1937-83), and Franco Teodoro (Turin, 1939-2005), worked together since 1965, designing in the fields of architecture, industrial design, urban design, corporate image, and product development.

15. The Archizoom, the Superstudio, Gruppo 9999, and Gruppo Strum were influenced by the Archigram movement that was established in London in 1961. The plans of these groups were models in paper that had never been realized, but they planted the seeds for the postmodern groups such as Alchemia and Memphis that emerged at the end of the 1970s and in the 1980s.

16. Mears 2010, 162.

17. Ibid., 181-88.

18. Alison Gill, "Deconstruction Fashion: The Making of Unfinished, Decomposing and Re-assembled Clothes," *Fashion Theory: The Journal of Dress, Body and Culture* 2, no. 1 (1988): 25-49.

19. It may be that Kawakubo's protest was part of the Japanese avant-garde movement that sought to recall the destruction left after World War II and the atomic bomb. This memory had been repressed under the momentum of the 1970s economic miracle, which brought along European bourgeois taste as well as a nostalgia for the traditional Japanese aesthetics of the Edo era.

20. Dianna Crane, *Fashion and Its Social Agendas: Class, Gender, and Identity in Clothing* (Chicago: University of Chicago Press, 2000), 158.

21. In these years the Licca (the Japanese Barbie doll) was created, and many ice cream and cake shops were established (such as Mister Donut), since these were considered as soft and milky food for children.

22. Sharon Kinsella, "Cuties in Japan," in *Women Media and Consumption in Japan*, ed. Lise Skov and Brian Moeran (Honolulu: University of Hawai'i Press, 1995), 220-54.

23. Matsui Midori, "Beyond the Pleasure Room to a Chaotic Street," in *Little Boy: The Arts of Japan's Exploding Subculture*, ed. Murakami Takashi (New York: Japan Society Gallery, and New Haven, CT: Yale University Press, 2005), 209-12.

24. Kelsky, *Women on the Verge*, 85; Moeran 1989, 19-24.

25. Kinsella 2000, 128-31.

26. The exhibition *OTAKU: Personality = Space = Cities* was curated by Tange Kenzō, Okada Toshio, Kaiyodo, Kaihatsu Yoshiaki, Ōshima Yūki, Saitō Tamaki, Comic Market Committee, Yotsuba Sutazio, and Jeong-u Seon for the Ninth International Architecture Exhibition in Venice, Italy, 2004.

27. This visual experience is well documented in American movies such as *Blade Runner* and *Black Rain* by Ridley Scott, as well *Lost in Translation* by Sofia Coppola.

28. Thierry Taittinger, *Murakami: Versailles* (Ivry-sur-Seine: Beaux Arts Éditions and TTM Éditions, 2010), 10.

29. Via the exhibition of his objects in the Palace of Versailles, Murakami presented the importance of the fantasy about Versailles Palace and how it is held firmly in Japanese popular culture. He presents the translation of the baroque and the rococo styles into a Japanese *kawaii* style. The dissonance between the over-adorned style of the palace and the cute pop objects emphasizes the Japanese fantasy regarding Western otherness as hedonistic, romantic, and as a sweet lifestyle, as can be seen in the influential *Rose of Versailles* manga, in the Takarazuka theater, and in Harajuku Lolitas. The exhibition also presents how these images helped the processing of this unfulfilled fantasy.

30. The *Little Boy* exhibition of 2005 presents the unspoken fear of mass annihilation by the atomic bomb as reflected in popular culture and how popular culture products help to process this unspoken fear.

31. The Louis Vuitton handbag shop was part of the installations in the exhibition and not part of the museum shop.

32. Valerie Steele, "Is Japan Still the Future?", *Japan Fashion Now*, ed. Steele et al., 97.

4. VISUAL COMMUNICATION STRATEGIES

1. Ron Beasley, Marcel Dansei, and Paul Perron, *Signs for Sale: An Outline of Semiotic Analysis for Advertising and Marketers* (New York: Legas, 2000).

2. Tanya Reinhart, *From Cubism to Madonna: Subject and Representation in 20th-Ccentury Art* (Tel Aviv: Hakibutz Hameuchad, 2000), 143 (Hebrew).

3. Roland Barthes argues that "in photogenia the connoted message is the image itself, 'embellishes' . . . by techniques of lighting, exposure and printing." See Barthes, *Image—Music —Text*, trans. Stephen Heath (London: Fontana Press, 1977), 15-31.

4. To increase the reality illusion, Saitō Makoto photographs a real human bone.

5. Quote from an interview with Saitō Makoto in his studio on June 28, 2005, Tokyo.

6. Williamson 1978, 20.

7. The use of color can help us analyze the various visual styles. Color in Japan was a mark of recognition for many eras, as well as for schools of artists who used different color spectra. Color was even used for marking social hierarchy. See Fukuda Kunio, "The Hierarchy of Colors," in *The Colors of Japan*, ed. Hibi Sadao (Tokyo: Kodansha International, 2000), 97-101.

8. Quote from an interview with Suzuki Hachirō in his studio, June 29, 2005, Tokyo.

9. Quote from an interview with Miyata Satoru in his studio, June 28, 2005, Tokyo.

10. Quote from an interview with Ōnuki Takuya in his studio, June 30, 2005, Tokyo.

11. The Dutch, who were the only foreigners left in Japan at that time, were called *komojin*. See Ben-Ami Shillony, *Modern Japan: Culture and History* (Tel Aviv: Schocken, 1997), 155 (Hebrew).

12. Quote from an interview with Aoki Katsunori in his studio, July 4, 2005, Tokyo.

13. *Yaoi* manga is a subgenre of *shojo* manga (manga for girls). This genre addresses the target audience of young girls and deals with homosexual themes and young men who question their sexual identity. See Kinsella 2000, 112–24.

14. This kind of coloring can be seen in the street fashion in the Harajuku neighborhood. See Aoki Shōichi, *Fruits* (London: Phaidon, 2001).

15. Kinsella 1995, 220–54.

16. Quote from an interview with Aoki Katsunori in his studio, July 4, 2005, Tokyo.

17. Quote from an interview with Watanabe Yoshie in her studio, July 7, 2005, Tokyo. Compare this advertisement for Mos Burger to the advertisement by Miyata Satoru.

18. Based on an interview with Yamamura Naoko in her office, July 9, 2005, Tokyo.

19. Quote from an interview with Miyata Satoru in his studio, June 28, 2005, Tokyo.

20. For further discussion about word/image relationship in Japanese advertising see Ory Bartal, "Text as Image in Japanese Advertising," *Design Issues* 29, no. 1 (2013), MIT Press.

21. Based on an interview with Nagai Kazufumi in his studio, July 6, 2005, Tokyo.

22. Quote from an interview with Suzuki Hachirō in his studio, June 29, 2005, Tokyo.

23. The scroll is considered a national treasure and is owned today by the Chogosonshi-ji temple in Nara.

24. Based on an interview with Suzuki Hachirō in his studio, June 29, 2005, Tokyo.

25. Ibid.

26. Ibid.

27. Based on an interview with Watanabe Kaoru in his studio, July 7, 2005, Tokyo.

28. See Werner Hofmann, *Caspar David Friedrich* (London: Thames & Hudson, 2000), 54–58.

29. Ikegami Yoshiko, ed. *The Empire of Signs: Semiotic Essays on Japanese Culture* (Amsterdam: John Benjamins Publishing Co., 1991), 16.

30. This argument was explained by Hara Kenya, in a panel conducted along with Sen Soushu, Mushakoji-Senke grand tea master, and Sergio Caltaroni, an architect and product designer who was a visiting lecturer at the Tokyo University Museum, when discussing an exhibition named *Tokyo Fiber Senseware*. The *Tokyo Fiber Senseware '09* exhibition was first curated by Hara Kenya in Milan design week in 2009. The exhibition presented the possibilities of new materials (synthetic fibers), developed by Japanese technological companies, in experimental product design.

31. Quote from an interview with Hara Kenya in the Design Museum of Holon, Israel, June 22, 2010.

32. This blurring is not new. Throughout history there were many eras that saw overlapping of design and art. Artists as diverse as Leonardo da Vinci and Kazimir Malevich designed useful products while creating art. Throughout history art itself was often functional, serving religions or political movements as a propaganda tool as well as a commercial product.

33. Quote from an interview with Toda Seijū in his studio, June 27, 2005, Tokyo.

34. Ory Bartal, "Vagina Dialogues: The 'Love Mother Earth' Advertisement by

Saitō Makoto," in *PostGender: Gender, Sexuality and Performativity in Japanese Culture*, ed. Ayelet Zohar (Newcastle, UK: Cambridge Scholars Press, 2009), 85-109.

35. Courbet's *The Origin of the World* (the title was not Courbet's) was commissioned in 1866 by Khalil Bey, a Turkish diplomat in Paris. Later it was in the possession of Jacques Lacan. The work has been seen by relatively few observers. It was hidden behind a green veil while in the possession of its original owner and was later, according to Léger, concealed by a panel depicting a castle in the snow. Today it is in the permanent collection of the Musée d'Orsay, Paris. *The Origin of the World* was associated with a drawing of a cave, and, like the cave, is impenetrable, yet symbolizes the longing for security. The painting has inspired numerous artists fascinated by this theme: Orlan's photograph *Origin of War*, 1989, and Marc Quinn's similarly named photograph *Origin of the World*, 1999. See Michael Fried, *Courbet's Realism* (Chicago: University of Chicago Press, 1990), 189-222.

36. Another significant context to understand this advertising is the changing laws about the representation of female nudity and *shunga* during the 1980s. See Bartal 2009.

37. Marcia Brennan, *Painting Gender, Constructing Theory: The Alfred Stieglitz Circle and American Formalist Aesthetics* (Cambridge, MA: MIT Press, 2001).

38. Sigmund Freud, "The Interpretation of Dreams" (1900-1901), in *The Standard Edition of the Complete Psychological Works of Sigmund Freud*, vols. 4-5, trans. James Strachey (London: Hogarth Press, 1953), 470-71; Freud, *Introductory Lectures on Psychoanalysis* (London: Penguin Books, 1991), 168-90, 494-97.

39. Freud 1953; Freud 1991.

40. Freud referred to "the part played by Mother Earth in the concepts and cults of antiquity" and how "their view of agriculture was determined by this symbolism."

41. Werner Spies and Wolfgang Volz, *Christo: Surrounded Islands, Biscayne Bay, Greater Miami, Florida, 1980-83*, trans. Stephen Reader (New York: Harry N. Abrams, 1985), 16-27.

42. Timothy Clark, "Utamaro and Yoshiwara: The 'Painter of the Green Houses' Reconsidered," in *The Passionate Art of Kitagawa Utamaro*, ed. Asano Shugo and Timothy Clark (London: British Museum Publications, 1995), 35-55.

5. MARKETING COMMUNICATIONS

1. Quote from an interview with Saitō Makoto, June 28, 2005.

2. Ibid.

3. For the meaning of "uncanny" see Freud, *The Standard Edition of the Complete Psychological Works of Sigmund Freud*, vol. 17, *An Infantile Neurosis and Other Works*, trans. James Strachey (London: Hogarth Press, 1963), 217-52.

4. Quote from an interview with Hara Kenya, July 22, 2010.

5. Jameson 1998, 33-37, 136-61.

6. During the growth of widespread consumption in the city of Edo, the book *Edo kaimono hitori annai* (Your personal guide to shopping in Edo city) was published, list-

ing 2,622 merchants, businesses, craftspeople, restaurants, and bars. See Pollack 2003, 71–88, esp. 75.

7. During this time, the first articles drafting the new economic concepts about marketing were written, opening up the theoretical study of the field of marketing. Among the most influential articles published in the 1960s that launched the theoretical discussion were by Robert Keith and Robert Holloway, who used the Pillsbury case study to explain marketing as a new managerial process in which the business world is changing focus from production to sales and marketing ("The Marketing Revolution," *Journal of Marketing* 32, no. 3 [July 1968]: 74–75) and Theodore Levitt, who presented the modern marketing concepts ("Marketing Myopia," *Harvard Business Review*, July–August 1960, 24–47). See also John B. McKitterick, "What Is the Marketing Management Concept?" in *The Frontiers of Marketing Thought and Science*, ed. Frank M. Bass (Chicago: American Marketing Association, 1957), 71–82.

8. Today, marketing is considered a crucial factor in the success of any company; see Baker and Hart 1989; Kheir-El-Din 1991, 1–28; Narver and Slater 1990, 20–35; Wong and Saunders 1993, 71–85. See Stephen Brown, *Postmodern Marketing* (London: Routledge, 1995), 68–69.

9. Research today is divided to subdisciplines such as micro-marketing (Schlossberg 1992), maxi-marketing (Rapp and Collins 1994); database marketing (Davies 1992), new marketing (McKenna 1991), wraparound marketing (Kotler quoted in Caruso 1992), value-added marketing (Nilson 1992), relationship marketing (Christopher et al. 1991), neo-marketing (Cova and Svanfeldt 1992). See Brown 1995, 43–63.

10. Marketing is not only a business activity that motivates commercial companies, but also is present in nonprofit social organizations and is used to promote cultural issues.

11. The core of marketing communications is based on linear communication models such as that of Lasswell (1948), Osgood and Schramm (1954), Gerbner (1962), Shannon-Weaver (1949), Berlo S-M-C-R Model (1960), and Maletzke (1987). These models present different variables that emphasize the complexity of communication—for example, the clutter issue, which is the main reason for the "noise" phenomena that creates difficulties in decoding meaning. Various factors affect communication, such as the influence of humor on the viewer's response to an ad, or a consumer's stance vis-à-vis the brand. In addition to the linear models, there are the semiotic models of communication that shifted attention from the communication process to the message format, its content, and the various interpretations reached, depending on society and context.

12. Daniel O'Keefe, *Persuasion: Theory and Research* (Thousand Oaks, CA: Sage Publications, 2002), 2.

13. The market is divided into four groups of buyers: consumers (individuals buying products), the institutional market (commercial companies purchasing products and services), the public market (government agencies and organizations purchasing products), and intermediaries (wholesalers and distributers). The method of persuasion varies according to the nature of the industry (food or vehicle) and the product life-cycle phase (market penetration phase or a mature product).

14. Rhetoric was one of the three liberal arts (trivium), along with grammar and logic.

15. Aristotle, *The Art of Rhetoric*, trans. John Henry Freese (London, 1959), bk. 1, chap. 2; bk. 3, chap. 16. *Logos* is the subject matter of the speech, the words themselves and the logic on which the argument is based. *Ethos* implies reliability: reliability is associated with the speaker and his standpoint toward the subject matter. Reliability also concerns the speaker's personality as revealed in the media, or in other words the speaker's *ethos*. The speaker must convince his audience of his credibility. *Pathos* aims to change the minds of listeners via emotion. However, it is the audience that determines the emotional level of the speech. *Pathos* may be used as a means of rhetorical persuasion at times when logical persuasion is not possible or not desirable, or when the speaker seeks to arouse emotional empathy, which will strengthen the power of reasoning. Aristotle suggested three possible uses for *pathos*: metaphor, story, or a series of questions arousing curiosity. Aristotle believed that the speaker-listener relationship is no less important than the subject that they speak of. He believed that good rhetoric is not only convincing but also ethical. But Plato, being a philosopher who sought to discover the truth, criticized rhetoric, since conviction is manipulative and hides the truth. He even defined it as one of the four arts of lying. This view of rhetoric is also relevant to the current criticism of modern advertising, which claims that the form of persuasion in the ad is not ethical since it is wrapping products with manipulative images and words unrelated to the product, thus distancing the consumer from the truth about the product. See also Charles U. Larson, *Persuasion: Reception and Responsibility* (Belmont, CA: Wadsworth/Thomson Learning, 2001), 8–19.

16. In the printing workshop of the Bauhaus school under the management of Herbert Bayer and the support of László Moholy-Nagy, some of the constructivist approaches to graphic design were adopted and developed by using new techniques such as photomechanical process to replace the older letterpress. Under constructivist influence, Bayer created a new, universal sans serif font. The Tokyo ADC members, who all knew and loved Bayer's work, invited him to Tokyo after World War II.

17. Barthes 1977b, 33–51.

18. The persuasion motif in Omo brand advertisement is based on the ultimate product outcome test while being compared to competing detergents. The advertisement overloads the cleaning action with new values by presenting it as policing and not fighting. The detergent does not kill the dirt, but instead it is "forced out." The dirt is presented as a small enemy, weak and black, running away from the pure white clothes and thus releasing them from "circumstantial imperfection." In addition the advertisement gives the product two desirable values: the deep and foamy. The laundry and the clothing material are presented as deep, establishing the product as an object with "favorable tendencies to enfold and caress which are found in any human body." The foam presents the product as luxurious, causing the consumer to imagine the product as something airy and fluffy. The foam is considered pleasurable, and also shows how the concentrated product is able to multiply itself, becoming plentiful and of great power. In other words, the product can govern the molecular order of the clothes without damaging them. Giving such values to a daily consumer product up-

grades it from a cleaning product to a mythical one. See Roland Barthes, *Mythologies*, trans. Annette Lavers (Frogmore, Hertfordshire, UK: Paladin, 1973), 36–38.

19. Kanehisa Tching, "Légende de la potion magique à la gloire des salariés: Publicité du remontant 'Regain,'" in Kanehisa Tching, *Société et publicité nipponnes*, 5:1–26.

20. Many scholars explained the difficulty in understanding contemporary marketing processes via modernist models and presented new ways to understand the new reality. For example, Roger Dickinson described nineteen concepts standing at the heart of modern market research. Dickinson claims that it is impossible to find a common denominator between all marketing phenomena in order to generalize a theory for contemporary reality. Calvin Hodock showed how the culture of ratings and technological progress created a reality in which traditional ideas are not aware of true market needs, nor are they attuned to voice and image of the contemporary customer. See S. Brown 1995, 43–63.

21. Research in persuasion studied the psychological foundations of the viewers and how they influence the decision-making process. The consistency theory, for example, shows how the desire for consistency and order in the human soul is a major factor in behavior building, and thus influences the process of accepting external opinion. A group of Yale researchers investigated the reliability of information sources and fear appeal, and its impact on the persuasive process. See Garth Jowett and Victoria O'Donnell, *Propaganda and Persuasion* (Thousand Oaks, CA: Sage Publications, 1999), 166–79. The mass media discipline introduced a theory of exposure learning that showed wide exposure as a learning element and thus a persuasion element. It would seem, then, that persuasive media—advertising—is being studied from multiple perspectives. See Erwin Bettinghaus and Cody Michael, *Persuasive Communication* (Fort Worth, TX: Harcourt Brace College Publishers, 1994), 4–7.

22. According to government statistics, in 1992, employees in Japan still worked 43.3 hours a week, as opposed to 42 in the United States and 39.8 in France.

23. After the 1985 signing of the Plaza Agreement, the Japanese government began to divert its resources from import to local production. The yen-dollar exchange rate strengthened Japan's exports, triggering an expansionist monetary policy that created the Japanese economic bubble. In February 1987, the Louvre Accord was signed by the G-5 in an attempt to stabilize exchange rates. This indirectly resulted in a stock market collapse in Hong Kong and New York. Japan's large investors (commercial companies and banks) were concerned about their market investments in the Tokyo Stock Exchange. To mitigate this risk, they turned their eyes toward domestic real estate, pushing real estate prices up to unrealistic levels. The government went to great measures to reduce prices of real estate and products artificially, but the Gulf War in 1991 caused a spike in crude oil prices, with prices across the economy following suit. The Japanese GNP rose by 56 percent, and disposable income levels per capita reached that of Europe. Later in the 1990s, Japan surpassed the per capita disposable income of the United States as well.

24. Makoto Akabane and Saitō Maki, "Du matériel au spirituel—changement de société au Japon et son reflet dans la publicité après l'effondrement de la bulle speculative," in Kanehisa Tching, *Société et publicité nipponnes*, 3:1–28.

25. Akabane measured in 1990: 40 percent extraneous and unnecessary shopping, 36 percent impulsive shopping, and 24 percent capricious shopping. See Akabane and Saitō 2002, 4.

26. Clammer 1997, 69-70.

27. Ivy 1989, 440-42.

28. The advertisements on television and the new media mix were embraced warmly by the audience at large. Words such as *sorenarini* (in his way) became a fashionable idiom on Japanese streets.

29. Clammer describes the Japanese as "informaniacs"—*informaniaku*. See Clammer 1997.

30. Amano Yukichi, "Design Clichés Hinder New Style in Japanese Advertising," *Asian Advertising & Marketing*, 1986, 38-40.

31. Ibid.

32. Mary Douglas and Baron Isherwood, *The World of Goods* (London: Routledge, 1996), 57-76.

33. Arjun Appadurai, *Modernity at Large* (Minneapolis: University of Minnesota Press, 1996), 83-85.

34. Stuart Ewen, *All Consuming Images: The Politics of Style in Contemporary Culture* (New York: Basic Books, 1999), 157.

35. Arthur J. Pulos, *American Design Ethic: A History of Industrial Design* (Cambridge, MA: MIT Press, 1983), 357-58.

36. Jean Baudrillard, *For a Critique of the Political Economy of the Sign*, trans. Charles Levin (St. Louis: Telos Press, 1981), 30, and note 4.

37. Moeran presents four values: (1) use value (*jitsuyo kachi*), given to a product by the manufacturer, consumer, or intermediary (ad agencies, marketers, sales people); (2) craft or technical value (*gijutsu kachi*), the technical values linked to production processes yet originating from the knowledge, the need, and the method of utilization by the different customers; (3) appreciative value (*hyoka kachi*), stating an aesthetic evaluation or any other product evaluation, in a cultural or a specific social context; and (4) social value (*shakai kachi*), presenting culture-specific values attached to products (e.g., clothing testifying to status in India) or a social value assigned to a product through advertising (e.g., using a celebrity to transfer the social reputation of the persona to the product); Moeran 1996a, 292-96.

38. Clammer 1997, 106-7.

39. Baudrillard 1981, 146-47.

40. Robert Goldman and Stephen Papson, *Sign Wars: The Cluttered Landscape of Advertising* (New York: Guilford Press, 1996), 5-8.

41. Baudrillard 1981, 146-47; Baudrillard 1998, 87-98.

42. Jean Baudrillard, *The Consumer Society, Myth and Structures* (London: Sage Publications, 1998 [1970]), 92-96; Kashiwagi 1993, 14-15; Goldman and Papson 1996, 194-97.

43. Claude Lévi-Strauss, *Totemism* (Boston: Beacon Press, 1963), 56-62; Williamson 1978, 45-50; Baudrillard 1998, 79.

44. Clammer 1997, 68-84.

45. Ewen 1999, 71.

46. Pierre Bourdieu, *Distinction: A Social Critique of the Judgement of Taste* (Cambridge, MA: Harvard University Press, 1984), 6; 169–225; he argues that "the producers are led by the logic of competition with other producers and by the specific interests linked to their position . . . to produce distinct products which meet the different cultural interests," 230–35. He also deals with the distinction of taste between the upper and lower classes in their attitudes to art and cultural consumption, 260–95. Note that Bourdieu is discussing the French social classes. Japanese society does not have the same class distinctions, though it is a hierarchical society, with much importance put on gaining social status. For example, Japanese view the value of education in a parallel manner to the cultural capital that Bourdieu speaks of. On the meaning of "habitus" see Richard Jenkins, *Pierre Bourdieu* (London: Routledge, 1992), 74–84. See also Sturken and Cartwright 2001, 227–28; Clammer 1997, 46–50.

47. Studies such as that of Philip G. Zimbardo and Michael R. Leippe explained that attitude and consumer behavior are linked to various parts of the behavioral system that reference the product and the complexity of the persuasion process: Zimbardo and Leippe, *The Psychology of Attitude Change and Social Influence* (New York: McGraw-Hill, 1991).

48. Ōtuska Eiji, "World and Variation: The Reproduction and Consumption of Narrative, Mechademia," vol. 5 (Fanthropologies) (Minneapolis: University of Minnesota Press, 2010), 104.

49. This positions it differently from similar products that usually have a colorful style, and from other *kamidana*-style altars (domestic Shinto altars).

50. Clammer argues that "differentiation through acts of consumption has become the primary means of locating and distinguishing oneself in contemporary Japan." Note that the new segmentation via style and fashion occurred mainly in the major cities of Japan (especially Tokyo), which developed a global urban culture. See Clammer 1997, 68–84.

51. Bourdieu explains that the denial of natural enjoyment and defining it as low, coarse, vulgar, venal, and servile implied an affirmation of the superiority of those who could be satisfied with the sublimated and refined. In this way, art and cultural consumption fulfilled a social function of legitimating social differences. See Bourdieu 1984, 5–7. However, we must also remember that Bourdieu speaks of values of European society, in which low-high differentiation is inherited from the Judeo-Christian tradition. These values changed in Europe as well in the 1960s, but they still represented the core foundation for differentiation. In Japan, low-high values and moral differentiation are significantly different than in Europe.

52. Richard Thornton quotes Stephen Bayley from *The Conran Directory of Design*, saying: "Japanese product design remained, and still is, deficient in ergonomics, and emphatic in expression and in emotive appeals to consumer psychology." See Thornton 1991, 165. On the importance of emotion in the context of consuming see Clammer 1997, 163–64.

53. Williamson argues that the advertisement creates a meta-structure that supplies rules regarding the relationship between the product system and reference system

within the same "frame." It gives the product meaning, establishing differentiation. She presents as an example the ads for Chanel No. 5 starring Catherine Deneuve, which transferred the image of French chic, as compared to Babe, a perfume with Margaux Hemingway appearing in its ads, transferring a youthful, sporty, active, and even male image. See Williamson 1978, 100.

54. Shimizu Keiichirō, "Advertising Language Becomes the Language of the Era: The 1980s," in *Advertising History, 1950–1990*, exhibition catalog (Tokyo: East Japan Railway Culture Foundation, 1993), 136.

55. For example, in 1991 (a peak year of the economic bubble) Hitachi Ltd. reached a record of advertising expenditure: 53 billion yen (US$366 million). See Campbell and Noble 1996, 9.

56. Virginia Postrel emphasizes the difference between modern and postmodern aesthetics: see *The Substance of Style* (London: HarperCollins, 2003), 34–65.

57. Jameson 1991, 1–16.

58. Messaris 1997, xviii, 219–25, 273–74.

59. Williamson 1978, 60–62.

60. "L'homme est renvoyé à l'incohérence par la cohérence de sa projection structurale. Face à l'objet fonctionnel et subjectif, une forme vide et ouverte alors aux mythes fonctionnels, aux projections phantasmatiques liés à cette efficience stupéfiante du monde." See Baudrillard, *Le système des objets* (Paris: Gallimard, 1968), 69.

61. Clammer 1997, 68–71.

62. Maggie Kinser Hohle, "Muji Creative Director, Kenya Hara," in *Theme*, no. 3 (Fall 2005). See online article http://www.thememagazine.com/stories/muji -kenya-hara/.

63. Quote from an interview with Hara Kenya, July 22, 2010. On the theme of "emptiness" see also Ikegami 1991, 10–12.

64. Kinser Hohle 2005.

6. CREATIVE INDUSTRY PROCESS AND STRUCTURE

1. Caves 2000, 2–17.

2. See Chapter 1.

3. Quote from an interview with Yamamura Naoko on July 6, 2005.

4. This type of indirect messaging is not new in Japan. Marilyn Ivy claims that the "Discover Japan" campaign in the 1970s addressed a male target audience, but via women. The advertising team wanted to persuade the Japanese to use the train when going on a vacation in Japan, and concluded that young women, more so than men, have the time and the desire to travel. Their belief was that if women could be encouraged to travel, then after they married, they would convince their husbands to travel as well. The advertisements addressed women and made them the seduction mediators for attracting the real target audience—the man, who has financial means. See Ivy 1995, 39–40.

5. Brian Moeran, "Japanese Advertising Discourse: Reconstructing Images," in *Exploring Japaneseness*, ed. Ray T. Danahue (Westport, CT: Ablex Publishing, 2002), 393.

6. Campbell and Noble 1996, 9.

7. Moeran explains different types of space transactions that were handled by the agencies. See Moeran 1996a, 9-10.

8. Among the earliest products to be advertised in Japan in the early twentieth century were cosmetics and toiletries (such as those of Kao and Shiseido). See Gennifer Weisenfeld 2004, "'From Baby's First Bath': Kao Soap and Modern Japanese Commercial Design," *Art Bulletin* 86, no. 3 (September 2004): 573-98.

9. Shimamura Kazue and Ishizaki Tooru, *The History of Advertising Research in Japan* (Tokyo: Dentsu, 1997), 235.

10. During World War II, the advertising world as well as the media was drafted to the Japanese propaganda department.

11. Ben-Ami Shillony, *Modern Japan: Culture and History* (Tel Aviv: Schocken, 1997), 89 (Hebrew).

12. Ibid., 256-57.

13. For example, in 1990, 4,858 ad agencies were registered in Japan, but most were very small, with 87 percent of the agencies having fewer than thirty employees, and the top five agencies holding 37 percent market share. By 2010, the number of agencies grew to 7,567 (2,194 in Tokyo, 829 in Osaka, 503 in Aichi), with only 151 agencies (2 percent) having more than one hundred employees. The average number of employees per agency is eighteen. See Campbell and Noble 1996, 12; Nihon koukokugyou kyoukai kyouiku seminar iinkai, *Koukoku bijinesu nyumon*, nihon Koukokugyou Kyoukai, 2010, 4. Based on Survey of Selected Service Industries 2008 by the Ministry of Economy (Heisei 20 nen tokutei Service Sangyo Jittai Chosa Houkokusho, Keizai Sangyo Sho).

14. Dai Ichi Kikaku merged with Asatsu in 1999 and formed Asatsu-DK Inc., the third-largest advertising agency in Japan.

15. Moeran 1996a, 19; Eleanor Westney, "Mass Media as Business Organization: A US-Japan Comparison," in *Media and Politics in Japan*, ed. S. Pharr and E. Krauss (Honolulu: University of Hawai'i Press, 1996), 47-88.

16. David Kilburn, "Advertising in Japan: Structural Differences," *Journal of Japanese Trade & Industry* (Autumn 1989): 20-22, http://www2.gol.com/users/kilburn/structure.htm.

17. Moeran 1996a, 259-60.

18. Moeran 2002, 392-93.

19. Moeran 1996a, 46-48.

20. Ueno 1998, 195.

21. Johny K. Johansson, "The Sense of 'Nonsense': Japanese TV Advertising," *Journal of Advertising* 23, no. 1 (March 1994): 17-26.

22. From an interview with Nakashima Shōbun, Tokyo ADC former president, July 4, 2005.

23. From the 1776 book *Seiro bijin awase sugata kagami* (literally, The appearance of the beautiful collection of green houses), illustrated by Katsukawa Shunshō and Kitao Shigemasa. The book is a collection of pictures that served as advertisements for the pleasure houses of the period. See also Kitagawa Utamaro's books *Seiro junitoki*

(The twelve hours of the green houses), 1794, and *Seiro ehon nenju gyoji* (Annals of the green houses), 1804; see Clark 1995, 35-55.

24. Campbell and Noble 1996, 474-75.

25. Ibid.

26. Pollack 2003, 71-88.

27. Allan Weill, "Makoto Saitō: The Image Maker," *Graphis: The International Journal of Design and Communication* 58, no. 341 (September-October 2002), 32-33.

28. Quote from an interview with Toda Seijū, July 27, 2005.

29. Nagai references Edward T. Hall's expression "high-context culture." Hall explained that "meaning and context are inextricably bound up with each other." According to Hall, high-context transactions involve implying a message through that which is not spoken; messages include other communication cues such as body language, eye movement, para-verbal cues, and the use of silence. Japan, according to Hall, is a high-context culture in which even sentences often lack key elements, and words become evident from context. See Hall, "Context and Meaning," in *Intercultural Communication: A Reader*, ed. Larry A. Samovar and R. E. Porter (Belmont, CA: Wadsworth Publishing, 2000), 36.

30. Quote from an interview with Nagai Kazufumi in his offices, July 6, 2005.

7. GLOBAL ADVERTISING DESIGN AND JAPAN

1. The Benetton advertising campaign was using this documentary photograph from Corbis Images (photographed by Patrick Robert) and added its slogan "United colors of Benetton" to create its advertisement. The actual advertisement can be seen in Marita Sturken and Lisa Cartwright, *Practices of Looking: An Introduction to Visual Culture* (Oxford: Oxford University Press, 2001), 231-32.

2. The color of his skin and the absence of a uniform, combined with the allusion to tribalism provided by the bone, play on cultural associations pertaining to Africa. At the same time, the ad does not provide the viewer with any definitive clues concerning the fighter's identity or location. The Benetton website did not further elaborate upon the context of this image, presenting it as "the image of a black soldier who, taken from behind with a Kalashnikov slung over his shoulder, clasps a human thigh-bone representing a terrible vision that arouses anxious questions about colonialism, racism and cultural poverty."

3. Sturken and Cartwright 2001, 275.

4. The original title on the Corbis Images website is *Civil War in Liberia.* The accompanying text states: "A young recruit for the National Patriotic Front of Liberia (NPFL) grasps a human leg bone while at a training camp in Gborplay, Liberia. Responding to years of government corruption and oppression, in 1989 the NPFL launched a revolt against President Samuel Doe, seizing control of much of Liberia and plunging the country into a massive civil war until 1996."

5. Moeran 1996a, 285.

6. Although the postmodern period and the new advertising began in the 1970s,

the following chapter starts off in the 1980s because this work focuses mainly on the advertising that grew within the economic bubble of the 1980s.

7. From an interview published on the company's website, http://press.benetton group.com/ben_en/about/campaigns/list/.

8. In 1989 Benetton released its provocative campaign called "We, on death row," showing twenty-eight inmates in American prisons who were sentenced to death. Responses were heated. The Sears department store, which represented four hundred Benetton stores, canceled its contract with them. Even the prisoners themselves sued Oliviero Toscani, who photographed the Benetton campaign, for misleading them. Toscani was forced to resign.

9. The revolutionary idea, referred to as anti-ads, earned this campaign many prestigious prizes, including the UNESCO Grand Prix and the New York Art Directors Club prize. The campaign achieved its goal of attracting attention and turning Benetton into a more global name than any other fashion brand, reaching a recognition level close to those of Coca-Cola and McDonalds. In 1995 Oliviero Toscani opened an exhibition titled *Benetton by Toscani* in the Contemporary Art Museum in Lausanne, showing ads from twelve years of Benetton campaigns.

10. Sturken and Cartwright 2001, 272.

11. Noguchi Isamu, "New York Mood-o," in Ishioka Eiko, *Eiko by Eiko* (San Francisco: Chronicle Books, 1990).

12. Sturken and Cartwright 2001, 276.

13. Clammer 1997, 40-50.

14. In the 1980s, the salaries of the young women still living with their parents turned them into the richest sector in Japan and one of the richest groups in the world. They began to devote themselves to the pleasures of consumption of brands in order to build their identity and their new lifestyle with an emphasis on their individuality. Alongside this, the consumption patterns of men who for years were rapt in work also changed. Men, like women, began to take pleasure in leisure and brands. In the 1980s, the *sarariman* workforce of the commercial companies was targeted by industries that produced cars, fashion, electronics, golf gear, as well as by after-work clubs and even aesthetic clubs. This targeted subgroup formed around a specific dress code, haircuts, certain magazines, specific consumer products, and recreation habits. See Kelsky 2001, 81; Skov and Moeran 1995, 27-37; Clammer 1997, 41.

15. Shimizu 1993a, 136. This is the second golden age of advertising in postwar Japan.

16. Marshall McLuhan, *Understanding Media: The Extensions of Man* (Cambridge, MA: MIT Press, 1994), 226-34.

17. Shimizu 1993a, 136.

18. Aoki Sadashige 2002, 10.

19. This generation of designers is often called "the third generation" since it was the first generation born after World War II. They started their professional careers during the 1980s. Thornton 1991, 186.

20. Kanehisa 1983, 998-1001.

21. Valentine's Day was promoted by Morozoff Ltd., a Kobe-based chocolate company. See Katherine Rupp, *Gift-Giving in Japan: Cash, Connections, Cosmologies* (Palo Alto, CA: Stanford University Press, 2003), 149–51.

22. Moeran 2002, 389.

23. Before the war, it was more customary to give companies and products Japanese names. Even the Western-sounding name "Canon" was taken from the Buddhist goddess of mercy. The name was chosen in 1934 by the founder, Yoshida Goro.

24. Tanaka Keiko, *Advertising Language: A Pragmatic Approach to Advertisement in Britain and Japan* (London: Routledge, 1994), 61–64.

25. John Clammer, "Consuming Bodies: Constructing and Representing of the Female Body in Contemporary Japanese Print Media," in *Woman, Media and Consumption in Japan*, ed. Lise Skov and Brian Moeran (Honolulu: University of Hawai'i Press, 1995), 213; Moeran 2002, 391.

26. William O'Barr, *Culture and the Ad: Exploring Otherness in the World of Advertising* (Boulder, CO: Westview Press, 1994), 176.

27. The TV commercials can be seen at www.japander.com.

28. Shimizu 1993a, 134.

8. LOCAL AND GLOCAL ADVERTISING DESIGN

1. Akabane and Saitō 2002, 5.

2. For example, the high-end men's boutiques like Aoyama, Aoki and Konaka organized together and cut out middleman costs, leading to a significant reduction in consumer price. See Akabane and Saitō 2002, 6.

3. Corporate structural reforms drastically cut down working hours per week from 43.1 in 1988 to 39 in 1994. By 1996, 59.3 percent of employees changed to a shortened five-day workweek. See Akabane and Saitō 2002, 5.

4. Managerial concepts of the large conglomerates and traditional companies, such as lifelong employment, advancement and compensation according to seniority, and a total commitment of the employee to the company and the company to the employee, which were considered eternal, changed during the 1990s; see Aoki Masahiko 2002.

5. Quote from an interview with Nagai Kazufumi in his offices, July 6, 2005.

6. Hara Kenya, *White* (Zurich: Lars Müller, 2009), 8.

7. Men's recreation style shifted to watching football (J-League), quality time spent with the family, and reading new men's magazines such as *Rapita*, *Ikkojin*, and *Jiyujin*, whose content is associated with leisure, sports, fashion, and male aesthetics. See Sakai Junko, "The Emergence of Men's Magazines," in *Japanese Book News*, no. 38 (Summer 2002), 4–5.

8. In 1997, 16.8 million people traveled abroad. This represents 14 percent of all Japanese citizens, 4.2 times the number of travelers in 1981.

9. Expenditures on clothing in Japan jumped in a two-year period, going from 376.6 billion yen in 1988 to 826.5 billion yen in 1990. See Akabane and Saitō 2002, 3.

10. Thornton 1991, 179.

11. Moeran claims that Japanese advertising is influenced by Western genres that

divide the body: feet are used to show shoes or socks, hands to advertise rings, and hair for shampoo.

12. The arm hanging loosely reminds us of Christ's arm in the *Pieta* of Michelangelo of 1449 and the same posture of Marat's arm in *La mort de Marat* by Jacques-Louis David of 1793.

13. See Suzuki Kyōichi, *Kidaore Hōjōki—Happy Victims* (Kyoto: Seigensha, 2008). The fashion-victim subject is discussed in this book, which was photographed in Tokyo. The book shows various fashion collectors who dedicate their entire apartments to their collections, similarly to art collectors in other countries.

14. Tattoos in Japan are divided into two types: *irezumi* and *tatoo*. *Irezumi* has traditional Japanese visual subjects and can be seen on *yakuza* members, while *tatoo* has Western visual subjects (dolphins, unicorns, flowers, and so on). Western-style tattoos are found on many Japanese youth. The tattoo in the ad is of this type, and it even appears somewhat like a brand tag on clothing.

15. Mizuno Hirozuke, "Style de vie et publicité au Japon dans les années 90," in Kanehisa Tching, *Société et publicité nipponnes*, 4:12.

16. Akabane and Saitō 2002, 7–8.

17. In 2010, the government published statistics showing that the number of children under fifteen years of age dropped to 16.9 million, or 13.3 percent of the population—the lowest proportion ever documented in Japan. According to this statistic, among twenty-seven countries with a population over forty million, Japan has the lowest percentage of children.

18. Yoshinaga Haruyuki, "Communication publicitaire des collectivités locales au Japon," in Kanehisa Tching, *Société et publicité nipponnes*, 9:3.

19. Named after the Ei Rokusuke best seller called *Owari: Dai ojo sonogo* (A peaceful death).

20. Mizuno 2002, 14.

21. Fukuda 2002a, 2–3.

22. For a broader discussion on postmodern Japan, how its new identity is built via appropriation of premodern elements (folklore, regional art, history, and mythology), and the invention of a local identity see Iwatake Mikako, *The Tokyo Renaissance: Constructing a Postmodern Identity in Contemporary Japan* (unpublished PhD diss., University of Pennsylvania, 1993). See electronic dissertations http://repository.upenn.edu/dissertations/AAI9413854/.

23. Shimizu 1993a, 134. That this trend was pioneered in the 1980s by the "Exotic Japan" campaign of Japan Railway see Ivy 1995, 48–59.

24. Fukuda 2002, 7–9.

25. Machimura Takashi, "The Urban Restructuring Process in Tokyo in 1980s: Transforming Tokyo into a World City," in *The Global Cities Reader*, ed. Neil Brenner and Roger Keil (London: Routledge, 2006), 151–52.

26. The policy of city branding via building a local identity was seen in many other cities at the time, as with the I ♥ NY campaign.

27. In 1985 there were only one million PCs, as opposed to six million in 1995. In 1989 there were 240 cellular phones, as opposed to 4.3 million in 1995.

28. In 2011, there were 99 million users (75 million of them cellular Internet users) out of a total of 126 million residents. For more information on the development of the cellular telephone industry in Japan see Akabane and Saitō 2002, 7.

29. In 2005 the government announced 3.55 million blogs, and in 2006 there were already 8.68 million blogs. Rakuten, an Internet service provider, reported that many blogs in Japan address women who are happy to express themselves without restrictions and to read and interact with other women regarding feelings.

30. This is in sharp contrast to the United States, where 60 percent of Internet users are on Facebook, according to the analytics site Socialbakers. See Tabuchi Hiroko, "Facebook Wins Relatively Few Friends in Japan," *New York Times*, January 9, 2011.

31. As a result of Parco's financial troubles associated with the bursting of Japan's bubble economy, the Mori Trust Group became the largest Parco stockholder in 2001. The new advertising campaign clearly relates, at least partially, to Parco's identity "conversation" with its new ownership, recognizing the fact that the company's target audience is not only the end consumer but also its stockholders. According to Sato Toyoko, this campaign appeared to be necessary in response to Parco's positional change in the Tokyo Stock Market. The ad was an expression of the identity of a new Parco speaking for transparency in regard to who it is, where it is going, and how it wishes to be seen by others. Sato Toyoko 2010, 55.

Aaker, David. 1991. *Managing Brand Equity: Capitalizing on the Value of a Brand Name*. New York: Free Press.

Adamson, Glenn, and Jane Pavitt. 2011. *Postmodernism: Style and Subversion, 1970–1990*. Exhibition catalog. London: V&A Publishing.

ADSEC (Advertising Semiotic Circle), ed. 1984. *Ushi-Tako-Sacchan: Kokouku o Meguru Kigoron Battle-Royal*. Tokyo: Senden Kaigi.

Akabane Makoto and Saitō Maki. 2002. "Du matériel au spirituel—changement de société au Japon et son reflet dans la publicité après l'effondrement de la bulle speculative." In *Société et publicité nipponnes*, edited by Kanehisa Tching, 3:1–28. Paris: Éditions You-Feng.

Alexander, James R. 2003. "Obscenity, Pornography, and the Law in Japan: Reconsidering Oshima's *In the Realm of the Senses*." *Asian-Pacific Law & Policy Journal* 4, no. 1 (Winter 2003): 148–57.

Alpers, Svetlana. 1983. *The Art of Describing: Dutch Art in the Seventeenth Century*. Chicago: University of Chicago Press.

Amano Yukichi. 1986. "Design Clichés Hinder New Style in Japanese Advertising." *Asian Advertising & Marketing*, 38–40.

Antonelli, Paola. 2001. "Postmodern Angel: Shiro Kurama." In *Postmodernism: Style and Subversion, 1970–1990*, edited by Glenn Adamson and Jane Pavitt, 150–54. London: V&A Publishing.

Aoki Masahiko. 2002. "Japan in the Process of Institutional Change." In *Glocom Platform: Japanese Institute of Global Communications*. www.glocom.org/opinions /essays/200201_aoki_japan_process.

Aoki Sadashige. 2002. "Le 'paraître' publicitaire, de l'après-guerre à l'après 'Bulle.'" In Kanehisa Tching, *Société et publicité nipponnes*, 2:1–19.

Aoki Shoichi. 2001. *Fruits*. London: Phaidon.

Appadurai, Arjun. 1996. *Modernity at Large*. Minneapolis: University of Minnesota Press.

Aristotle. 1959. *The Art of Rhetoric*. London: John Henry Freese (trans.).

Arnheim, Rudolf. 1969. *Visual Thinking*. Berkeley: University of California Press.

——. 1974. *Art and Visual Perception: The Psychology of the Creative Eye*. London: Faber.

——. 1982. *The Power of the Center: A Study of Composition in the Visual Arts*. Berkeley: University of California Press.

Baker, Michael J., and Susan J. Hart. 1989. *Marketing and Competitive Success.* London: Philip Allan Publishers.

Bartal, Ory. 2009. "Vagina Dialogues: The 'Love Mother Earth' Advertisement by Saitō Makoto." In *PostGender: Gender, Sexuality and Performativity in Japanese Culture*, edited by Zohar Ayelet, 81–104. Newcastle, UK: Cambridge Scholars Press.

———. 2013. "Text as Image in Japanese Advertising." *Design Issues* 29, no. 1. MIT Press.

Barthes, Roland. 1967. *Elements of Semiology.* London: Cape Publishing.

———. 1973. *Mythologies.* Translated by Annette Lavers. Frogmore, Hertfordshire, UK: Paladin Books.

———. 1976. *Système de la mode.* Paris: Éditions du Seuil.

———. 1977a (1964). "The Death of the Author." In Barthes, *Image–Music–Text*. Translated by Stephen Heath. London: Fontana Press, 142–48.

———. 1977b (1964). "The Rhetoric of the Image." In Barthes, *Image–Music–Text*, 33–51.

———. 1982. *Empire of Signs.* New York: Hill & Wang.

Bateson, Gregory, and Margaret Mead. 1942. *Balinese Character: A Photographic Analysis.* New York: New York Academy of Science.

Baudrillard, Jean. 1968. *Le système des objects.* Paris: Gallimard.

———. 1981. *For a Critique of the Political Economy of the Sign.* Translated with introduction by Charles Levin. St. Louis: Telos Press.

———. 1988. *Selected Writings.* Edited by Mark Poster. Stanford, CA: Stanford University Press.

———. 1998 (1970). *The Consumer Society: Myth and Structures.* London: Sage Publications.

Baxandall, Michael. 1972. *Painting and Experience in Fifteenth-Century Italy: A Primer in the Social History of Pictorial Style.* Oxford: Oxford University Press.

———. 1985. *Patterns of Intention: On the Historical Explanation of Pictures.* New Haven, CT: Yale University Press.

Beasley, Ron, Marcel Dansei, and Paul Perron. 2000. *Signs for Sale: An Outline of Semiotic Analysis for Advertising and Marketers.* New York: Legas.

Befu Harumi, 1980. "The Group Model of Japanese Society and an Alternative." *Rice Studies* 66, no. 1 (1980): 169–87.

Bell, Philip. 2001. "Content Analysis of Visual Images." In *Handbook of Visual Analysis*, edited by Theo Van Leeuwen and Carey Jewitt, 10–34. London: Sage Publications.

Benedict, Ruth. 1946. *The Chrysanthemum and the Sword: Patterns of Japanese Culture.* Boston: Houghton Mifflin Co.

Benefey, Stephen. 1996. "Japanese Advertising: The Soft Sell." In *Japan: An Illustrated Encyclopedia*, edited by A. Campbell and D. S. Noble, 10–11. Tokyo: Kodansha.

Berger, John. 1972. "Problems of Socialist Art." In *Radical Perspectives in Arts*, edited by Lee Baxandall, 209–44. Harmondsworth, UK: Penguin Books.

Bettinghaus, Erwin, and Michael Cody. 1994. *Persuasive Communication.* Fort Worth, TX: Harcourt Brace College Publishers.

Boorstin, Daniel. 1963. *The Image: Or, What Happened to the American Dream.* Harmondsworth, UK: Penguin Books.

Bourdieu, Pierre. 1984. *Distinction: A Social Critique of the Judgement of Taste.* Cambridge, MA: Harvard University Press.

Brandon, James R., trans. 1975. *Kabuki: Five Classic Plays.* Cambridge, MA: Harvard University Press.

Brennan, Marica. 2001. *Painting Gender, Constructing Theory: The Alfred Stieglitz Circle and American Formalist Aesthetics.* Cambridge, MA: MIT Press.

Brown, Kendall H. 2001. "Flowers of Taishō: Images of Woman in Japanese Society and Art, 1915-1935." In Kendell H. Brown and Sharon A. Minichiello, *Taishō Chic: Japanese Modernity, Nostalgia, and Deco.* Honolulu: Honolulu Academy of Arts.

——. 2013. *Deco Japan: Shaping Art and Culture, 1920-1945.* Alexandria, VA: Arts Services International.

Brown, Stephen. 1995. *Postmodern Marketing.* London: Routledge.

——. 1998. *Postmodern Marketing Two: Telling Tales.* London: International Thomson Business Press.

Bryson, Norman, and Mieke Bal. 1991. "Semiotics and Art History." *Art Bulletin* 73, no. 2 (June 1991): 174-208.

Burgin, Victor. 1996. *In Different Spaces: Place and Memory in Visual Culture.* Berkeley: University of California Press.

Burton, J. 1983. "Lintas Executive Learns Lesson in Compromise." *Advertising Age,* October.

Buruma, Ian. 1984. *Behind the Mask.* New York: Meridian Books.

Campbell, A., and D. S. Noble, eds. 1996. *Japan: An Illustrated Encyclopedia.* Tokyo: Kodansha.

Caruso, Thomas E. 1992. "Kotler: Future Marketers Will Focus on Customer Database to Compete Globally." *Marketing News* 8, no. 21 (June 1992): 21-22.

Caves, Richard E. 2000. *Creative Industries.* Cambridge, MA: Harvard University Press.

Christopher, Martin, Adrian Payne, and David Ballantyne. 1991. *Relationship Marketing.* Oxford: Butterworth-Heinemann.

Chong, Doryun. 2012. "Tokyo 1955-1970: A New Avant-Garde," in *Tokyo 1955-1970: A New Avant-Garde,* edited by Doryun Chong (New York: Museum of Modern Art, 2012).

Clammer, John. 1995. "Consuming Bodies: Constructing and Representing of the Female Body in Contemporary Japanese Print Media." In *Woman, Media and Consumption in Japan,* edited by Skov Lise and Brian Moeran, 197-219. Honolulu: University of Hawai'i Press.

——. 1997. *Contemporary Urban Japan: A Sociology of Consumption.* Oxford: Blackwell Publishers.

Clark, Timothy. 1995. "Utamaro and Yoshiwara: The 'Painter of the Green Houses' Reconsidered." In *The Passionate Art of Kitagawa Utamaro,* edited by Asano Shugo and Timothy Clark, 35-55. London: British Museum Publishing.

Colley, H. Russell. 1961. *Defining Advertising Goals for Measured Advertising Results.* New York: Association of National Advertisers.

Collier, Malcolm. 2001. "Approaches to Analysis in Visual Anthropology." In *Handbook of Visual Analysis*, edited by Theo Van Leeuwen and Carey Jewitt, 35-60. London: Sage Publications.

Condry, Ian. 2001. "Japanese Hip-Hop and the Globalization of Popular Culture." In *Urban Life: Readings in the Anthropology of the City*, edited by George Gmelch and Walter Zenner, 357-87. Prospect Heights, IL: Waveland Press.

Cook, Guy. 1992. *The Discourse of Advertising.* London: Routledge.

Cova, Bernard, and Christian Svanfeldt. 1992. "Marketing beyond Marketing in a Postmodern Europe: The Creation of Societal Innovations." in *Marketing for Europe—Marketing for the Future: Proceedings of the 21st Annual Conference of the European Marketing Academy*, edited by K. G. Grunert and D. Fuglede, 155-71. Aarhus, Denmark.

Crane, Dianna. 2000. *Fashion and Its Social Agendas: Class, Gender, and Identity in Clothing.* Chicago: University of Chicago Press.

Creighton, Millie R. 1995. "Imaging the Other in Japanese Advertising Campaigns." In *Occidentalism: Images of the West*, edited by J. Carrier, 134-60. Oxford: Clarendon Press.

Culler, Jonathan. 1983. *Barthes.* London: Fontana Paperbacks.

Dale, Peter. 1986. *The Myth of Japanese Uniqueness.* New York: St. Martin's Press.

Daliot-Bul, Michal. 2004. *Licensed to Play: Play and Playfulness in Japan.* Unpublished dissertation, Tel-Aviv University.

Danahue, Ray T. 2002. *Exploring Japaneseness.* Westport, CT: Ablex Publishing.

Danesi, Marcel. 1999. *Of Cigarettes, High Heels, and Other Interesting Things.* New York: St. Martin's Press.

Davies, John M. 1992. *The Essential Guide to Database Marketing.* John Fraser-Robinson Direct Marketing Series. London: McGraw-Hill.

Day, Barry. 1984. "The Advertising of Ambiguity." *Ad Magazine*, October 1984, 8-18.

Deleuze, Gilles, and Félix Guattari. 1987. *A Thousand Plateaus.* Minneapolis: University of Minnesota Press.

de Mann, Paul. 1986. "The Resistance to Theory." In *Theory and History of Literature*, 33:3-20. Minneapolis: University of Minnesota Press.

Dickinson, A. Roger. 1992. *The Myths of Marketing.* Unpublished manuscript.

Dickinson, A. Roger, Anthony Herbst, and John O'Shaughnessy. 1986. "Marketing Concept and Customer Orientation." *European Journal of Marketing* 20, no. 10 (1986): 18-23.

Diem-Wille, G. 2001. "Therapeutic Perspective: The Use of Drawing in Child Psychoanalysis and Social Science." In Van Leeuwen and Jewitt, *Handbook of Visual Analysis*, 119-33.

Dikovitskaya, Margaret. 2005. *Visual Culture: The Study of the Visual after the Cultural Turn.* Cambridge, MA: MIT Press.

Dingwall, Robert, Horoko Tanaka, and Satoshi Minamikata. 1991. "Images of Parenthood in the United Kingdom and Japan." *Sociology* 25, no. 3 (1991): 423-46.

Doi Takeo. 1973. *The Anatomy of Dependence.* Tokyo: Kodansha International.

Douglas, Mary, and Baron Isherwood 1996. *The World of Goods.* London: Routledge.

Dyer, Gillian. 1982. *Advertising as Communication*. London: Methuen.

Eco, Umberto. 1984 (1979). *The Role of the Reader: Explorations in the Semiotics of Texts*. Bloomington: Indiana University Press.

Economist. 1993. "The Enigma of Japanese Advertising." August 14, pp. 61–62.

Ekuan, Kenji. 1998. *The Aesthetics of the Japanese Lunchbox*. Cambridge, MA: MIT Press.

Eldredge, Charles C. 1991. *Georgia O'Keeffe: One Hundred Flowers*. New York: Harry N. Abrams.

Eskilson, Stephen. 2007. *Graphic Design: A New History*. New Haven, CT: Yale University Press.

Ewen, Stuart. 1999. *All Consuming Images: The Politics of Style in Contemporary Culture*. New York: Basic Books.

Featherstone, Mike. 1991. *Consumer Culture and Postmodernism*. London: Sage Publications.

Fields, George. 1983. *From Bonsai to Levi's: When West Meets East—An Insider's Surprising Account of How the Japanese Live*. New York: Macmillan.

———. 1988. *The Japanese Market Culture*. Tokyo: Japan Times.

Fiske, John. 1989. *Understanding Popular Culture*. London: Routledge.

———. 1997. *Reading the Popular*. London: Routledge.

Florida, Richard. 2002. *The Rise of the Creative Class: And How It's Transforming Work, Leisure, Community, and Everyday Life*. New York: Basic Books.

Forceville, Charles. 1996. *Pictorial Metaphor in Advertising*. London: Routledge.

Foucault, Michel. 2002 (1969). *The Archaeology of Knowledge*. Translated by A. M. Sheridan Smith. London: Routledge.

Fowles, Jib. 1996. *Advertising and Popular Language*. London: Sage Publications.

Fox, Stephen. 1990. *The Mirror Makers: A History of American Advertising*. London: Heinemann.

Freud, Sigmund. 1953. "The Interpretation of Dreams" (1900–1901). In *The Standard Edition of the Complete Psychological Works of Sigmund Freud*, vols. 4–5, edited and translated by James Strachey. London: Hogarth Press.

———. 1963. "The Uncanny." In Strachey, *Complete Psychological Works of Sigmund Freud*, vol. 17.

———. 1991. *Introductory Lectures on Psychoanalysis*. London: Penguin Books.

Fried, Michael. 1990. *Courbet's Realism*. Chicago: University of Chicago Press.

Fukuda Kunio. 2000. "The Colors of Japan (The Hierarchy of Colors)." In *The Colors of Japan*, edited by Hibi Sadao, 97–101. Tokyo: Kodansha International.

Fukuda Toshihiko. 2002a. "Décentralisation et communications des collectivités locales au Japon." In Kanehisa Tching, *Société et publicité nipponnes*, 8:1–16.

———. 2002b. "La charte de communication des entreprises japonaises." In Kanehisa Tching, *Société et publicité nipponnes*, 6:1–19.

Gill, Alison. 1988. "Deconstruction Fashion: The Making of Unfinished, Decomposing and Re-assembled Clothes." *Fashion Theory: The Journal of Dress, Body and Culture* 2, no. 1: 25–49.

Glaser, Barney, and Anselm Strauss. 1967. *The Discovery of Grounded Theory: Strategies for Qualitative Research*. Chicago: Aldine De Gruyter.

Goffman, Erving. 1979. *Gender Advertisements*. London: Macmillan.

Golden, Jeremy. 1986. "Mood Advertising Pioneer Agitates Images, Stimulates Minds." *Asian Advertising & Marketing*, 61-63.

Goldman, Robert, and Stephen Papson. 1996. *Sign Wars: The Cluttered Landscape of Advertising*. New York: Guilford Press.

Gombrich, Ernst. 1972. *Art and Illusion: A Study in Psychology of Pictorial Representation*. Princeton, NJ: Princeton University Press.

Goodman, David. 1999. *Angura: Posters of the Japanese Avant-Garde*. New York: Princeton Architectural Press.

Greetz, Clifford. 1973. *The Interpretation of Cultures*. New York: Basic Books.

Gubrium, Jaber, and James Holstein. 1997. *The New Language of Qualitative Method*. Oxford: Oxford University Press.

Hagen, Rose-Marie, and Rainer Hagen. 2003. *What Great Paintings Say*. Cologne: Taschen.

Hall, Edward T. 1989. *Beyond Culture*. New York: Doubleday.

——. 1990. *The Silent Language*. New York: Doubleday.

——. 2000. "Context and Meaning." In *Intercultural Communication: A Reader*, edited by Larry A. Samovar and R. E. Porter, 34-42. Belmont, CA: Wadsworth Publishing.

Halliday, M. K. 1978. *Language as Social Semiotic: The Social Interpretation of Language and Meaning*. London: Open University Press.

——. 1985. *An Introduction to Functional Grammar*. London: Edward Arnold Publishing.

Hara, Kenya. 2009. *White*. Zurich: Lars Müller.

Hayashi Michio. 2012. "Tracing the Graphics in Postwar Japanese Art." In *Tokyo 1955-1970: A New Avant-Garde*, edited by Chong Dotyun, 94-120. New York: Museum of Modern Art.

Herbig, Paul. 1995. *Marketing Japanese Style*. London: Quorum Books.

Heywood, Ian, and Barry Sandywell, eds. 1998. *Interpreting Visual Culture: Explorations in the Hermeneutics of the Vision*. New York: Routledge.

Hodge, Robert, and Gunther Kress. 1988. *Social Semiotics*. Cambridge: Polity Press.

Hodock, Calvin I. 1991. "The Decline and Fall of Marketing Research in Corporate America." *Marketing Research*, June, 12-22.

Hofmann, Werner. 2000. *Caspar David Friedrich*. London: Thames & Hudson.

Holly, Michael Ann. 1996. *Past Looking: Historical Imagination and the Rhetoric of the Image*. Ithaca, NY: Cornell University Press.

Holly, Michael Ann, Norman Bryson, and Keith Moxey, eds. 1994. *Visual Culture: Images and Interpretations*. Hanover, NH: University Press of New England.

Hong, Jae, Aydin Muderrisoglu, and George Zinkhan. 1987. "Cultural Differences and Advertising Expressions: A Comparative Content Analysis of Japanese and U.S. Magazine Advertising." *Journal of Advertising* 16, no. 1 (1987): 55-68.

Hutchinson, Sally A. 1988. "Education and Grounded Theory." In *Qualitative Research in Education: Focus and Methods*, edited by Robert R. Sherman and Rodman B. Webb, 123-40. London: Falmer.

Ihab, Hassan. 2001. "From Postmodernism to Postmodernity: The Local/Global Context." *Philosophy and Literature* 25, no. 1 (April 2001): 1–13. www.ihabhassan.com/postmodernism_to_postmodernity.htm.

Ikegami Yoshiko, ed. 1991. *The Empire of Signs: Semiotic Essays on Japanese Culture.* Amsterdam: John Benjamins Publishing Co.

Ince, Catherine, and Rei Nii, eds. 2011. *Future Beauty: 30 Years of Japanese Fashion.* London: Merrell.

Ishioka Eiko. 1990. *Eiko by Eiko.* San Francisco: Chronicle Books.

Ito Ruri. 2008. "The 'Modern Girl' Question in the Periphery of Empire: Colonial Modernity and Mobility among Okinawan Women in the 1920s and 1930s." In *The Modern Girl around the World: Consumption, Modernity, and Globalization*, edited by Alys Eve Weinbaum, Lynn M. Thomas, Priti Ramamurthy, Uta G. Poiger, Madeleine Yue Dong, and Tani E. Barlow, 240–62. Durham, NC: Duke Univeristy Press.

Ivy, Marilyn. 1989. "Critical Texts, Mass Artifacts: The Consumption of Knowledge in Postmodern Japan." In *Postmodernism and Japan*, edited by H. D. Harootunian and Masao Miyoshi, 21–46. Durham, NC: Duke University Press.

——. 1993. "Formations of Mass Culture." In *Japan as Post-war History*, edited by Andrew Gordon, 239–58. Berkeley: University of California Press.

——. 1995. *Discourses of the Vanishing: Modernity, Phantasm, Japan.* Chicago: University of Chicago Press.

Iwabuchi Koichi. 1994. "Complicit Exoticism: Japan and Its Other." *Continuum: The Australian Journal of Media and Popular Culture* 8, no. 2 (1994): 49–82.

Iwatake Mikako. 1993. *The Tokyo Renaissance: Constructing a Postmodern Identity in Contemporary Japan.* Unpublished PhD dissertation, University of Pennsylvania. See electronic dissertations, http://repository.upenn.edu/dissertations/AAI9413854/.

Jameson, Fredric. 1991. *Postmodernism: Or, the Cultural Logic of Late Capitalism.* Durham, NC: Duke University Press.

——. 1998. *The Cultural Turn: Selected Writings on the Postmodern, 1983–1998.* London: Verso.

Jewitt, Carey, and Rumiko Ōyama. 2001. "Visual Meaning: Social Semiotic Approach." In Van Leeuwen and Carey, *Handbook of Visual Analysis*, 134–56.

Jhally, Sut. 1990. *The Codes of Advertising.* London: Routledge.

Johansson, Johny K. 1994. "The Sense of 'Nonsense': Japanese TV Advertising." *Journal of Advertising* 23, no. 1 (March 1994): 17–26.

Jowett, Garth S., and Victoria O'Donnell. 1999. *Propaganda and Persuasion.* Thousand Oaks, CA: Sage Publications.

Kanehisa Tching. 1983. "Whiskey et sake: La publicité façon Japonais." *La Recherche* 14, no. 146 (July–August 1983): 998–1001.

——. 1984. *La publicité au Japon: Image de la société.* Paris: Éditions Maisonneuve et Larose.

——. 2002a. "Jeu graphique des caracteres chinois dans la publicité et les illustrations au Japon." In Kanehisa Tching, *Société et publicité nipponnes*, 12:1–28.

——. 2002b. "Légende de la potion magique à la gloire des salariés: Publicité du re-
montant 'Regain.'" In Kanehisa Tching, *Société et publicité nipponnes*, 5:1–26.

Kashiwagi Hiroshi. 1993. "Post-war History in Advertising Design." In *Advertising
History, 1950–1990*. Exhibition catalog, pp. 14–15. Tokyo: East Japan Railway Cul-
ture Foundation.

Kawahata Naomichi. 1995. "Yamawaki Iwao: His Life and Work." In *Déjà-Vu, a Pho-
tography Quarterly*, edited by Sawada Yoko. Tokyo, Photo-Planete, no. 19 (Spring):
34–39.

Kawamura Yuniya. 2004. *The Japanese Revolution in Paris Fashion*. New York: Berg.

Keith, Robert, and Robert Holloway. 1968. "The Marketing Revolution." *Journal of
Marketing* 32, no. 3 (July 1968): 74–75.

Kelly, Dan. 1982. "Where Mood Speaks Louder Than Words." *Advertising Age* 52, no.
23 (August 1982): M2(2).

Kelsky, Karen. 2001. *Women on the Verge: Japanese Women, Western Dreams*.
Durham, NC: Duke University Press.

Kheir-El-Din, A. 1991. "The Contribution of Marketing to Competitive Success." In
Perspective on Marketing Management, vol. 1, edited by M. J. Baker, 1–28. Chiches-
ter, UK: Wiley Publishers.

Kikuchi Yuko. 2008. "Russel Wright and Japan: Bridging Japonism and Good Design
through Craft." *Journal of Modern Craft* 1, no. 3 (November): 357–82.

Kilburn, David. 1987. "Comparison Ads Makes First Flight in Japan." *Advertising Age*,
June. http://www2.gol.com/users/kilburn/structure.htm.

——. 1989. "Advertising in Japan: Structural Differences." *Journal of Japanese Trade
& Industry* (Autumn). http://www2.gol.com/users/kilburn/structure.htm.

Kinsella, Sharon. 1995. "Cuties in Japan." In *Women Media and Consumption in
Japan*, edited by Lise Skov and Brian Moeran, 220–54. Honolulu: University of
Hawai'i Press.

——. 2000. *Adult Manga: Culture and Power in Contemporary Japanese Society*. Ho-
nolulu: University of Hawai'i Press.

Kinser Hohle, Maggie. 2005. "Muji Creative Director, Kenya Hara." *Theme*, no. 3
(Fall).

Knibbs, David. 1992. "The Kansei Factor: Image Making in Japanese Advertising."
Japan International Journal 2, no. 1 (1992): 18–23.

Kondo, Dorinne. 1997. *About Face: Performing Race in Fashion and Theater*. New
York: Routledge.

Koren, Leonard. 1994. *Wabi-Sabi: For Artists, Designers, Poets and Philosophers*.
Berkeley, CA: Stone Bridge Press.

Kozak, Gisela, and Julius Wiedemann. 2001. *Japanese Graphics Now*. Cologne:
Taschen.

Kvale, Steinar. 1995. "The Social Construction of Validity." *Qualitative Inquiry* 1, no.
1 (1995): 19–40.

Larson, Charles U. 2001. *Persuasion: Reception and Responsibility*. Belmont, CA:
Wadsworth/Thomson Learning.

Lévi-Strauss, Claude. 1963. *Totemism*. Boston: Beacon Press.

Levitt, Theodore. 1960. "Marketing Myopia." *Harvard Business Review,* July–August, 24–47.

Lister, Martin, and Liz Wells. 2001. "Seeing beyond Belief: Cultural Studies as an Approach to Analyzing the Visual." In Van Leeuwen and Carey, *Handbook of Visual Analysis*, 61–91.

Lyotard, Jean-François. 1984 (1979). *The Postmodern Condition: A Report on Knowledge*. Manchester: Manchester University Press.

Machimura Takashi. 2006. "The Urban Restructuring Process in Tokyo in the 1980s: Transforming Tokyo into a World City." In *The Global Cities Reader*, edited by Neil Brenner and Roger Keil, 145-54. London: Routledge.

MacPherson, Kerrie L., ed. 1998. *Asian Department Stores*. Honolulu: University of Hawai'i Press.

Madden, Charles, Marjorie Caballero, and Shinya Matsukubo. 1986. "Analysis of Information Content in U.S. and Japanese Magazine Advertising." *Journal of Advertising* 15, no. 3 (1986): 38-45.

Matsui Midori. 2005. "Beyond the Pleasure Room to a Chaotic Street." In *Little Boy: The Arts of Japan's Exploding Subculture*, edited by Murakami Takashi, 208-40. New York: Japan Society Gallery, and New Haven, CT: Yale University Press.

Matsuo Bashō. 2000. *Narrow Road to the Interior and Other Writings*. Boston: Shambhala.

McKenna, Regis. 1991. *Relationship Marketing: Successful Strategies for the Age of the Customer*. Reading, MA: Addison-Wesley.

McKitterick, John B. 1957. "What Is the Marketing Management Concept?" In *The Frontiers of Marketing Thought and Science*, edited by Frank M. Bass, 71–82. Chicago: American Marketing Association.

McLuhan, Marshall. 1994. *Understanding Media: The Extensions of Man*. Cambridge, MA: MIT Press.

Mears, Patricia. 2010. "Formalism and Revolution." In *Japan Fashion Now*, by Valerie Steele, Patricia Mears, Yuniya Kawamura, and Hiroshi Narumi. New Haven, CT: Yale University Press.

Messaris, Paul. 1997. *Visual Persuasion*. London: Sage Publications.

Mirzoeff, Nicholas, ed. 1998. *The Visual Culture Reader*. London: Routledge.

——. 1999. *An Introduction to Visual Culture*. London: Routledge.

Mitchell, Thomas W. J. 1986. *Iconology: Image, Text, Ideology*. Chicago: University of Chicago Press.

——. 1994. *Picture Theory: Essays on Verbal and Visual Representation*. Chicago: University of Chicago Press.

Miyoshi Masao and H. D. Harootunian. 1989. *Postmodernism and Japan*. Durham, NC: Duke University Press.

Mizuno Hirozuke. 2002. "Style de vie et publicité au Japon dans les années 90." In Kanehisa Tching, *Société et publicité nipponnes*, 4:1-16.

Moeran, Brian. 1989. "Homo Harmonicus and the Yenjoy Girls: The Production and Consumption of Japanese Myths." *Encounter* 72, no. 5 (May 1989): 19-24.

———. 1996a: *A Japanese Advertising Agency: An Anthropology of Media and Markets.* Honolulu: University of Hawai'i Press.

———. 1996b: "The Orient Strikes Back: Advertising and Imagining Japan." *Theory, Culture & Society* 13, no. 3, 77-112.

———. 1998. "The Birth of the Japanese Department Store." In *Asian Department Stores*, edited by Kerrie L. MacPherson, 141-77. Honolulu: University of Hawai'i Press.

———. 2002. "Japanese Advertising Discourse: Reconstructing Images." In *Exploring Japaneseness: On Japanese Enactments of Culture and Consciousness*, edited by Ray T. Danahue, 385-423. Westport, CT: Ablex Publishing.

Morley, David, and Kevin Robins. 1995. *Spaces and Identity: Global Media, Electronic Landscapes and Cultural Boundaries.* London: Routledge.

Mosdell, Chris. 1986. *The Mirror Maker: Cultural Differences between America and Japan Seen through the Eye of Advertising.* Tokyo: Macmillan Language House.

Mueller, Barbara. 1987. "Reflections of Culture: An Analysis of Japanese and American Advertising Appeals." *Journal of Advertising Research* 27, no 3 (June-July): 51-59.

Munroe, Alexandra. 1994. *Japanese Art after 1945: Scream against the Sky.* New York: Harry N. Abrams.

Myers, Greg. 1994. *Words in Ads.* London: Edward Arnold.

Nakada Sadanosuke. 1925. "Kikuritsu Bauhasu," *Mizu-e*, no. 244 (June): 2-7.

Nakane, Chie. 1979. *Japanese Society.* Harmondsworth, UK: Penguin Books.

Narver, John C., and Stanley Slater. 1990. "The Effect of Marketing Orientation on Business Profitability." *Journal of Marketing* 54 (October): 20-35.

Nihon koukokugyou kyoukai kyouiku seminar iinkai, *Koukoku bijinesu nyumon*, nihon Koukokugyou Kyoukai, 2010.

Nilson, Torsten H. 1992. *Value-Added Marketing: Marketing Management for Superior Results.* London: McGraw-Hill.

Nochlin, Linda. 1974. "Some Woman Realists." *Art Magazine* 48, no. 5 (February): 46-57.

Noguchi Isamu. 1990. "New York Mood-o." In Ishioka Eiko, *Eiko by Eiko.* San Francisco: Chronicle Books.

O'Barr, William. 1994. *Culture and the Ad: Exploring Otherness in the World of Advertising.* Boulder, CO: Westview Press.

Ōhashi Norio. 1993. "Dezain shinenpyo." In *Advertising History, 1950-1990.* Exhibition catalog, 175-96. Tokyo: East Japan Railway Culture Foundation.

O'Keefe, Daniel. 2002. *Persuasion: Theory and Research.* Thousand Oaks, CA: Sage Publications.

Ōtuska Eiji. 2010. *World and Variation: The Reproduction and Consumption of Narrative, Mechademia*, vol. 5 (Fanthropologies), 89-116. Minneapolis: University of Minnesota Press.

Oyama Rumiko. 1998. *Visual Semiotics: A Study of Images in Japanese Advertisements.* Unpublished PhD dissertation, Institute of Education, University of London.

Panovsky, Erwin. 1970. *Meaning in the Visual Arts*. Harmondsworth, UK: Penguin Books.

Patton, Michael Quinn. 1990. *Qualitative Evaluation and Research Methods*. 2nd ed. Newbury Park, CA: Sage Publications.

Pollack, David. 2003. "Marketing Desire: Advertising and Sexuality in Edo Literature, Drama, and Art." In *Gender and Power in the Japanese Visual Field*, edited by Joshua Mostow, Norman Bryson, and Maribeth Graybill, 71–88. Honolulu: University of Hawai'i Press.

Postrel, Virginia. 2003. *The Substance of Style*. London: HarperCollins.

Pulos, Arthur J. 1983. *American Design Ethic: A History of Industrial Design to 1940*. Cambridge, MA: MIT Press.

Raizman, David Seth. 2003. *History of Modern Design*. London: Laurence King Publishing.

Rapp, Stan, and Thomas L. Collins. 1994. *Beyond Maxi-Marketing: The New Power of Caring and Daring*. New York: McGraw-Hill.

Raz, Jacob. 1980. "The Audience Evaluated: Shikitei Samba's Kyakusha Hyobanki." *Monumenta Nipponica* 35, no. 2 (Summer): 199–222.

——. 1991. "Japan: Image and Reality, or Japan: Reality of Images." *Studio – Art Magazine* (Tel-Aviv, Givat-Haviva Art Center [Hebrew]), August, 42–47.

Raz, Jacob, and Aviad Raz. 1996. "America Meets Japan: A Journey for Real between Two Imaginaries." *Theory, Culture & Society* 13, no. 3 (1996): 153–78.

Reinhart, Tanya. 2000. *From Cubism to Madonna: Subject and Representation in 20th-Century Art*. Tel Aviv: Hakibutz Hameuchad (Hebrew).

Rodowick, N. David. 1997. *Gilles Deleuze's Time-Machine*. Durham, NC: Duke University Press.

Rosenau, Pauline Marie. 1992. *Post-Modernism and the Social Sciences*. Princeton, NJ: Princenton University Press.

Rupp, Katherine. 2003. *Gift-Giving in Japan: Cash, Connections, Cosmologies*. Palo Alto, CA: Stanford University Press.

Said, Edward. 1979. *Orientalism*. New York: Vintage Books.

Sakai Junko. 2002. "The Emergence of Men's Magazines." *Japanese Book News*, no. 38 (Summer): 4–5.

Sapin, Julia. 2004. "Merchandizing Art and Identity in Meiji Japan: Kyoto Nihonga Artists' Design for Takashimaya Department Store, 1868–1912." *Journal of Design History* 17, no. 4: 317–36.

Sato, Barbara. 2003. *The New Japanese Woman: Modernity, Media, and Women in Interwar Japan*. Durham, NC: Duke University Press.

Sato Toyoko. 2010. "Organizational Identity and Symbioticity: Parco as an Urban Medium." *Journal of Management History* 16, no. 1: 44–58.

Saussure, Ferdinand de. 1974. *Course in General Linguistics*. London: Vintage.

Schlossberg, Howard. 1992. "Battle Rages between Attitude and Behavior Researchers." *Marketing News* (March): 18–19.

Screech, Timon. 1999. *Sex and the Floating World*. Honolulu: University of Hawai'i Press.

Shein, Jean-Emmanuel. 1991. "Hello Kitty as Style-Maker: Advertising and Popular Culture in Japan." *Japan Society Newsletter* 34, no. 5.

Shillony, Ben-Ami. 1995. *Traditional Japan: Culture and History.* Tel Aviv: Schocken.

———. 1997. *Modern Japan: Culture and History.* Tel Aviv: Schocken.

Shimamura Kazue and Ishizaki Tooru. 1997. *The History of Advertising Research in Japan.* Tokyo: Dentsu.

Shimizu Keiichirō. 1993a. "Advertising Language Becomes the Language of the Era: The 1980s." In *Advertising History, 1950-1990.* Exhibition catalog, p. 136. Tokyo: East Japan Railway Culture Foundation.

———. 1993b. "When Advertising Was Transformed: The 70s." In *Advertising History, 1950-1990.* Exhibition catalog, p. 100. Tokyo: East Japan Railway Culture Foundation.

Skov, Lise. 1996. "Fashion Trends, *Japonisme* and Postmodernism: Or 'What Is So Japanese about *Comme des Garçons*?'" *Theory, Culture & Society* 13, no. 3: 129-51.

Skov, Lise, and Brian Moeran. 1995. "Introduction: Hiding in the Light: From Oshin to Yoshimoto Banana." In *Women Media and Consumption in Japan*, edited by Lise Skov and Brian Moeran, 1-75. Honolulu: University of Hawai'i Press.

Spies, Werner, and Wolfgang Volz. 1985. *Christo: Surrounded Islands, Biscayne Bay, Greater Miami, Florida 1980-83.* Translated by Stephen Reader. New York: Harry N. Abrams.

Steele, Valerie, Partricia Mears, Yuniya Kawamura, and Hiroshi Narumi. 2010. *Japan Fashion Now.* New Haven, CT: Yale University Press.

Strauss, Anselm, and Juliet Corbin. 1992. *Basics of Qualitative Research.* London: Sage Publications.

———. 1994. "Grounded Theory Methodology: An Overview." In *The Handbook of Qualitative Research*, edited by Norman K. Denzin and Yvonna S. Lincoln, 273-85. Thousand Oaks, CA: Sage Publications.

Sturken, Marita, and Lisa Cartwright. 2001. *Practices of Looking: An Introduction to Visual Culture.* Oxford: Oxford University Press.

Suzuki Kyōichi. 2008. *Kidaore Hōjōki—Happy Victims.* Kyoto: Seigensha.

Tabuchi Hiroko. 2011. "Facebook Wins Relatively Few Friends in Japan." *New York Times*, January 9.

Taittinger, Thierry, ed. 2010. *Murakami: Versailles.* Ivry-sur-Seine: Beaux Arts Éditions and TTM Éditions.

Tanaka Keiko. 1994. *Advertising Language: A Pragmatic Approach to Advertisement in Britain and Japan.* London: Routledge.

Thornton, Richard. 1991. *Japanese Graphic Design.* London: Laurence King.

Tipton, Elise, and John Clark, eds. 2000. *Being Modern in Japan: Culture and Society from the 1910s to the 1930s.* Honolulu: University of Hawai'i Press.

Tobin, Joseph J. 1992. "Introduction: Domesticating the West." In *Re-made in Japan: Everyday Life and Consumer Taste in a Changing Society*, edited by Josef J. Tobin, 1-41. New Haven, CT: Yale University Press.

Tokyo Art Directors Club. 1982. *Nenkan Kōkoku Bijutsu* (ADC Annual, 1982). Tokyo: Bijutsu Shuppan.

——. 1983. *Nenkan Kōkoku Bijutsu* (ADC Annual, 1983). Tokyo: Bijutsu Shuppan.

Traganou, Jilly. 2011. "Tokyo's 1964 Olympic Design as a 'Realm of [Design] Memory.'" *Sport in Society: Cultures, Commerce, Media, Politics* 14, no. 4: 466-81.

Ueno Chizuko. 1987. "The Position of Women Reconsidered." *Current Anthropology* 28, no. 4 (August-October): S75-S84.

——. 1998. "Seibu Department Store and Image Marketing: Japanese Consumerism in the Postwar Period." In MacPherson, *Asian Department Stores*, 177-205.

Van Leeuwen, Theo. 2001. "Semiotics and Iconography" In Van Leeuwen and Jewitt, *Handbook of Visual Analysis*, 92-118.

Van Leeuwen, Theo, and Gunther Kress. 1996. *Reading Images: The Grammar of Visual Design*. London: Routledge.

Van Wolferen, Karel. 1989. *The Enigma of Japanese Power*. New York: Alfred A. Knopf.

Vestergaard, Torben, and Kim Schroder. 1985. *The Language of Advertising*. Oxford: Blackwell.

Vogel, Ezra F. 1979. *Japan as Number One: Lessons for America*. Cambridge, MA: Harvard University Press.

Watanabe Toshio. 1996. "Josiah Conder's Rokumeikan: Architecture and National Representation in Meiji Japan." *Art Journal* 22 (Fall): 21-27.

Weill, Allan. 2002. "Makoto Saito: The Image Maker." *Graphis: The International Journal of Design and Communication* 58, no. 341 (September-October): 32-33.

Weisenfeld, Gennifer. 2002. *Mavo: Japanese Artists and the Avant-Garde, 1905-1931*. Berkeley: University of California Press.

——. 2004. "'From Baby's First Bath': Kao Soap and Modern Japanese Commercial Design." *Art Bulletin* 86, no. 3 (September): 573-98.

——. 2008. "Selling Shiseido: Japanese Cosmetics Advertising and Design in the Early 20th Century." In *Visualizing Cultures* website. Cambridge, MA: MIT Press.

——. 2009. "Publicity and Propaganda in 1930s Japan: Modernism as Method." *Design Issues* 25, no. 4 (Autumn): 13-28.

Westney, Eleanor. 1996. "Mass Media as Business Organization: A US-Japan Comparison." In *Media and Politics in Japan*, edited by S. Pharr and E. Krauss, 47-88. Honolulu: University of Hawai'i Press.

Wilk, Robert. 1994. "The 'Difference' in Japanese Advertising." *Japan Society Proceedings* 123 (Spring): 29-37.

Williamson, Judith. 1978. *Decoding Advertisements: Ideology and Meaning in Advertising*. London: Marion Boyars.

——. 1986. *Consuming Passions: The Dynamics of Popular Culture*. London: Marion Boyars.

Wilson, Eric. 1990. "These New Components of the Spectacle: Fashion and Postmodernism." In *Postmodernism and Society*, edited by R. Boyne and A. Rattansi, 209-36. London: Macmillan.

Wolff, Janet. 1993. *The Social Production of Art*. London: Macmillan.

Wong, Veronica, and John Saunders. 1993. "Business Orientations and Corporate Success." *Journal of Strategic Marketing* 1, no. 1 (March): 20-40.

Yamaki Toshio. 2002. "Consommation, publicité et crise au Japon après l'éclatement de la bulle speculative." in Kanehisa Tching, *Société et publicité nipponnes*, 1:1-17.

——. 2002. "Vieillissement de la société et publicité." In Kanehisa Tching, *Société et publicité nipponnes*, 10:1-19.

Yamawaki Iwao. 1954. *Bauhaus no hitobito*. Tokyo: Shokokusha.

Yasuda Teruo. 1997. *Ano Kōkoku wa Sugokatta!* Tokyo: Chukei shupan.

——. 2001. *Ano Kōkoku Kopi wa Sugokatta!* Tokyo: Chukei shupan.

Yomiuri Shimbun. 2007. *Advertising Bureau Newsletter* 10, no. 9 (December).

Yoshinaga Haruyuki. 2002. "Communication publicitaire des collectivités locales au Japon." In Kanehisa Tching, *Société et publicité nipponnes*, 9:1-18.

Yoshimoto Mitsuhiro. 1989. "The Postmodern and Mass Images in Japan." *Public Culture* 1, no. 2 (Spring): 8-25.

Yusuke Kaji. 1993a. "The Era of Individualization of Expression: The 1960s." In *Advertising History, 1950-1990*. Exhibition catalog, p. 56. Tokyo: East Japan Railway Culture Foundation.

——. 1993b. "The Florescence of Advertising Communication: The 1950s." In *Advertising History, 1950-1990*. Exhibition catalog, p. 28. Tokyo: East Japan Railway Culture Foundation.

Zimbardo, Philip G., and Michael R. Leippe. 1991. *The Psychology of Attitude Change and Social Influence*. New York: McGraw-Hill.

INTERVIEWS

Aoki Katsunori[*]

Hara Kenya[*]

Hattori Kazunari[*]

Hoshiba Kunikazu (Studio Katachi)

Miyata Satoru[*]

Nagai Kazufumi[*]

Nakashima Shōbun[*] (former president of Tokyo ADC)

Ōnuki Takuya[*]

Saitō Makoto[**]

Suzuki Hachirō[*]

Toda Seijū[**]

Watanabe Kaoru[*]

Watanabe Yoshie[*]

Yamamura Naoko (Hakuhodo account manager)

[*] Tokyo ADC member

[**] Former Tokyo ADC member

Page numbers in *italics* indicate figures. Page numbers with "n" indicate terms in the endnote section.

Index

color: monochromatic, 79–80, 80–81, 82–85, 87–88, 90–93, 160; polychromatic, 93, 94–95, 96, 97, 98–99; symbolic meaning for Japanese, 87–88, 89, 90, 103–4, 224n7

Comme des Garçons, 69

commercials, broadcast. *See* television and radio

commodity exchange value, 143, 150

commodity self, 145

competitive accounts, agency management of, 167–68

compositional quotation, *115, 115–18, 115–19*

computer/video games, 71, 105

constructivist movement, 5, 23, 25, 27, 135, 215n36

consumer culture: bubble economy (1980s), 11, 70, 138–42, 183–90; historical perspective, 20–21, 36–39, 49; rediscovery of unique Japanese identity, 43–44; refocus on spiritual needs, 196, 200–201, 205. *See also* late consumer culture in Japan; values of consumer; visual culture

context for poster campaigns, importance of, 173, 234n29. *See also* social context

corporate-agency relationships, 165–66

corporate identity: advertising design for, 6, 8, 25, 38, 169, 210n14; bubble economy era focus on, 150, 151; reputation *(ethos)*, 134, 136, 169, 181, 187, 198–99; and sign value branding, 155–56; as socially responsible, 198–200; Tokyo ADC's focus on, 11. *See also* branding

cuteness visual culture. See *kawaii* style

death-life dichotomy, 82, 84, 87, 131–32, 182, 201, 202

decentralization in Japan, 201, 203

deconstruction theory, 66–67

decryption of enigmatic imagery and connection to consumer, 152, 154, 157

Dentsu advertising agency, 164, 165, 166

design. *See* graphic design

designer-art strategy for ad campaigns, 172–73

desire and pleasure, consumer focus on, 139, 142–43, 144, 183, 189, 235n14

differentiation, social: and affiliation through style choice, 148–49; and corporate identity, 156; and late consumer culture, 144–46, 231n50; and market structure of Japanese advertising, 168; taste and style, 145–46, 231n46, 231n51; in traditional Japanese product design, 149

digital aesthetic, 103–4

digital technology: computer/video games, 71, 105; impact on visual culture, 64; and rise of glocal style, 204–5

Douglas, Mary, 142

Dünkelsbühler, Otto, 25

economy of Japan: economic boom of 1960s, 37, 38; influence on advertising industry, 9, 157; local production focus after 1985, 229n23; middle class growth, 40–41, 183; modern product-focused period, 32–36; oil crisis (1973), 40, 42, 218n85; post-bubble economy (1990s), 191–96, 199, 200–201, 203, 206, 236n3, 237n17; postwar focus on exports, 33, 36; postwar privations' influence on, 30–32; postwar recovery under U.S. occupation, 46–47; vs. social influences, 134. *See also* bubble economy

Edo period (1603–1867), 20, 93, 133, 170, 214nn13–14

Eisenstein, Sergei, 88–89

elite aesthetic milieu, 64–65, 74–77, 87, 127

embedded marketing, 89, 214n13

emotional branding *(pathos)*, 89, 135, 136, 160

empty space *(ma)*, meaning in, 85, 160